To Charles K. Feldman

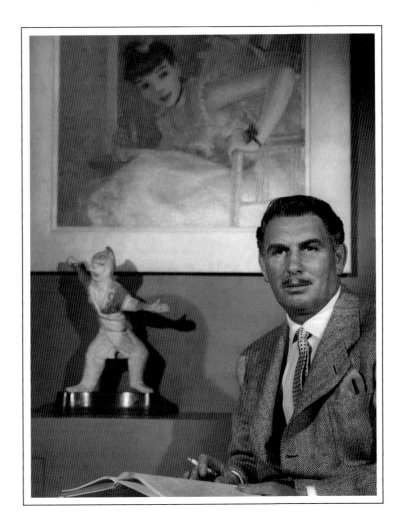

Charlie dear,
Here is your world as I saw it.
Love, Jean

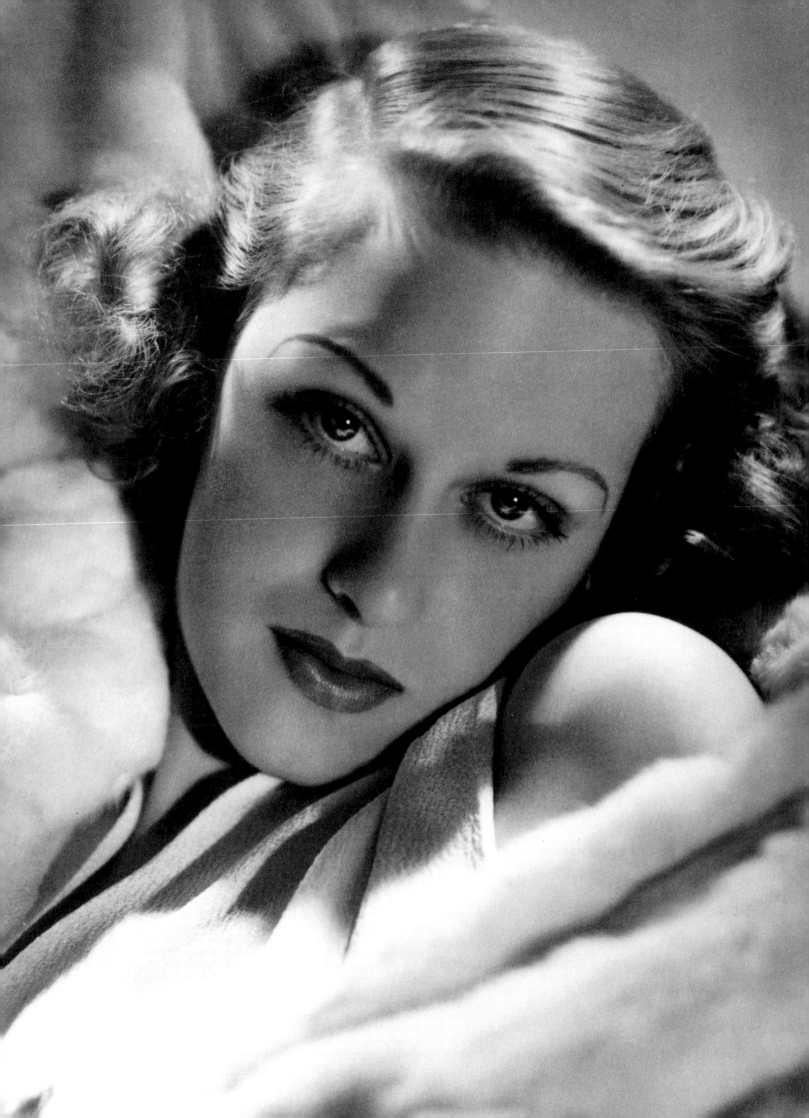

Jean Howard's

PHOTOGRAPHS BY
JEAN HOWARD

WITH TEXT BY
JAMES WATTERS

DESIGN BY
JOHN LYNCH

Hollywood
A Photo Memoir

ABRADALE PRESS

HARRY N. ABRAMS, INC., PUBLISHERS, NEW YORK

Up Front:

Page 1: Charles K. Feldman, 1946

Page 2: Jean Howard, 1933

Page 3: Jean Howard, 1946

This page, above: Flo (Mrs. Earl) Smith, Palm Beach, Florida, c. 1952

This page, below: Jimmy Devries, New York City, c. 1950

Page 6: Marlene Dietrich (left) and Ann Warner (wife of studio chief Jack Warner, at the postpremiere party held at the Trocadero in Los Angeles for the 1939 Warner Bros. film Juarez.

James Watters wishes to thank John Bryson, the photographer who introduced him to Jean Howard's pictures; Lloyd Ibert, Howard Mandelbaum, and Gordon Mathews for research and support; and especially Bob Tabian, his agent.

Editor: Harriet Whelchel
Produced by: Jean Howard, Stuart Jacobson, Jane Lahr, John Lynch.

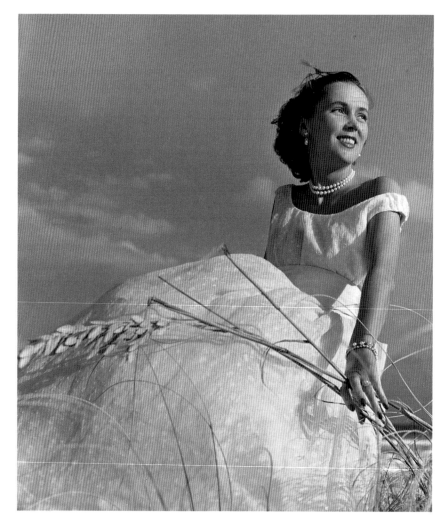

The Library of Congress has cataloged the Abrams edition as follows:

Howard, Jean.
 Jean Howard's Hollywood: a photo memoir/
photographs by Jean Howard; text by James Watters.
 p. cm.
 Bibliography: p. 246
 Includes index.
 ISBN 0–8109–2679–2 (pbk.)
 1. Howard, Jean. 2. Motion picture actors and
actresses—United States—Biography. 3. Women photographers—United States—Biography. 4. Motion
picture actors and actresses—United States—Portraits.
5. Motion pictures—California—History.
I. Watters, James. II. Title.
PN2287.H724A3 1989
791.43'028'0922—dc19 89–264
Abradale ISBN 0–8109–8218–8

Clothbound edition published in 1989 by
Harry N. Abrams, Inc.

Printed and bound in China

10 9 8 7 6 5 4 3 2 1

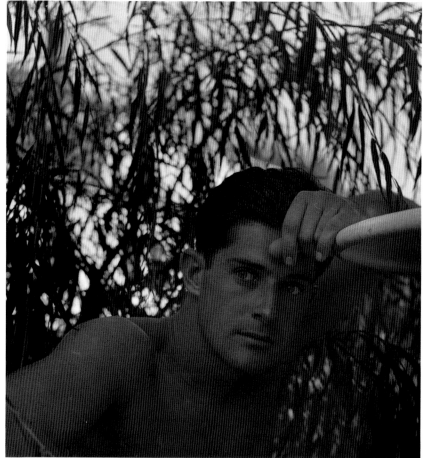

ACKNOWLEDGMENTS

The past is such a subtle thing. In the end nothing else exists,
everything is made of the past, even the future. —Natalie Barney

Had it not been for Rupert Allan of Beverly Hills, California, I would never have known Stuart Jacobson, and had I not met Stuart I would not have met Jane Lahr, and had I not met Jane I would never have known John Lynch. And had I not met these three delightfully gifted people, I would never have found myself in the office of Paul Gottlieb, publisher and president of Harry N. Abrams, Inc., in New York City.

It all began when Rupert Allan telephoned me one day to ask if I would see a fellow who was putting a book together. I thought, Another one! but said, "Send him over." Expecting to see some odd-looking person, I opened the door and in breezed the best-looking fellow I'd seen in years—Stuart Jacobson, not only handsome but the most positively appealing personality I have ever known.

I have a Verdura cigarette case once owned by Cole Porter that Stuart wanted to photograph for his book, *Only the Best.* As the photographer was arranging the picture, Stuart picked up some photographs and began thumbing through them. "What's this?" he asked, handing me a couple of pictures. I told him they were some of my photographs. "What have you done about them? Have you ever thought of doing a book?" "I've tried—saw a couple of publishers," I replied. "They liked the pictures but didn't know what to do with them." Stuart suddenly said, "These are great! I'll get this book published." I smiled, gave a feeble thanks, and thought no more about it until months later, when Stuart telephoned to say he would be in San Francisco the following week and to ask if I could bring some pictures to him there to show his associate Jane Lahr. I could. I did. Jane liked the pictures and said she would get back to me.

Months went by. One day Stuart called: could I send everything I had to New York? He wanted to show them to someone. I sent a boxful of photographs—everything. Weeks went by with no word from anyone.

Stuart's book came out and was a tremendous success. I went to the book party in New York, but Stuart and Jane weren't there.

I began to panic. Where was that box that contained my whole life? Stuart was on the road selling his book; Jane was working on something else; and I, thinking the box was lost, was going crazy when Jane called to invite me to lunch. She wanted me to meet the book designer John Lynch, who was wild about my photographs. Ah, so *he* had the box; I couldn't wait to meet him. Here was someone who not only liked my work but also had purple hair. We clicked—spoke the same language from the beginning and will until the end.

All that began in 1984. At last, here we are five years later with my life finally on the bookshelves. And for that I extend deepest and everlasting thanks to Stuart, whose enthusiasm as he looked at my pictures and visualized a book made it a fact; to Jane, whose thoughtful and knowing suggestions brought us and *it* all together; to John, whose perceptive attention to detail and quality made me see my pictures as I had never seen them before; and to Diane Lynch, whose patience and keen eye as we went through the pictures with John again and again were greatly appreciated.

I also wish to thank the following friends: Grace Dobish, Charles Feldman's secretary from the beginning of his business life in 1930 until the day he died in 1968, for standing by me through thick and thin; Harriet Whelchel, possibly the greatest long-distance editor ever, for her intuitive perception; George Christy for the splendid photo essay that he gave my pictures in the "1978 Collectors' Edition" of *The Hollywood Reporter,* and for his friendship; Jim Watters, LIFE magazine editor and writer, for his nice LIFE essay in 1980; Robert Kimball for his knowledgeable and endless encouragement and advice toward gaining attention for my work; D. V.!, Diana Vreeland, simply the greatest fashion editor ever, for her interest and gentle nudging ("Do it, Jean"); Suzy, Aileen Mehle, who liked my pictures but had too much work of her own to get involved; Leonard Stanley, for his continued encouragement and applause; Verna Hull, advanced Art Center student, who taught me to read the light meter; Moss Hart, whose funny captions really sold LIFE magazine on my croquet pictures in 1946—blessings and fond memories, Moss; George "Slim" Aarons, a combat photographer for the *Stars and Stripes,* whom I met in 1945 when he was just out of the army and I was finishing my course at the Art Center: we talked photography and became pals—Slim has held the lights for me through the years as I have for him; Michael Pearman for the years of deepest friendship and for his laughter when I told him about this book ("At last!"); Iva S. V.-Patcévitch, president, Alexander Liberman, art director, and Allene Talmey, feature editor, at Condé Nast Publications, Inc., special thanks for putting Hollywood and my photographs in their first-rate publications; Nadia Gardiner for remembering dates and spelling certain names, and especially for the fun we shared in those days; Marti Stevens for her enthusiasm and belief through the years; Sam Shaw, artist, art director, movie producer, and photographer, a solid, generous friend to so many, and loved by all; and Tony Santoro for firmly holding my hand and settling me and telling me to "drop everything and stay with the book."

Hollywood as I knew it had glamour and a touch of mystery. Hollywood *was* glamour; the studio bosses—the Mayers, the Warners, and the Zanucks—saw to it. They guarded their stars carefully and had them photographed in highly stylized poses that gave them an alluring but impenetrable charm. Stars rarely were pictured completely relaxed and having fun. They worked hard; they played hard. Saturday night was party night. Our living rooms overflowed with an abundance of talent—possibly the most and best that Hollywood has ever seen or ever will see again in one period of time.

These photographs bring back memories of a time and a place that have long since faded. Hollywood has changed, and things don't happen as they once did. Never mind. The people who crowd these pages are as clear as snowcapped mountains on a bright sunny day. J. H.

Contents

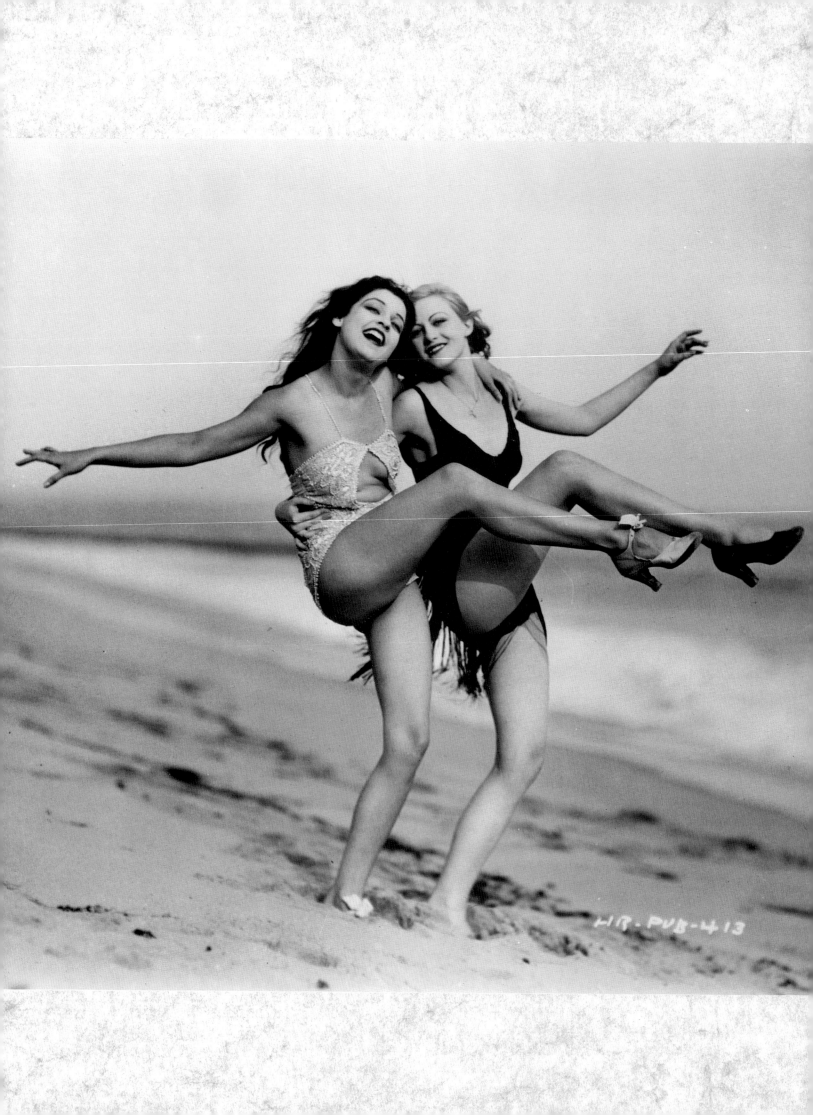

A Cute Kid from Texas

Opposite: I was at Santa Monica doing some high kicks with another movie hopeful. I cannot recall a thing about this shot or, alas, my busty brunet friend. How it happened, or why, is lost in time. The photograph does have the Hal Roach Studio stamp on it, but I never made a movie or a short for the Roach company. My mystery friend and I seem to be having a good time, or at least giving our all in the spirit of innocent cheesecake, early 1930s– style. Right: I grew up in Dallas, Texas. One day, when I was in my mid-teens, my father sent me to Paul Mahoney's photography studio in downtown Dallas with my nephew, Richard Hill, to have his picture taken as a Christmas gift for the boy's mother. It was a fateful journey. Mr. Mahoney, who would become my mentor and teacher, said, "Why don't we take one of you?" and it was the beginning of a new life for me.

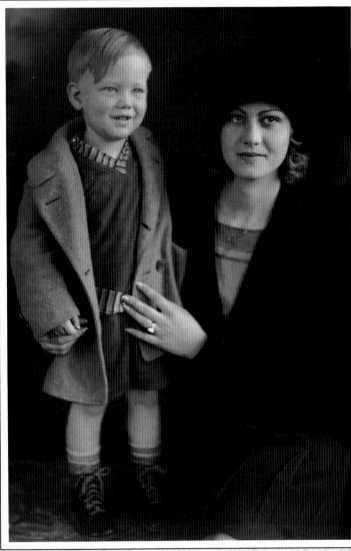

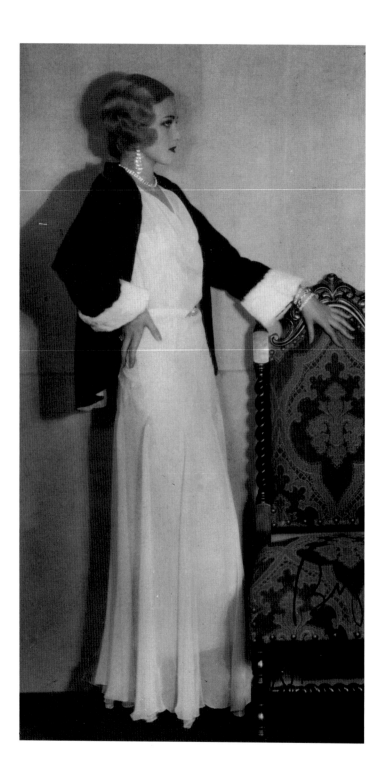

I was young, eager, and frustrated. I had a stepmother I didn't like and I longed for a change, which is what I found the day I took my nephew to Paul Mahoney's studio. In that atmosphere I was changed myself. Mr. Mahoney had a solid reputation. I believe he discovered little Mary Brian, the memorable Wendy of the silent *Peter Pan*, and he had helped other homegrown talent like Ginger Rogers. I was born Ernestine Hill, but soon I took my surrogate family's name and rechristened myself Ernestine Mahoney. Oh, my father footed the bills, but with Mr. Mahoney's tutelage I got into fashion shows and what were referred to as "Miss" shows. I usually won the prize. Mrs. Mahoney taught me to tint photographs, which I did between modeling jobs.

In my first photograph as a model (left), I was a strong-jawed, marcelled sixteen-year-old doing my best to look like Vilma Banky, Rudolph Valentino's favorite leading lady. This picture went into the window of the A. Harris Department Store.

I was already scheming escape when my real father took me to Hollywood one summer in the late 1920s. I was his cover-up while he was on a two-week toot with a girlfriend behind my stepmother's back. It's hard to express what the movies meant to a youngster in those days. Hollywood was no less than heaven on earth. With the movies, you entered a darkened room and dreamed. Well, that summer in Hollywood I couldn't stop dreaming after I saw a movie being made. I've forgotten its name, but I vividly remember Constance Talmadge, one of the three Talmadge sisters, and Antonio Moreno, a cross between Rudolph Valentino and Ramon Novarro, shooting a scene in a boat in Westlake Park. I just had to get back to Hollywood, and the Mahoneys fulfilled my wish. They brought me back and checked me into the all-girl Studio Club, founded by Mary Pickford to help young hopefuls toward movie careers. I had been a good pupil in Dallas. I knew how to pose, how to walk, had gone to dancing school, and had done enough local theater to feel confident in my naïveté. My break came when I answered an ad from the Goldwyn studios: "Bring bathing suit and an evening frock." I bought a flaming red sheath for twelve dollars on Hollywood Boulevard and was hired. Samuel Goldwyn and Florenz Ziegfeld had joined forces in 1930 to film Eddie Cantor's Broadway musical hit, *Whoopee*. With Busby Berkeley making his movie debut as the dance director, I got to parade around in chiffon and a big picture hat for a wedding scene with other young hopefuls, including Claire Dodd and Virginia Bruce. Betty Grable, then just fourteen

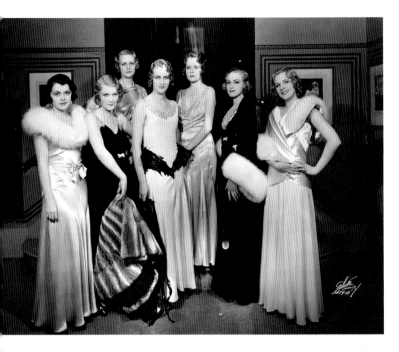

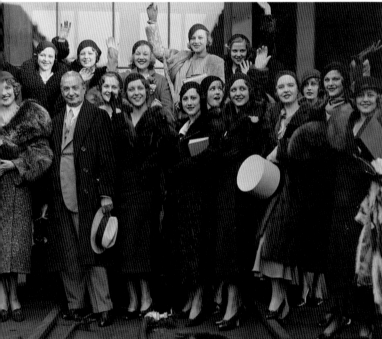

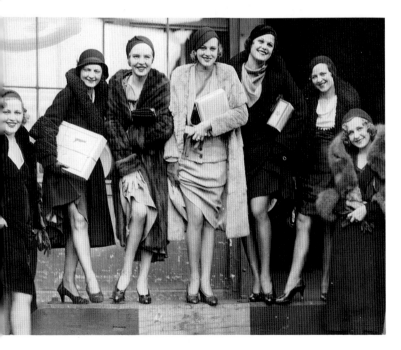

years old, and Paulette Goddard were also part of the ensemble. Just six months after the crash on Wall Street, I had a contract as a "lady of the ensemble" for seventy-five dollars per week.

From *Whoopee* Ziegfeld picked four show girls to go to New York for his next musical, *Smiles*, starring Marilyn Miller. I was one of the four, but my father was killed in an automobile accident, and I had to return to Dallas and miss Broadway. Six months later, however, Ziegfeld cast me in his last *Follies* under the name Jean Howard, which seemed less cumbersome than Ernestine Mahoney. I was named one of the most beautiful girls in the production for my "pulchritude, figure, and charm," none of which helped the show to run. Ziegfeld was by now an exhausted man. His last shows were more extravagant than ever, and he was going bankrupt, a victim of the 1929 crash along with his rich backers. He was losing his health as well. He signed me for his Broadway swan song, *Hot-Cha*, starring Buddy Rogers, Bert Lahr, and Lupe Velez; it failed, despite Lupe spitting fire on and off the stage. Ziegfeld died in 1932, heavily in debt. His wife, Billie Burke, had found work in Hollywood and eventually paid off all his creditors.

Although I arrived at the end of the Ziegfeld era, I had got my foot in the theatrical door. Today I may be one of the last, if not *the* last, of Ziegfeld's show girls. It's odd to think of myself as an endangered species.

During my short-lived stage career, I was primarily a show girl, although in the *Ziegfeld Follies* I understudied Helen Morgan in her sketches. I wasn't a chorine, however. The latter could be cute and cuddly, the former had to be tall and poised. The chorus girl had to pass muster as a singer, dancer, even an acrobat at times. A show girl was required to walk well and wear costumes alluringly. And the Ziegfeld show girl was presented as the glorification of all that was graceful and beautiful in American womanhood. If she had a come-hither sexuality tempered by aloofness that sparked across the footlights, she was the Ziegfeld ideal. It wasn't easy!

Above: Here I am (second from right) in the lobby of the Ziegfeld Theatre with a few of my comrades from the 1931 *Ziegfeld Follies*. The others are (from left) Dorothy Dianne, Jean Audree, Marie Stevens, Caja Eric, Eunice Holmes, and Catherine Clark. Middle: Ziegfeld and his show girls—I'm at the top with Boots Mallory. Below: There I am in the middle of the picture. Many of the names from this period are lost to me now, but memories of the excitement, the glamour, and the good times remain.

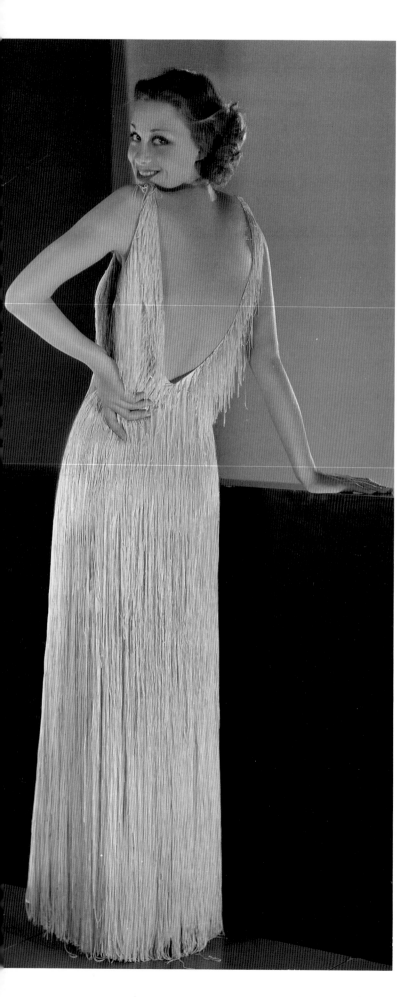

The two faces of me, circa 1933. <u>Left</u>: The real me, in a white fringe number I bought for myself (for a hundred dollars at Jay Thorpe's) when I knew I was going to Hollywood and might need to slip into something glamorous. <u>Opposite</u>: The Metro-Goldwyn-Mayer me, more glamorous than I ever had a right to be. With my MGM contract I spent more time in the photography gallery posing for publicity stills than in front of a movie camera making films. I averaged one day a week doing these high-glamour shots. George Hurrell was one of the great Hollywood portrait photographers. Although only briefly active at the studio, he was responsible for many of the glamorous photographs of the MGM "Queen Bees" like Joan Crawford, Greta Garbo, and Norma Shearer. It was Hurrell who made the photograph of me on page 2. MGM also had many talented photographers on staff, such as Clarence Sinclair Bull and Russell Ball, who took the photographs at left and opposite, respectively.

Indirectly, the man who was in love with me at that time made my MGM contract possible and, in doing so, lost me. Bertrand Taylor was one of the most desirable bachelors in Manhattan. He was understanding and realized I wanted to be an actress, and he respected my independence. Bert's sister was the Contessa Dorothy di Frasso, née Dorothy Taylor, and she had put her mark on many men, but never more rewardingly than with Gary Cooper. Dorothy and Gary were a modern-day Pygmalion and Galatea in reverse. I don't know if it's true, but once when Dorothy and Gary didn't show up at a party hosted by Tallulah Bankhead, she was heard to drawl in her best Alabama accent, "He must be worn to a Frasso."

Dorothy had another important friend, Robert J. Rubin, an attorney for MGM. She insisted that he have lunch with Bert and me at The Colony, and at that meeting a screen test was arranged. But Dorothy's real coup was Coop. He was in town only four days, and she asked him to feed me lines one of the days—it took a whole day to screen-test. She knew, as I knew, that the Hollywood muckamucks would sit up and take notice if a new blonde flashed on screen with the hottest male star of 1933. Years later it amused me to think that had it not been for Coop, I would never have made it to Hollywood with a nice MGM contract.

After I married Charles Feldman in the fall of 1934, however, I gradually discarded what I once thought was my reason for living. It turned out that living was more important than acting to me. I did a few acting roles throughout the 1930s, but my most important role was to be behind a camera, not at all what Ernestine Hill had dreamed about.

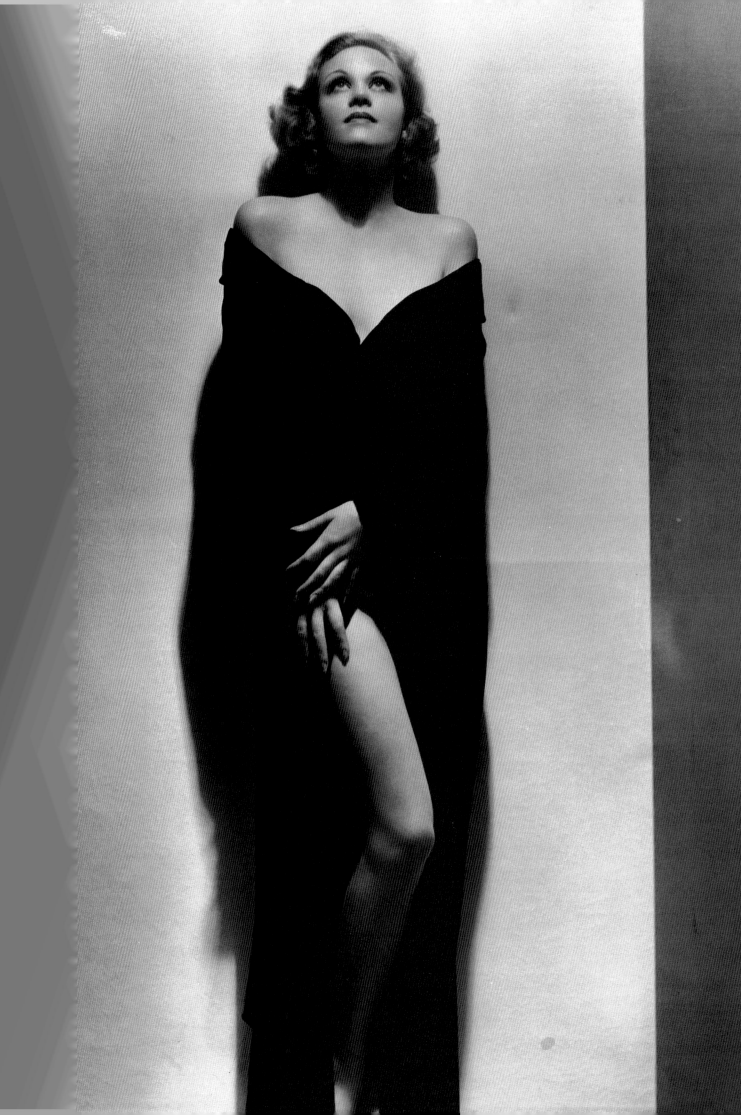

In the 1930s, the Beverly Wilshire (opposite) was the place to go tea dancing on weekends from four to seven P.M. It was one of these afternoons that Charles Feldman spotted me dancing with Tommy Phipps, my dashing English friend who was visiting Mary Pickford and Douglas Fairbanks, Sr. Tommy was a wonderful dancer; he could make any woman look good on the dance floor, and maybe that's one of the reasons I made an impression on Charlie.

Candy and flowers began to arrive, the first with this note (below). When I asked who Charles Feldman was and was told he was an agent, all I could visualize was an unattractive little guy, the stereotype of what every fast-talking agent supposedly looks like. There was no phone number, no address, so I couldn't thank him or return the gifts.

Hollywood was a small town in 1933, and I chalked this attention up to my being a new face with a feature-player

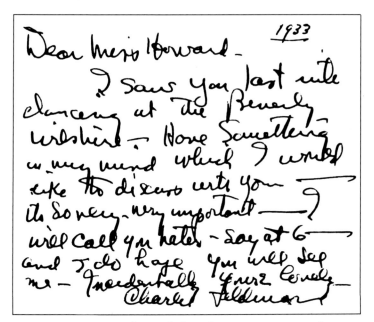

contract at a top studio and therefore an easy target for any hustling agent. The flowers continued, and when a business card finally was attached, I simply tossed it aside. "Oh, those agents," I sighed, beginning to think this mystery man was some kind of nut.

Then one weekend my *Ziegfeld Follies* friend Billie Seward asked me to go to a farewell bash for Louie Shurr, a New York agent who used to hang around backstage at the *Follies* trying to date up any willing chorus girl. He became known in the gossip columns as the guy with the ermine coat because he passed it around from girl to girl. I told Billie I wouldn't cross the street to tell him good-bye, but she said, "Why stay home alone on a Saturday night?"

At the party I found a sofa where I could see everything and everybody. I had my eye on the door because I knew I wasn't going to stay very long. Suddenly, the best-looking man I had ever seen sauntered through the door. I turned

to the man next to me, who happened to be Mervyn LeRoy, already a hotshot director of early sound hits, and asked who that man was. "Charlie Feldman!" I almost shouted. Mervyn motioned for him to come over, and it seemed to take years for Charlie to cross the room to us.

Mervyn said, "Charlie, meet this beautiful girl; she's just out from New York. This is . . ." "Jean Howard," Charlie interrupted. "You're very rude, Miss Howard. You never answer my messages."

I apologized awkwardly. I was a nervous wreck, for in all my twenty-three years I had never felt the way I did

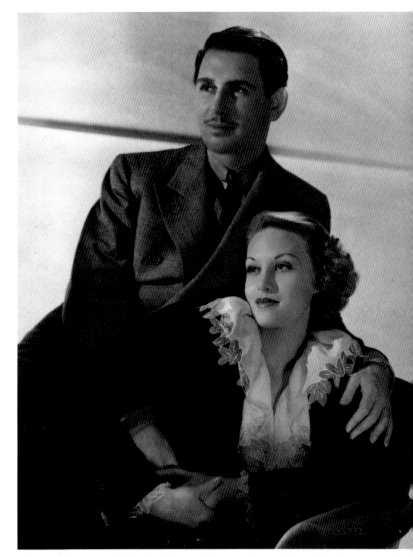

when I first met Charlie. It was love at first sight. Charlie always said that it was love for him when he saw me dancing in the ballroom with Tommy.

As the party drew to a close, Mervyn asked if Charlie was going down to the railroad station to see Louie off on the Super Chief. "Only if Miss Howard comes with me," was the reply. So I, who wouldn't go across the street to say good-bye to Louie Shurr, went all the way to downtown Los Angeles from Beverly Hills to see him off. But I went in Charlie Feldman's car.

Above: Mr. and Mrs. Charles K. Feldman, c. 1939

If you were new to Hollywood in the 1930s as I was, you heard about the great days of the 1920s, when Mary Pickford and Douglas Fairbanks were king and queen of the movies and Gloria Swanson and Pola Negri were archrivals and Valentino was the shopgirl's sheikh. The forties crowd lamented the golden thirties of Garbo and Dietrich, Fred and Ginger, Shirley Temple and Snow White, and it continues on today as generation after generation sees the past through tinted glasses.

You had not *really* arrived in Hollywood in the 1930s until you got your invitation to the Enchanted Hill, William Randolph Hearst's $50 million (and those are pre–World War II dollars) playground in the Santa Lucia Mountains of central California. I was invited to San Simeon through my buddy from the *Ziegfeld Follies*, Lorelle McCarver, who married William Randolph Hearst, Jr. (Bill). Clockwise from top left: Billy Revere, Lorelle's brother, and I pose in front of the main entrance to San Simeon in 1933. The great silent star Lois Wilson (left) with Hearst's irresistible and much-maligned mistress, Marion Davies. At the landing strip at San Simeon: George Rosenberg, Randolph Hearst, Buster Collier, Jr., Aileen Pringe in white, and three

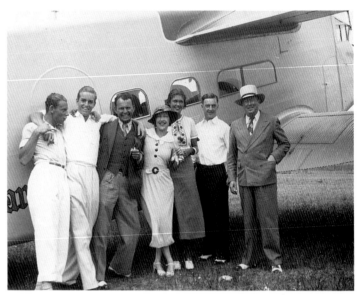

forgotten faces. At Santa Monica, another favorite gathering spot, Lorelle watches while Randy Hearst (on whom I had a tremendous crush) and George Rosenberg converse. Billie Seward with Georgie Hale and Johnny Weissmuller just

the theme of things at a "kiddie" party hosted by the Hearst brothers, Bill, Randy, and David, at Hollywood's Vendome Restaurant. At the Santa Fe, New Mexico, stop on the Super Chief in 1938, Sally Eilers is on my right and Eloise O'Brien my left,

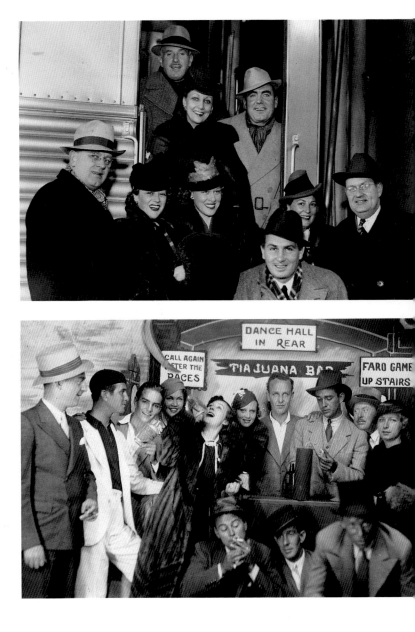

after his first Tarzan triumph; Billie married another Billy, Billy Wilkerson, founder of *The Hollywood Reporter* trade paper. Billie and I ride on a bicycle built for two.

Above, clockwise from left: My husband and I get into

with Ann Warner and Pat O'Brien behind us, Jack Warner on top, as befitting a mogul, and Charlie up front. Fun at the fun house in Ocean Park in 1933; Lorelle Hearst sounds off on my right while Bill Hearst smiles for the camera on my left.

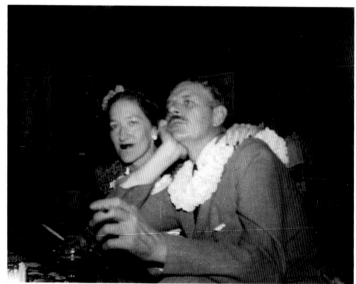

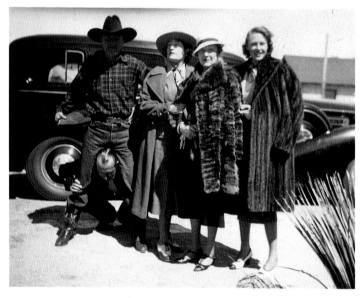

Opposite, above left: Linda (Mrs. Cole) Porter and I take a break during a trip to Tucson, Arizona, where Linda went for her health. The official biographers can sort out the complexities of the Porter marriage, but I must say that Linda was as sharp as Cole. When asked if she believed in sex before marriage, Linda replied, "As long as it doesn't delay the wedding." Opposite, below left: Our companion on that trip was Constance Collier. Constance, a grande dame of the British theater, came to Hollywood seeking work as a character actress. Jobs were few and far between, however, and on the advice of Charlie Chaplin she also gave acting and voice lessons. Charlie arranged sessions with Paulette Goddard, but it was Katharine Hepburn who was Constance's star pupil.

The "dude" with us is Howard Sturges, a close friend of the Porters. He was born to wealth, and his uncle was the philosopher George Santayana. As a member of The Lost Generation, Howard hit bottom in the drug dens of Paris until Linda, a saint, saved him from certain early death. He rewarded her with the kind of friendship that is religious. He was drug-free for the rest of his life. Uncle George, however, in his autobiography, *The Last Puritan*, complained that his nephew spent all his money throwing parties, at which Howard played both "host and hostess."

Although as yet untrained, I carried my camera to some choice parties. At this Cole Porter gathering in 1938, the theme was Hawaiian, and some generally camera-shy types let me snap away. Opposite, from top right: Charles Feldman with Benita Hume (Mrs. Ronald Colman), Rex Benson, and Cole; Kitty (Mrs. Gilbert) Miller and screenwriter-producer Charles Brackett; Sir Charles Mendl with Phyllis and Fred Astaire; Ronald Colman with Barbara Hutton and Cary Grant, before they married.

Right: Antibes, 1938. My husband, Charlie, had gone to the casinos for an afternoon of roulette. I was hot and bored, so I just finished off the roll in my camera with a nude self-portrait. When he saw the picture, Charlie said, "Keep it. Some day you'll want to see how you looked *then*."

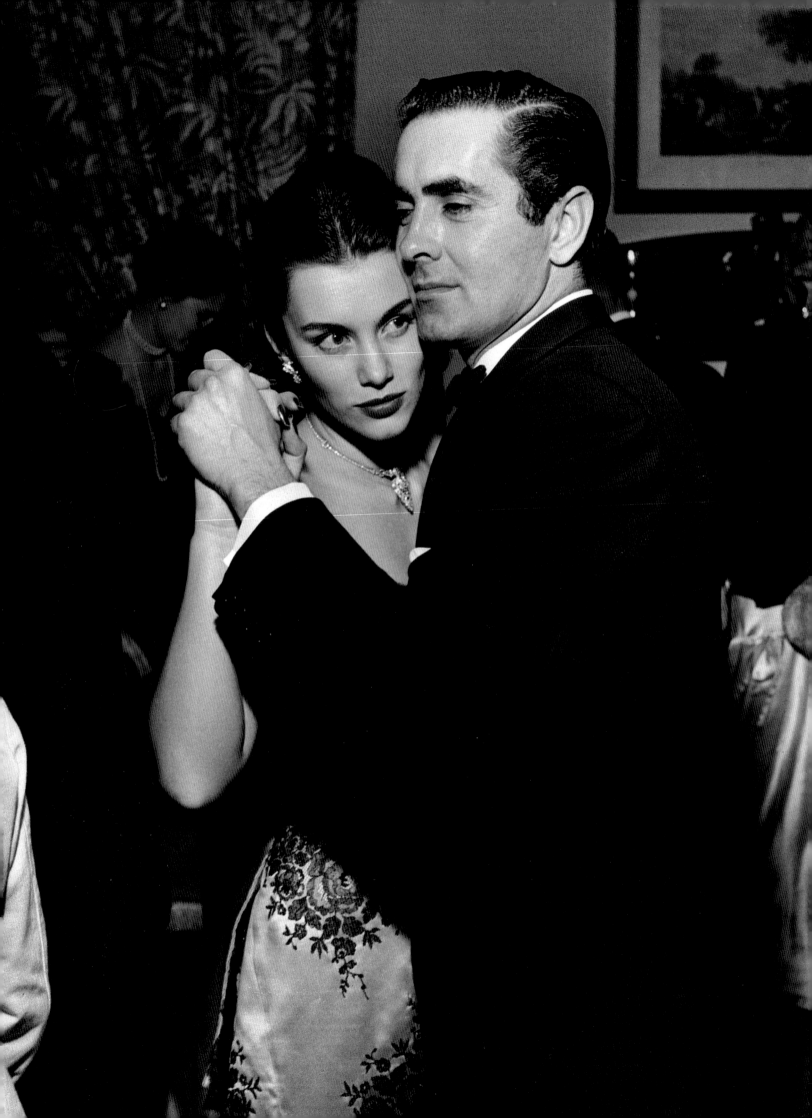

Opposite: Dancing cheek to cheek in Rome in January 1949, the week before the most publicized celebrity wedding of the 1940s, Tyrone Power, who was then America's number one dreamboat, looks as if he's in a world of his own in the arms of his intended, the beautiful Dutch-Mexican actress Linda Christian.

My movie career lasted just a decade. On the set of my swan song in 1943, the film version of the Broadway hit *Claudia*, Robert Young and I are visited by two servicemen (right), a regular routine in the war years. *Claudia* was immensely popular—Twentieth Century-Fox even made a sequel to it before sequelitis ruled the industry. The film introduced the wistful, wonderful Dorothy McGuire to Hollywood and also was the final film of that divine comedienne Ina Claire, who, playing against type, was very moving as Dorothy's dying mother.

The

Forties

On the Road with the Hollywood Caravan

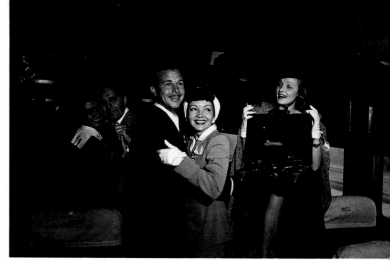

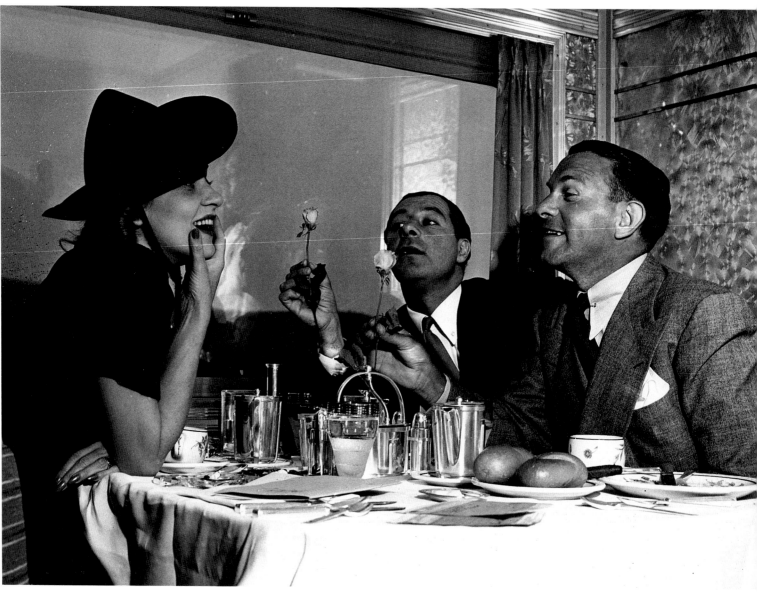

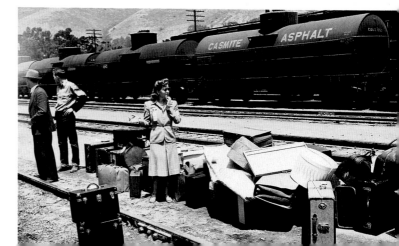

When I think of dedication to a good cause and the unbelievable generosity of show folks, one event stands out above all in my memory, the Hollywood Victory Caravan for Army and Navy Relief in 1942. Patriotism has never been so selfless and shining. Charles Feldman headed up the talent committee and rounded up a staggering array of stars, from James Cagney and Charles Boyer to Marlene Dietrich and Olivia de Havilland. To see movie stars, many of whom were not exactly at ease with public appearances and variety-show performances, live in a cross-country tour proved to be a moving experience for the audiences. Also, this maiden war effort set the standards by which all other entertainment packages during World War II were measured. With material written by Moss Hart and George S. Kaufman and special music and lyrics by Jerome Kern, Johnny Mercer, Frank Loesser, and Arthur Schwartz, it wasn't surprising the Caravan was cited by the government as the "finest civilian patriotic act of the first year of the war." The public turned out at every stop, and the final attendance total came to 8 million. In Des Moines, Iowa, for example, 100,000 of its 150,000 denizens showed up and poured $4,000 in nickels alone into a big American flag. I took these photographs at Fort Ord, California, on the first leg of the train trip.

<u>Opposite, above:</u> Crooner Dick Powell and sophisticated Claudette Colbert cuddle a little closer with the approval of the ever-glamorous Marlene Dietrich. That's Joan Blondell, who was then Mrs. Powell, with Jack Benny behind the friendly duo. <u>Opposite, middle:</u> Always the jokers, George Jessel (center) and George Burns have a captive audience in Marlene in the dining car of the Victory Caravan. <u>Opposite, bottom:</u> Gracie Allen, bemused as ever, tries to gather her luggage, but I don't think she relished the chore. <u>Above right:</u> Eddie "Rochester" Anderson and his wife arrive at Fort Ord. Best loved as Jack Benny's nemesis, Eddie, with his raspy voice, was a first-rate song stylist and, as they said in 1942, he could really cut a rug. <u>Below right:</u> Jack Benny and his wife, Mary Livingston, head for their tent dressing room.

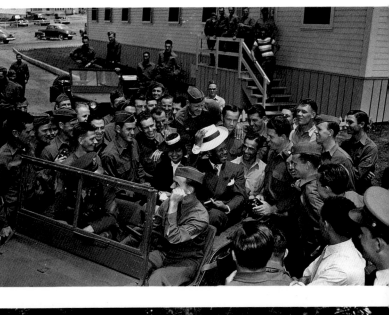

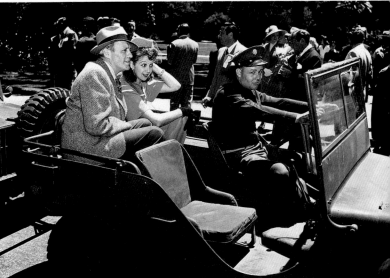

Below left: What soldier wouldn't grin while giving Claudette Colbert a helping hand getting in or out of a jeep? Claudette seems pretty pleased, also. Below right: Gracie Allen and George Burns, probably the most happily married couple in the history of show business, survey the sights. Opposite, clockwise from top left: Claudette pitches in for some chow duty. Jackie Coogan, the silent-screen-

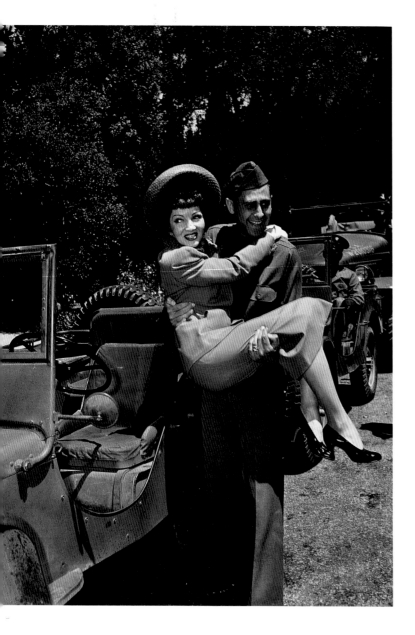

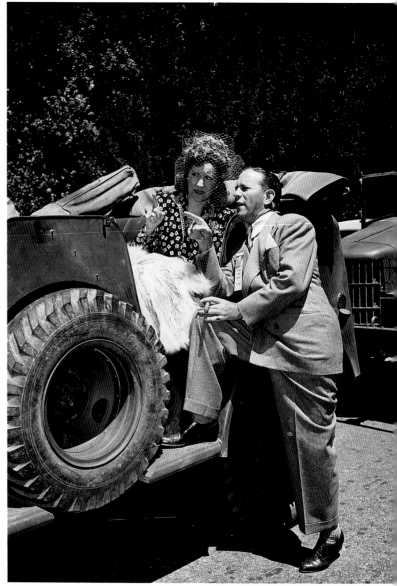

child-star-turned-enlistee, plots the day's activities for Jack Benny, Mary Livingston, Marlene Dietrich, George, and Gracie. Marlene, whose impressive wartime work culminated in her famous tour of the North African bases, lunches in the mess hall—her specialty, by the way, was playing the saw. Another beauty, leggy Joan Blondell, appears to take to tent living.

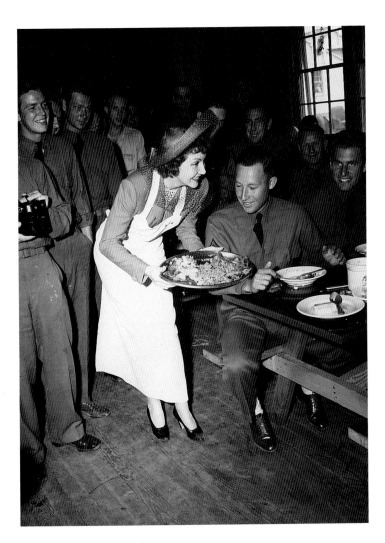

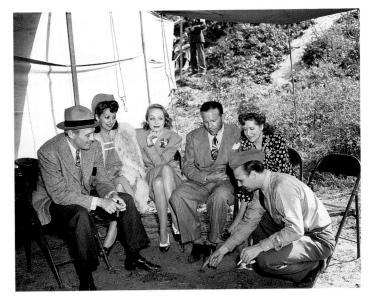

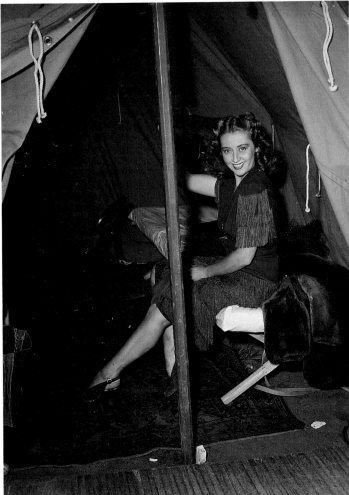

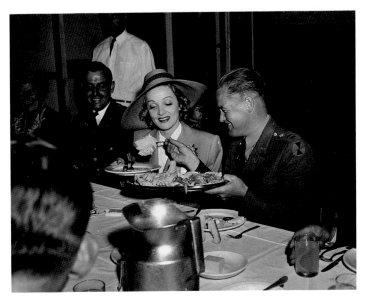

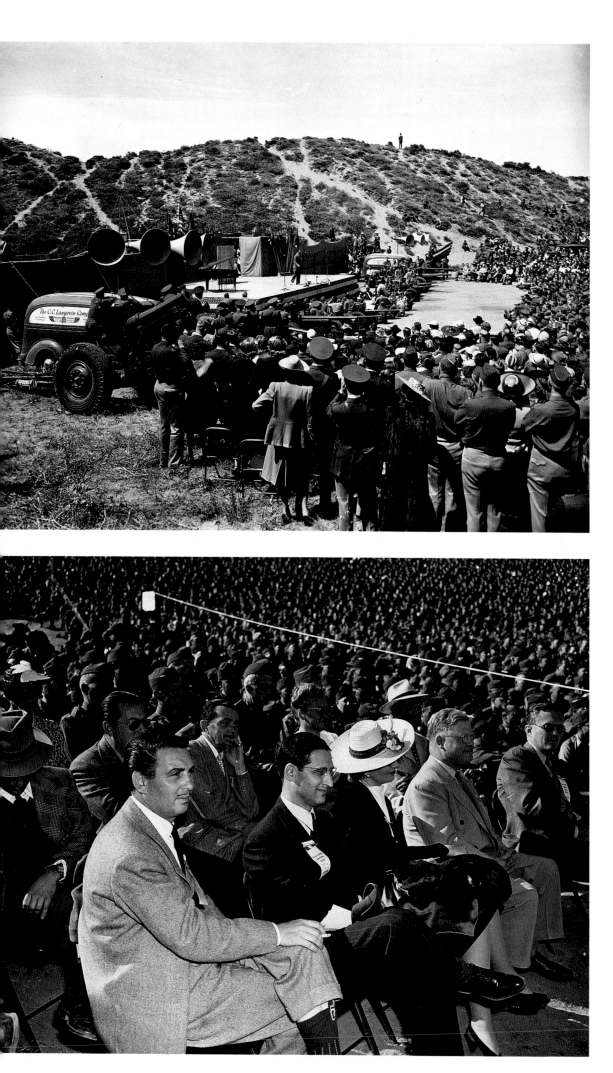

Above left: President Roosevelt's favorite song was *Home on the Range*, and it easily could have doubled as the theme song for the Caravan, with its makeshift prairie stages. Below left: Charlie Feldman and some VIPs join the audience of soldiers at Fort Ord. Opposite, clockwise from top left: It's on with the show as George Jessel (his nickname was Toastmaster General of the United States) follows a hard act under the best of circumstances, that of the seductive Marlene Dietrich. George Burns and Gracie Allen run through one of their classic vaudeville routines. Rubber-legs Ray Bolger goes into his dance. Eddie Anderson struts his stuff.

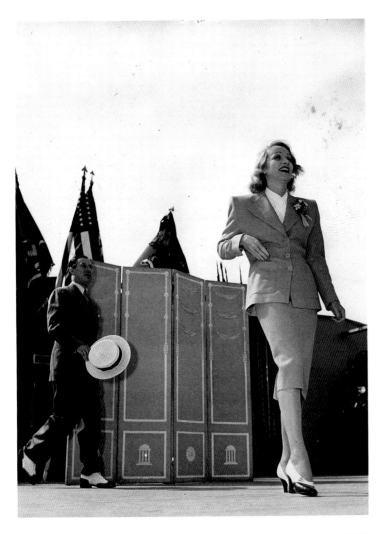
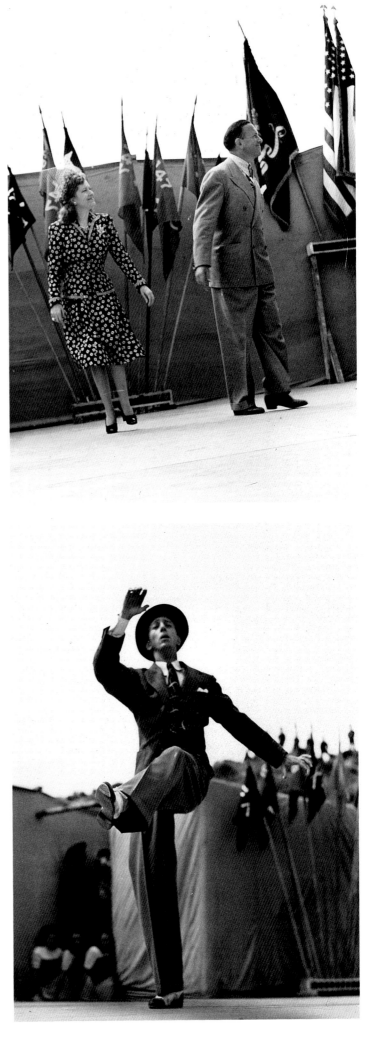

Getting Into Photography

Hilde Berle (left) changed my life. On a gloomy, rainy February day in 1944, Frances (Mrs. Samuel) Goldwyn phoned and asked if I was free for lunch the next day because she had a "very, very interesting person" I should meet. "Man or woman?" I asked. "It's a woman," Frances laughed, "and she's a graphologist." "A grasshopper?" I teased. "What in heaven's name is a graphologist?" A specialist in reading one's character by studying one's handwriting, Frances explained. As I hung up, I thought, here I go again to another fortune-teller.

Hilde turned out to be a quiet type who spoke with a slight accent; she was Czechoslovakian and had lived and studied in Germany; her husband was a well-known physicist, Dr. Otto Halpern. After our lunch Frances left us alone. We talked a bit and then Hilde pushed a piece of paper across the table and asked me to write anything that came to mind and sign my name. Puzzled, suspicious, I wrote, "Today is a beautiful day." If she can read my secrets in that, I thought, she's a genius. Silence. I waited, imagining, a great writer, a great painter, anything great will do. Hilde spoke: "You have a remarkable gift"—I waited—"for photography. One of the best schools is right here in Los Angeles, the Art Center. You could be one of the finest portrait photographers; you have a natural gift for portraiture." Gad, how dull, I thought, and offered polite thanks.

A few months later I learned that Hilde was back in Los Angeles, and I got in touch with her. Again sitting with a sheet of paper in front of me, I wrote, "Today is a beautiful day." I wanted to know if she could still see that I had that natural gift. Hilde studied my writing and said, "By the way, have you done anything about photography; did you find that school, the Art Center?" Despite my protestations of being stupid about all that mechanical stuff, Hilde said quite firmly, "It's a school, they teach you these things." This time I took her advice and enrolled in a course at the Art Center. Opposite: In Apple Valley, I practiced what I learned at the Art Center on Buck, of the rodeo team of Buck and Jean. But for some reason I shied away from portraiture at this point. Perhaps I was afraid of failure, or of success.

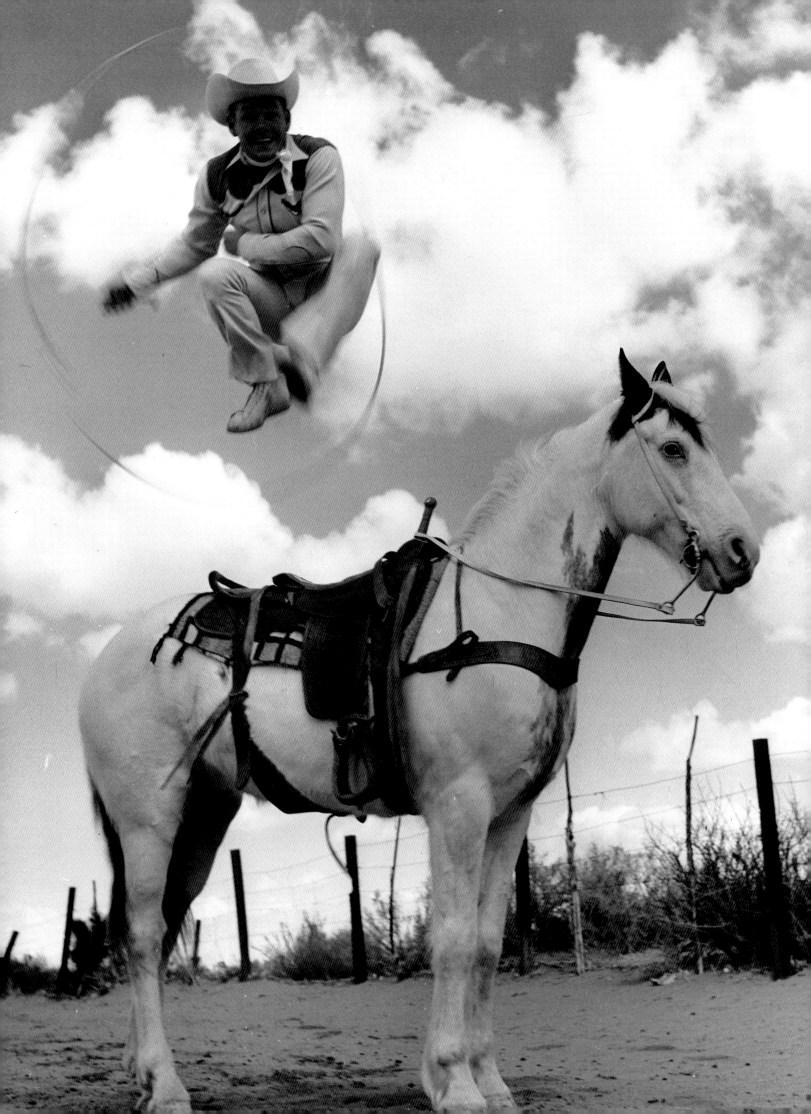

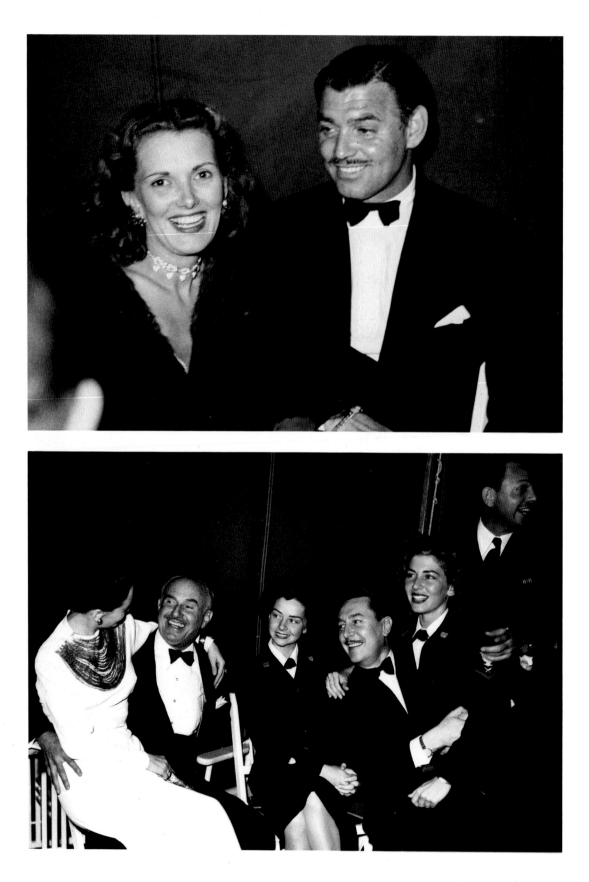

Some pretty good Hollywood parties were in my own garden on Coldwater Canyon in Beverly Hills. For me, those parties conjure up memories that bring a smile and a tear. The little shindig on these pages was held right after the war and was a mix of the famous and the fortunate, the latter being some service people stationed in Los Angeles who got to hobnob with the stars. Above left: Anita Colby and Clark Gable arrive rather formally dressed. She was a natural glamour puss, but Clark was not a party animal; yet he always looked smashing in a dinner jacket. Anita and Clark were at the zenith of their well-publicized friendship, but in later years she went on record that they were never lovers. Anita stated: "I loved him, but I wasn't in love with him. He was a dream and a darling but I would no more have thought of going to bed with him than with the man in the moon." Below left: Nadia (Mrs. Reginald) Gardiner takes to Jack Warner's knee while her husband returns the favor with a Wave. Milton Bren, who married Claire Trevor, is on the far right—he made his millions in Southern California real estate. Opposite: Lady-killer Errol Flynn would talk to any girl who appealed to him, but I didn't eaves-drop on this chat with a truly lovely Wave.

California

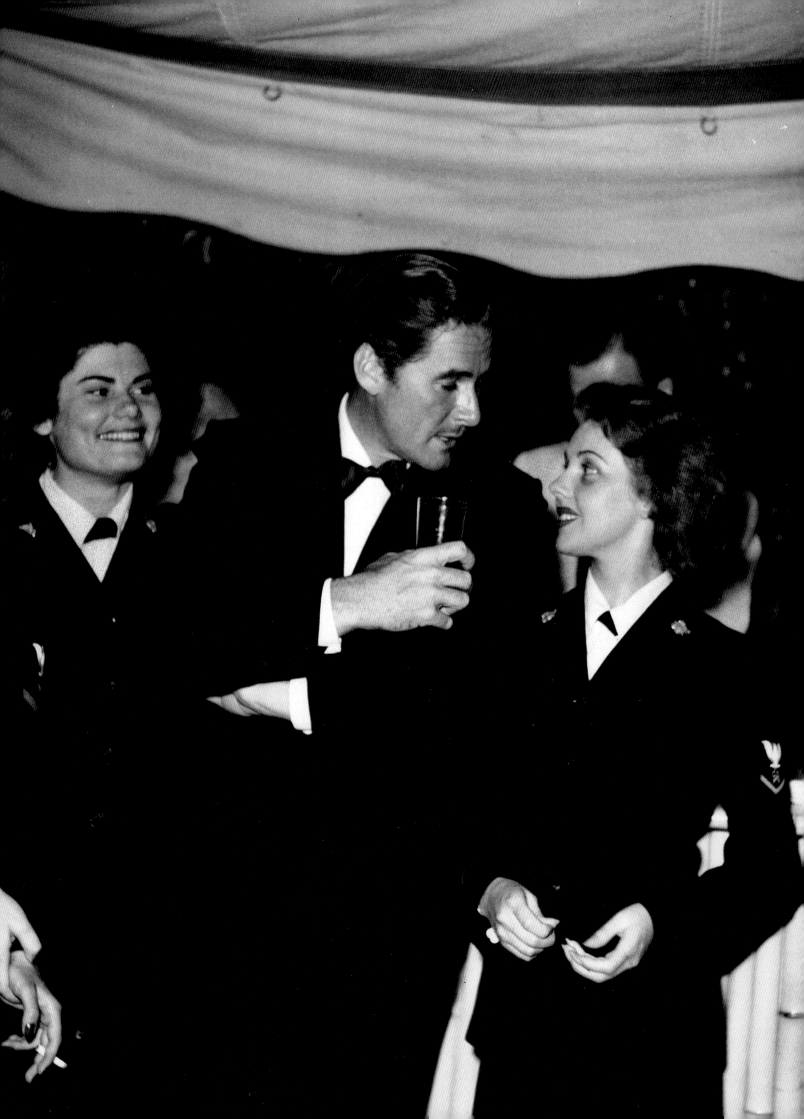

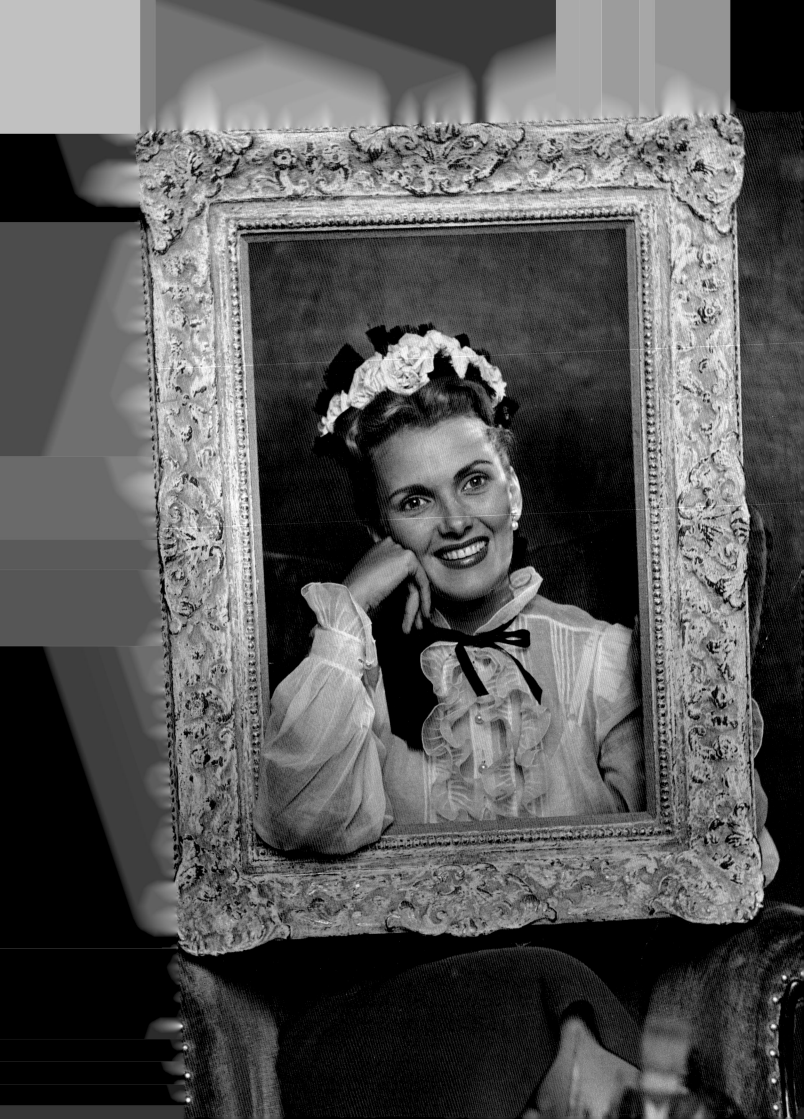

Pretty as a picture, Anita Colby (opposite), known as The Face, was that rare bird in the Hollywood cage. An ex–Conover Girl, she graced as many as a dozen magazine covers in a month during the peak of her career. Yet she had no ambition to be a big star, and why should she when, as a consultant to producer David O. Selznick in the 1940s, she earned more than the actresses she was hired to groom and refine.

I shot these photographs at Paul Clemens's studio; he ranked as the top portrait painter for a generation in Los Angeles; he went on to marry the underrated actress Eleanor Parker. This visit to his studio took place in 1946, when he was at work on a commission for Selznick in which both Anita and Ethel Barrymore were involved. Above right: At Paul's studio were Brenda Marshall, the Warner Bros. starlet then married to William Holden; Robert Sterling; Mrs. Paul Clemens; Ann Sothern, who was the current Mrs. Sterling—both Sterlings were under contract to MGM in those days—and Paul. I don't remember the man in the middle of this shot. Below right: Paul; Anita; Skitch Henderson, who was Anita's beau of the moment; Bob; and Ann mix business with pleasure.

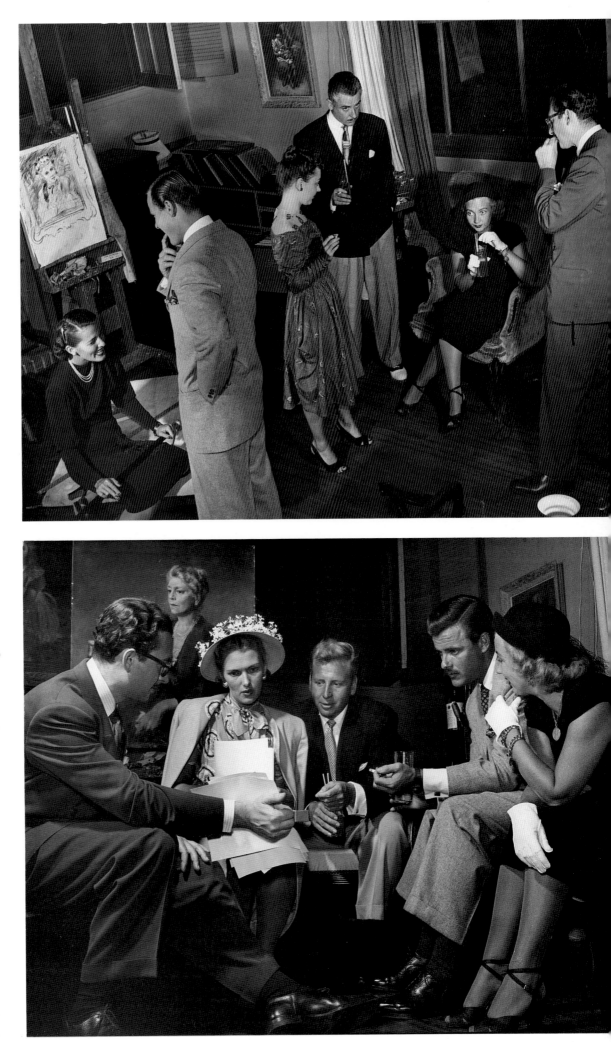

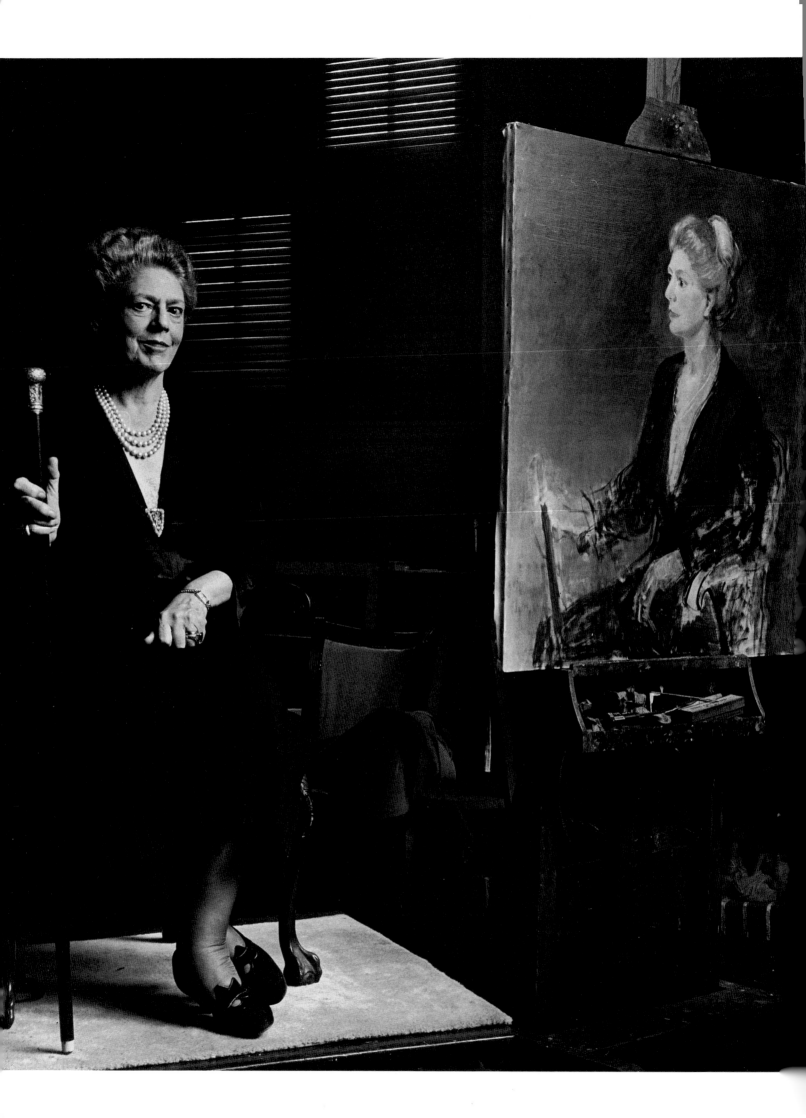

Ethel Barrymore was doing some film work for David O. Selznick—maybe *Portrait of Jennie* or *The Paradine Case*. I'm vague on the details, but who wouldn't be coming face to face with a sacred institution like the formidable

Barrymore. I relaxed a bit when she flashed me her disarming Cheshire-cat smile and, what's more important, I had my camera ready. Paul Clemens, stirring his colors, was oblivious to my nerves.

PALM SPRINGS CROQUET
and YACHT CLUB

PALM SPRINGS,
CALIFORNIA

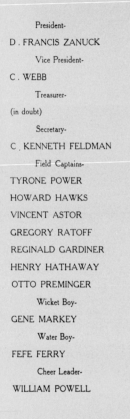

President-
D. FRANCIS ZANUCK

Vice President-
C. WEBB

Treasurer-
(in doubt)

Secretary-
C. KENNETH FELDMAN

Field Captains-
TYRONE POWER

HOWARD HAWKS

VINCENT ASTOR

GREGORY RATOFF

REGINALD GARDINER

HENRY HATHAWAY

OTTO PREMINGER

Wicket Boy-
GENE MARKEY

Water Boy-
FEFE FERRY

Cheer Leader-
WILLIAM POWELL

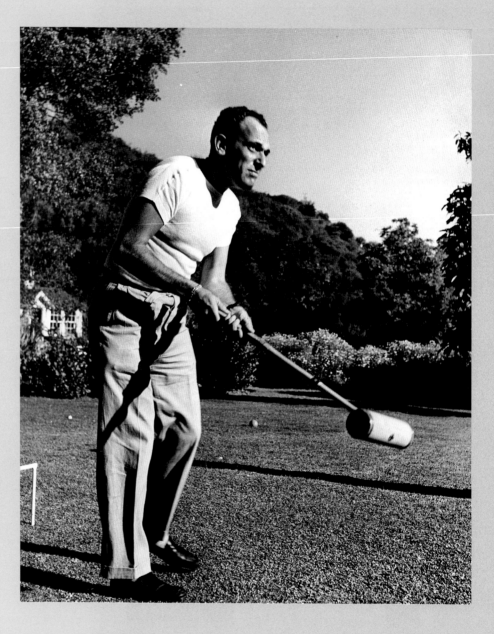

DEDICATED TO THE PROMOTION OF CLEAN SPORTS AND THE
ELIMINATION OF ALL CROQUET BARRIERS INCLUDING MOSS HART.

The longest party that I ever attended lasted three years. It started in 1946 at the Brentwood home of director Howard Hawks and ended in Palm Springs at the Darryl Zanuck estate, Ric-Su-Dar. It lasted so long because everybody in Los Angeles caught croquet fever, and they caught it bad. On the East Coast Alexander Woollcott had been the high priest of the English game in fierce matches played with Herbert Bayard Swope, Averell Harriman, Vincent Astor, and Richard Rodgers. After World War II Moss Hart (opposite, framed by the group's letterhead) brought croquet west when he came out to write *Gentleman's Agreement* for Darryl Zanuck (right) at Twentieth Century-Fox. Now Darryl, avid sportsman and hard-driven competitor in all things he touched, became a master of the game, which by the way is no child's diversion. As Moss said, it took "skill, stamina, and iron nerves." Darryl and the famous names who joined the games had all three, but Darryl's team met its match in the first of the East-West croquet play-offs. That game was set off by a letter from Moss to Darryl in which Moss jokingly questioned the abilities of the neophyte western players. The Zanuck loss was softened only when the winning easterners bitterly complained about the size of the championship cup, which, as I recall, was hardly visible to the naked eye.

The enthusiastically contested match, and my coverage of it, came to the attention of an editor at LIFE magazine, and in 1946 LIFE featured my photographs from that first play-off. What's more, the magazine paid me handsomely and even gave me a byline. This development was unexpected but certainly not unpleasing. In my application to the Art Center, I had been asked what I hoped to accomplish with my photography, and I replied that I simply wanted to photograph people and places for my own pleasure. Now, for the first time, I began to take seriously the idea of selling my work.

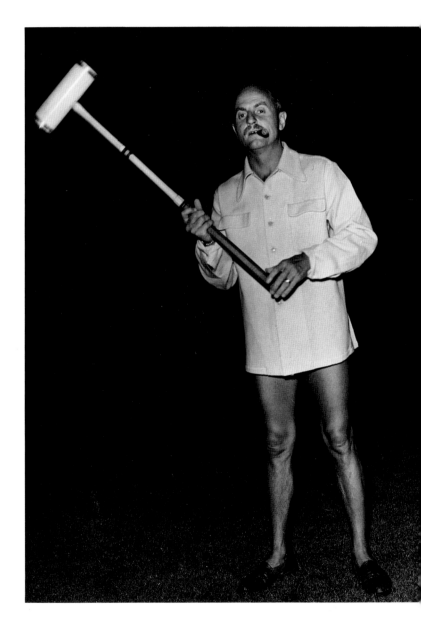

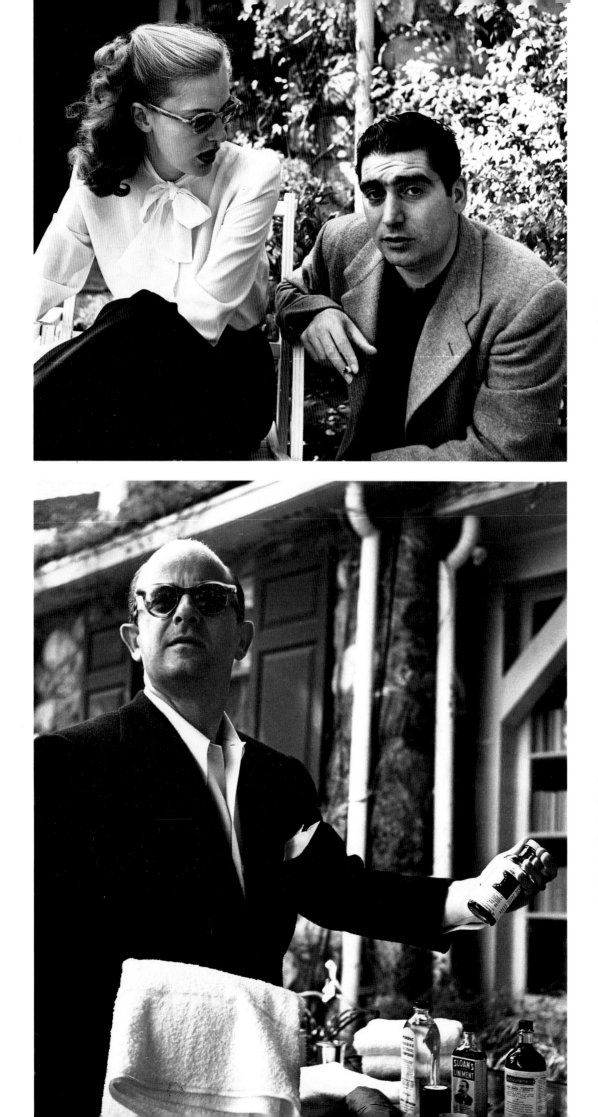

The East-West match drew fabled spectators, and at the Hawks ranch the gallery totaled more than a hundred one day. Above left: Slim (Mrs. Howard) Hawks chats with Robert Capa. Below left: Irving "Swifty" Lazar, Moss Hart's agent, called himself "the medicine man" because he handled all the remedies for the aches and pains. Opposite: Darryl Zanuck, with his ever-present cigar, questions a point with his teammate Howard Hawks. Fox stars Cesar Romero (left) and Tyrone Power were cast in supporting roles for the moment.

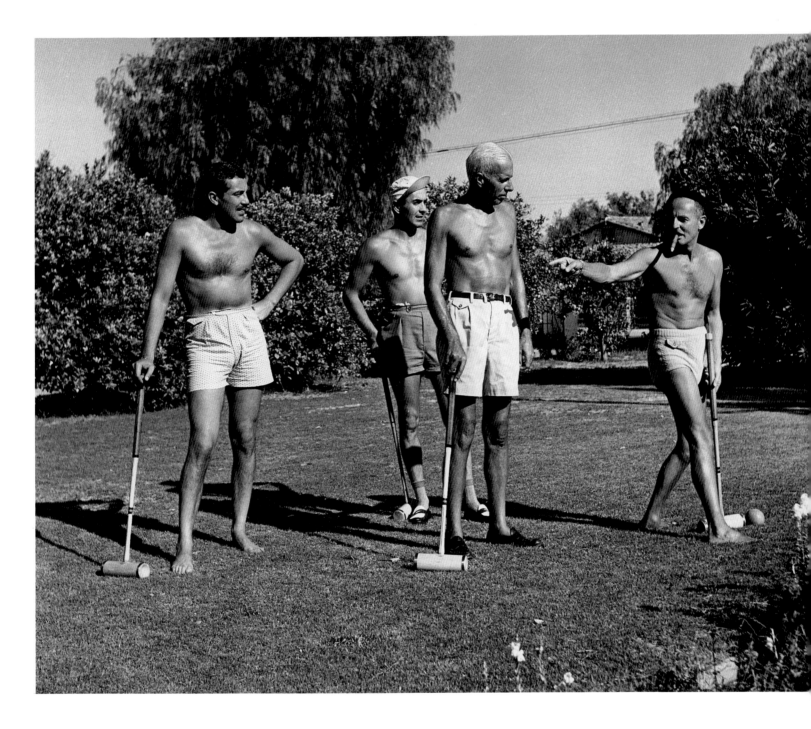

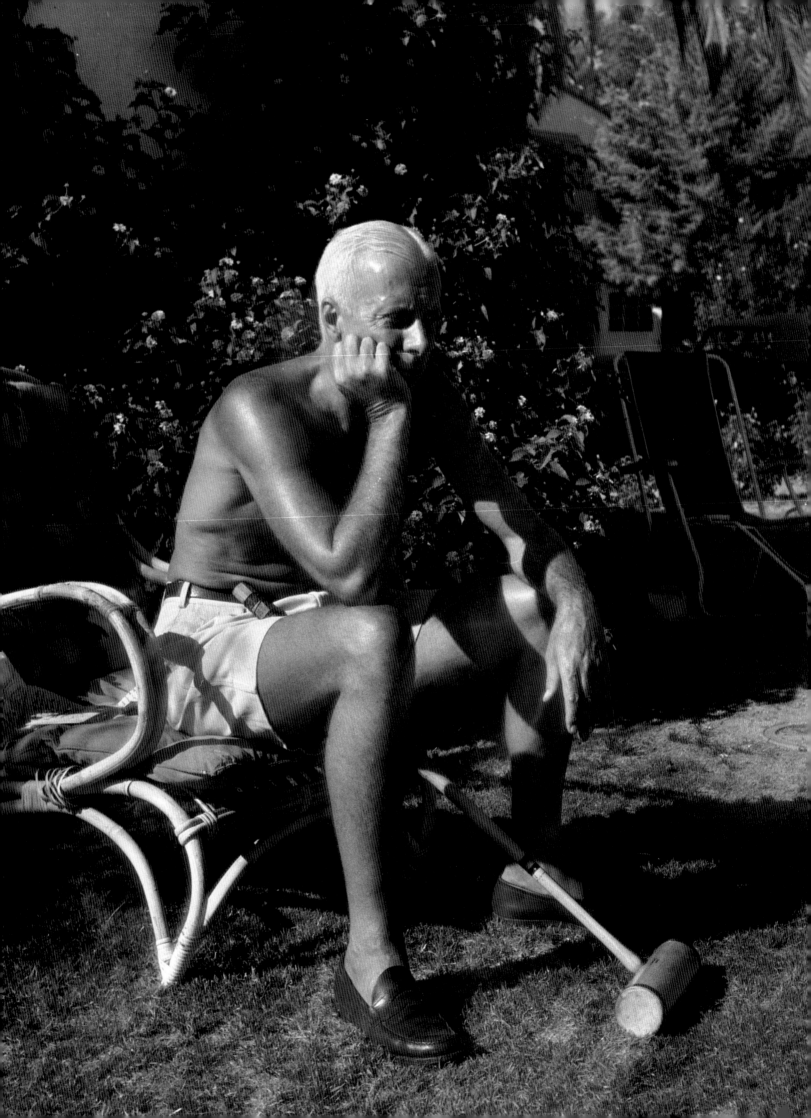

Opposite: Howard Hawks takes a breather. After all, it could take more than eleven hours to play two games. Right: Cesar Romero and Tyrone Power discuss an intricate bit of strategy. Each team had long-range plans for attack and defense. They played for real.

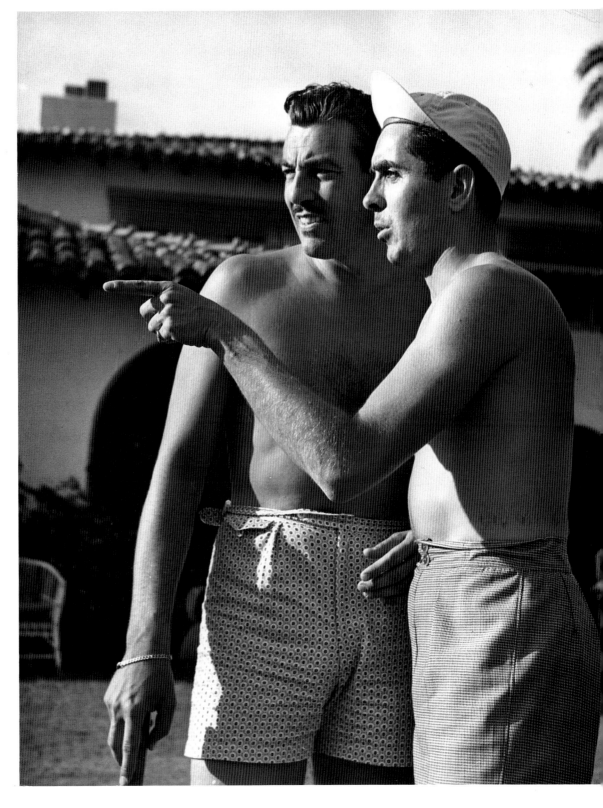

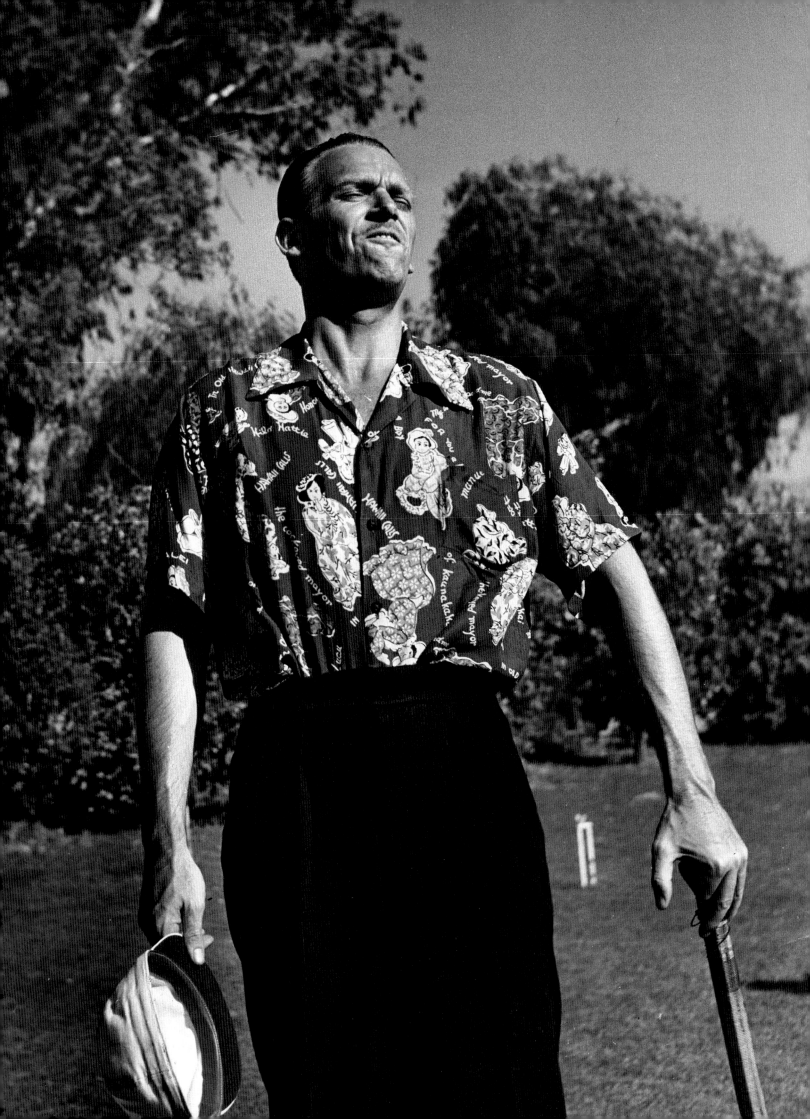

Opposite: Douglas Fair-
banks, Jr., obviously did
not hit a winning drive.
Below: Fairbanks (left) and
Zanuck demonstrate

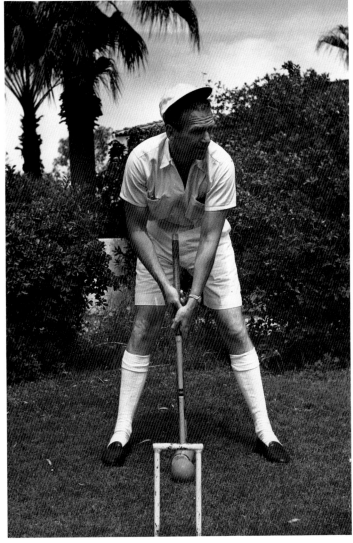
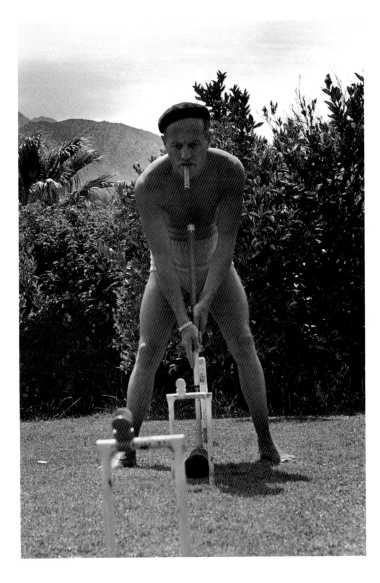

correct form for the strictly
English sets that were used.
The wickets were just wide
enough for the ball to pass
through.

Below: In those days
Howard Hughes still
appeared in public and in
the daylight. Gene Tier-
ney, one of Zanuck's
biggest stars at Twentieth
Century-Fox in the 1940s,
was married to designer
Oleg Cassini, but I believe

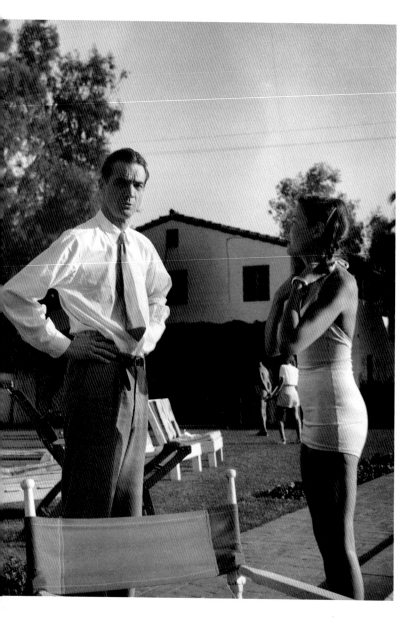

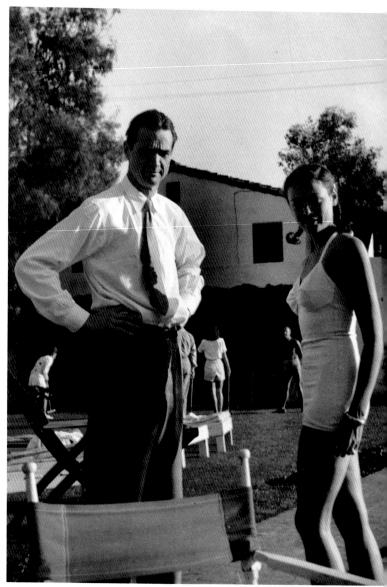

she must have been pretty
smitten—as many others
were—with Howard at this
time. They stopped by Ric-
Su-Dar for lunch; Gene
wanted a swim and some
fun, also. Opposite:
Virginia (Mrs. Darryl)
Zanuck and Gene

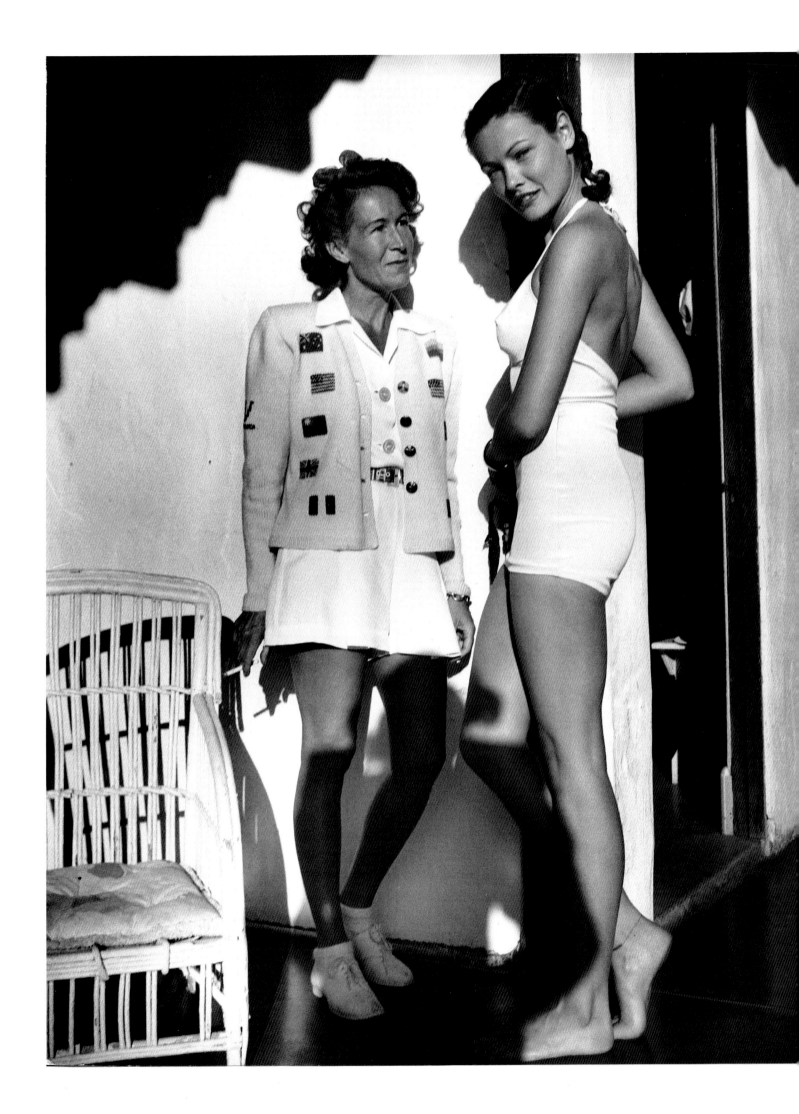

Below: Constance Bennett's star had fallen by the mid-1940s, but she still looked and played the part. When Zanuck first formed Twentieth Century Pictures, his independent organization prior to the merger that created Twentieth Century-

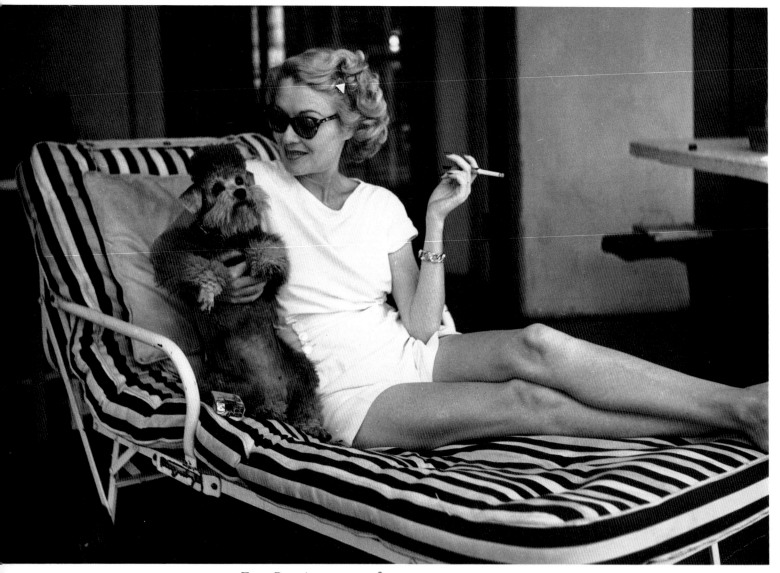

Fox, Connie was one of the first names to break away from other contract commitments to go with him. She became part of the Zanuck inner circle. Opposite: Joseph Cotten, captain of the West team, looks as if he knows his team will lose.

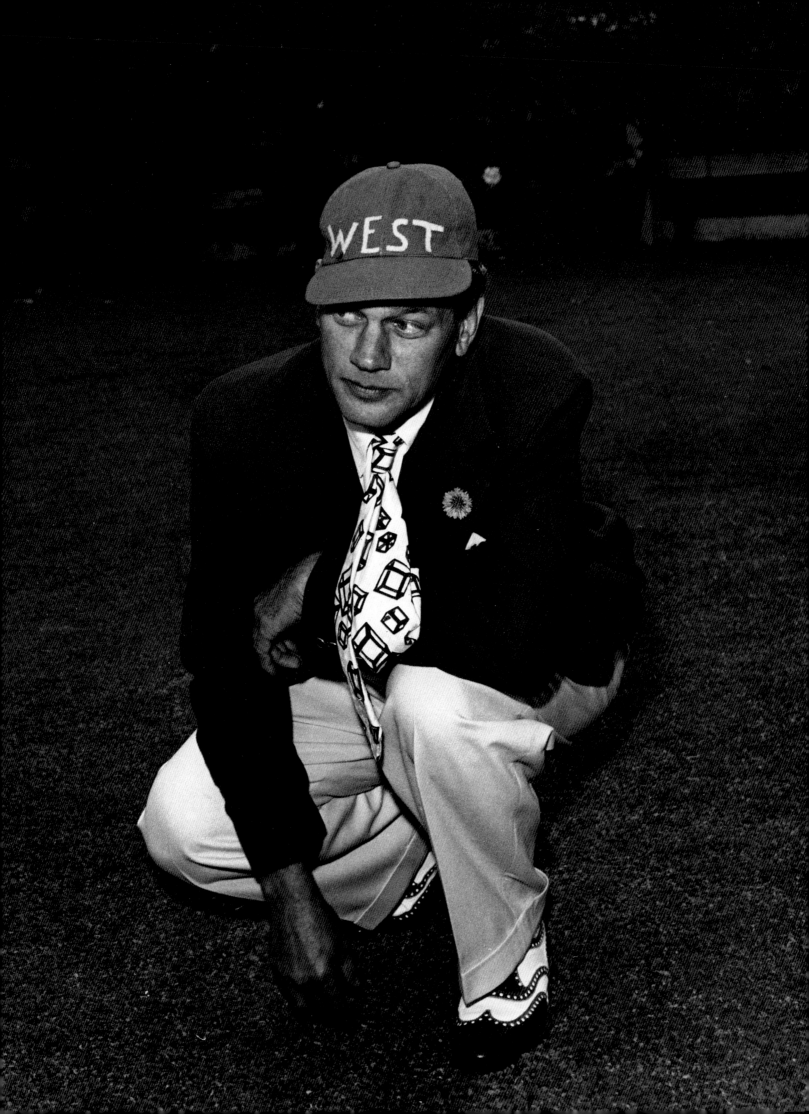

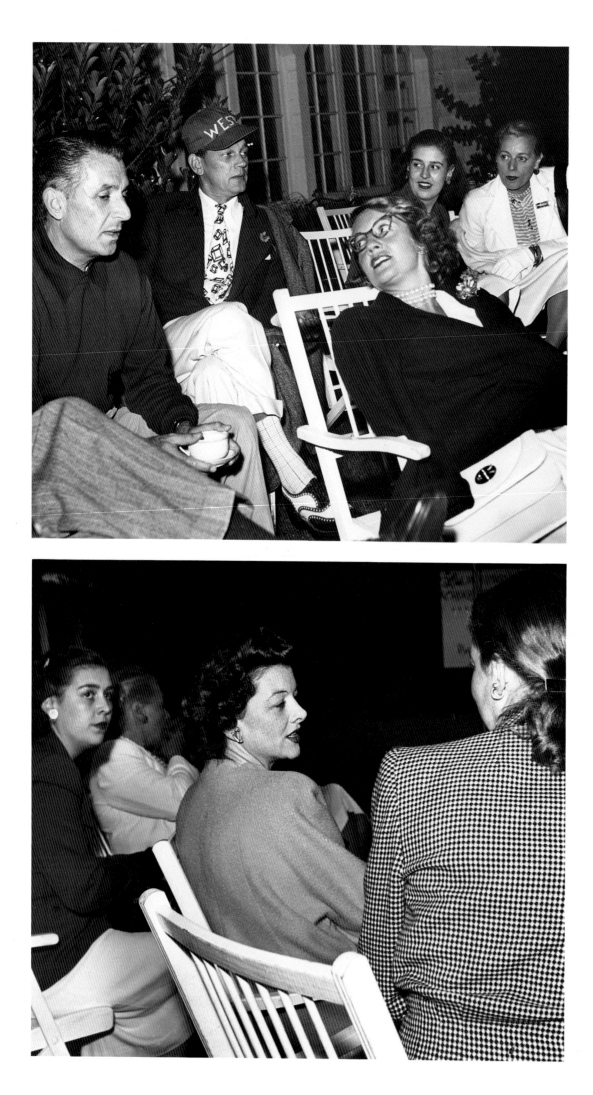

More croquet fans. Above (from left): Agent Fefe Ferry, Joseph Cotten, Mary Lee (Mrs. Douglas) Fairbanks, Judy Cotten, and her mother, Lenore (Mrs. Joseph) Cotten. Below (from left): Judy, Lenore, and Myrna Loy of the piquant profile. Opposite: Breaking the tension at Howard Hawks's place are (clockwise from top left) Richard Greene, Charles Feldman, Lee Bowman, Clifton Webb, William Powell, Reggie Gardiner, and his wife, Nadia.

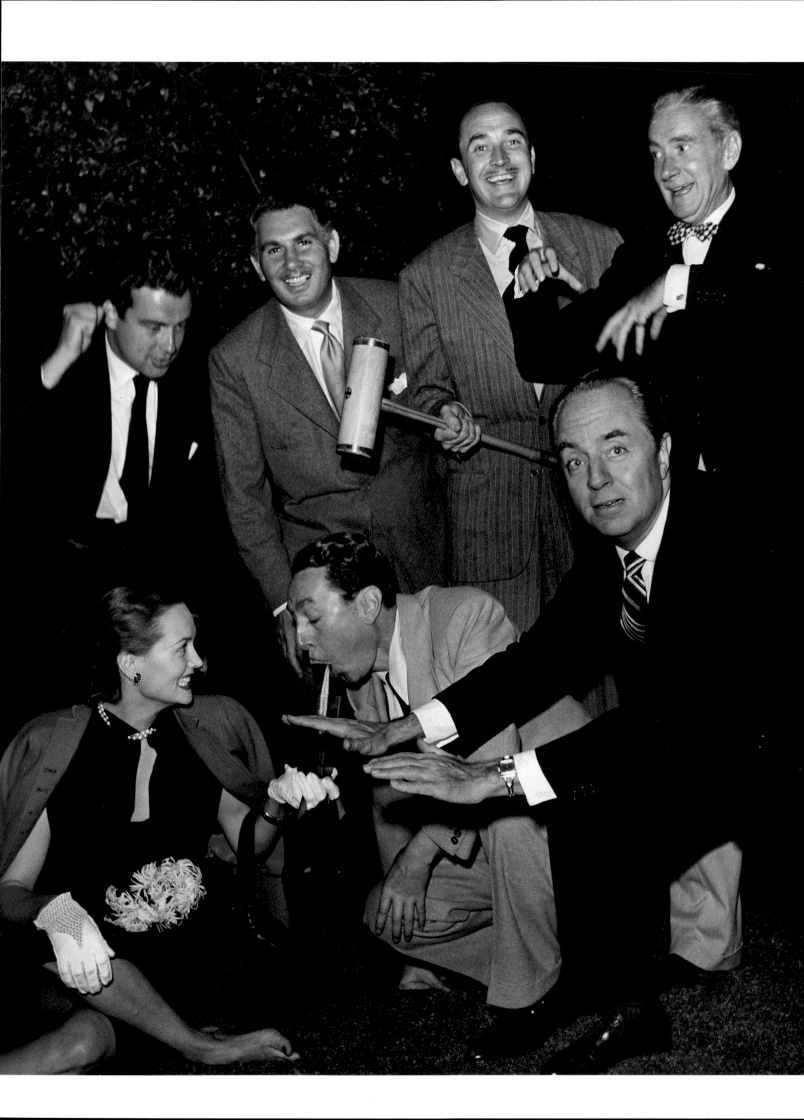

Below: Howard Hughes was just one of the gallery spectators, seen here with his date, Peggy Cummins. Zanuck had brought her from London to play the lead in *Forever Amber*, but she photographed too young, and her career never took off. The day after this picture Howard was in a serious plane crash. Reggie Gardiner is on the left, and in

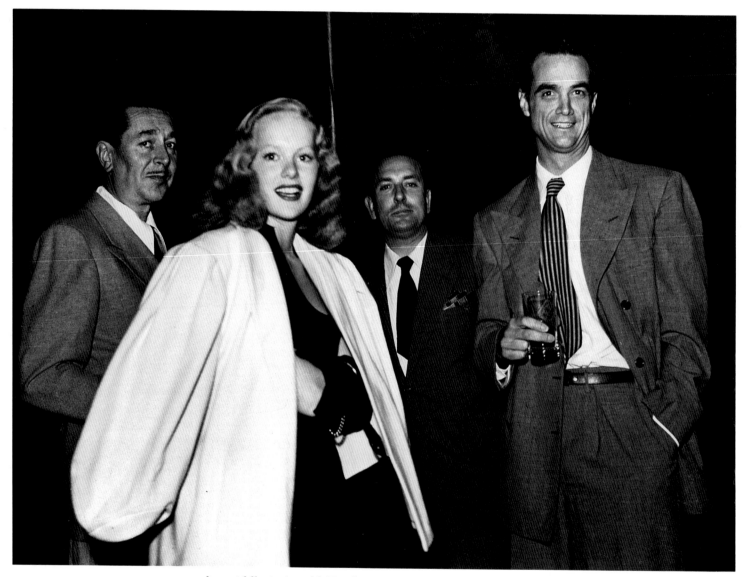

the middle is Arnold Knody, an employee of Howard's. Opposite, clockwise from top left: Danny Kaye and Diana (Mrs. William) Powell. Producer Sam Goldwyn and restaurateur Mike Romanoff, in the candy-cane sports jacket, were heavy bettors; a westerner, Goldwyn bet on the East and won. Hoagy Carmichael and Mary Lee Fairbanks

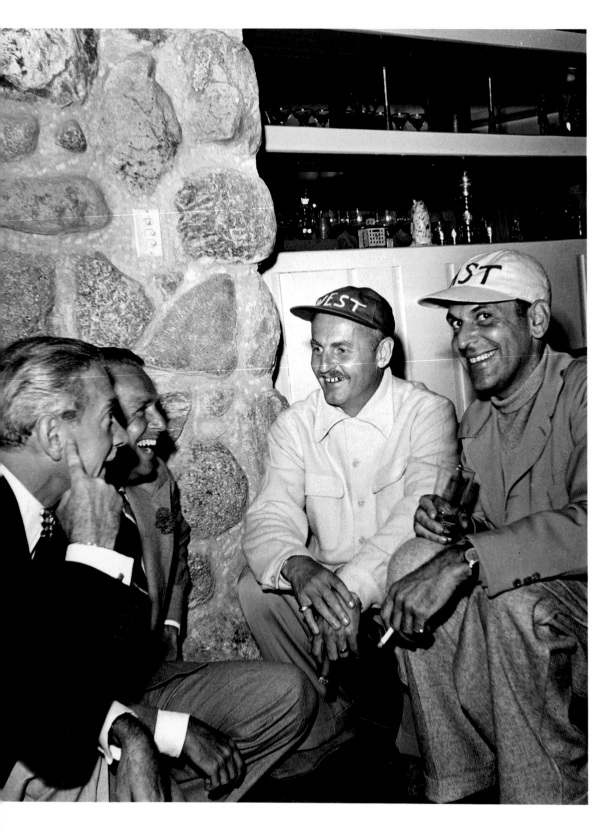

Left: Clifton Webb and Douglas Fairbanks, Jr., join Darryl Zanuck and Moss Hart for a postmortem. Opposite: With a helping hand from Ty Power, Virginia Zanuck presents the winning cup to Moss Hart, with Fefe Ferry, Howard Hawks, and Darryl in attendance.

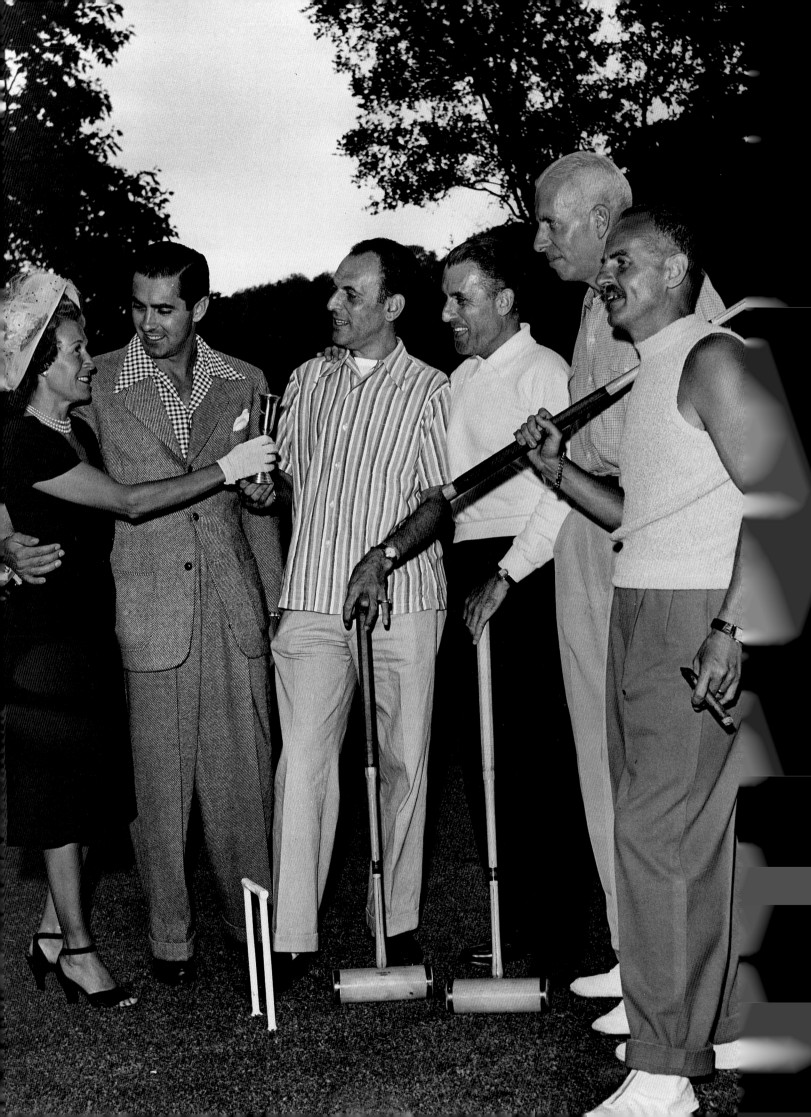

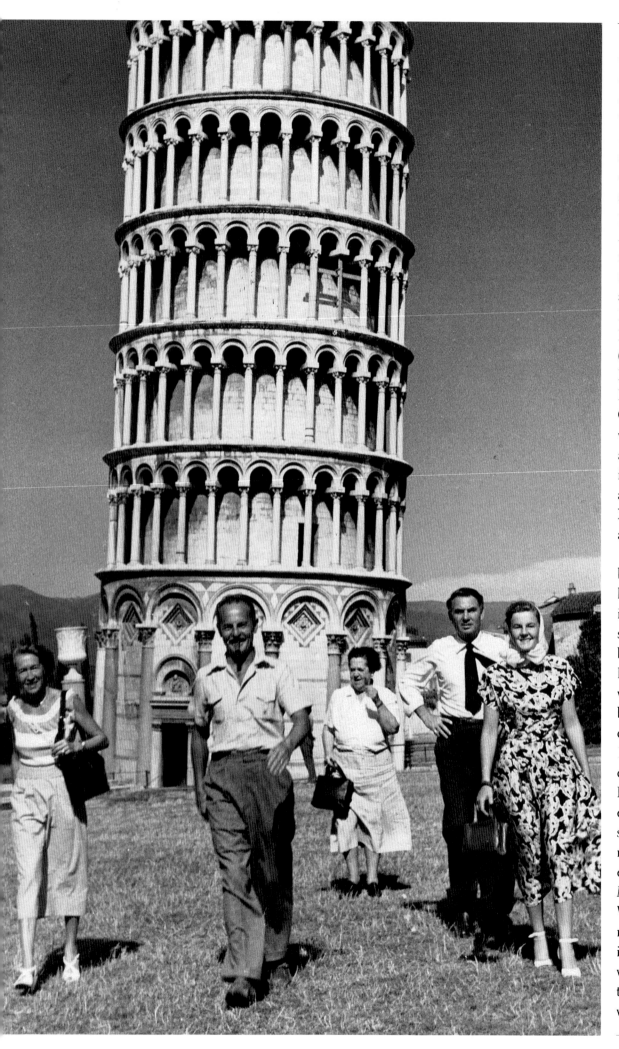

After World War II a still-devastated Europe became a traveler's playground, and a mass exodus from Hollywood began. Whether inspired by tax breaks abroad or the U.S. political climate turning sour or some exotic love affair or just old-fashioned tourism, American stars and filmmakers crossed the Atlantic in droves, mostly for the sunny souths of France and Italy. Left: I motored from Monte Carlo with my pals (from left) Virginia and Darryl Zanuck, Elsa Maxwell, my ex-husband, Charles Feldman—we were divorced in 1946—and Susan Zanuck, heading for Rome and an audience with Pope Pius XII. In Pisa we oohed and aahed like all tourists.

Elsa (opposite) was a born traveler, ever since her birth in a theater box in Keokuk, Iowa. At three she was named the most beautiful baby in San Francisco, of which she was quite proud. She became one of Darryl's few confidants in the late 1930s, when their paths crossed at a party Connie Bennett gave for the Duchess of Westminster. On the spot, he offered Elsa a movie role for $25,000—even calling the film *Elsa Maxwell's Hotel for Women*, which is now remembered, if at all, for introducing Linda Darnell, who hailed from my hometown of Dallas. Since Elsa was better at self-promotion

and spending other people's money than earning her own, she and Darryl became fast friends. I'd venture that the Zanuck money was the first real money she earned since writing a 1914 ditty for Grace LaRue entitled *Tango Dream*. The legend

goes that as a child, who was becoming less beautiful with each succeeding year, Elsa was so poor she wasn't invited to a rich kid's party, and from that early age she vowed she'd become the greatest party giver of all time. For her, it all came true.

Italy

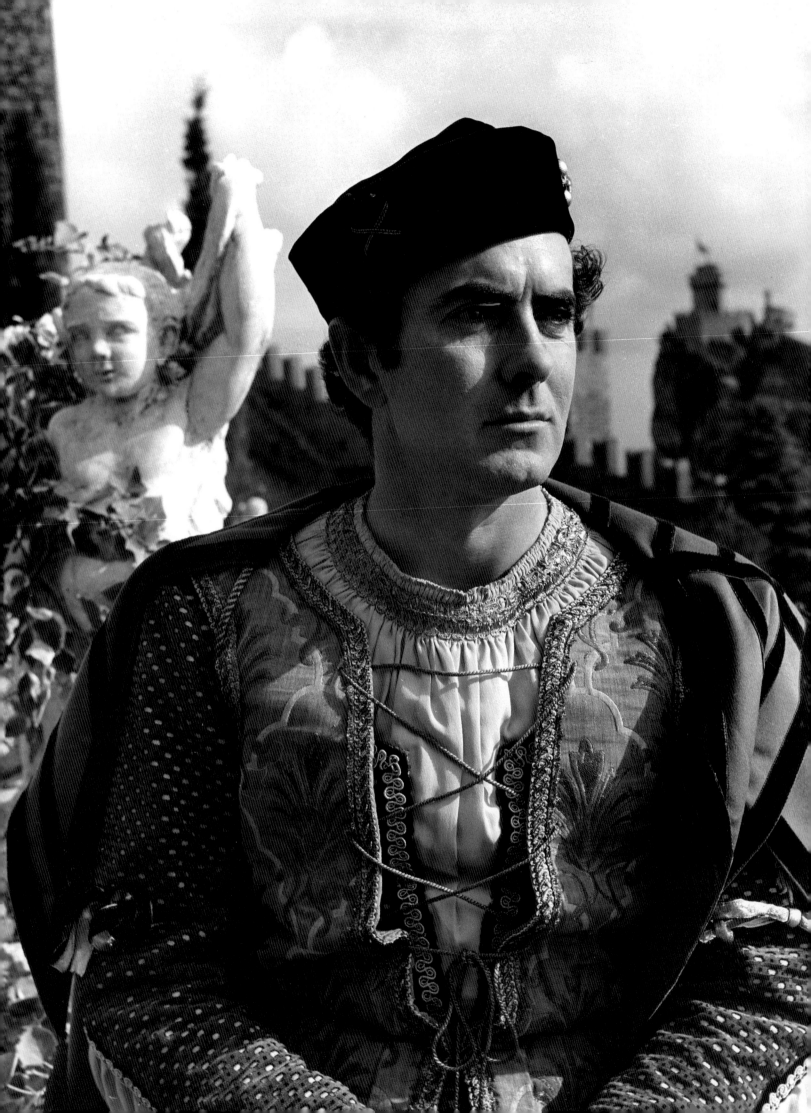

In its day *Prince of Foxes* by Samuel Shellabarger was a fat best-seller; it was snatched up by Darryl Zanuck for Tyrone Power. The epic movie on the Medici family, released in 1949, did less than epic business at the box office. Veteran director Henry King laid his heavy hand on the proceedings, and the movie was in production for months in the original locations of the Renaissance courts of intrigue. I was taking behind-the-scenes shots for Twentieth Century-Fox, and so I toured Italy as the film crew traveled from Rome to Florence, Rimini, and the Republic of San Marino. Opposite: Ty poses in costume at the top of the San Marino mountain state. Right: King works with Ty and Marina Berti, an Italian beauty who graced some of Hollywood's better costumers shot on the Tiber. Her biggest scenes in *Foxes*, *Quo Vadis*, and *Cleopatra*, alas, ended up on the cutting-room floor. She did have talent.

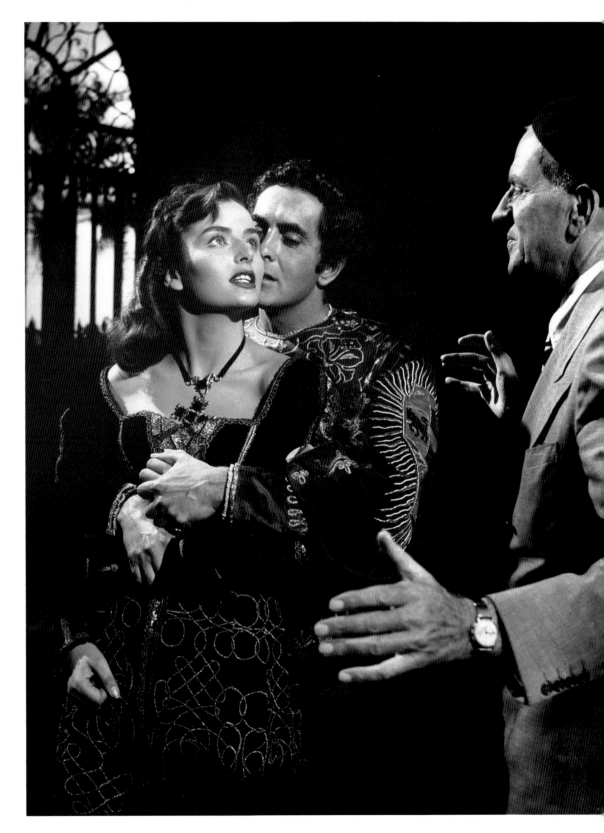

Right: Sinclair Lewis and his sister (seated at right) pay a visit to the *Prince of Foxes* set. Below: Orson Welles (far left) was Ty's costar in the movie. Ty's legs were skinny, and the dressers gave him some extra help with forms

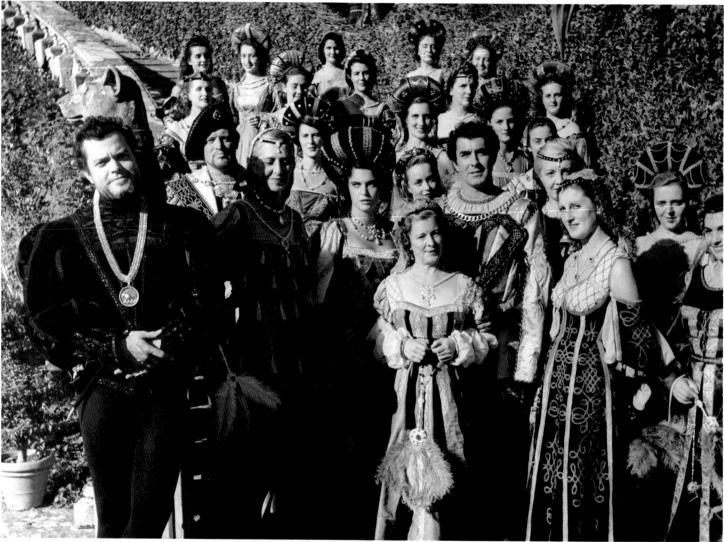

inside his tights to fill out his calves, a secret long used on stage by Maurice Evans and Laurence Olivier. Orson had no such problem. Bottom: The extras had their own way of relaxing between takes. Opposite: Orson and Ty rehearse a scene.

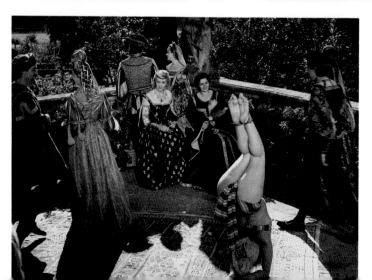

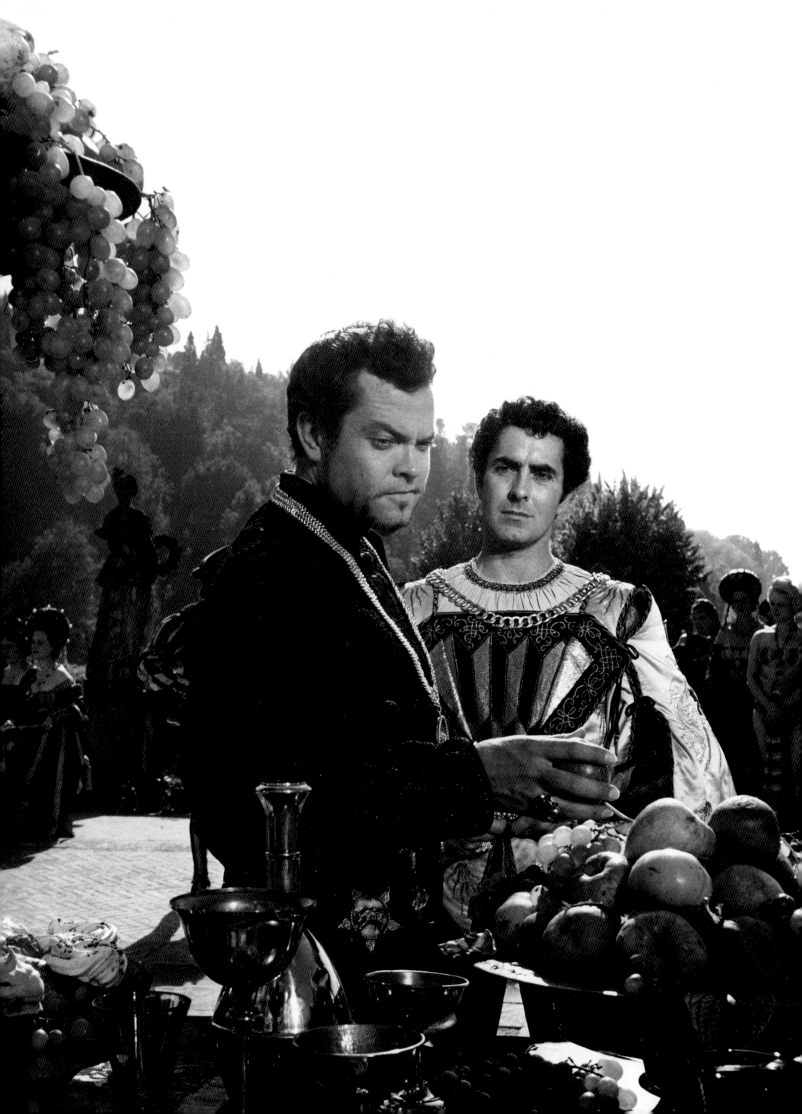

My Margaret Bourke-White phase. I was up on the battlements watching the stuntmen take their falls. Special nets were used, yet some of the Italians were brave enough to work netless had Henry King allowed it. <u>Opposite, below:</u> Photographing a street child

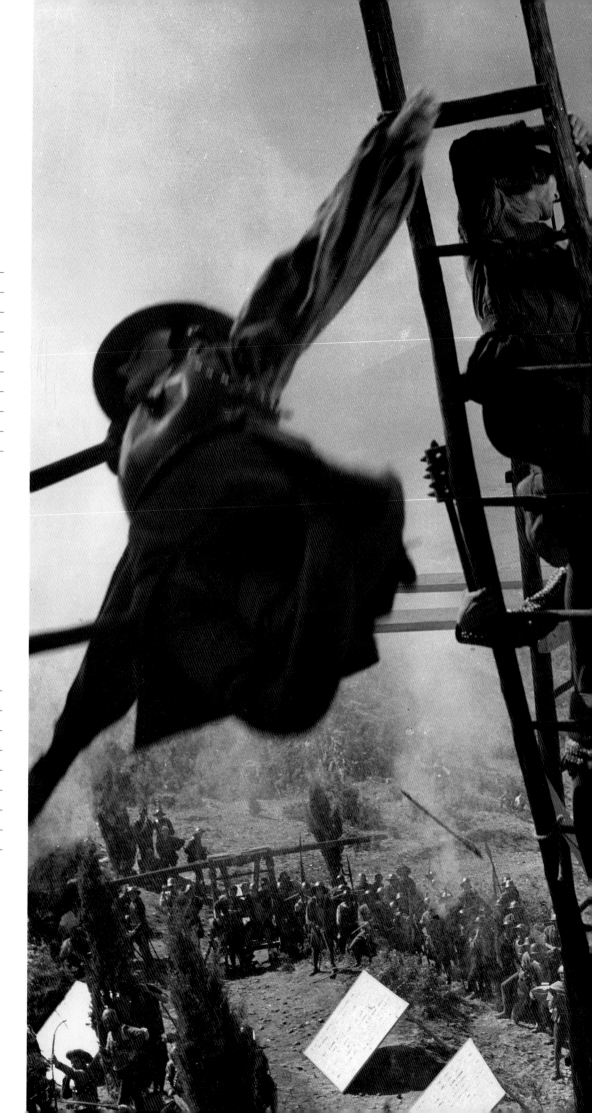

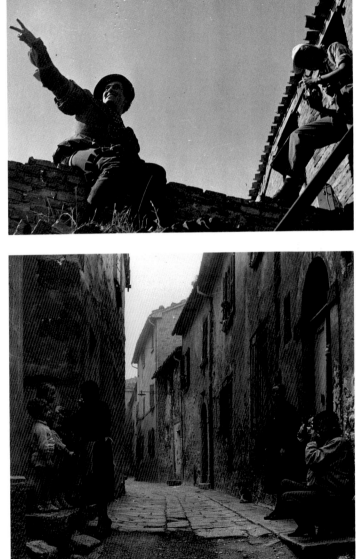

Excluding the wedding of Queen Elizabeth II, the marriage of Tyrone Power to Linda Christian was *the* international social event of its time, bringing the 1940s to a storybook end in January 1949. *Look* magazine asked me to photograph the wedding, an assignment I gladly accepted.

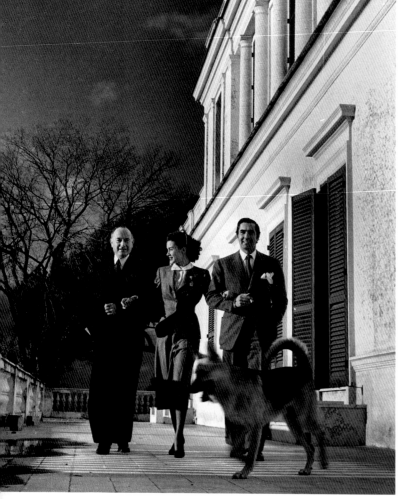

Ty had been awaiting his divorce from the delightful French star, Annabella, and running around with Paulette Goddard and Lana Turner when he encountered Linda in Acapulco in early 1948. She was both aloof and captivating. Linda had been in a few small movie parts and had done some modeling, but she was no "name" in Hollywood. Her looks were all: five feet five, measuring 36–24–36, with tawny red hair. Somebody in Hollywood dubbed her The Anatomic Bomb. Her father was Dutch, her mother Mexican, and though she was born in Tampico, Mexico, her father's profession as a petroleum engineer took the family from Johannesburg to Haifa to Hollywood. Linda spoke Dutch, French, Italian, Spanish, German, and English impeccably. One columnist described her as "a fascinating girl, a little like a wild mountain lion up a tree. Her bright green eyes are far apart and when she smiles she looks as though she'd bite."

Although Linda was a devout Roman Catholic, the wedding date was chosen by her astrologer. Her trousseau and wedding gown, created by Fontana, then the top designer in Rome, were the talk of the international set. She ordered two dozen outfits plus a dozen ski things and five fur coats for the Austrian honeymoon.

Left: Before the big day, Ty and Linda stroll with their friend Count Miani along the veranda of the count's villa. Opposite: Linda is fitted for her gown, which was a gift from Madame Fontana.

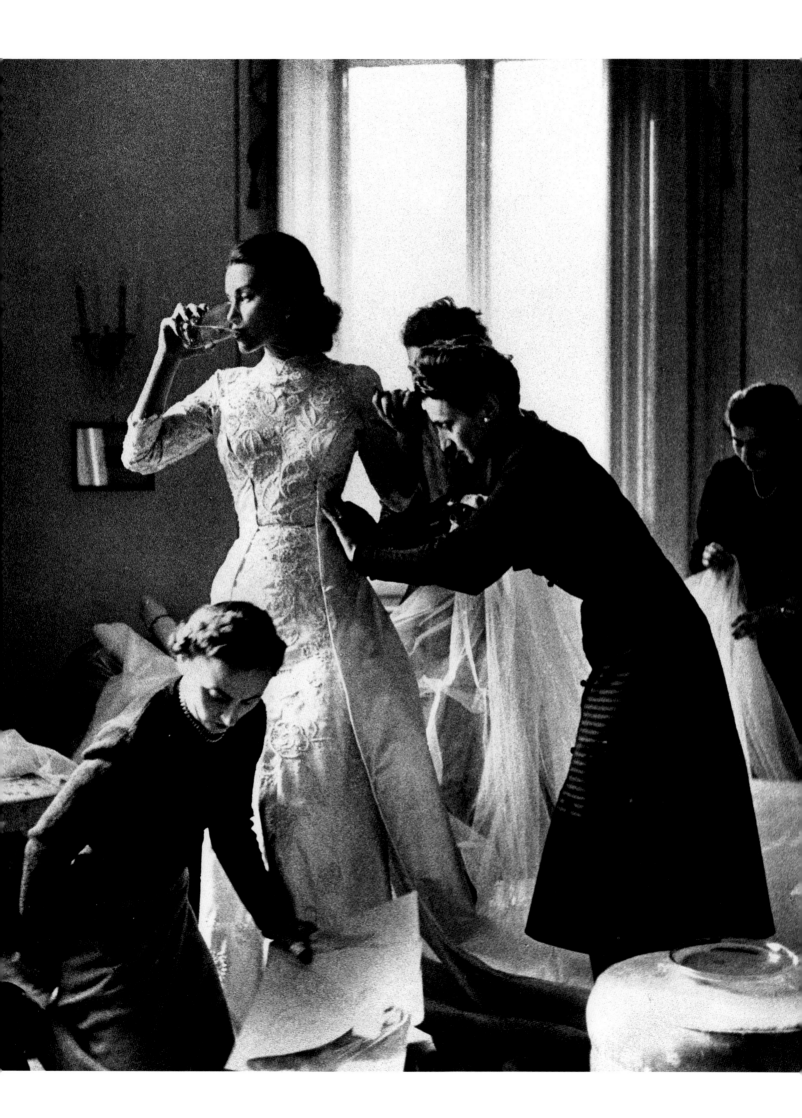

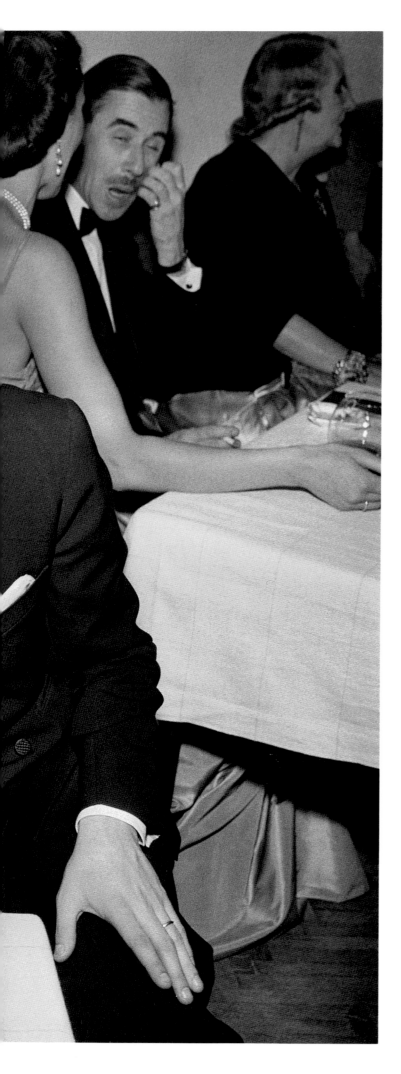

The pre-wedding party was held at Rome's "in" spot, The Whip. Opposite: Count Rudi Crespi and his wife, Consuelo, who always reminded me of Vivien Leigh. Below: Ty and Contessa Dorothy di Frasso take a whirl. Dorothy had come a long way

from Watertown, New York, and the $12 million she inherited from her father's leather-goods business had helped. Marriages were her specialty. It was Dorothy who masterminded the match between Cary Grant and Barbara Hutton.

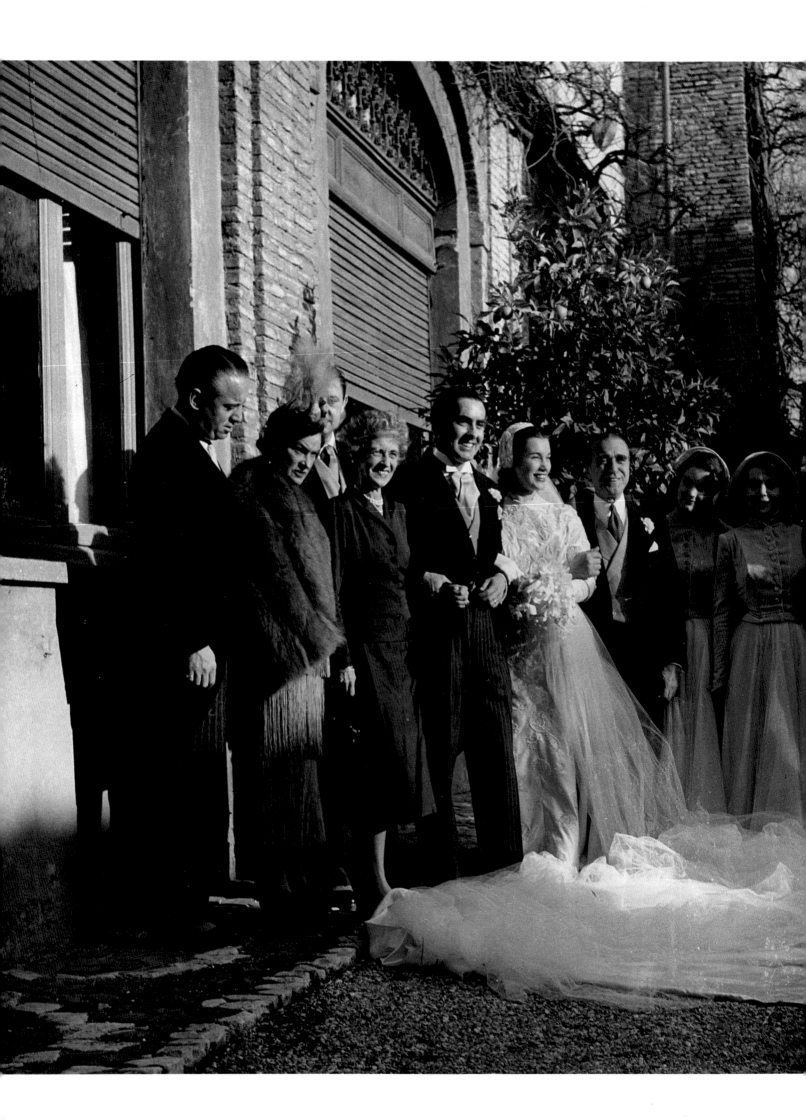

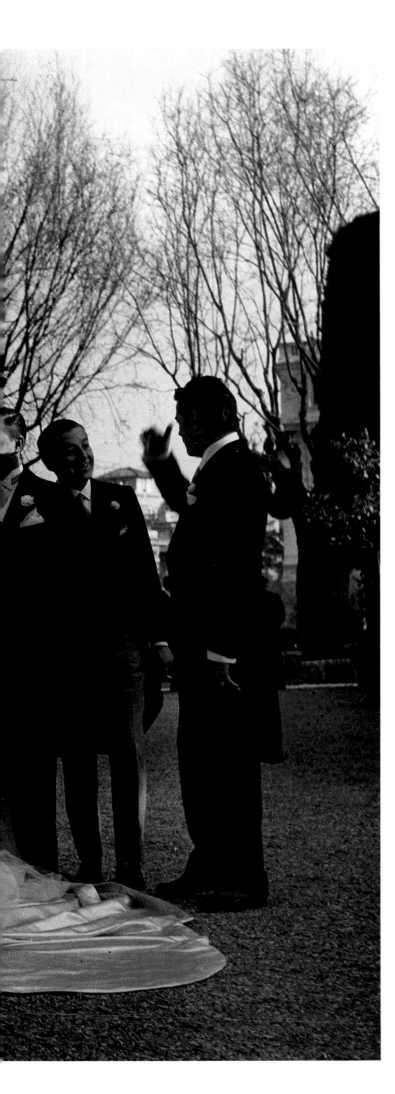

Opposite: The wedding luncheon was given by the U.S. ambassador, James Dunn, and the wedding group outside the American Embassy included (from left) producer Mike Frankovich, Contessa Dorothy di Frasso, Mrs.

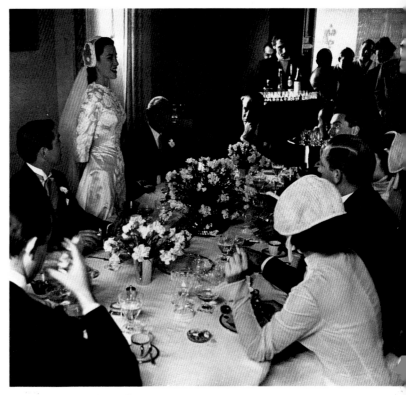

Dunn, the newlyweds, Ambassador Dunn, and Linda's sister. Above: In her little speech of thanks, Linda was all smiles as she relished "the fun you all have given us." The fun did not last: Ty and Linda were divorced in 1955.

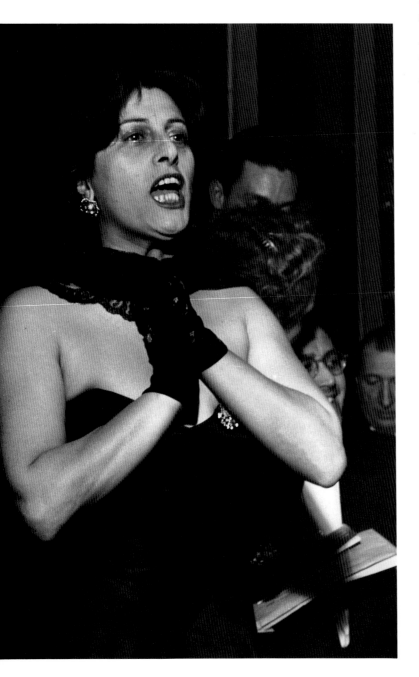

One Roman spring, for *Harper's Bazaar*, I covered the annual *Bal de Têtes*, a society ball to benefit Italian child welfare. Held in the grand ballroom of the Excelsior Hotel, the 1949 *Bal* turned out to be unusually magnificent, reflecting the Italians' love of crowds, noise, excitement—and elegance. Romantic music played as the beauties of Roman society, in elaborate headdresses decorated with feathers and jewels, dazzled the other guests. The guest of honor was actress Anna Magnani (left). She entertained the crowd when she announced the prizes for the most imaginative headdresses—everyone screamed with laughter. But all stood still and listened while she spoke her piece for the United Nations Appeal for Children, and when she had finished they went wild with applause. Everyone loved her, and she had a ball also (opposite).

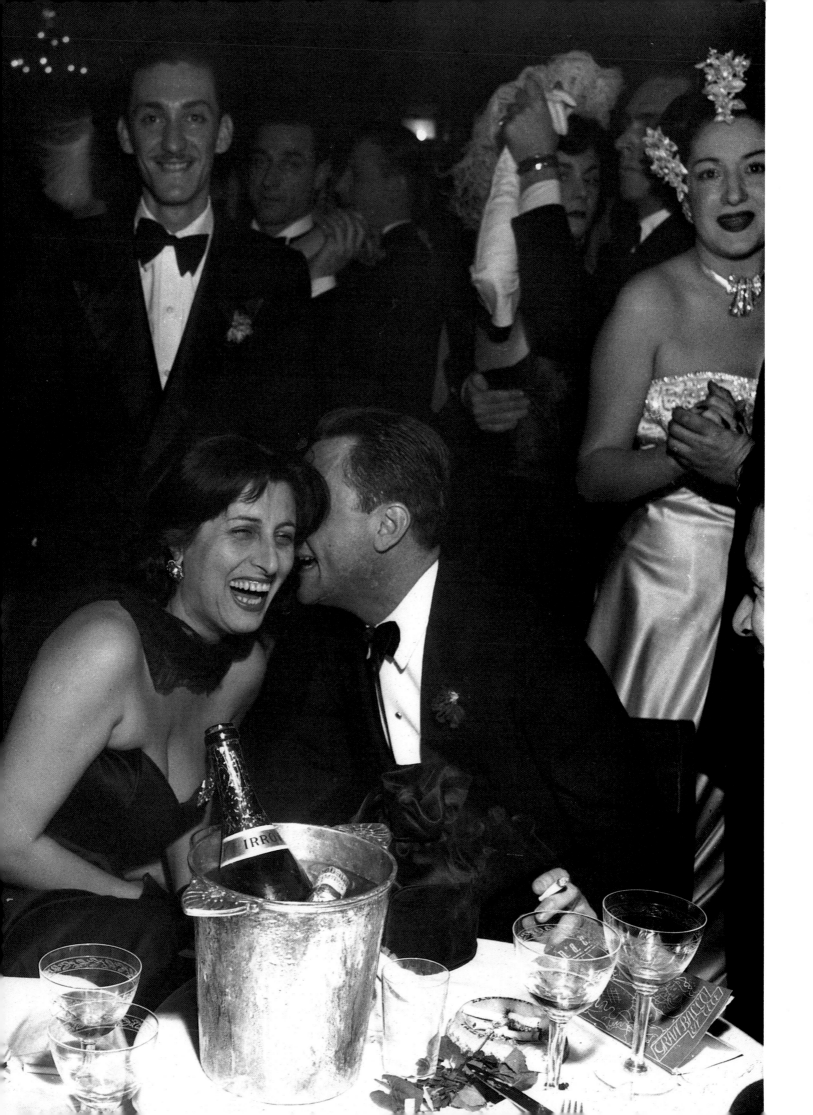

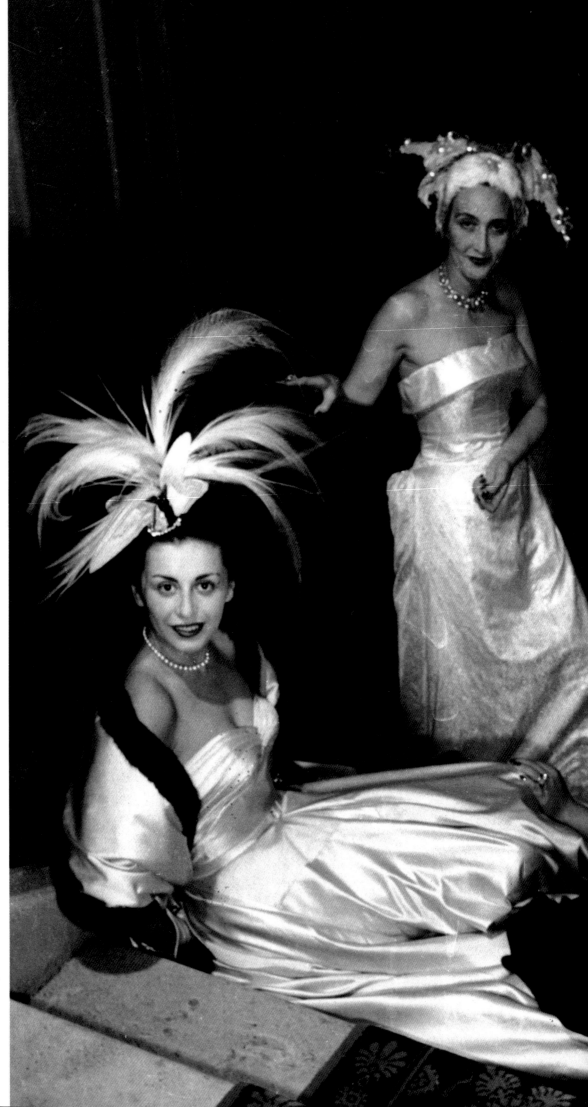

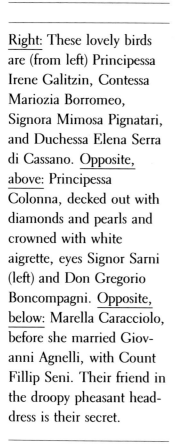

Right: These lovely birds are (from left) Principessa Irene Galitzin, Contessa Mariozia Borromeo, Signora Mimosa Pignatari, and Duchessa Elena Serra di Cassano. Opposite, above: Principessa Colonna, decked out with diamonds and pearls and crowned with white aigrette, eyes Signor Sarni (left) and Don Gregorio Boncompagni. Opposite, below: Marella Caracciolo, before she married Giovanni Agnelli, with Count Fillip Seni. Their friend in the droopy pheasant headdress is their secret.

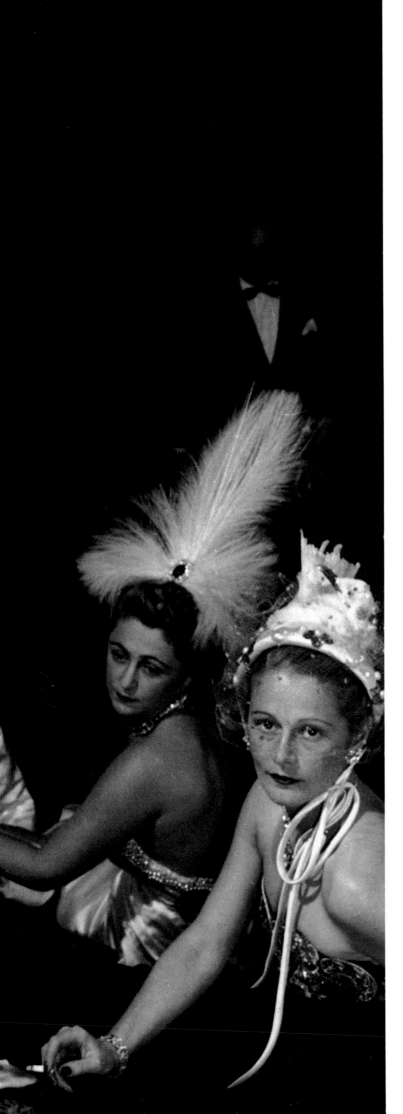
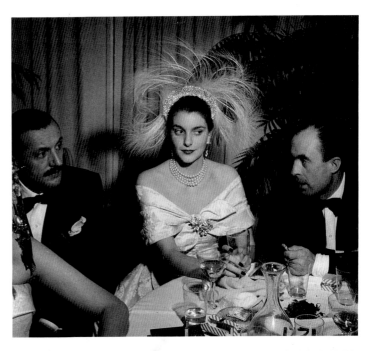
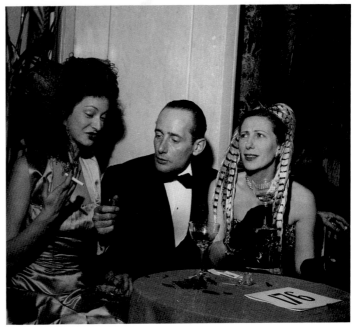

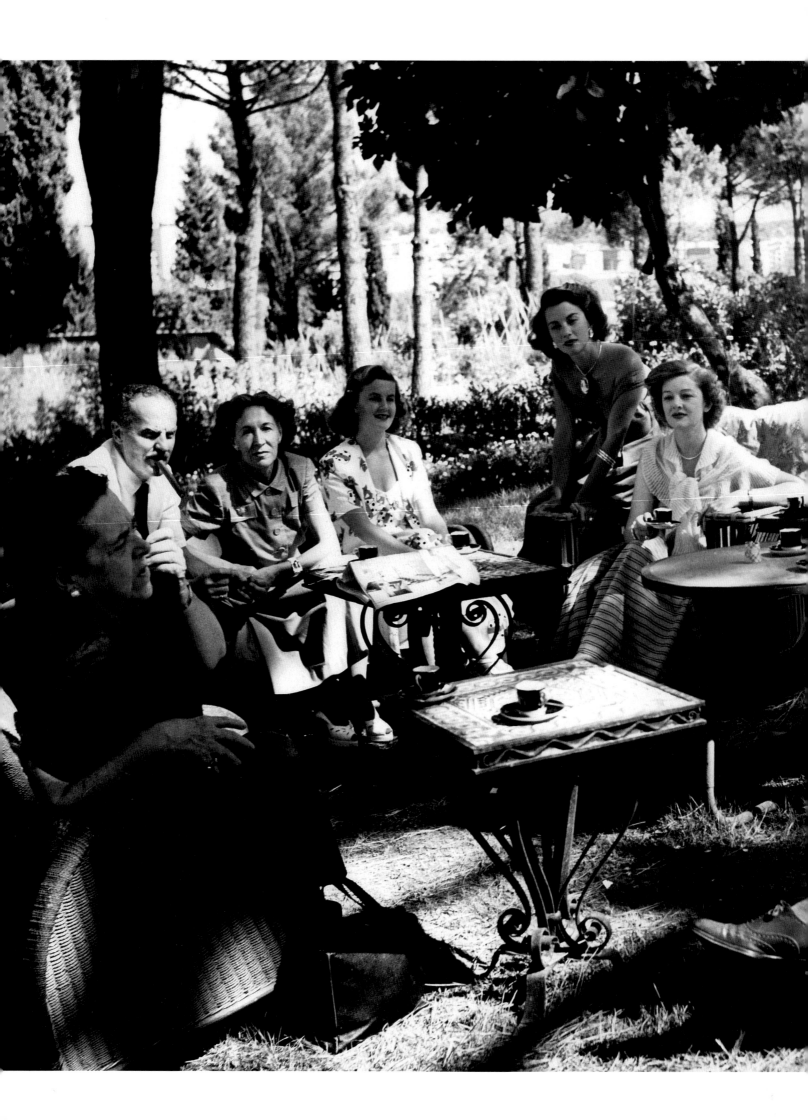

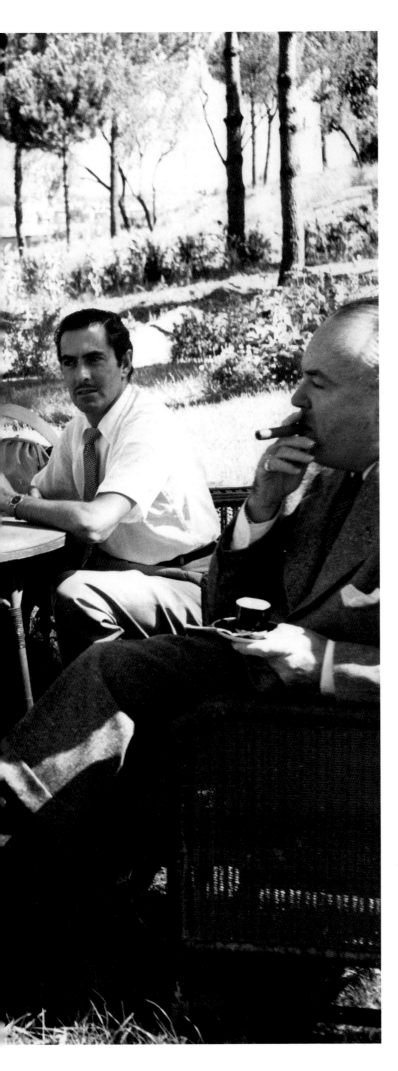

Opposite: Tyrone Power was the biggest male star at Twentieth Century-Fox but his boss, Darryl Zanuck, could not attend Ty's wedding to Linda Christian in Rome in January of 1949, so he stopped by in the spring to pay his respects. The setting was the garden of my friend Contessa Dorothy di Frasso at her Villa Madama, a sixteenth-century estate overlooking the Eternal City. From left are Elsa

Maxwell, Darryl and Virginia Zanuck, their daughter Susan, Linda, Myrna Loy, Ty, and Gene Markey, Myrna's husband. Sensible woman though she was, Myrna married Gene despite the fact he had been through two other star marriages to look-alikes, Joan Bennett and Hedy Lamarr. They divorced a year later.
Above: Charles Feldman (third from left) was also on hand.

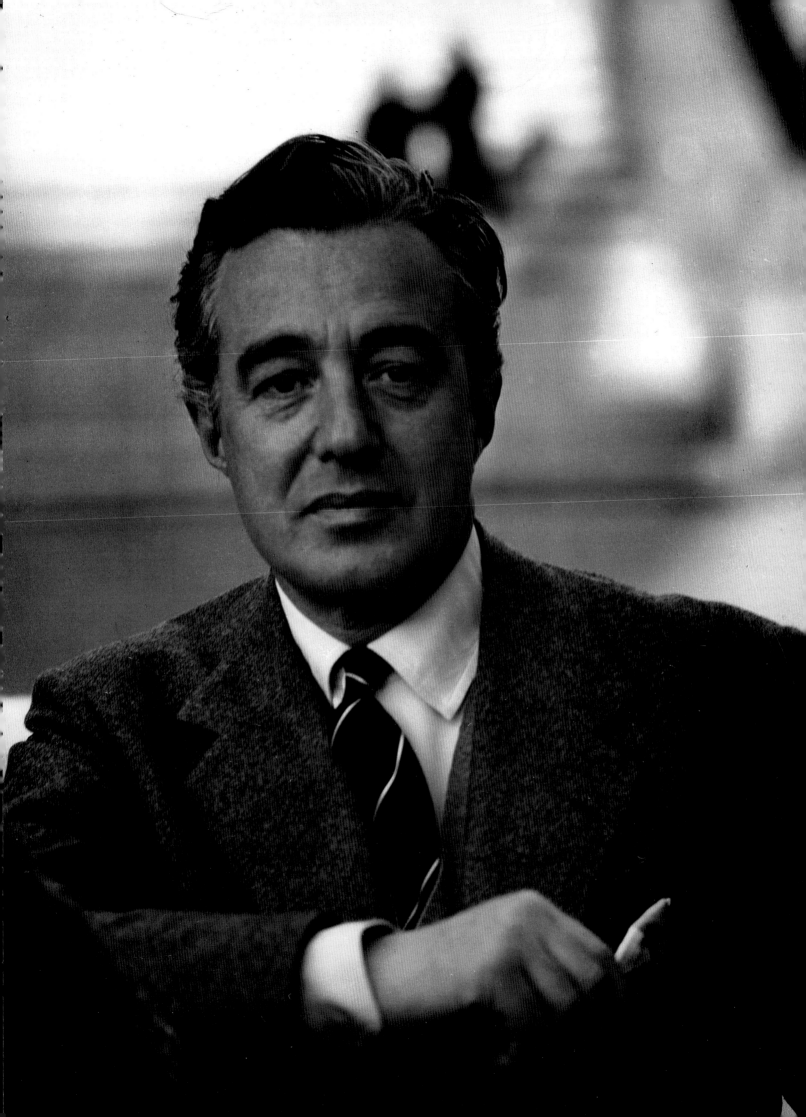

The post–World War II
Italian film artists caused
an earthquake with their
new documentary realism,
an inspired antidote to the
artificial, glamorized Holly-
wood tradition. In the
forefront with his *Ladri di
Biciclette* was director
Vittorio De Sica (opposite),
a suave charmer whom you
would never suspect of
being able to relate to the
struggles of a poor
mechanic and his son look-
ing for a stolen bicycle. De
Sica, who had been a
matinee idol, instilled that
slice-of-life masterpiece
with incomparable tender-
ness and his own
Neapolitan love for life. It
wasn't until he acted in
Max Ophuls's elegiac *The
Earrings of Madame de . . .*
that his charisma as an
actor was fully appreciated.
When I returned from
Rome I told Charles Feld-
man about De Sica.
Feldman took him on as a
client, and they became
friends.

Sir Osbert Sitwell
(right), next-to-youngest of
that eccentric writing tribe,
at his Italian villa, Castello
di Montegufoni, near
Siena, only slightly more
ornate than the stately
homes of his native
England.

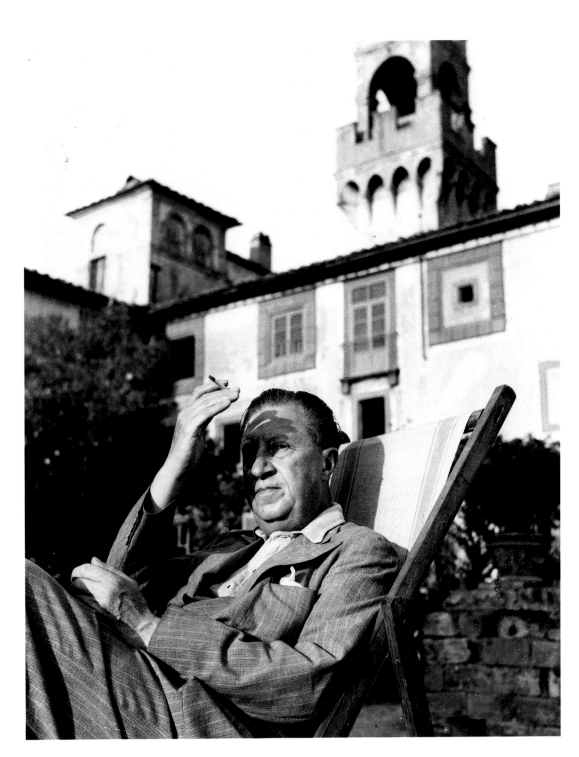

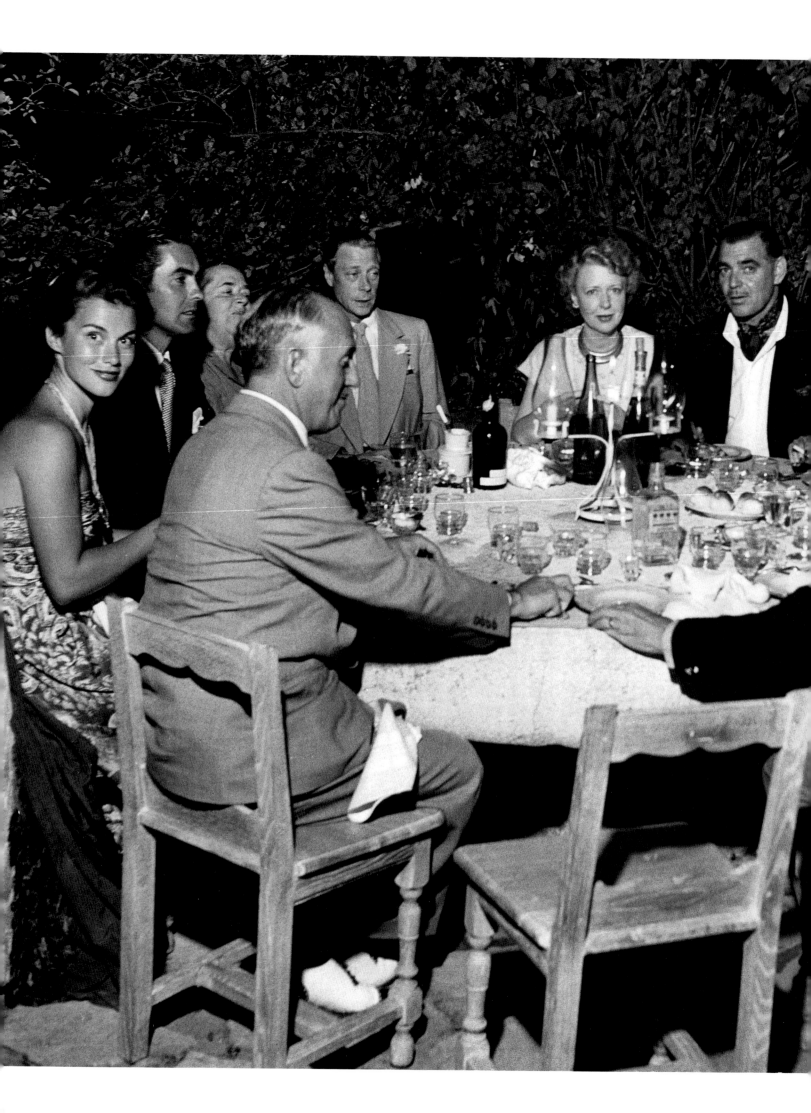

Though Elsa Maxwell played hostess to the world with other people's money, she often took a stand on principle that contradicted what many criticized most in her, the Maxwell brand of freeloading. One would have thought that with Elsa's life-style, it would have been essential for her to indulge the clique swirling around the Duke and Duchess of Windsor. Although she claimed always to have felt sorry for the Duke, having often encountered him before his abdication, Elsa did not meet the Duchess until after World War II. For five or six years their friendship ran hot and cold, then froze permanently around 1953. Elsa had deplored the Windsors' visit with Hitler at Berchtesgaden on their honeymoon, and she went public with her ire. Their friendship with Charles Bedaux, in whose home they were married, enraged her. Bedaux committed suicide while under indictment in this country for Nazi conspiracy. She even said the Duke ran "a frivolous administration" while governor general of the Bahamas during the war years. It was a wonder they ever made up, but as you can see on these pages, for a time Elsa and the Duke, if not the Duchess, enjoyed peace.

The site for this dinner party, given in 1948, was an unpretentious farmhouse owned by Elsa's friend Dorothy "Dickie" Fellowes-Gordon in Auribeau, a small village above Cannes. Opposite (from left): Linda Christian; Tyrone Power; Elsa; the Duke; socialite Dolly O'Brien; Clark Gable; Virginia Zanuck; David Milford-Haven, one of the Duke's buddies; the Duchess; Darryl Zanuck; and Jack Warner

South of France

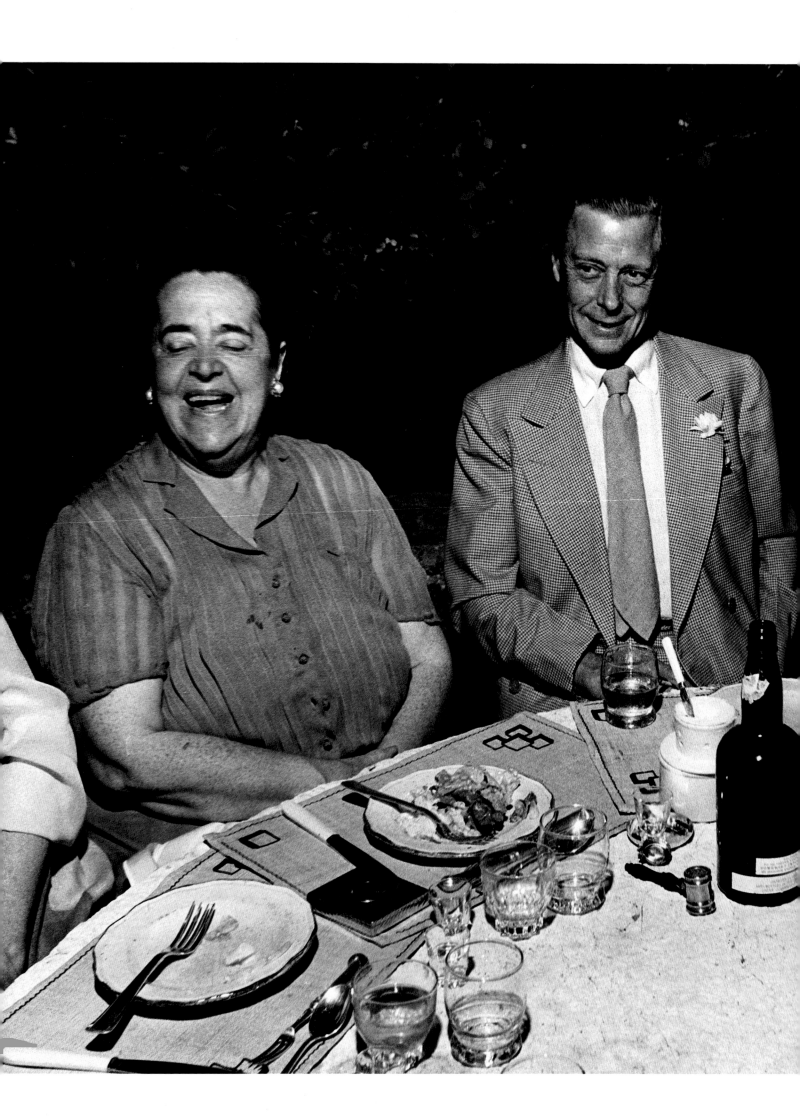

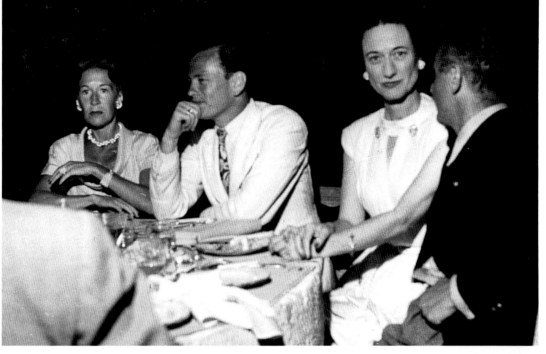

Opposite: Maybe the Duke and Elsa are smiling while remembering the time she sat down at the piano and pounded out some Rodgers and Hammerstein numbers, which inspired the Duke, in blue-and-white kilt, to burst into a chorus of "The Surrey with the Fringe on Top." He loved American show tunes. Despite such tales of informality, with the Windsors there was always the question of the curtsy. Personally, I didn't mind a tiny dip to him, but he expected it for the Duchess too. <u>Right, from top:</u> Virginia Zanuck, David Milford-Haven, the Duchess, and Darryl Zanuck. Elsa sits between the two most popular male stars of their time, Clark Gable and Tyrone Power. Elsa has her eye on me, the Duke gazes at the Duchess, and Clark and Virginia, I wager, talk shop, Hollywood-style.

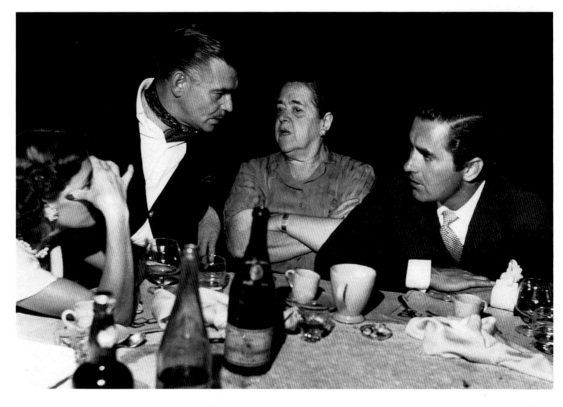

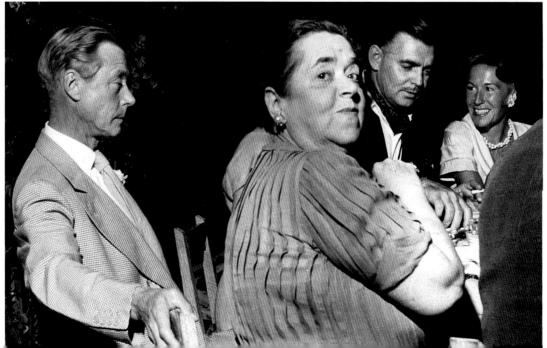

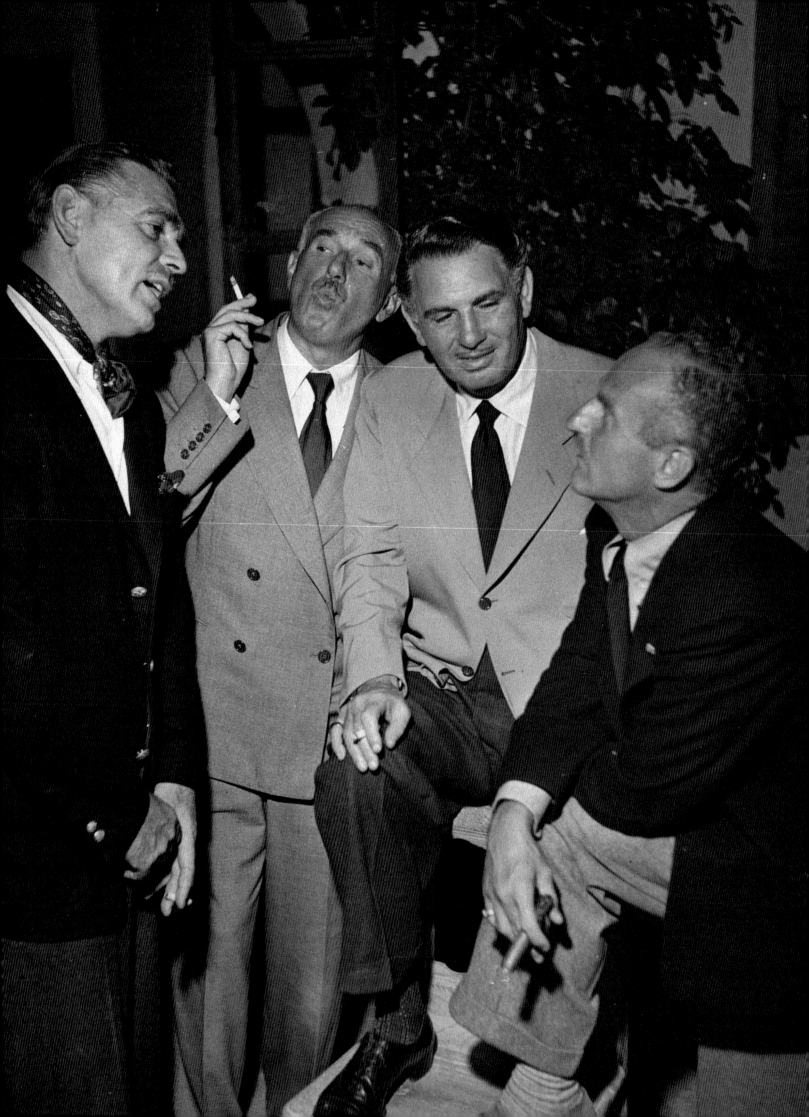

Those were the days when the women went upstairs after dinner and the men retired to the library with their cigars, even if, as in this case, there was no upstairs, no library; the men improvised. <u>Opposite</u>: Clark Gable, Jack Warner, Charles Feldman, and Darryl Zanuck. <u>Below</u>: Elsa takes the weight off, but that grin on her face is a sure sign the evening was a success. The tall woman (left) with Virginia Zanuck and Elsa is Dickie Fellowes-Gordon. She and Elsa had met on an Atlantic crossing forty years earlier. The

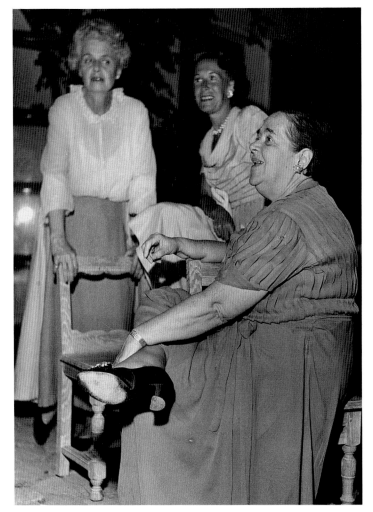

five-foot-ten daughter of a wealthy Scottish family and the five-foot-one party queen from Keokuk left the ship friends for life. Dickie didn't like the Windsors; in fact, with her Scottish heritage, she thought all English kings after the House of Stuart were "German upstarts," according to Elsa. "I'll never sit down at the same table with Hanoverians," Dickie vowed. But Elsa was persuasive, and after a few encounters, Dickie begrudgingly admitted "the Duke has charm." She never came around with the Duchess.

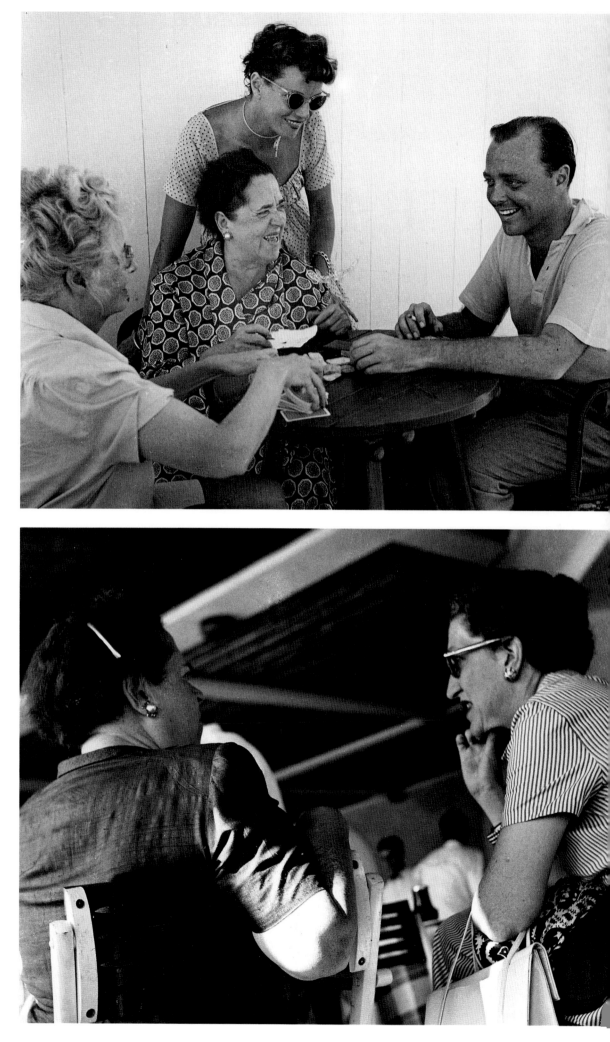

Catching up with the gossip on the Côte d'Azur. Opposite, left: Elsa Maxwell and Darryl Zanuck trade tidbits. Darryl was a sunbathing fanatic and, unlike other meaty moguls, he had the kind of tight but lithe body made for a bikini. Dickie Fellowes-Gordon didn't, but she takes a dip anyway (opposite, right), as long as the Riviera sun spoils not her English complexion. When it came to sex, Elsa always stressed that "I wouldn't submit myself to it. Sex is the most tiring thing in the world." If true, then she and Dickie had the longest platonic relationship on record. Above right: Dickie, Elsa, Tyrone Power's ex-wife Annabella, and Jimmy Donahue are sitting at a card table, but the game is talk. Below right: Elsa gossips with her old chum Kitty (Mrs. Gilbert) Miller, one of the sovereigns of mid-century society.

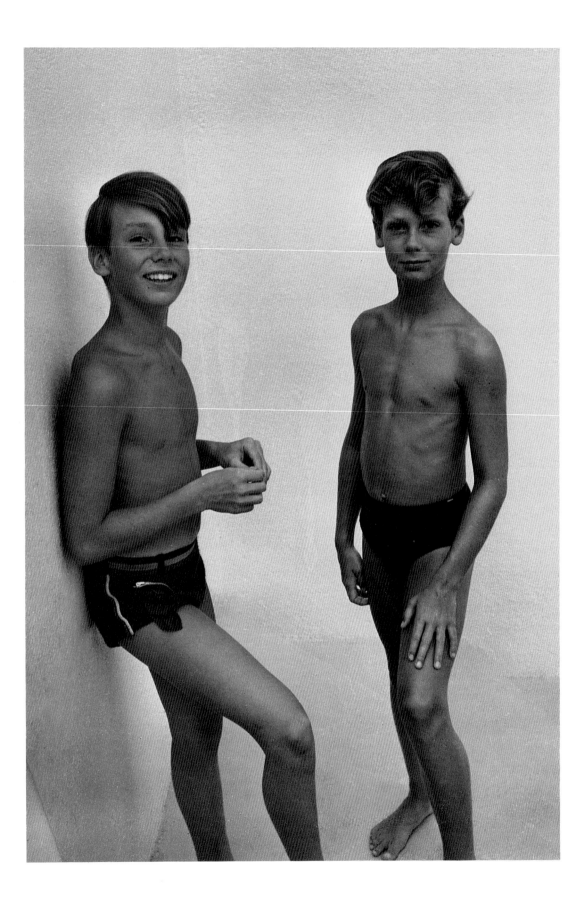

Elsa Maxwell introduced Aly Khan, descendant of the prophet Muhammad, to Rita Hayworth in the summer of 1948, when America's love goddess was waiting out her final divorce papers from Orson Welles in Europe. The whole world took note. Aly's father, the ancient Aga Khan, the revered Muslim leader, disapproved of the romance, and Harry Cohn, the big bad wolf who held Rita's contract at Columbia Pictures, suspended her. *The Hollywood Reporter* ran a classic headline: "From Cohn to Cannes to Khan to Canned." Rita, a shy, simple soul, didn't care; she was in love. When I took this shot of the happy couple (opposite), a few days before their wedding in May 1949, Rita was blissful, and pregnant. Aly Khan was the sexiest man I've ever known. Elsa called Aly *un homme fatal*—women were wild about him. Left: Aly's beautiful boys, Karim and Amyn, were from his first marriage to Joan Yarde-Buller, ex-wife of Tory M.P. Thomas Loel Guinness. Karim, the oldest (on the left), is now the secretive Aga Khan IV, billionaire and spiritual leader to millions of Ismaili Muslims.

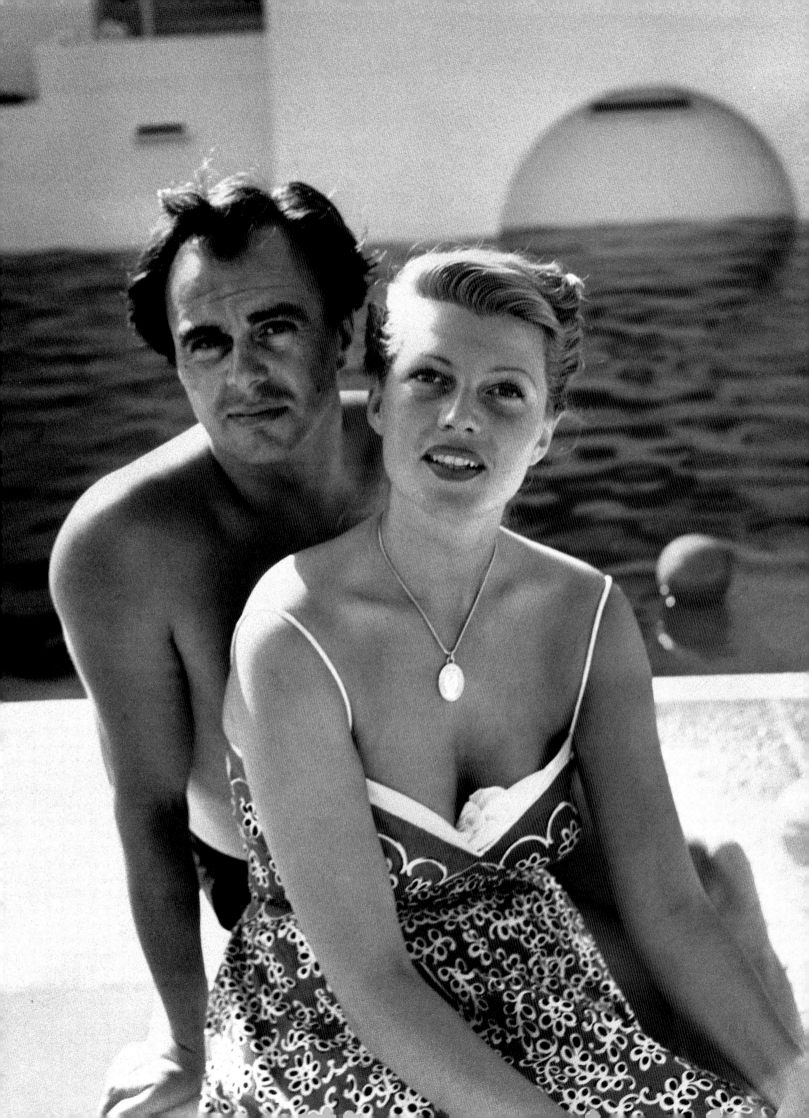

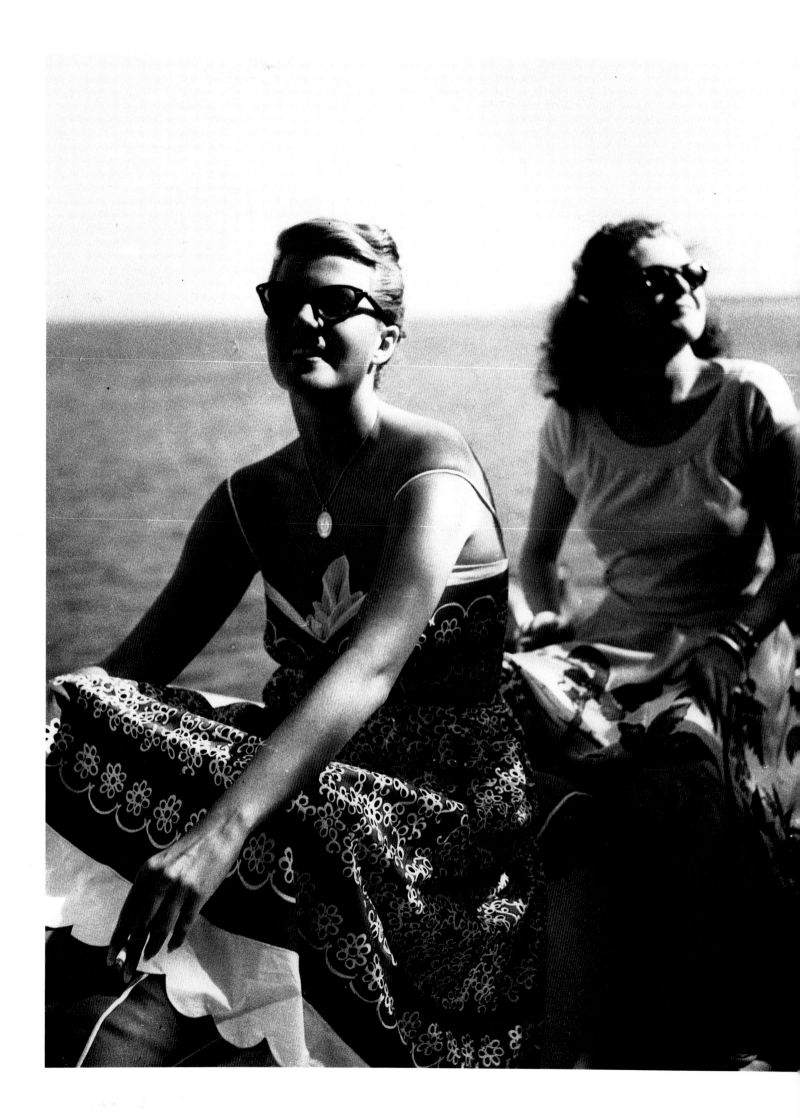

Opposite: Two genuine femmes fatales, Rita Hayworth and Pamela Churchill, who prove you don't have to get dolled up like Marlene Dietrich to wow the stronger sex. Rita has gone into the history books as a symbol of the crusade to understand Alzheimer's disease. Pamela, I have no doubt, will make the history books too. Recently dubbed empress of the Democratic party and acknowledged as the major Washington, D.C., hostess of the 1980s, she has been married to Randolph Churchill, producer Leland

Hayward, and Averell Harriman, who left her his millions. Her romances outside of marriage number Edward R. Murrow, Frank Sinatra, and Gianni Agnelli. In the 1940s she had a natural, fresh-faced look of an earlier era. Cole Porter told me that the secret behind Pamela's power to seduce is simple: she listens. Above left: Little Winston Churchill III, son of Randolph and Pamela Churchill. Above right: Aly Khan on the sea steps of his Cannes villa with his sons, Karim and Amyn

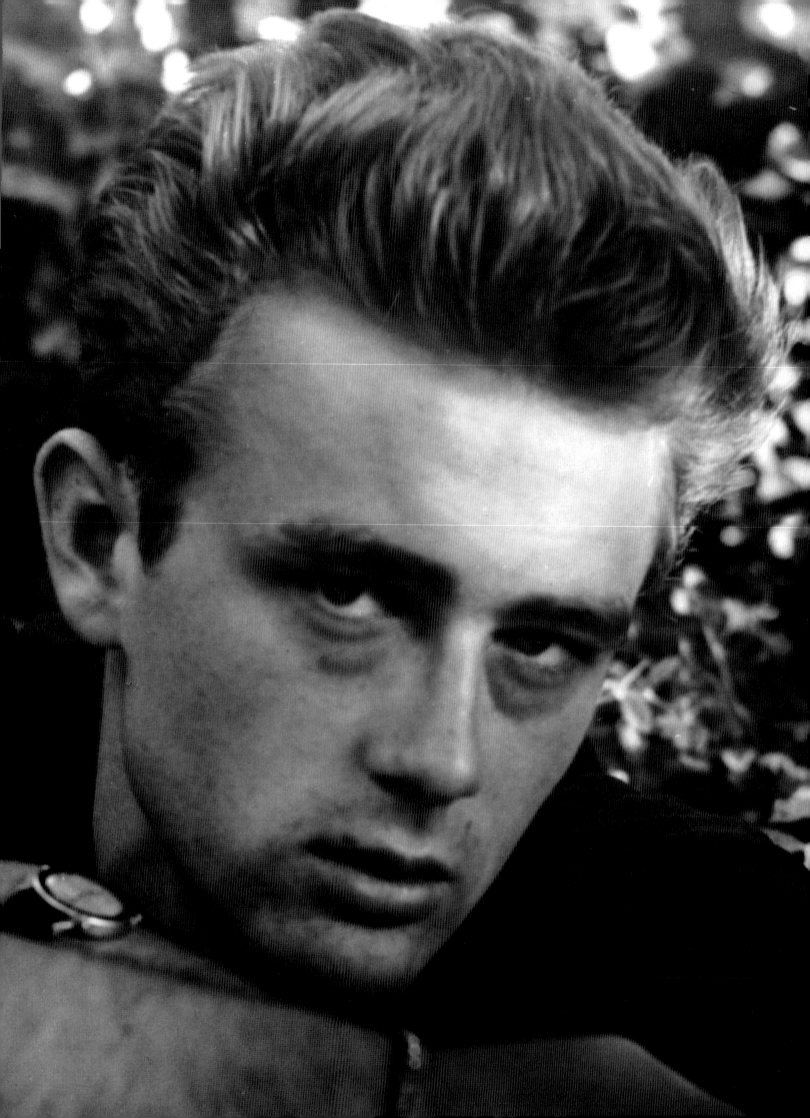

The

Opposite: I jotted down this teenage accolade (from where I don't know) to James Dean: "Everything he said was cool." Jimmy arrived at my house all disheveled, with a two-day growth of beard and eyes as red as a Salonika sunset. My first impression was, "Gosh, there are dozens of fellows who look like this hanging around the streets of downtown L.A." There was a rather awkward greeting but no apology for being late. It was a beautiful September afternoon in 1953, and late, so the sun was low on the horizon.

Right: Before Jimmy would pose for me, I had to first pose for him. The pictures of me alone I destroyed long ago, but I liked this trio shot with his agent and dear friend, Dick Clayton (left), and Leonard Rosenman, who composed the haunting *East of Eden* score. A quote from John Dos Passos makes me think of Jimmy: "The deep eyes floating in lonesomeness, the bitter, beat look, the scorn of the lips. . . ." Two Septembers later he was dead.

Fifties

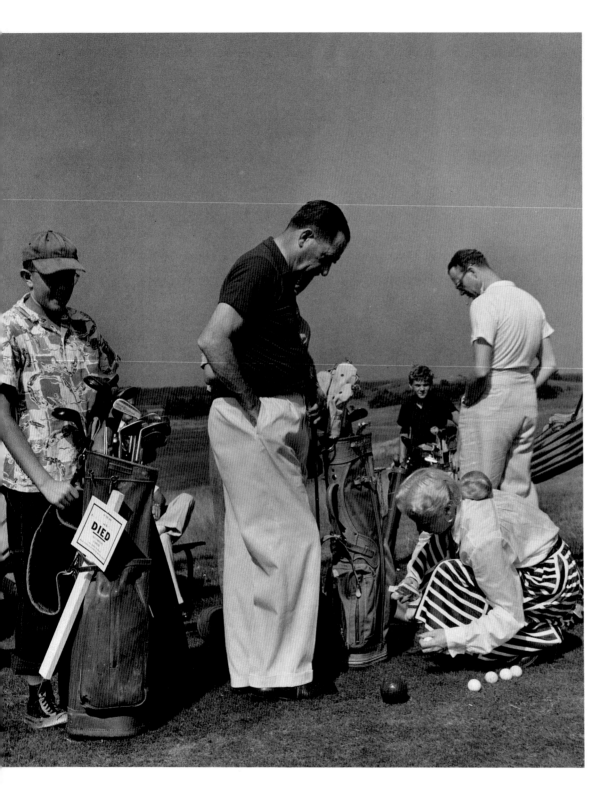

Southampton, New York, in September is not the liveliest place to be, but for this 1950 tournament at Shinnecock Hills Golf Club, a mixed bag of celebrities and socialites had gathered. Left: Harold Talbot and Ginger Rogers. Opposite: Herbie Weston (left) talks with friends while Jay Rutherford and Mrs. Tommy Phipps scout the green.

Southampton

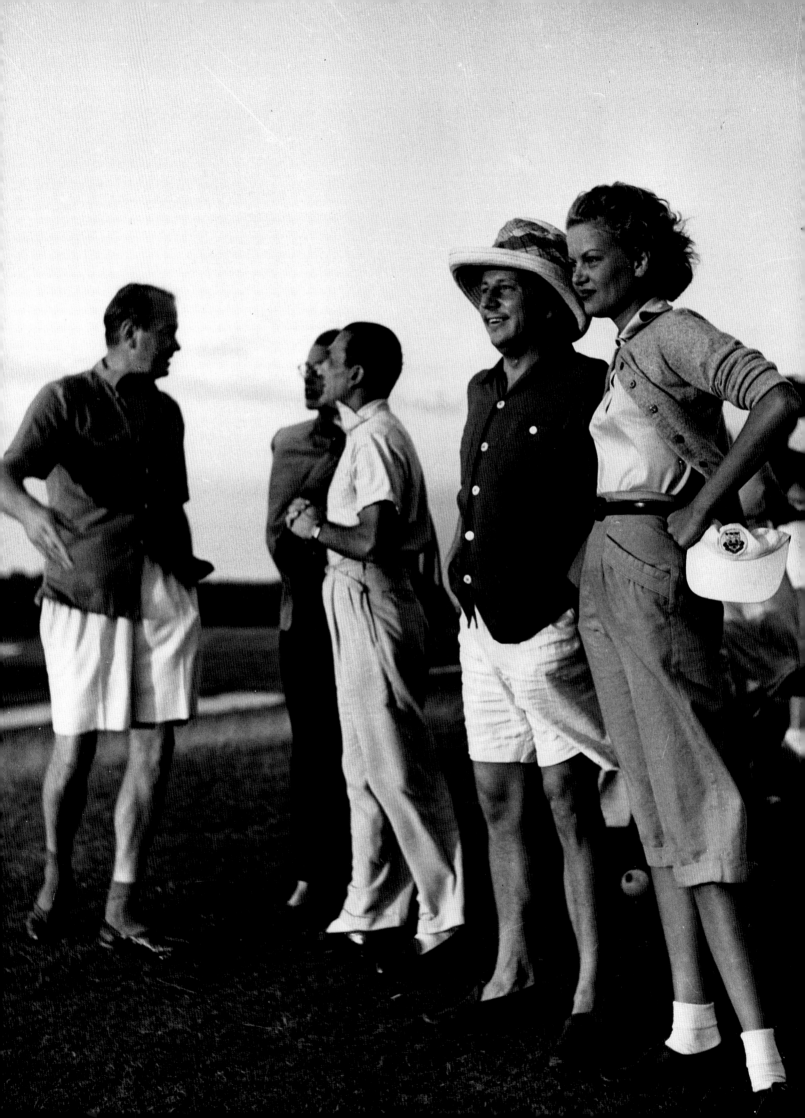

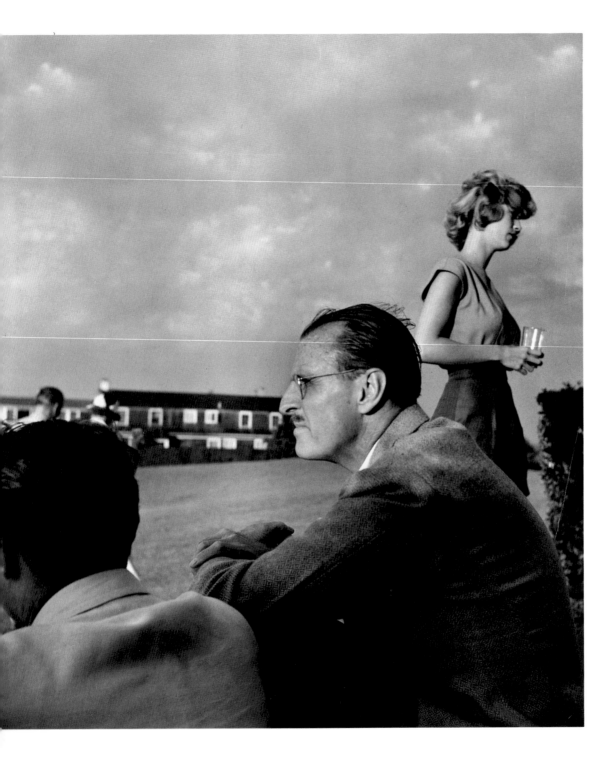

Left: Princely social arbiter
and one of the last of the
Russian royals, Serge Obo-
lensky observes the action
while Missy Weston
doesn't seem too keen on
the game or the green.
Opposite: Tommy Phipps
and Hedy Lamarr have
matching poses, but all
similarities end there. Hedy
in her short shorts rather
scandalized the gathering. I
mean in 1950 modesty still
prevailed, but then Hedy
did scamper around nude
in *Ecstasy*.

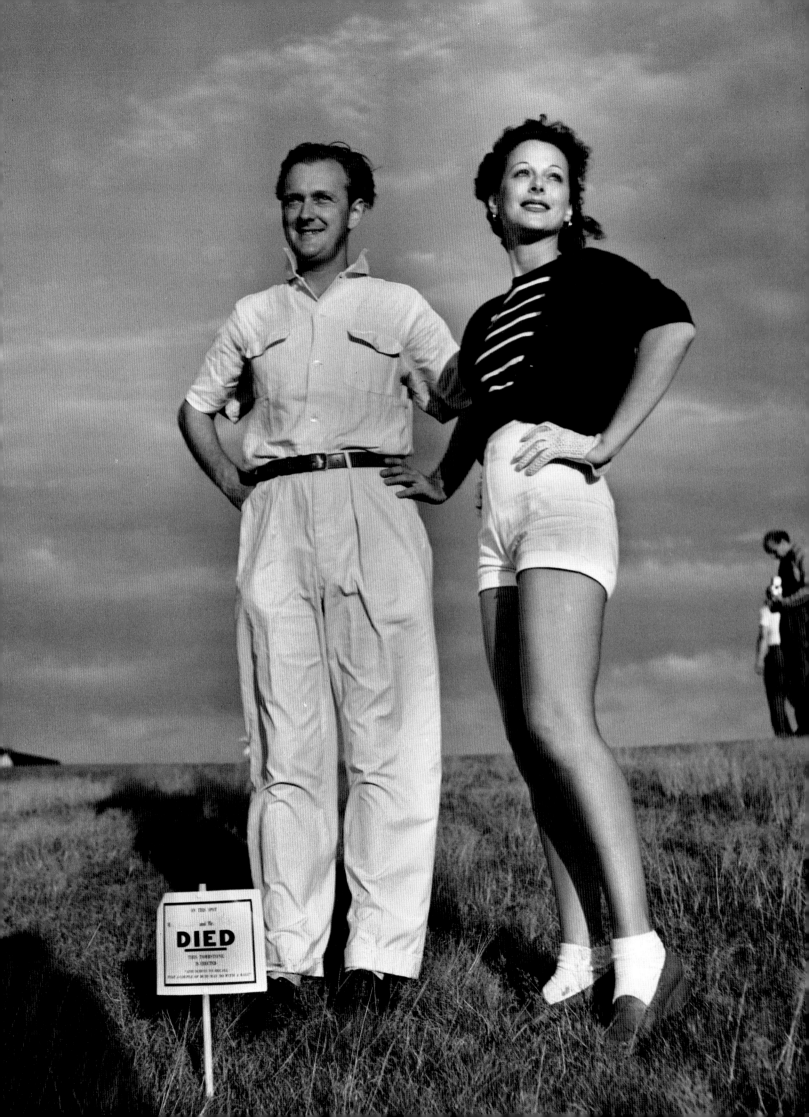

Another lineup that defies age or bank account. Right, from top: Mrs. Henry Ford, Mrs. Charles Addams, Jay Rutherford, and Charles Addams. Here I am with my fellow Texan, Ginger Rogers. Sarah (Mrs. Ed) Russell, daughter of the Duke of Marlborough, and Jay Rutherford

Opposite: Cordelia Robertson (left) of the Biddle Duke fortune seems more camera conscious than Ginger, who was about to mark her first appearance on Broadway in twenty years, but the play, *Love and Let Love*, found little love from the critics and closed after fifty-six performances in the fall of 1951.

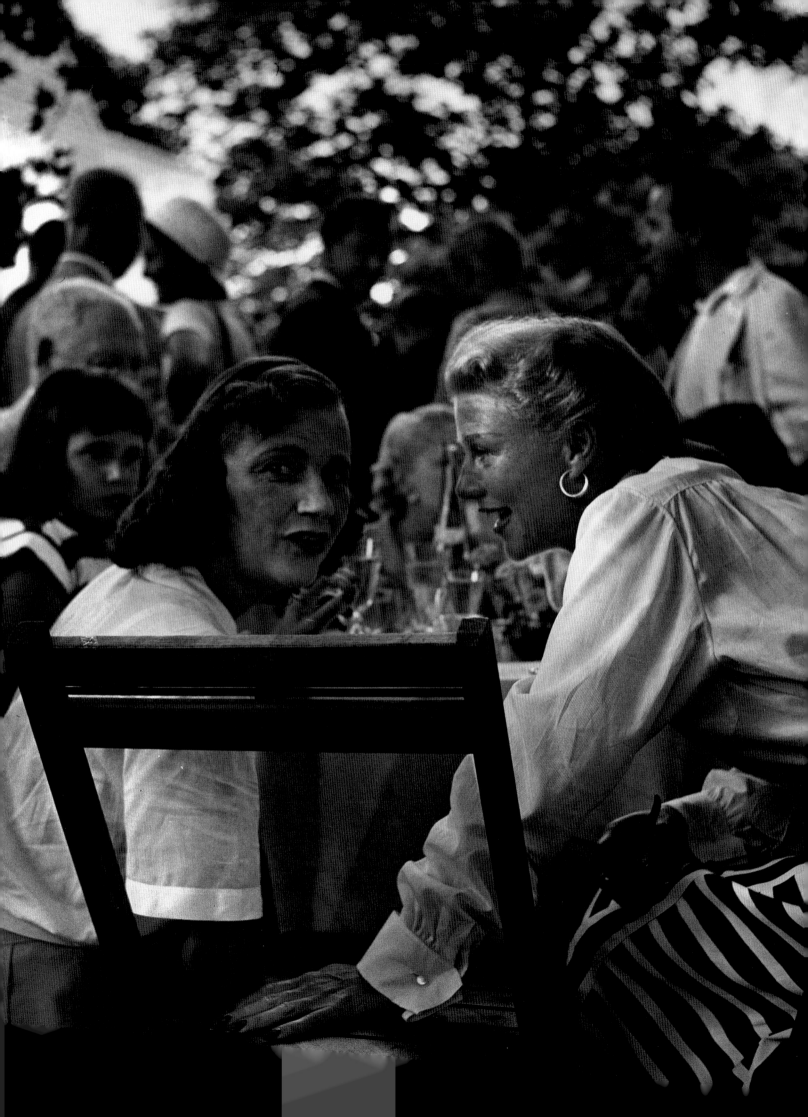

Below left: Fashion editor D.V.!, Diana Vreeland, flanked by Jay Rutherford (left) and Charles Russell, is caught in a rare moment of relaxation at Shinnecock Hills. She was not born a great beauty, so she created her own, irresistibly fascinating style. There will never be another like her.

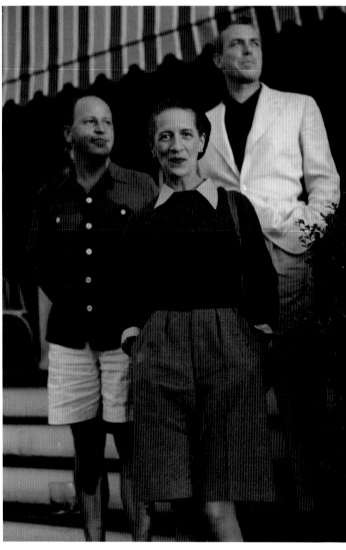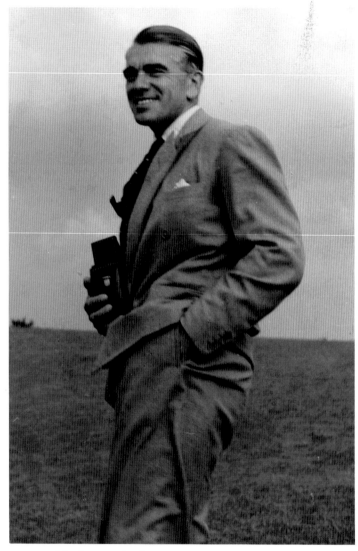

Above right: The golf course seems an odd place to find Horst, one of the best fashion photographers of our time. Accustomed to huge studio cameras, here he happily hugs his small Rolleiflex. Opposite: Thelma Foy (left), heir to the Chrysler fortune, and Kay Denckler take an after-lunch stroll near the finishing hole.

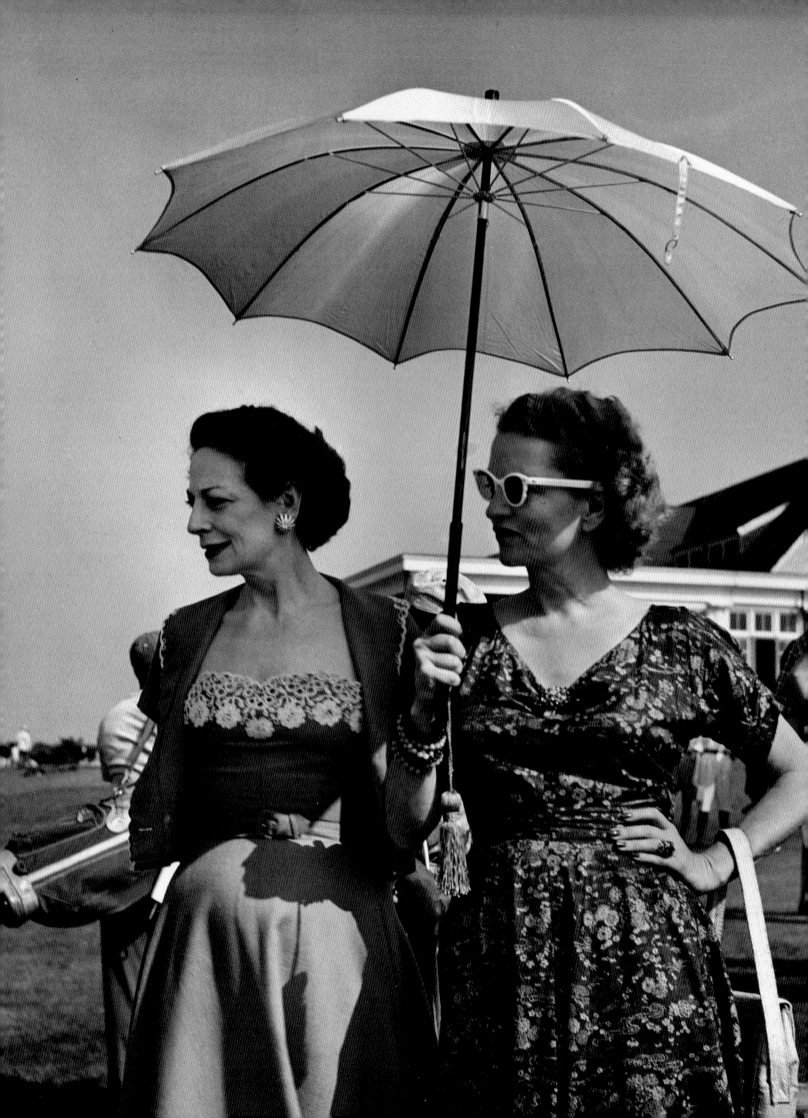

Clinging to the clubhouse in the final hours of the tournament. Below: Stylish Serge Obolensky (left), Ed Russell, John McClain (seated), and Mr. and Mrs. Lew Preston (back row,

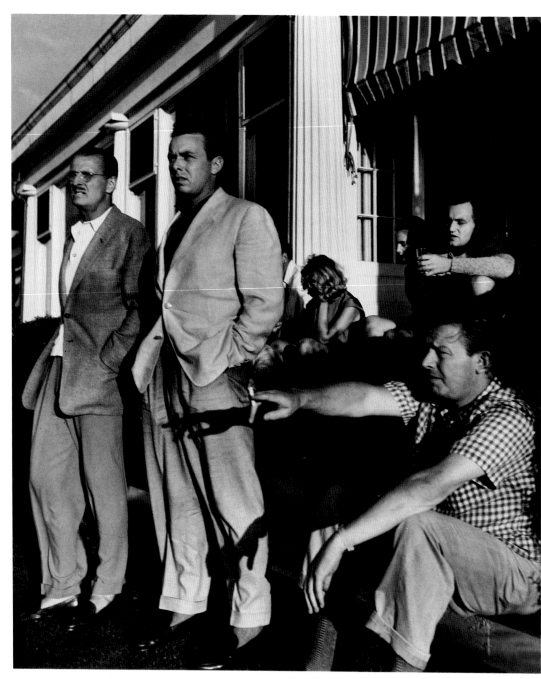

seated). Opposite: Ginger Rogers (in the middle) leans on R. Fulton Cutting II. To his left are Constantin Alajalov, who designed covers for *The New Yorker*, and Josie (Mrs. Watson) Blair.

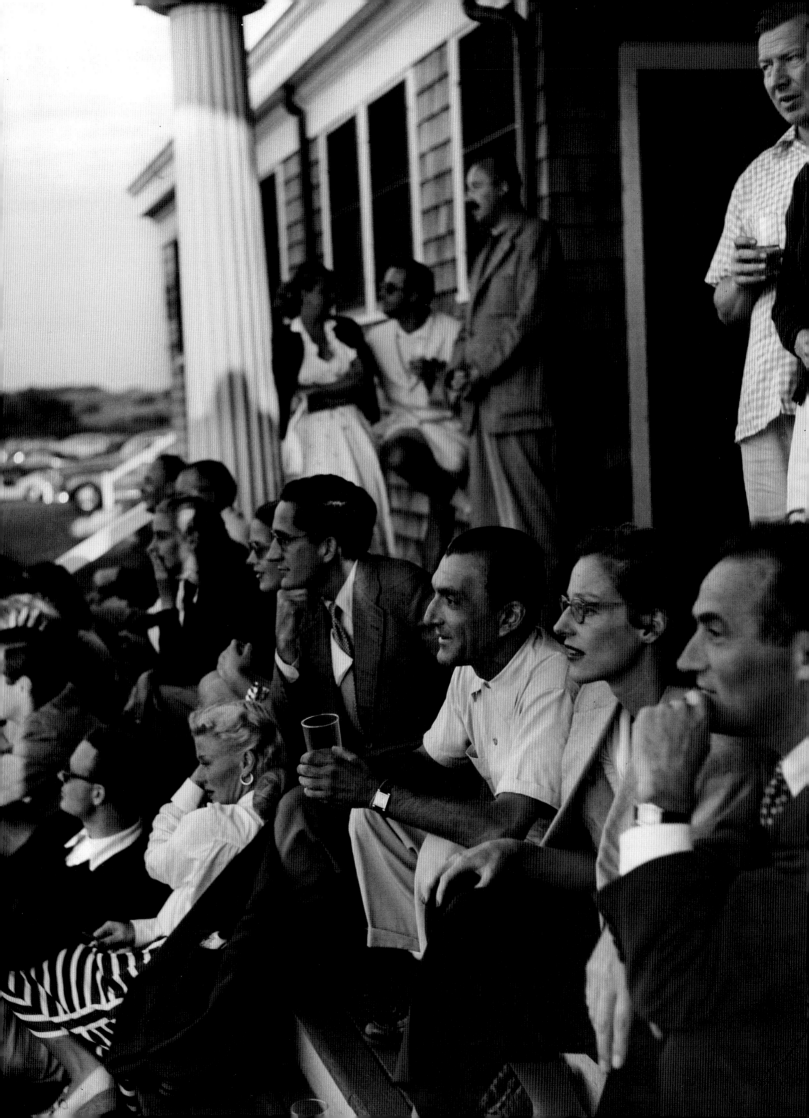

The greatest comeback in the movies was Gloria Swanson's in *Sunset Boulevard* in 1950. It doesn't matter now that the role of the mad Norma Desmond was first offered to Mary Pickford and Norma Shearer, both of whom,

for years she had a maisonette on New York's Fifth Avenue—she rented Falcon Lair, the old Valentino estate. She looked so fabulous she didn't mind references to the fact that Valentino had once supported her in *Beyond the Rocks* back in 1922. Opposite: Mrs. Charles Amory (left) and Margaret Duke pay a call on Gloria (right).

Left: Minna Wallis, a name you should but probably won't find in the Hollywood history books, stands at the gates of Falcon Lair. She was the sister of producer Hal Wallis and as a top Hollywood agent hustled long and hard, indifferent to the limelight. Minna was a loyal friend, a quality best exemplified by the way she relinquished Clark Gable to another agent in the early 1930s because she knew it would help his career and allow him to honor *his* word to a friend. They still remained close after the business break. I always thought Minna was a minisiren because her house overflowed with the handsomest of men. Errol Flynn was a regular, and George Brent, whose wives included Ruth Chatterton and Ann Sheridan, loved Minna but never proposed marriage.

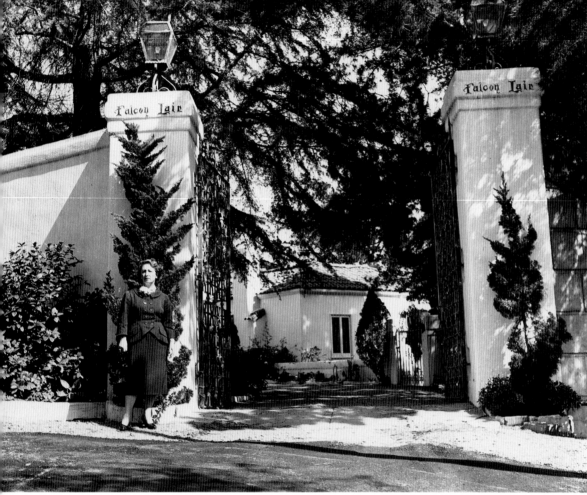

ironically, later became recluses. It must have been kismet for Gloria to win the role of a lifetime, an indelible mating of star and character rivaled only by Vivien Leigh's Scarlett O'Hara. When Gloria returned to Hollywood—

California

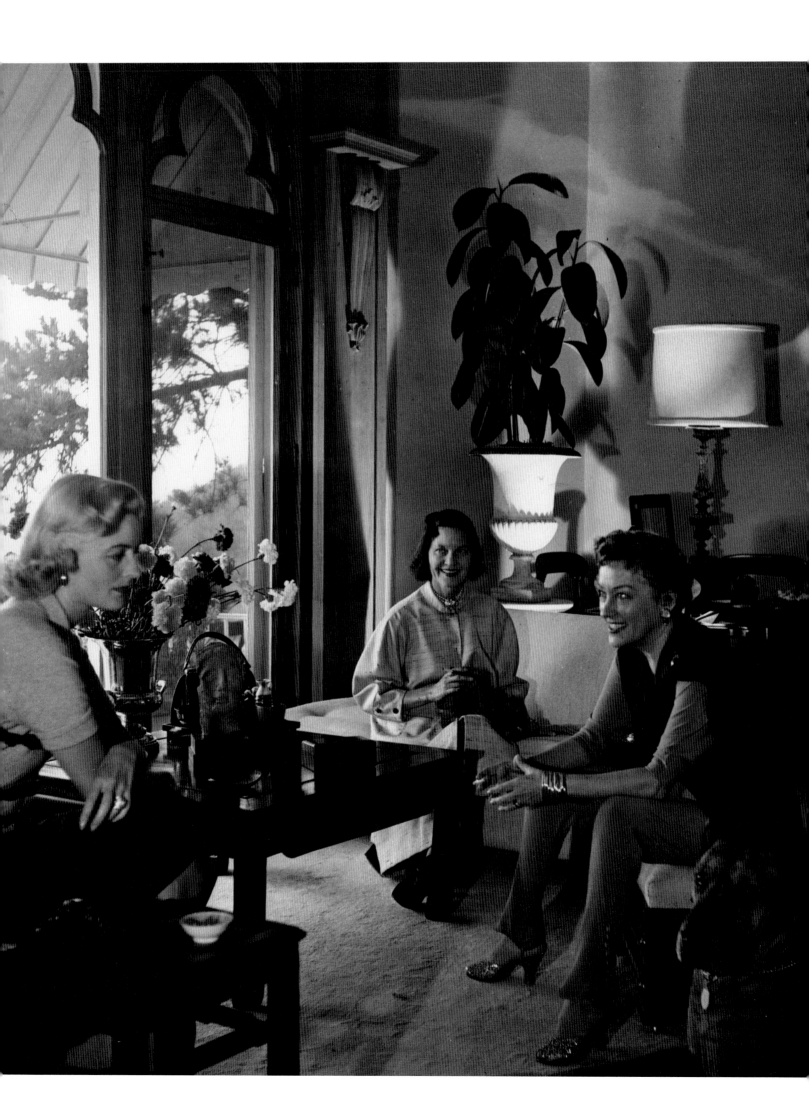

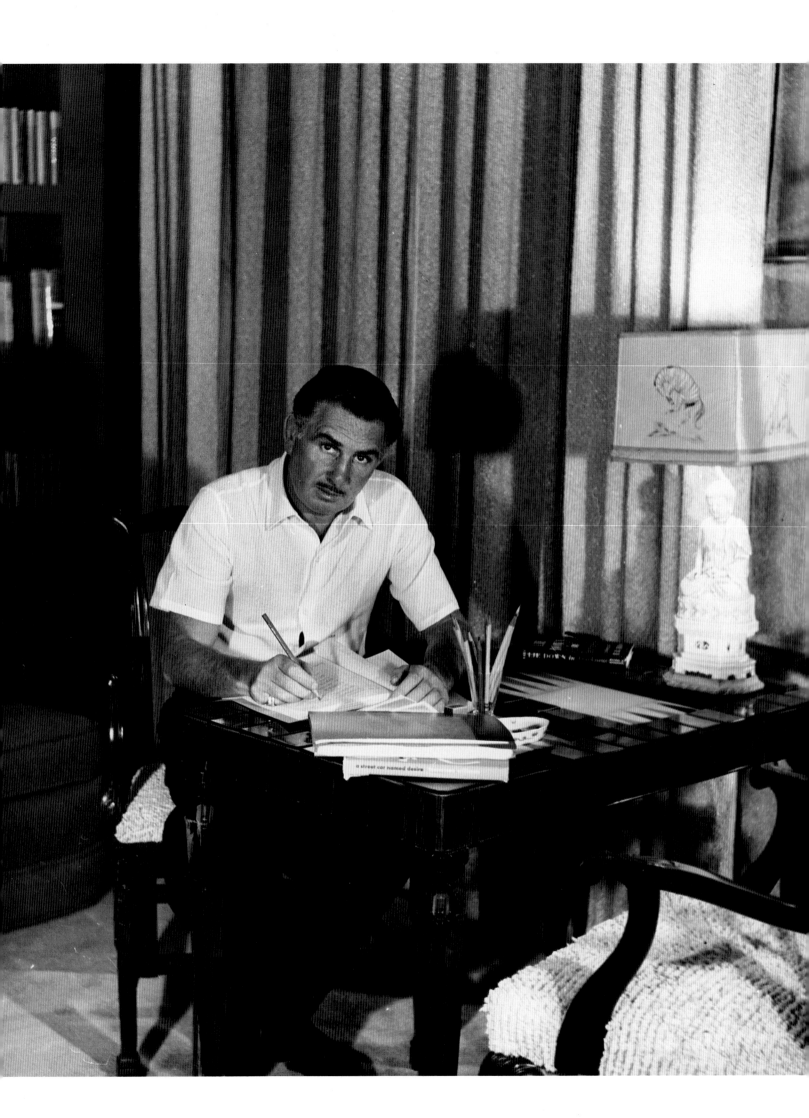

In 1950 LIFE magazine featured Charles Feldman (opposite) at the zenith of his career as agent and producer *extraordinaire*, earning a half million a year when the dollar was worth a dollar. LIFE depicted him as appearing extremely conservative, soft-spoken, self-effacing, and given to dark suits and quiet ties, but underneath his photograph they wrote that he had "the soul of a check-vested gambler." His gambles almost always paid off. Charlie created the "package deal," a practice of putting together story, stars, and director and bringing them as a package to a film company. That concept is the unwritten

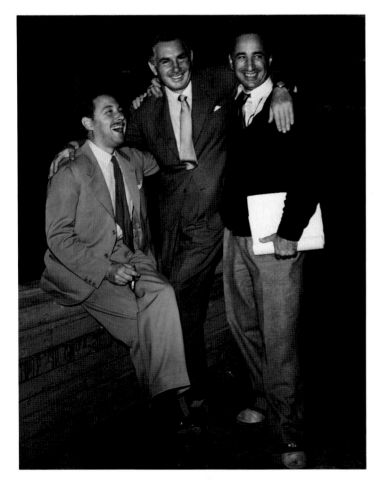

law today. He also was the power broker who first severed the old studio system of exclusive star bondage. In the late 1930s Charlie took a handful of the biggest names and made them independent of those hellish, seven-year contracts. Irene Dunne was a prime example: she had simultaneous deals at Columbia, Universal, Twentieth Century-Fox, and Paramount. She wouldn't make a move without Charlie, and Irene was one of the smartest and most respected (as well as versatile) actresses ever. Claudette Colbert, Cary Grant, John Wayne, and William Holden also flourished with Charlie's guidance.

Charles Gould started life in a family of eight but was orphaned early, losing both parents to cancer. A kind-hearted family named Feldman offered to take in one of the six children but couldn't choose among them, so a footrace the length of Mr. Feldman's furniture store was organized to settle the issue. Charlie tripped over chairs and rolls of carpet to be the first to reach his new father's outstretched arms. Later he worked his way through law school at the University of Southern California, and just when he was making a reputation as an attorney with a secure future, he entered the jungle of agentry. A horrified

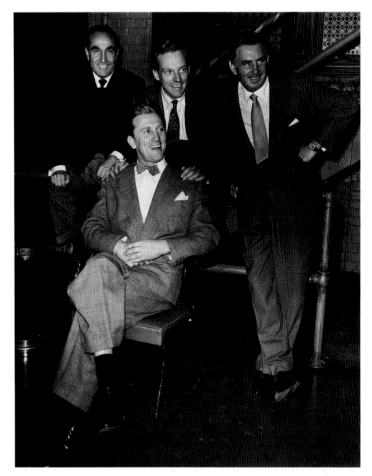

buddy said, "Charlie, you sweated five years for that law degree, and now you give it up for a business where you don't even have to know how to read!" I wonder where that voice of doom was when Charlie produced the film versions of A *Streetcar Named Desire* and *The Seven Year Itch*, among other wonderful, literate examples. Above left: He visits author Tennessee Williams (seated) and director Elia Kazan on the *Streetcar* set. Above right: The smiling foursome during the making of *The Glass Menagerie*: director Irving Rapper, Arthur Kennedy, Charlie, and Kirk Douglas (in front)

Below: In Beverly Hills, class, culture, and genius converged at the court of Arthur Rubinstein. His house up on Tower Road was awash in art, antiques, rare books, and scintillating guests. I photographed this luncheon in 1950 with the always gracious host and his lovely wife, Nela, at the head of the table. Included are (from left) Clifton Webb; agent John Maschio; Cobina Wright; the

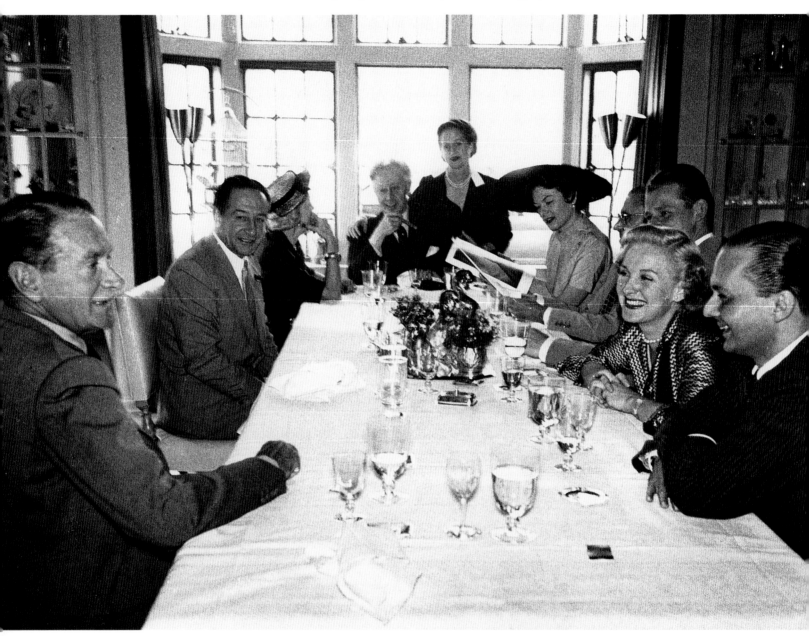

Rubinsteins; Mrs. Jorge Guinle, whose husband owned Rio's Copacabana Hotel; George Cukor; an unknown guest; Connie Moore; and Jorge Guinle. Opposite: The Rubinsteins' youngest children are John, who has since become an important actor, and Alina, whose pet name was "Lali." They were darling children, and by age three Johnny had fallen madly in love with Candice Bergen. After every party he would shout, "I want Candy, I want Candy."

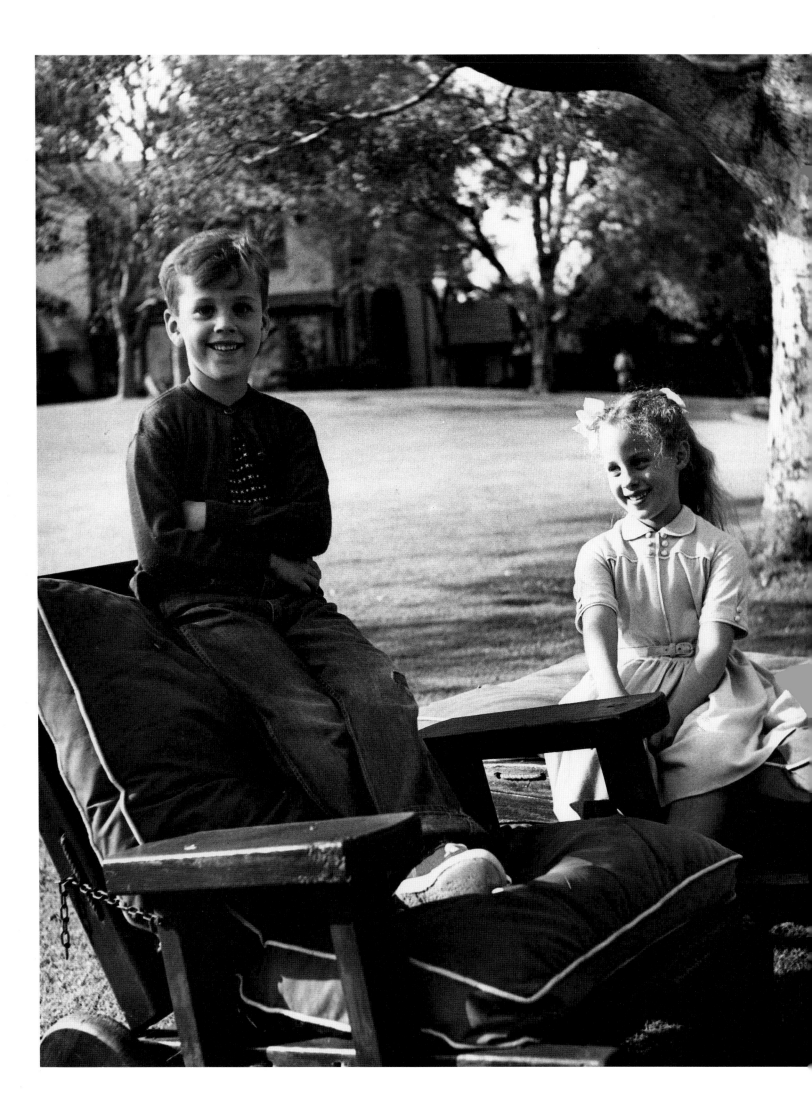

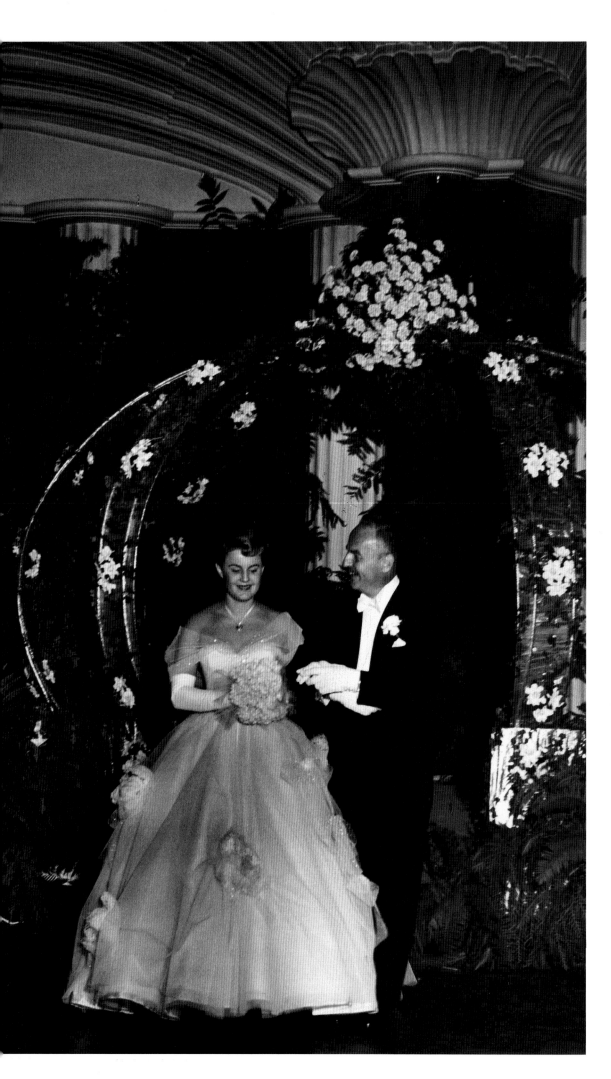

New Hollywood money imitated the social customs of the old money of the East, and often the movie millionaires outdid the blue bloods of Boston, Philadelphia, and New York. No movie mogul worth his studio would let a daughter escape without a grand coming-out party. In November 1951, I covered the grandest, Darryl F. Zanuck's debutante ball for his second daughter, Susan. Dynamo Darryl was Wahoo, Nebraska's gift to the film industry; he headed Twentieth Century-Fox. The future of the Zanuck clan was not to be the happiest, but that night at the Beverly Hills Hotel marked a joyous family celebration. Left: Darryl Zanuck beams as he leads Susan to the dance floor for the first waltz of the evening. Opposite, above (left to right): Virginia Zanuck and Douglas Fairbanks, Jr.; ballerina-turned-dramatic-actress Tamara Toumanova, John Hodiak, and Quique (Mrs. Louis) Jourdan. Opposite, below (left to right): Andre Hakim, who later married Susan, Anne Baxter, then married to John Hodiak, and Louis Jourdan; Pat O'Brien (at far right) with his wife, Eloise

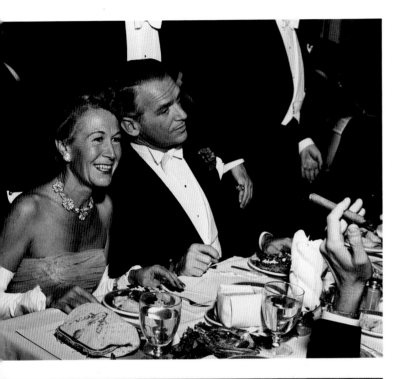

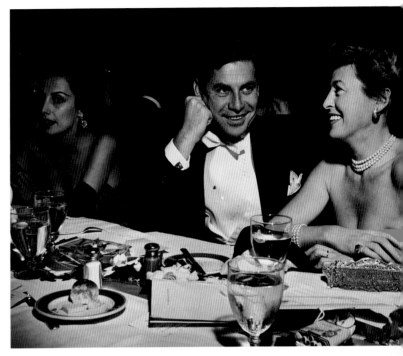

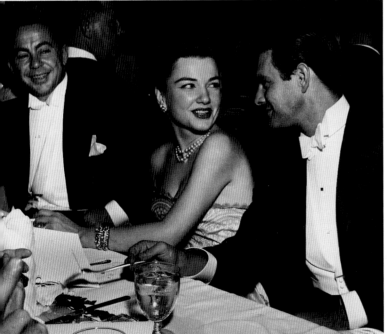

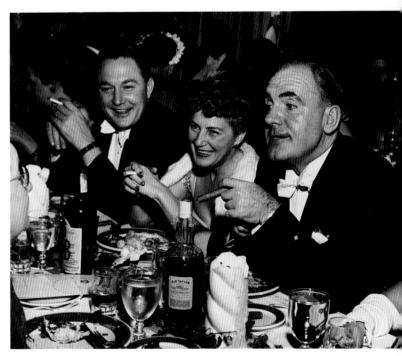

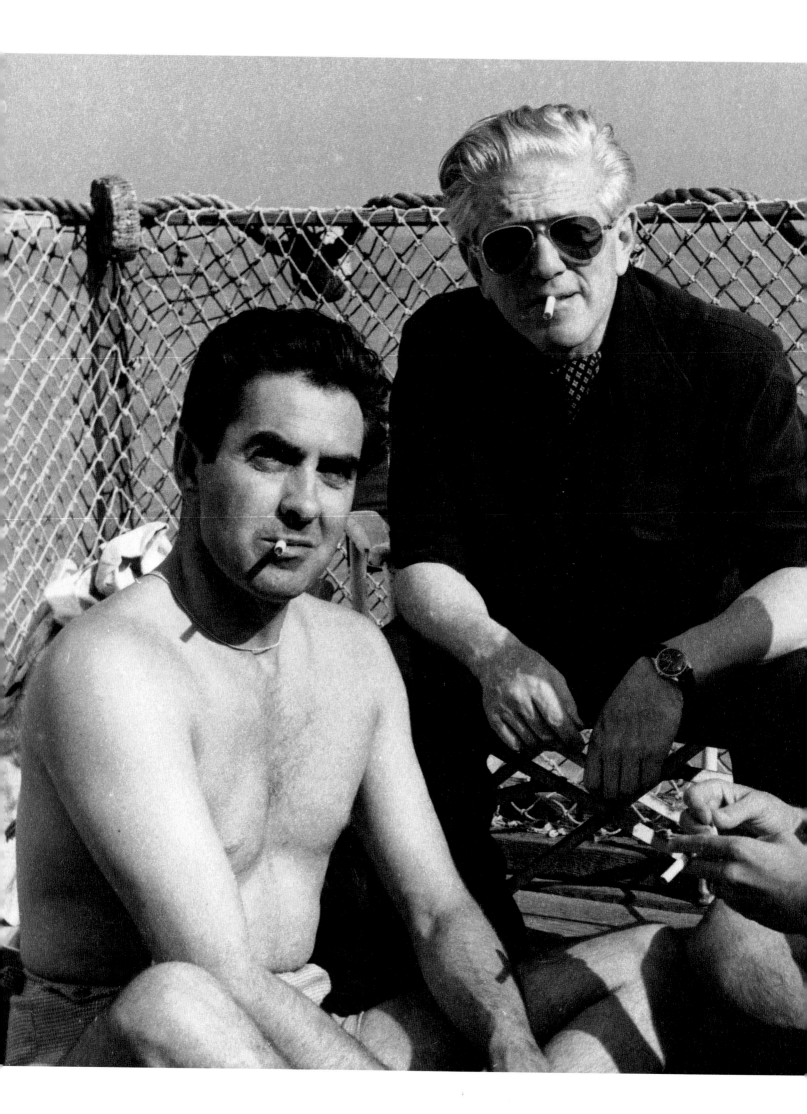

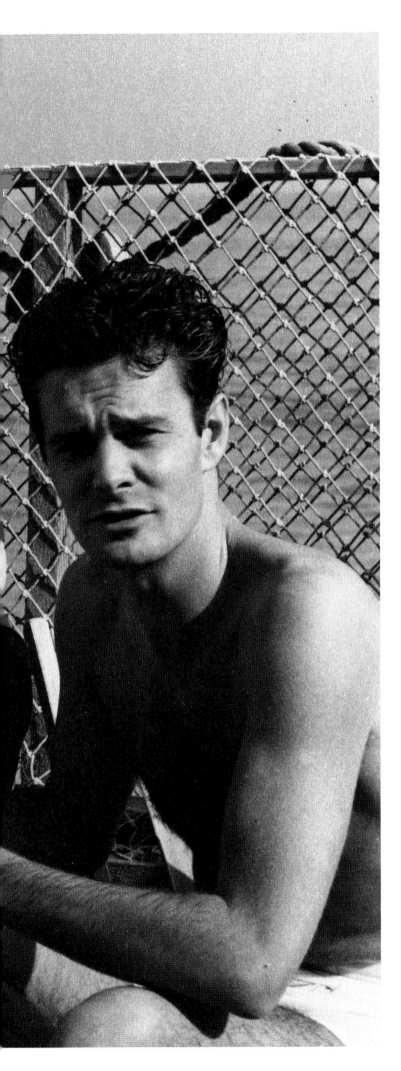

The international crowd often gathered at director Anatole Litvak's Sunday lunches at his Santa Monica beach house. He had studied philosophy in Saint Petersburg before the Russian Revolution, and that may have prepared him for career highs such as directing Olivia de Havilland in *The Snake Pit* and Barbara Stanwyck in *Sorry, Wrong Number*, two of the more hysterical women's pictures, and then such lows as a stormy, two-year marriage to Miriam Hopkins and that mythic incident with Paulette Goddard at one of Hollywood's better night spots. In fact, Charlie and I were there. Paulette's earring had fallen off, and Tola went under the table to look for it. Thereby hangs the myth that something naughty was going on under the table. On this day, however, Tola (center), with Tyrone Power and Louis Jourdan, seemed relaxed and happy.

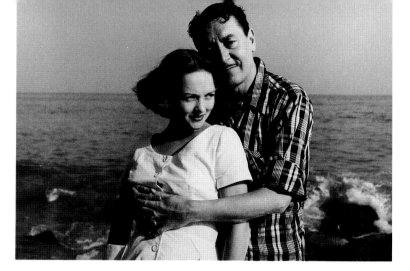

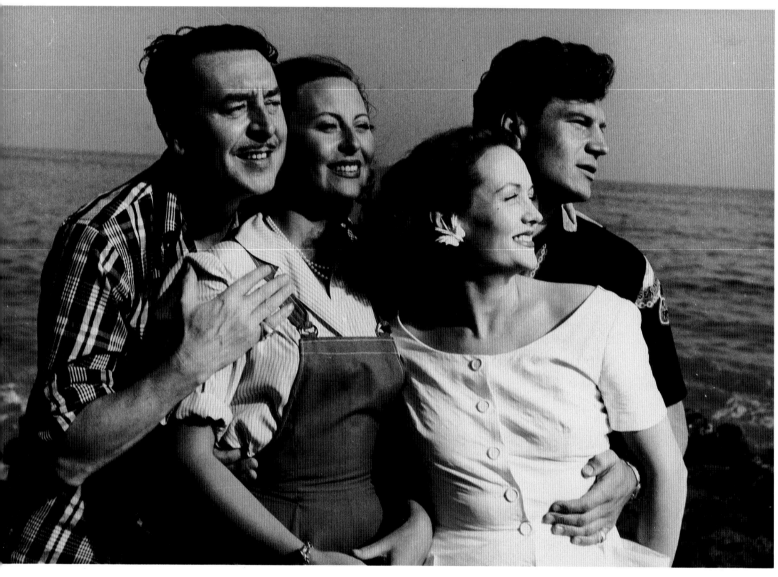

More Litvak merrymakers.
Opposite, from top: Reginald and Nadia Gardiner.
Reggie, Michèle Morgan,
Nadia, and Michèle's

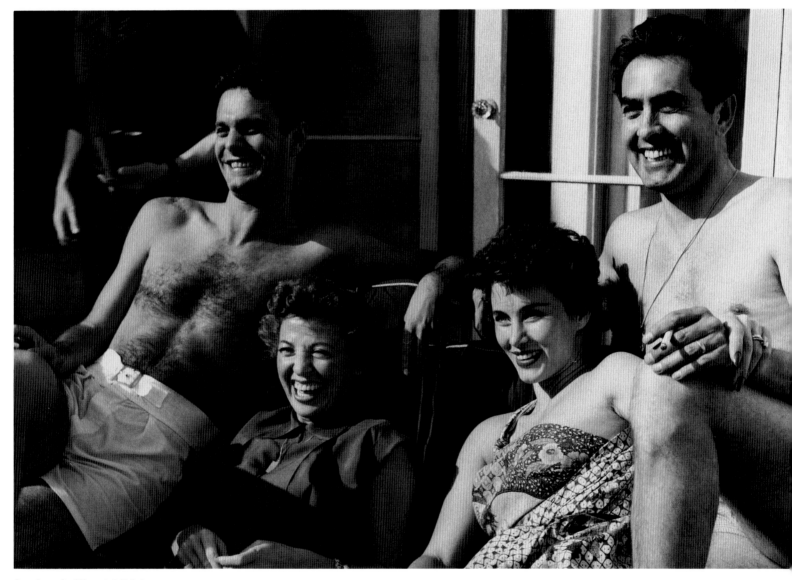

husband, Henri Vidal,
Charles Feldman, Virginia
Zanuck, and Reggie.
Above: Louis Jourdan and
his wife, Quique, with Ty
and Linda Power

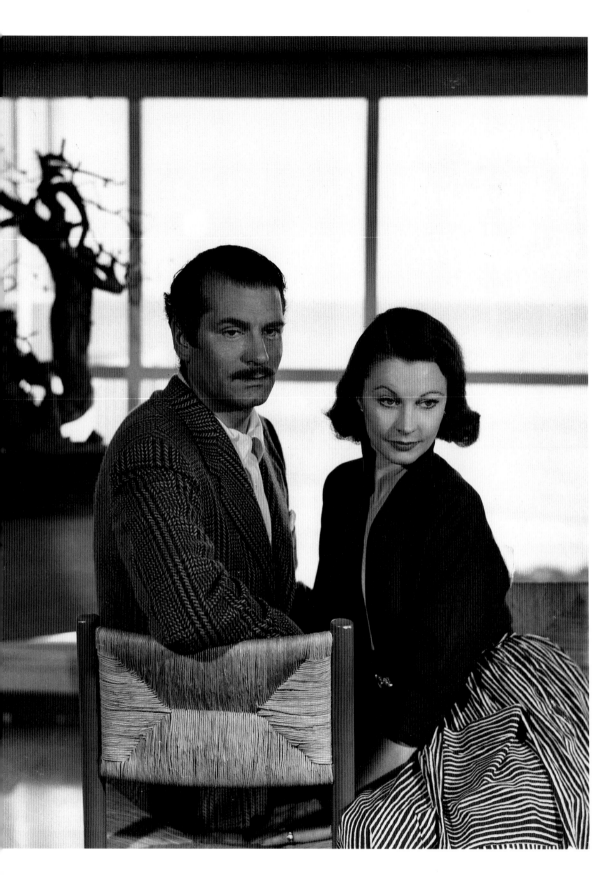

There was never a more romantic and professional acting team than Vivien Leigh and Laurence Olivier. They epitomized ideal love to many of us. Yet when they sat so willingly and patiently for these portraits in 1953, they were on the verge of a separation. It was shortly after, during the filming of *Elephant Walk*, that Vivien's health worsened. She collapsed with a nervous breakdown and had to be taken back to England. It's sad that they could not have had a happier, healthier life together; Vivien's depressions brought great suffering to both of them.

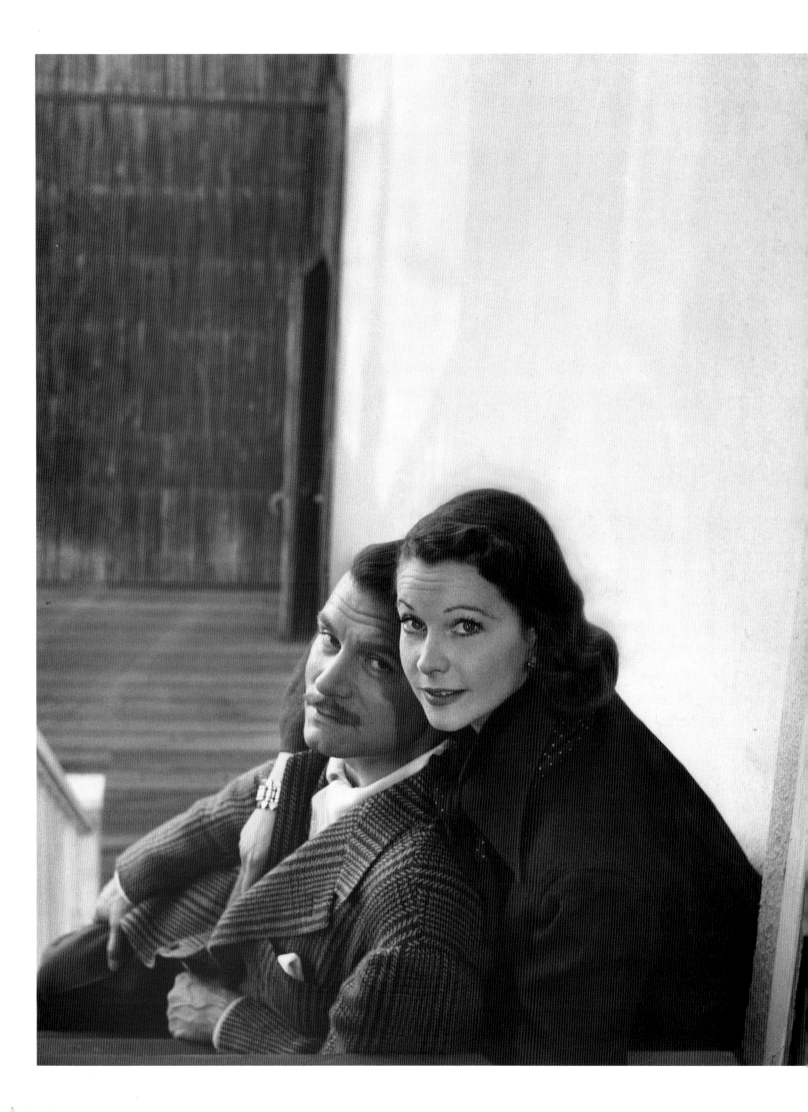

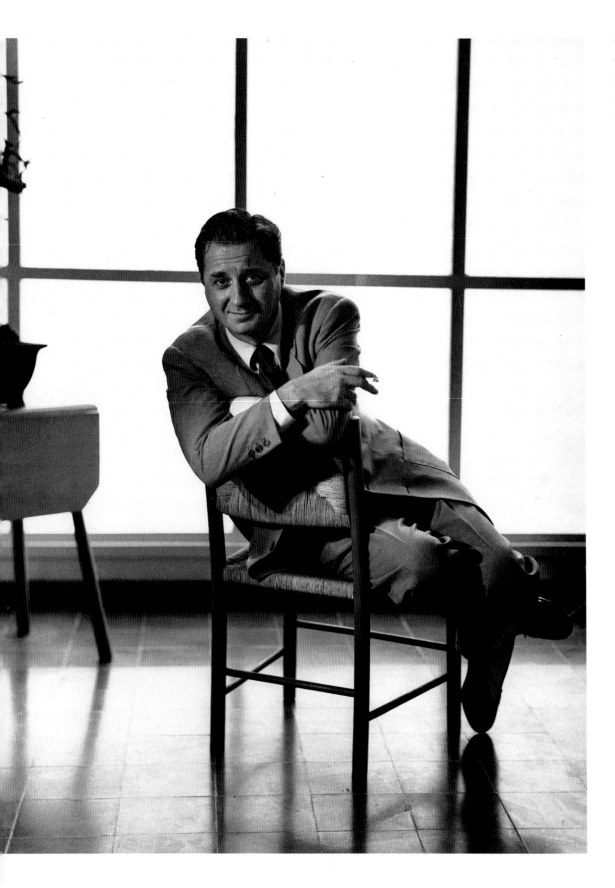

The dapper Frenchman Claude Dauphin (left) was never a major star, but I hope he is remembered fondly by staunch fans. Opposite: I was just trying out a strobe light, but this playful foursome put on quite a show for me. John Huston (left) and Billy Wilder decided to lynch Anatole Litvak in his own beach house. Evelyn Keyes, who was then Huston's wife and one of the more circumspect stars of her day, feigns boredom and turns her back on such mock behavior. I subtitled this photograph: "How far can the subconscious go?"

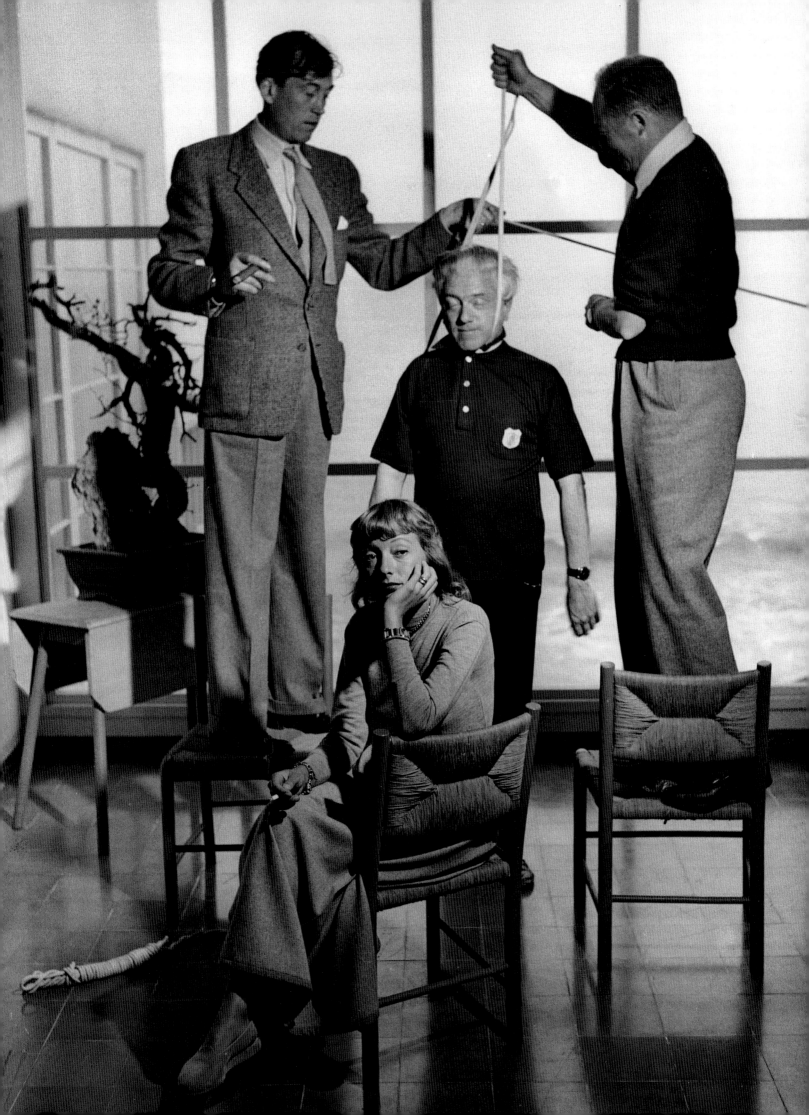

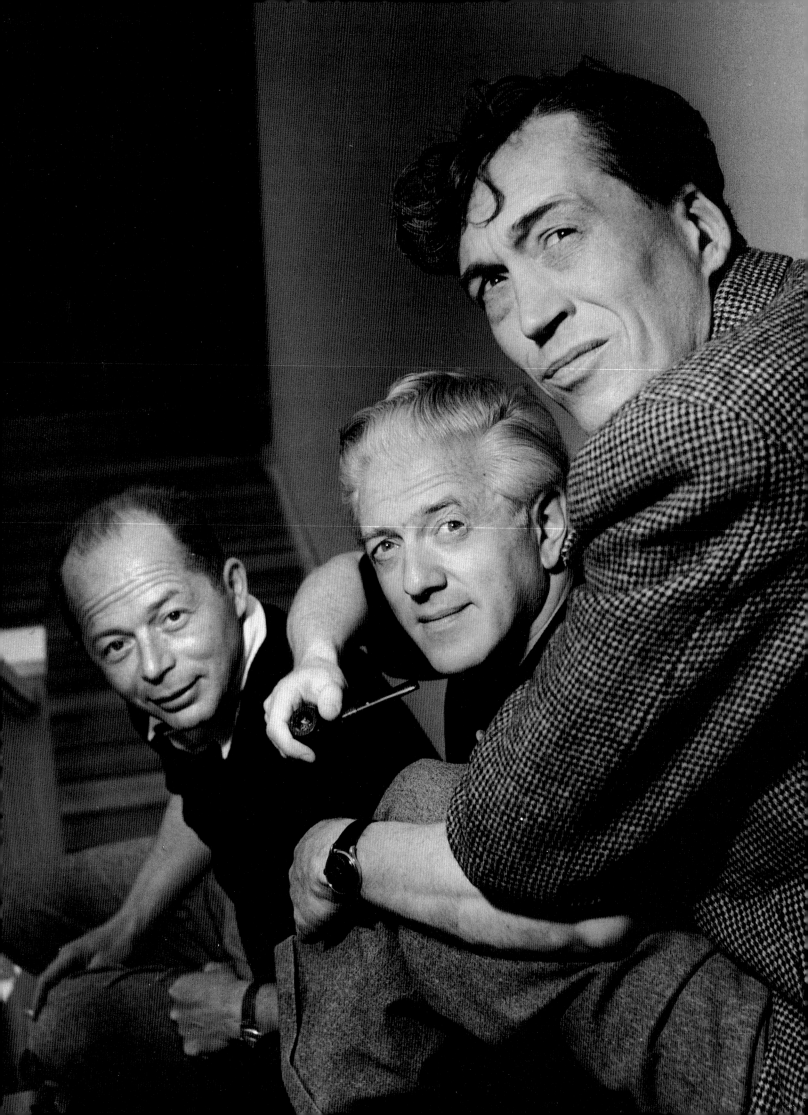

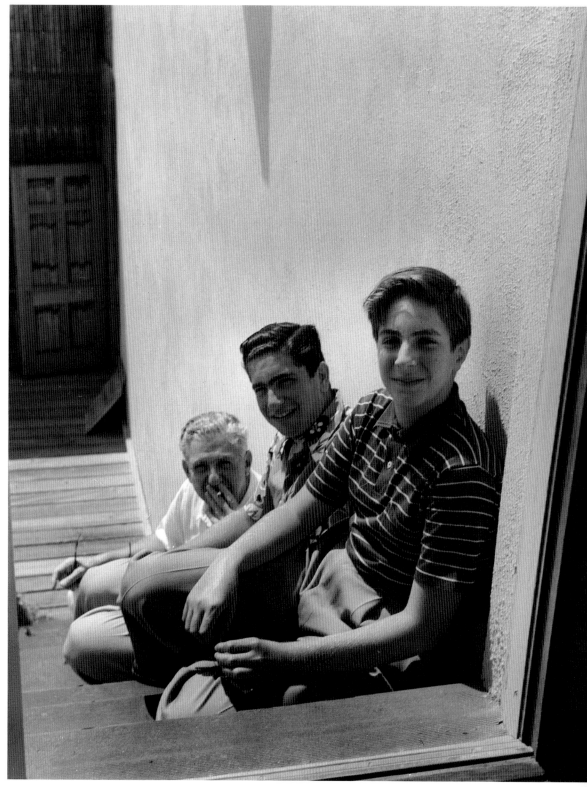

Opposite: In a saner mood, the directors three—(from left) Billy Wilder, Anatole Litvak, and John Huston—show their best sides. (Tola obviously survived the hanging.) <u>Right</u>: I cast my vote with those who think David O. Selznick was the greatest producer of his generation. Here, he willingly brought up the bottom as long as his sons, Jeffrey (left) and Daniel, were on top.

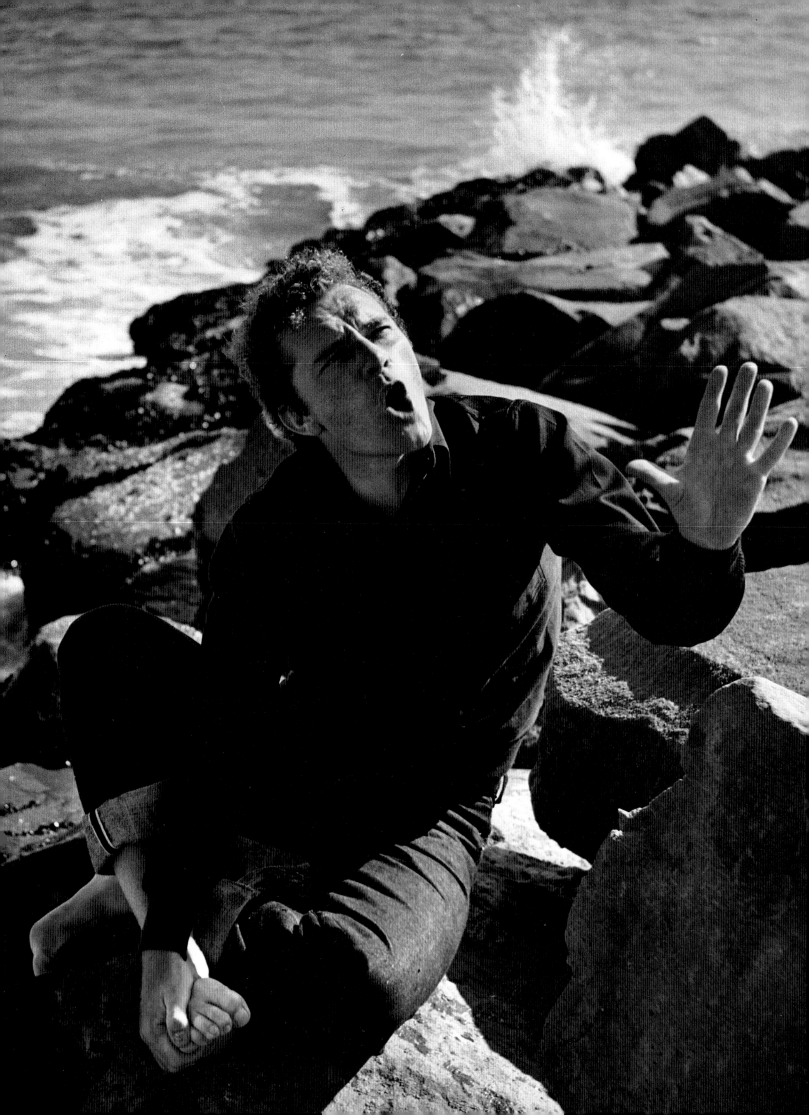

Opposite: After two martinis Richard Burton, his hair curled for the Roman soldier he played in the 1953 film *The Robe,* declaims to the western winds of the Pacific. The elements met their match in the beauty of the rousing, robust voice of this twelfth son of a Welsh coal miner's thirteen children. On the other hand, could Richard, who was so savvy, already be cursing out Hollywood, which in this his first year under contract at Twentieth Century-Fox had largely abused his talent by casting him only in costumers? Early on the seeds for a reputation of being a latter-day John Barrymore, an abuser of his own unique gifts, began to haunt this princely man.

Right: Arm in arm at Anatole Litvak's Santa Monica beach house are Annabella (left) and Skip Hathaway, whose husband was film director Henry Hathaway, perhaps best remembered for his Westerns. Annabella was France's most celebrated young actress in the 1930s. She had come to Hollywood and married Tyrone Power in 1939, but by the time this photograph was taken around 1950, she and Ty were divorced and he was married to Linda Christian.

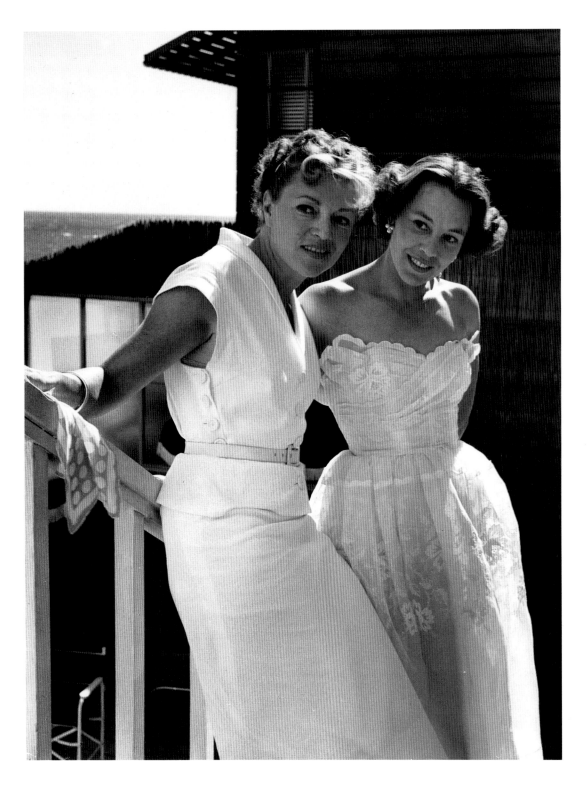

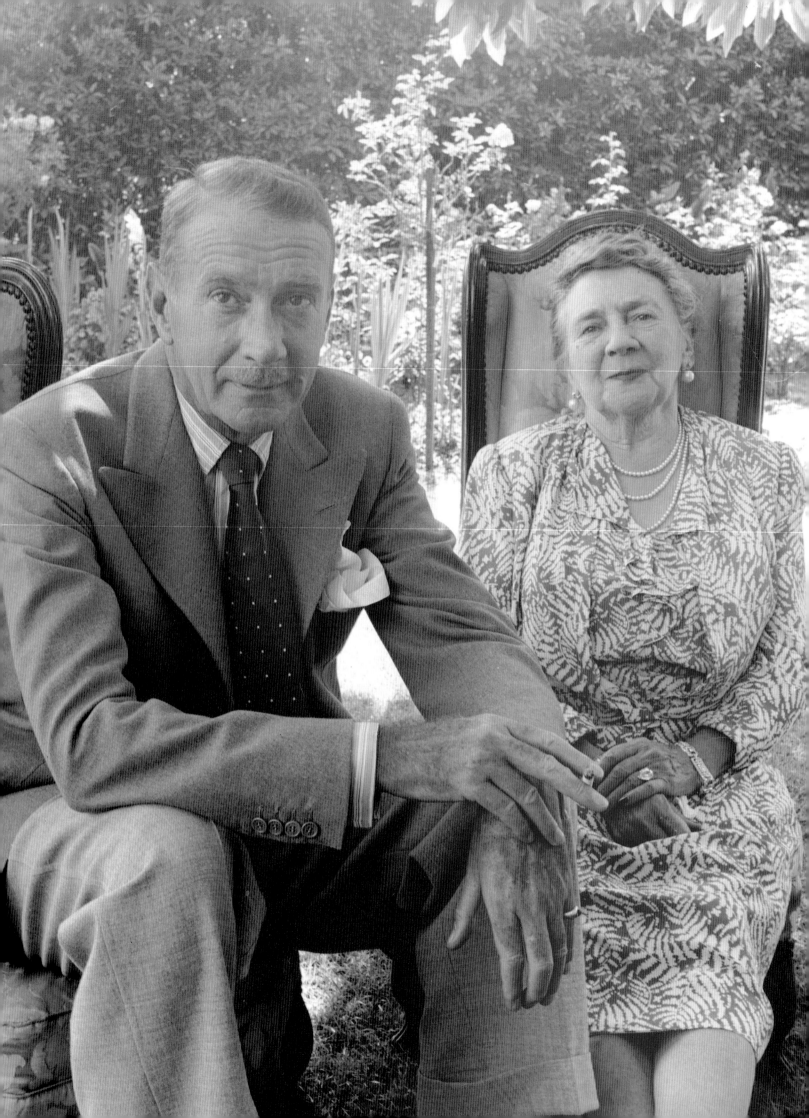

I used to go down the road from my house to visit Clifton Webb and his mother, Mabelle (opposite), who never cut the umbilical cord. I spent hours enthralled with their yarns about his adventures in the theatrical world, much of which was not top drawer until Clifton hit fifty and Otto Preminger cast him as the bitchy villain Waldo Lydecker in *Laura* in 1944. Initially Clifton was a ballroom dancer comparable to Vernon Castle, and he backed acts like the Dolly Sisters in Paris. He did a bit of silent film work, and after some Broadway stage success in the 1930s, MGM signed him on hoping he'd be a debonair rival to RKO's Fred Astaire. But MGM forgot to put him in a movie. Mabelle always held down the fort; she could manage anything. I heard her tell many times about when Valentino died suddenly and she "laid him out," a quaint expression for making the dead look presentable. She loved New York and never fully came round to Hollywood's slower pace. Mabelle called it "the land of nod," referring both to the "yes men" and the "sleepy-time" atmosphere. She and Clifton loved to party and entertained a stimulating crowd at Sunday lunches. Clifton was never the same after Mabelle died in 1960, and Noel Coward's famous crack about Clifton being

the world's oldest orphan proved too true. He grieved himself to death just six years later. Below right: Richard Burton chats with

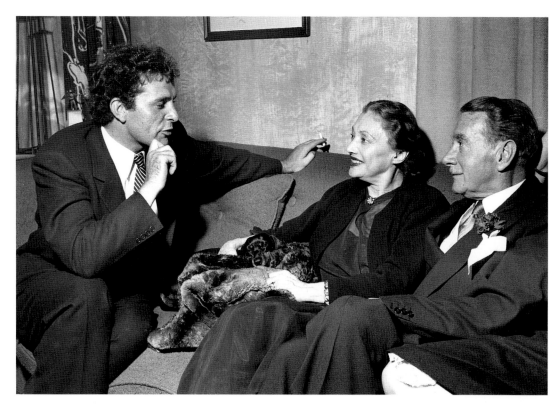

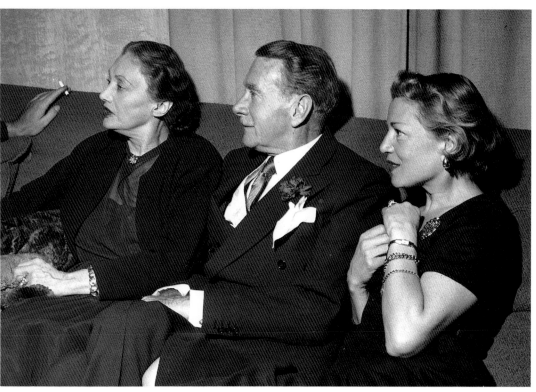

Katharine Cornell, grande dame of Broadway, and Clifton. Above right: Katharine and Clifton with Annabella

At the Webbs' with the Sunday all-stars. <u>Below</u>: It's Vivien Leigh versus Lauren Bacall at gin rummy, and no telling whose side Reggie Gardiner is taking. <u>Opposite</u>: This is one of my most published shots. Lauren used it in her autobiography. From left to right are Laurence Olivier;

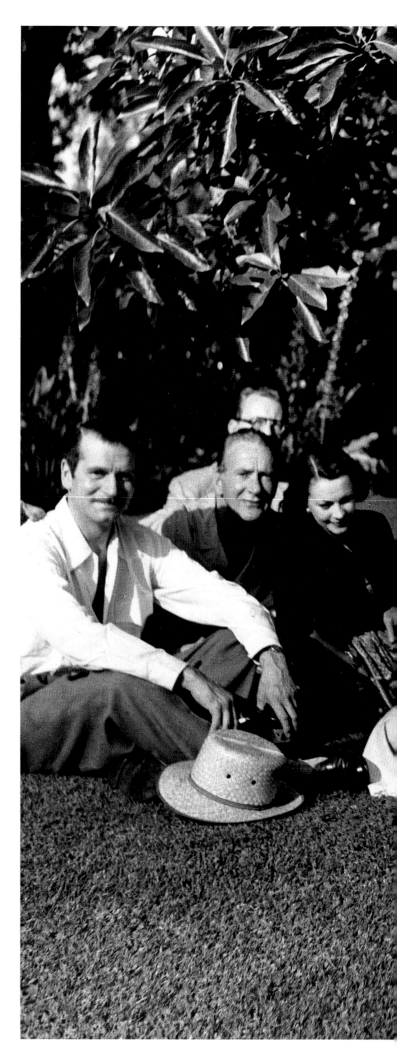

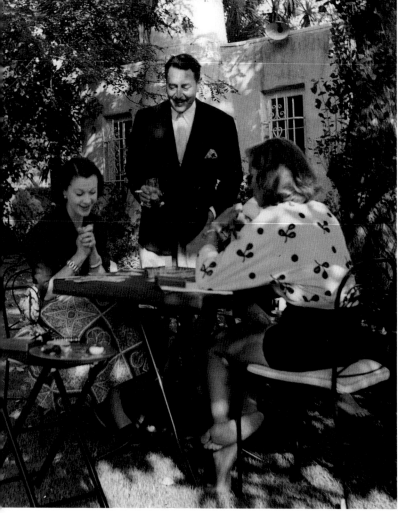

Clifton Webb; director Richard Sale (behind Webb); Vivien; Joan Bennett; Vivien's daughter, Suzanne (behind Joan); Lauren with Humphrey Bogart; Charlie Feldman (behind Humphrey); Nadia Gardiner; Mary (Mrs. Richard) Loos Sale (beside Charlie); Lucia Davidova; Reggie; and Mabelle Webb.

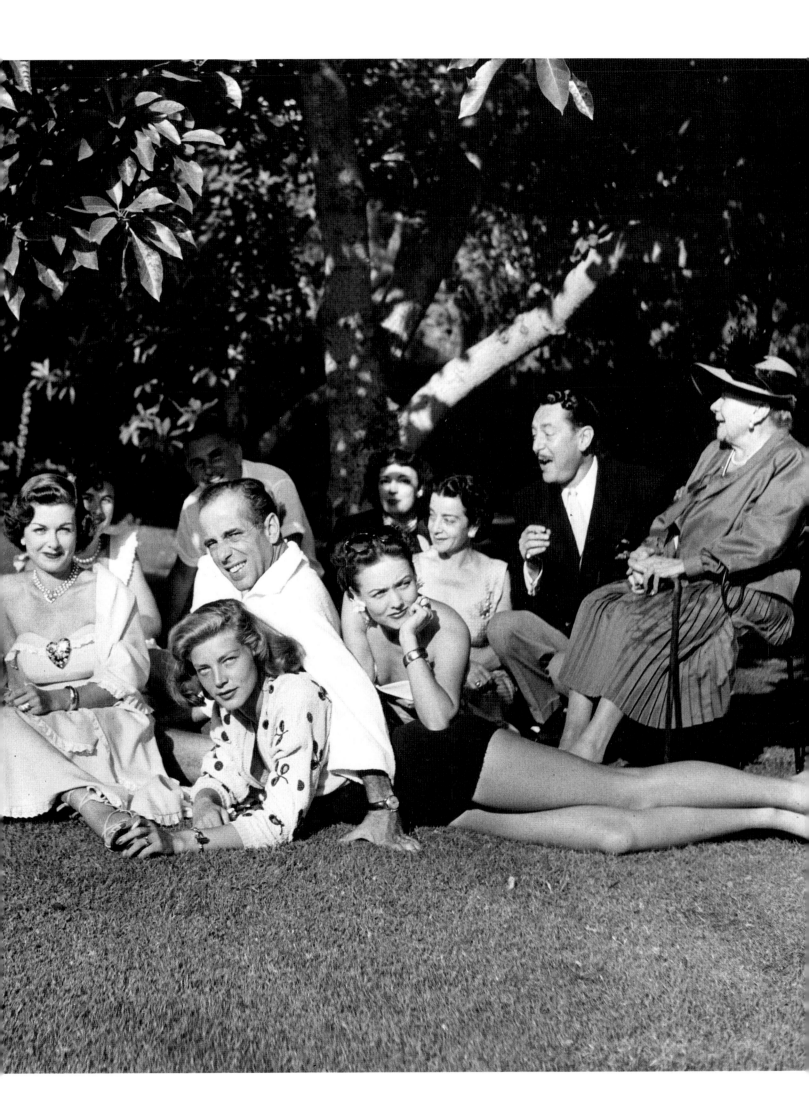

Below: Nadia Gardiner
strikes a pinup pose with a
handsome quartet, (from
left) Charles Feldman,
Laurence Olivier, Reggie
Gardiner, and Clifton
Webb. Opposite: Clifton

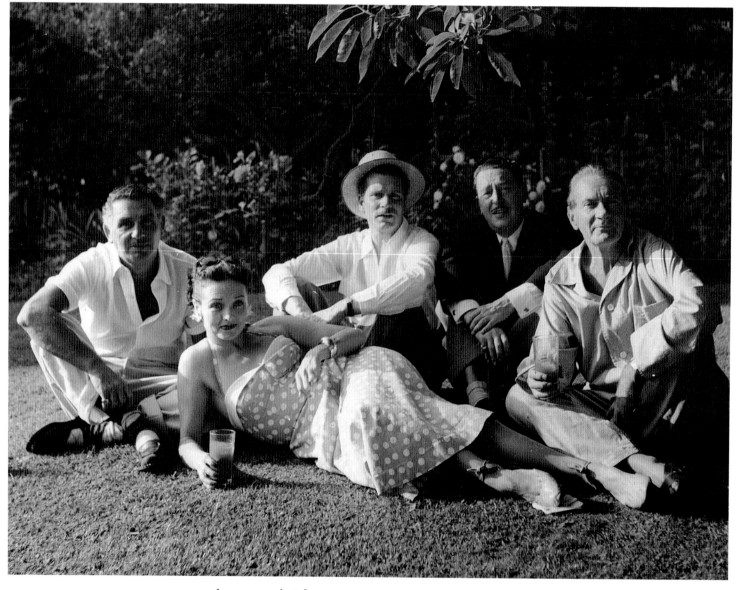

angles a straw hat for an
unusually docile
Humphrey Bogart seated
on his lap, and in shorts,
no less. Laurence Olivier
seems more blasé than
interested.

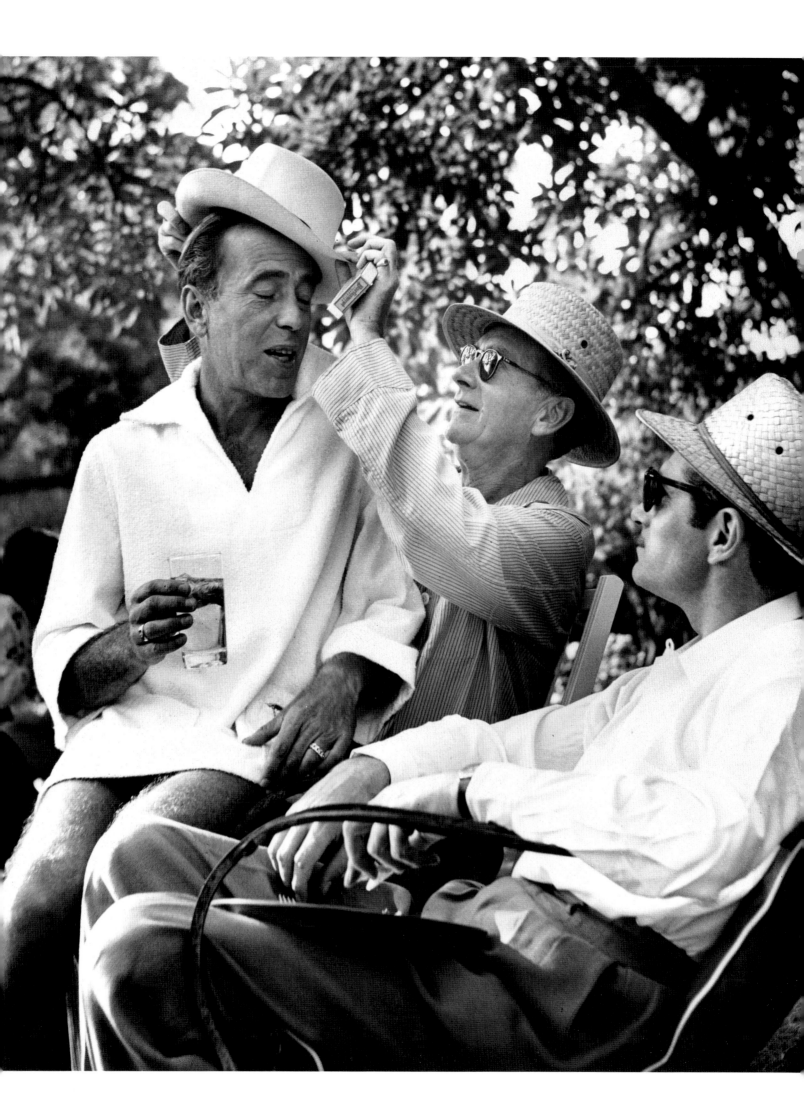

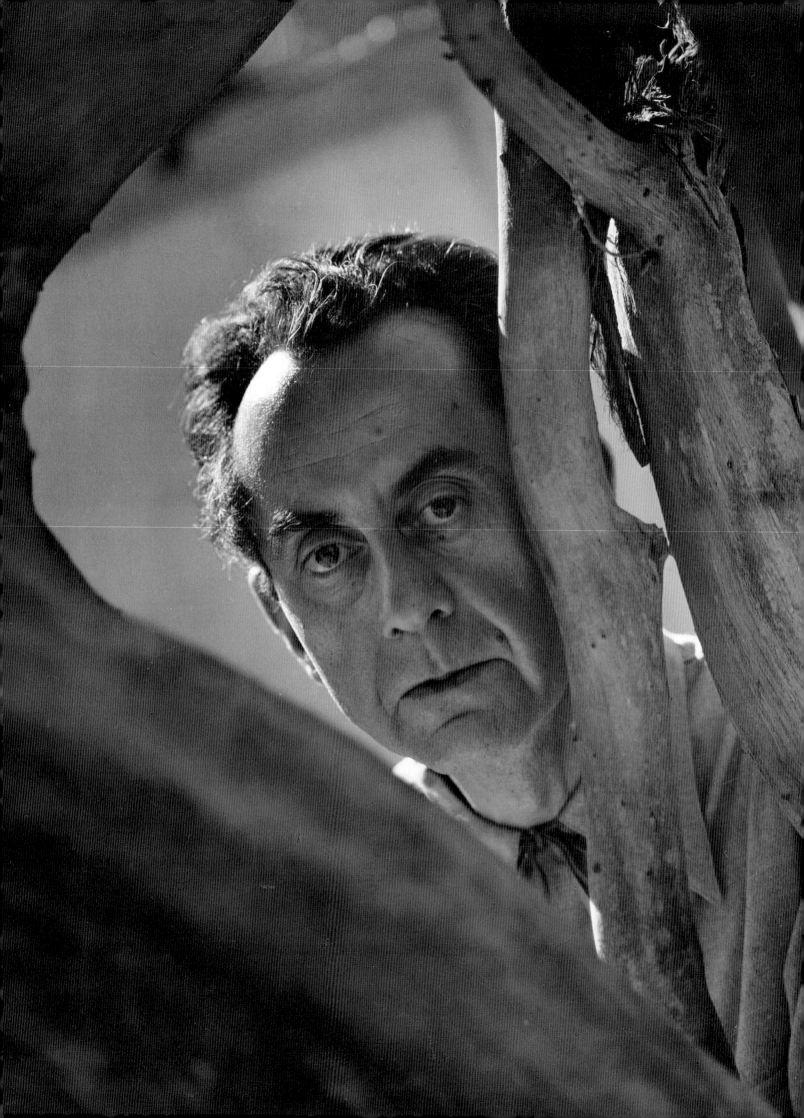

In the early 1950s I began to get my portraits in print in magazines such as *Vogue, Harper's Bazaar,* and *Look.* These magazines wanted to portray the Hollywood crowd but on a level beyond that of *Silver Screen* and *Photoplay,* and I was able to give them what they wanted. Although I rarely received a formal assignment, once I had established myself with a few publications, they used selections from almost everything I showed them. I came to think Hilde Berle's prediction had become fact. Opposite: I met Man Ray through Hilde. Nowadays his own photographs are highly collectible, fetching top prices at auction. Right: Otto Preminger smiled for me. I don't think his bite was as bad as his reputation, but then some of the actresses he terrorized— Gene Tierney, Faye Dunaway, Lee Remick, Kim Novak—are better judges than I.

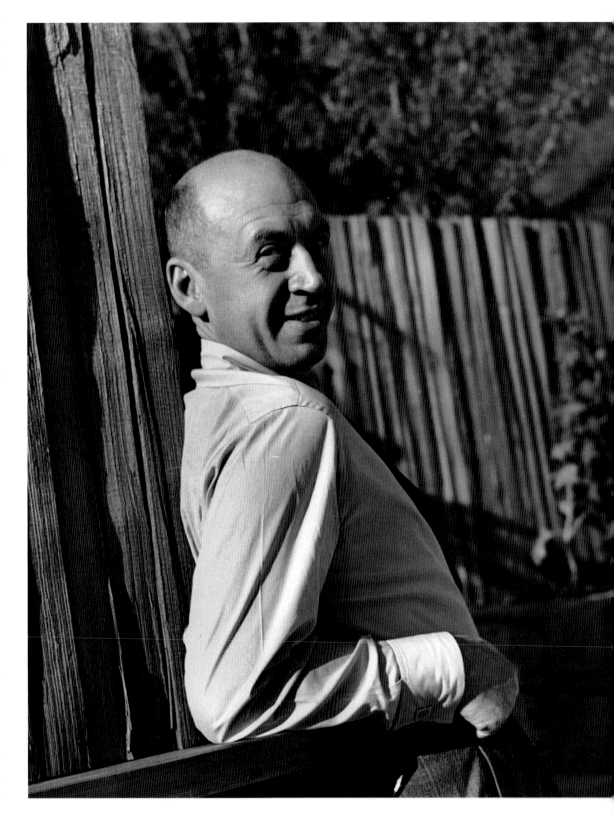

Left: Darryl Zanuck
changed the spelling of
Hildegarde Knef's last
name to Neff and tried to
jam her into the Garbo-
Dietrich mold when she
hit Hollywood. Her throaty
voice and Germanic back-
ground might have
indicated those possibilities,
but she was brainy and
independent, and in the
1950s who needed a siren
when we had Marilyn
Monroe. I believe Hilde-
garde's only real satisfaction
from her American years
was starring in Cole Porter's
last Broadway musical, *Silk
Stockings.* On opening night,
as if to pass the torch to the
next generation, Marlene
Dietrich came on stage to
give her blessing to Hilde-
garde in her conquest of
the Great White Way. I
never got into retouching
or special filters or
anything like that, but I
sometimes played with
lenses for varying effects.
In this photograph I
wanted to emphasize Hilde-
garde's beauty, so I used a
telephoto lens. I was able
to make a sharp photo-
graph but from far enough
away to avoid showing any
telltale lines. *Vogue* ran
this photograph in 1952.
Opposite: A year earlier the
magazine published my
Marlon Brando portrait
along with a prescient
comment about his way of
"draw[ing] down a glass
window to separate himself
from the world, which
persists in throwing at him
the highest praise."

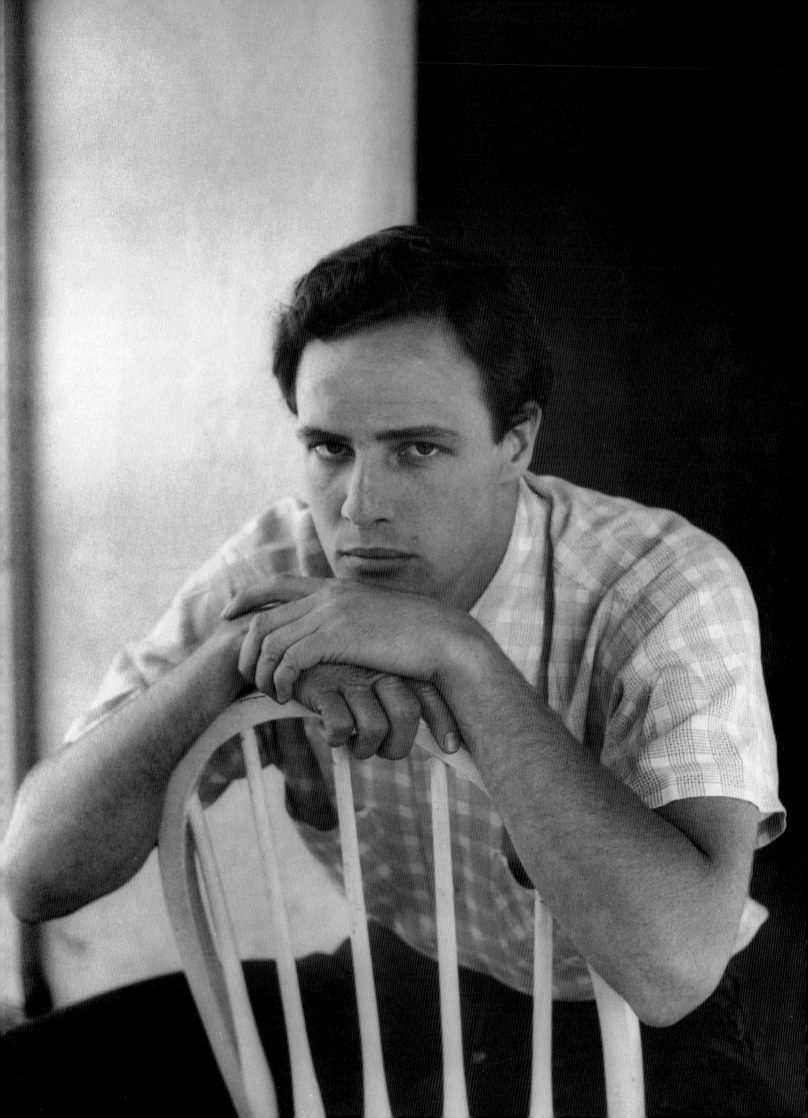

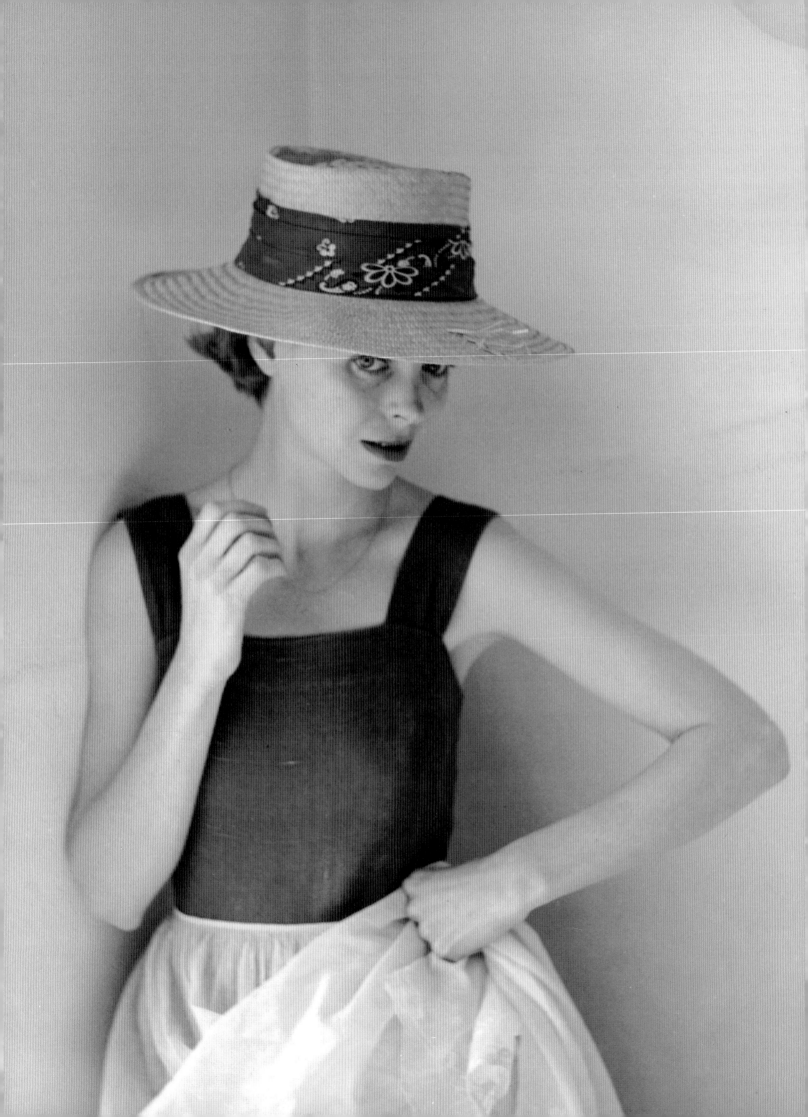

Opposite: Dorothy McGuire poses against her garden wall in 1954, about the time she was appearing in *Three Coins in the Fountain*. With her serene demeanor, she was destined to play the Virgin Mary (in George Stevens's *The Greatest Story Ever Told*). But Dorothy had temperament; it just wasn't captured in any of those sweet-little-things she portrayed so lovingly in her heyday. She married a terrific fellow, John Swope, who was not only rich but also a great photographer.

Right: William Saroyan tips his hat in 1951, when he was still married to Carol Grace. She later found a better marriage with the droll Walter Matthau. MGM hired Saroyan to write screenplays. He told me he spent all his time viewing old MGM classics going back to the silent days and never produced anything for them. He said it was the easiest money he ever earned.

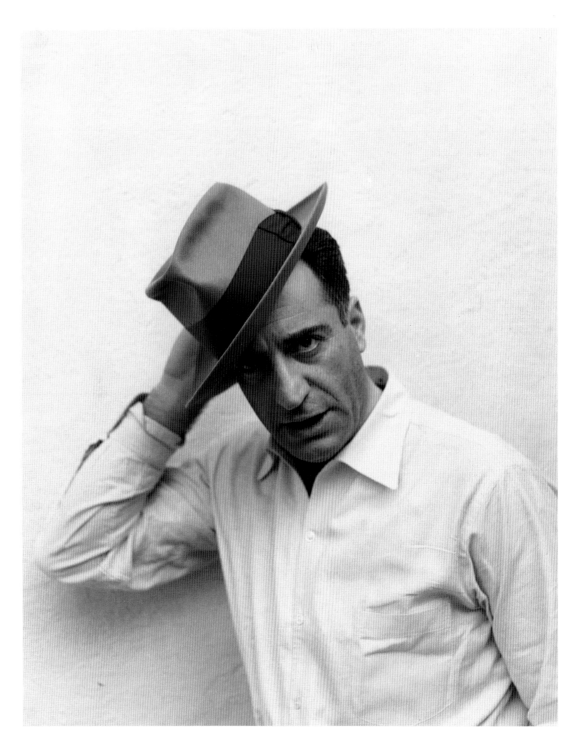

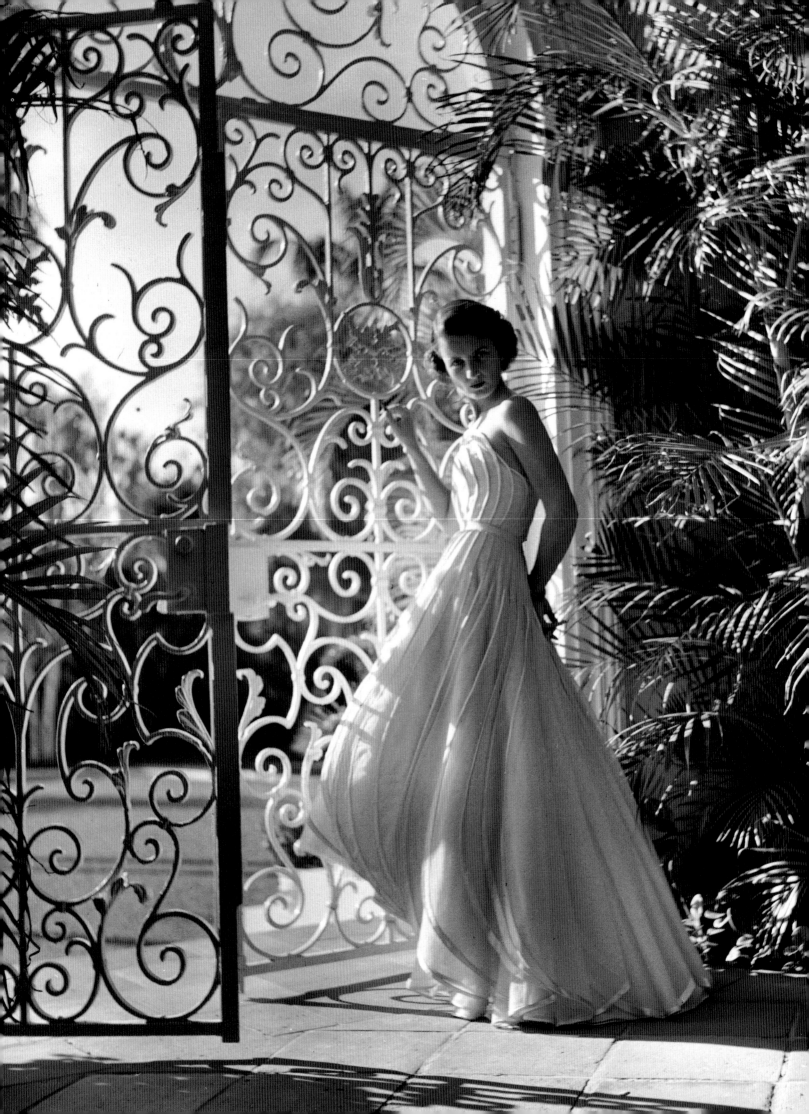

Charles Wrightsman was not only heir to his father's oil millions, he was an astute businessman in his own right. By 1953 he was president of Standard Oil of Kansas. Charles will always be remembered for the Wrightsman Galleries, a series of beautiful eighteenth-century French period rooms at The Metropolitan Museum of Art in New

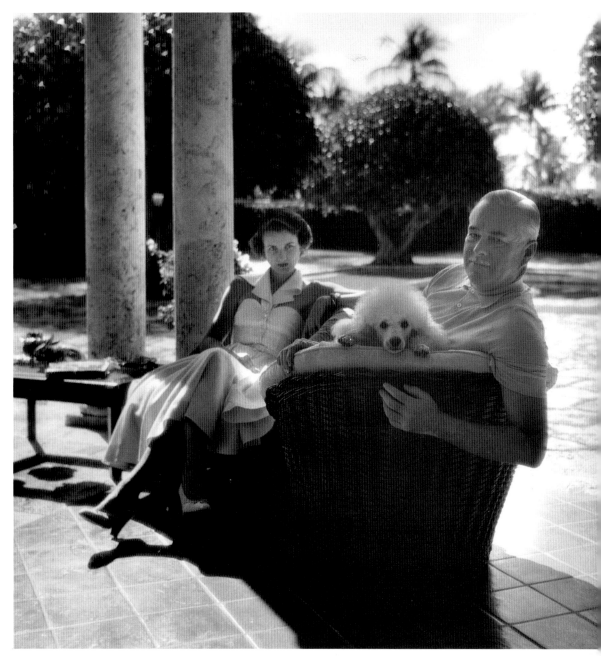

York. When I took these pictures, around 1953, he had just bought Mona Williams's estate in Palm Beach, Florida, which he filled with art treasures the envy of two continents. Opposite: To many, Jayne Wrightsman, Charles's second wife, is herself a work of art—elegant beyond words and classic in her tastes. She and her Dior make time stand still. Above: The Wrightsmans at home

Palm Beach

My Palm Beach friends were rolling in riches during the Eisenhower years. They were flush but not fancy. <u>Left</u>: Lord and Lady Sefton—we called her Foxie—in front of Dolly O'Brien's house. <u>Opposite, clockwise from top right</u>: Woolworth Donahue, grandson of the five-and-ten founder, and Count Dorelis, Dolly's husband at the time; Flo Smith and Reinaldo Herrera in Dolly's garden; Dolly and her count with Ned McLean (left), whose mother owned the Hope diamond; Dolly with her son Marshall Heminway; Lord Sefton (left) with Flo Smith and husband Earl, mayor of Palm Beach and then ambassador to Cuba for about five minutes, thanks to Fidel Castro

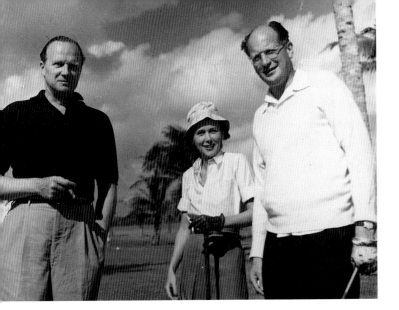

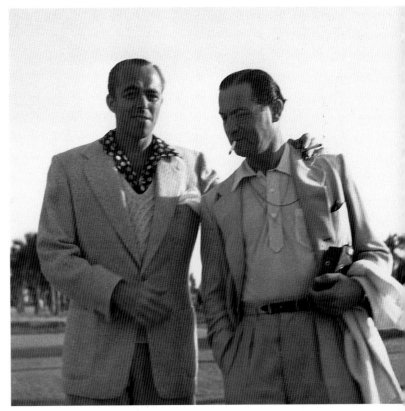

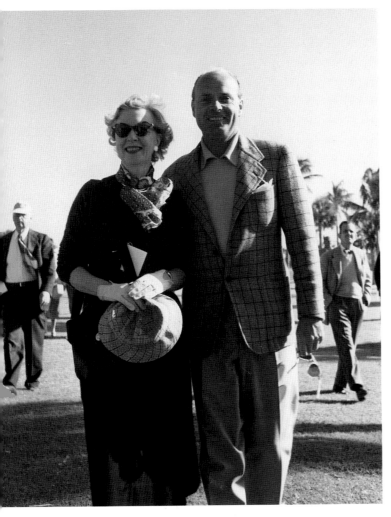

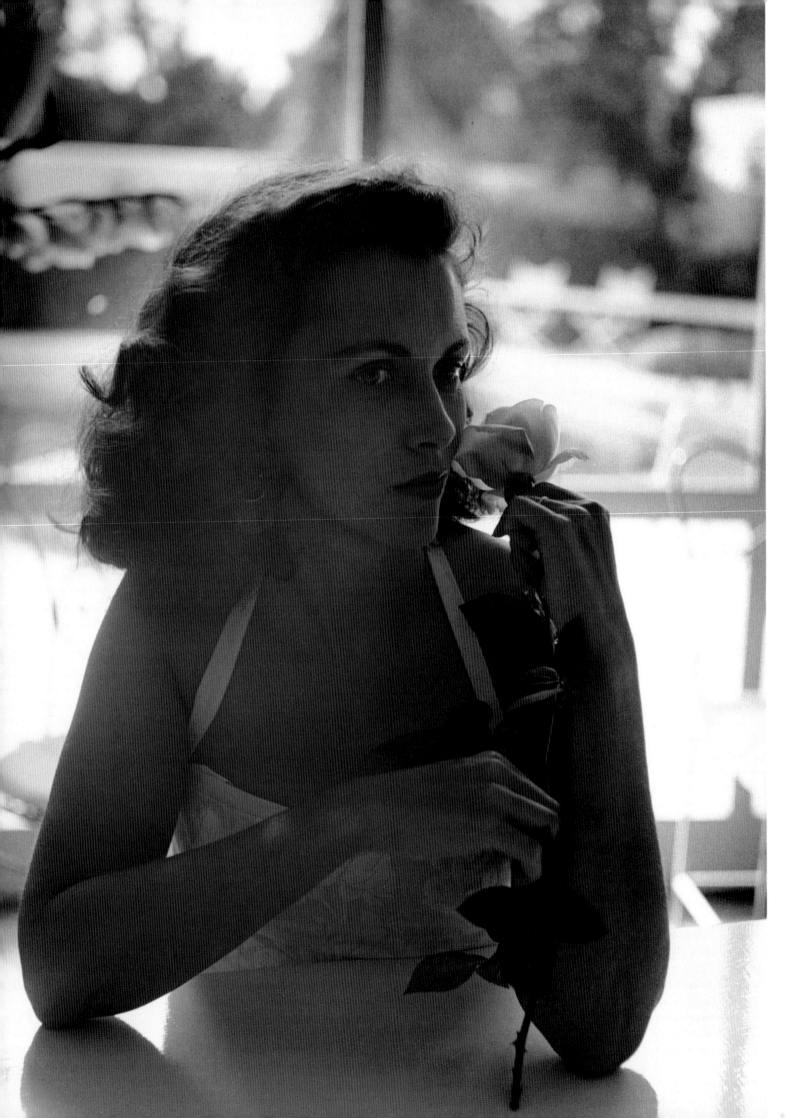

Dolly O'Brien (below right), born Willow Laura Hylan, was the toast of two continents. Her most famous husband was yeast millionaire Julius Fleischmann, but Dolly hit the headlines in the mid-1940s when Clark Gable became infatuated with her. Dolly didn't want to marry Clark because it would have meant moving to California and living the Hollywood life-style, and the romance ended. Then Lady Sylvia Ashley, widow of Douglas Fairbanks, Sr., caught Clark's attention. Dolly had a great sense of

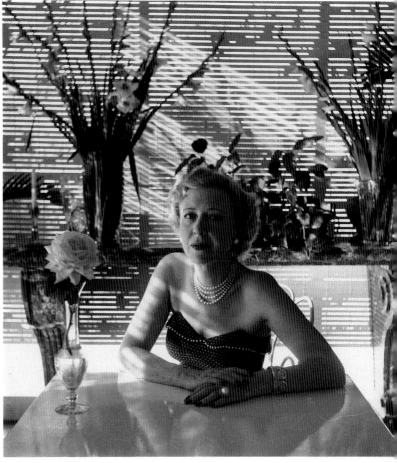

humor, and when Clark and Sylvia were on their honeymoon in Hawaii, she sent them this cable: "Happy leis, happy days." Above left: Dolly with Jessie Donahue, whose immense fortune was left to her by her father, dime-store magnate F. W. Woolworth. Jessie was the mother of Jimmy and Woolworth and the aunt of Barbara Hutton. Opposite: Dolly's daughter-in-law, Natalie (Mrs. Marshall) Heminway

<u>Below</u>: In their garden in Palm Beach, I photographed Rose and Joseph Kennedy before history took its toll. <u>Opposite</u>: At Jessie Donahue's luncheon table are (from left) Lord Sefton, Jessie, Rose

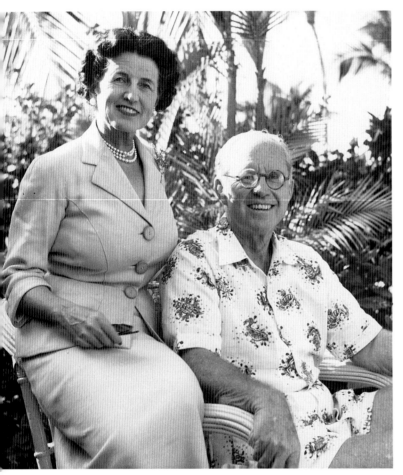

Kennedy, Dolly O'Brien, shoe designer Hélène Arpels, Mr. and Mrs. Morton Downey, Sr., Foxie Sefton, and the Kennedys' close friend Arthur Houghton.

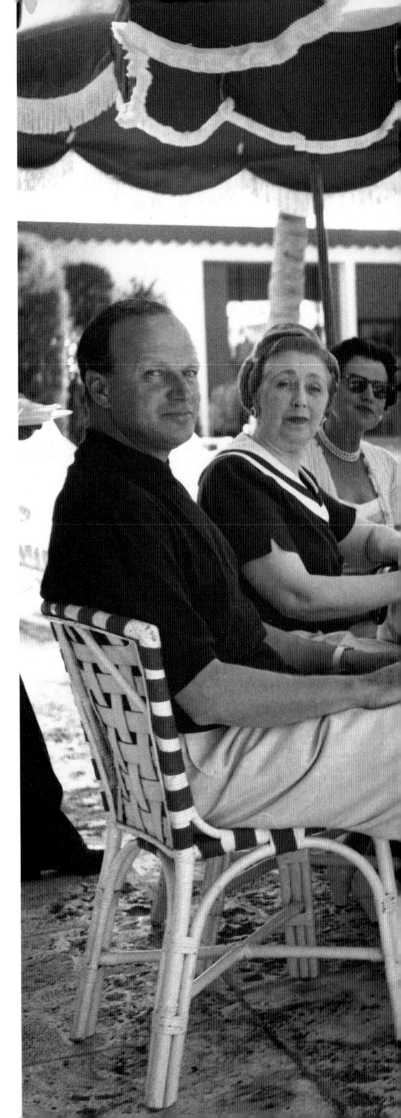

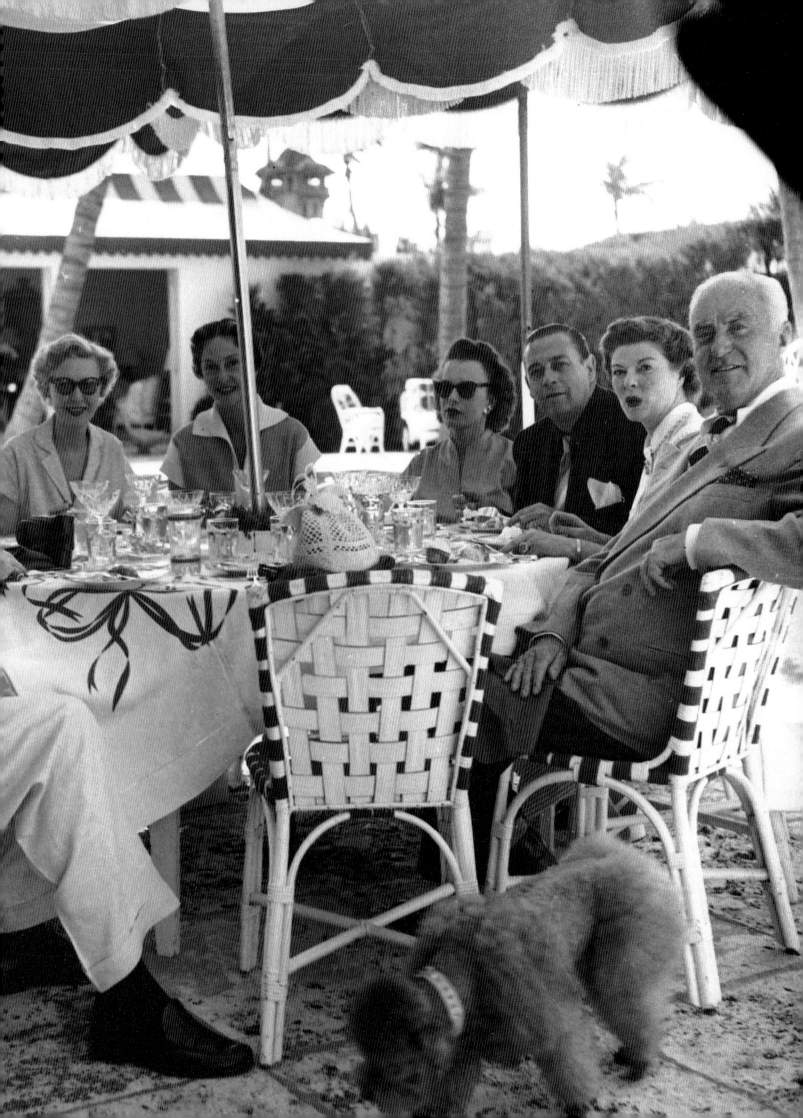

Opposite: Joe Kennedy with a few show biz cronies (from left), Dr. "Dockie" Martin, who was Louella Parsons's notorious spouse; Joe; Charlie Feldman; Joe Schenck; and Arthur Houghton

Below: Here are two characters who both came from Russia through Ellis Island to live the American Dream. Irving Berlin (left) as he was in 1951, around the time of

his second Ethel Merman stage hit, *Call Me Madam*, and Joe Schenck, the movie pioneer, once president of United Artists at the same time his brother Nicholas was the head of Loews, parent company of MGM. I shot them at Nick's Miami place. Irving and Joe grew up together on New York's Lower East Side and, whatever their other talents, they were the best poker players who ever lived.

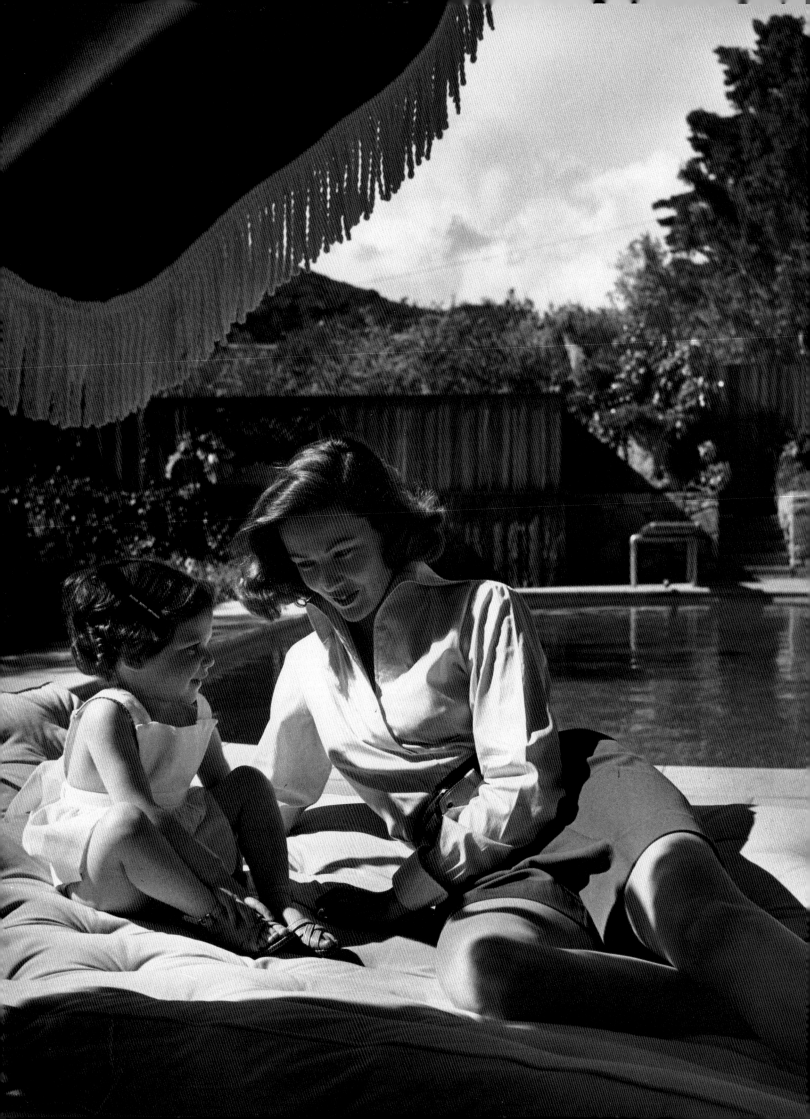

When in the spring of 1951 I shot a group of mother-daughter pairings, my first assignment for *Vogue*, who would have dreamed of the "Mommie Dearest" syndrome? Everyone in Hollywood knew of affairs and divorces and certain awful tragedies—the ravishing Gene Tierney, while pregnant, contracted measles at an army camp benefit and her first child, Daria, was born retarded. Yet as I look at these pictures I remember the happy moments of those days—and shake my head in disbelief when I see how so much of it turned out. Opposite: Beside my pool, Gene Tierney sits with her second daughter, Christina. Gene was still a big name in 1951; she was then married to Oleg Cassini, who was a count, so we could have addressed her as contessa (but didn't). After subsequent romances with Aly Khan, John F. Kennedy, divorce from Cassini, and deep personal problems, she married oilman Howard Lee, Hedy Lamarr's ex, and retired to a rich and, I do hope, happy life in Houston. Right: Susan Hayward was the wife of actor Jess Barker, and her six-year-old twins, Timothy and Gregory, were full of the dickens like their mom. Susan was soon to be Hollywood's highest-paid star. The last time I saw her was on the 1974 Oscar telecast. She had cancer of

the brain but made a gallant appearance on the arm of Charlton Heston, who whispered, "Easy, girl. . . ." Frank Westmore did her makeup, and she

had to wear the "Hayward" wig, but her entrance was electrifying. Susan died a torturous, untimely death in 1975. She was fifty-seven.

California

Left: Deborah Kerr, here with her younger daughter, Melanie, was married to Anthony Bartley, the epitome of the dashing World War II RAF ace. After *From Here to Eternity*, Deborah's career took off and, eventually, Tony did too. In 1960 she married another handsome catch, writer Peter Viertel, and today they spend most of their time in Spain and Switzerland. Though she inherited Greer Garson's mantle as the screen's most starched lady, I've always heard she was a lady with fire, the best kind to be. Opposite: Of these mother-daughter pictures, the most personal has to be this one of Dorothy McGuire with her husband, John Swope, and their daughter. In 1949 John had bought my little Italian Fiat Topolino, which means little mouse, and they gallivanted all over Italy and France in it. Before long they had this lovely child, and they named her Topo. Wonder why?

I had an idea for a story on Hollywood parties and the diverse crowd they attracted. *Vogue* loved the concept and in 1953 ran an article with my photographs, saying: "The best Hollywood parties nowadays are small—generally about twenty people—with an unexpected coziness, the guests usually a pleasant mishmash of East and West coasts. At Mrs. Gary [Rocky] Cooper's, there's apt to be singing around the piano; at the Charles Amorys' (of New York), bridge and canasta after dinner. At the Gilbert Adrians' modern house, part of the attraction is the studio, with its live birds and its Adrian paintings of Africa."

What Hollywood parties lacked in size, they made up in

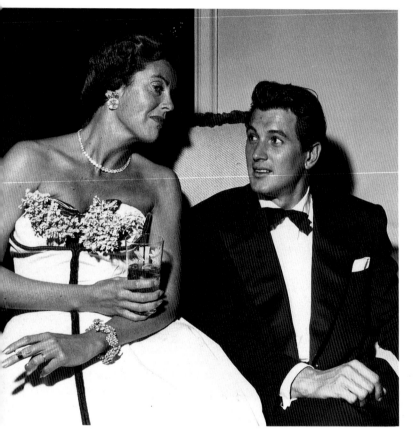 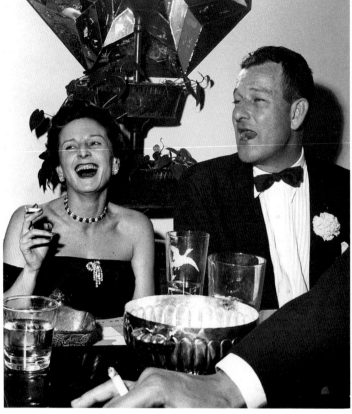

numbers, because there were parties, luncheons, dinners, picnics, and more parties. One of the most active party givers was Rocky Cooper. Born Veronica Balfe, Rocky was a New York socialite who had been doing movie bits under the name Sandra Shaw when she met Gary, who was then ending his romance with another social figure, my friend Contessa Dorothy di Frasso. On this particular evening, Rocky had gathered a few friends to honor Mr. and Mrs. Henry Ford II. <u>Above left</u>: Rocky with Rock Hudson. <u>Above right</u>: Anne (Mrs. Henry II) Ford with MGM music master Roger Edens. <u>Opposite</u>: R. Fulton Cutting II; Jack Warner, who was always "on"; and Anne

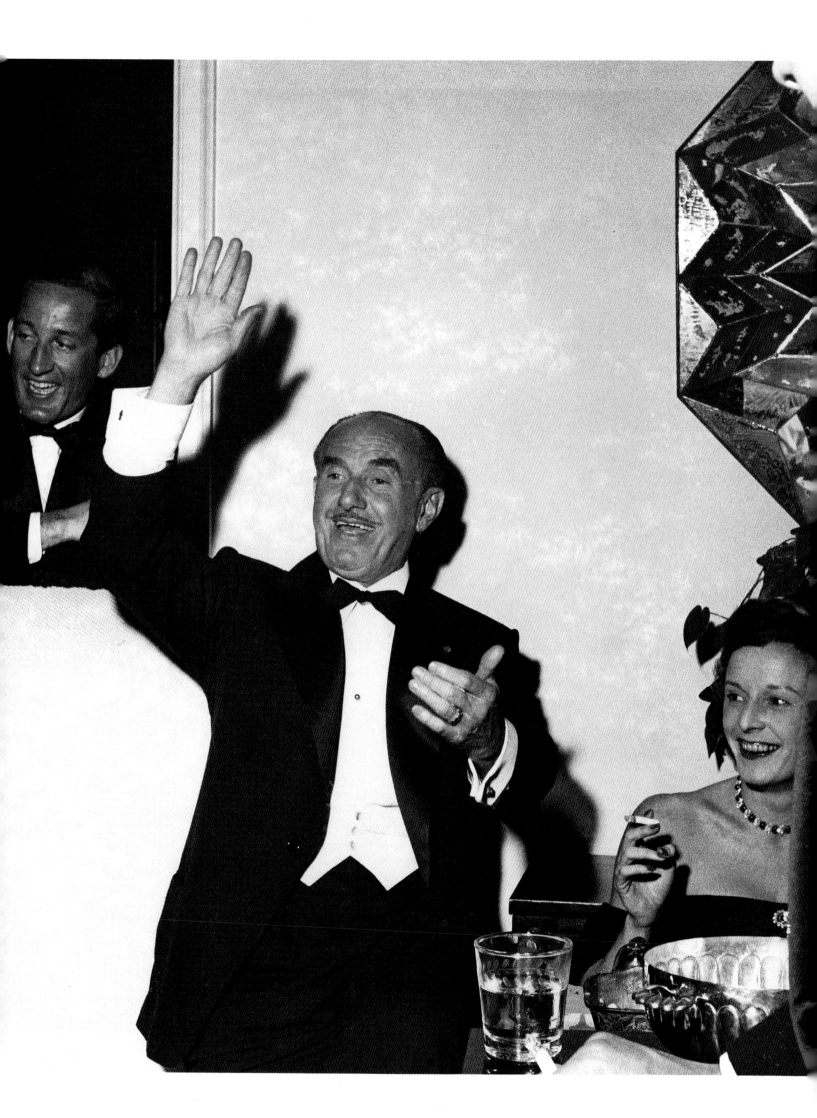

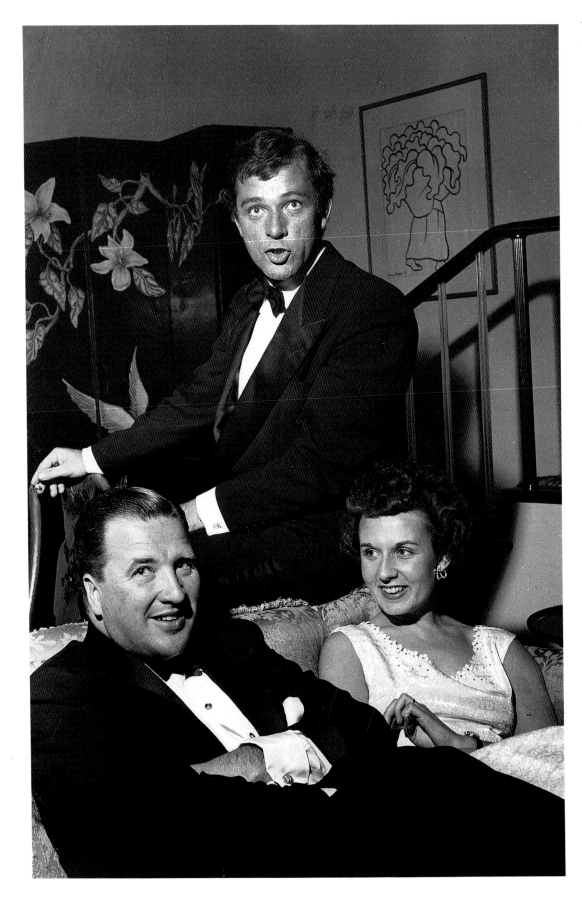

Left: Richard Burton, in 1953 still a fairly new addition to the Beverly Hills party circuit, with the guest of honor, Henry Ford II, and Richard's first wife, Sybil Williams, at Rocky Cooper's party. Opposite: Henry Ford, Jack Warner, and Jeanne Martin, Dean Martin's pretty wife at the time, with Sybil in the background

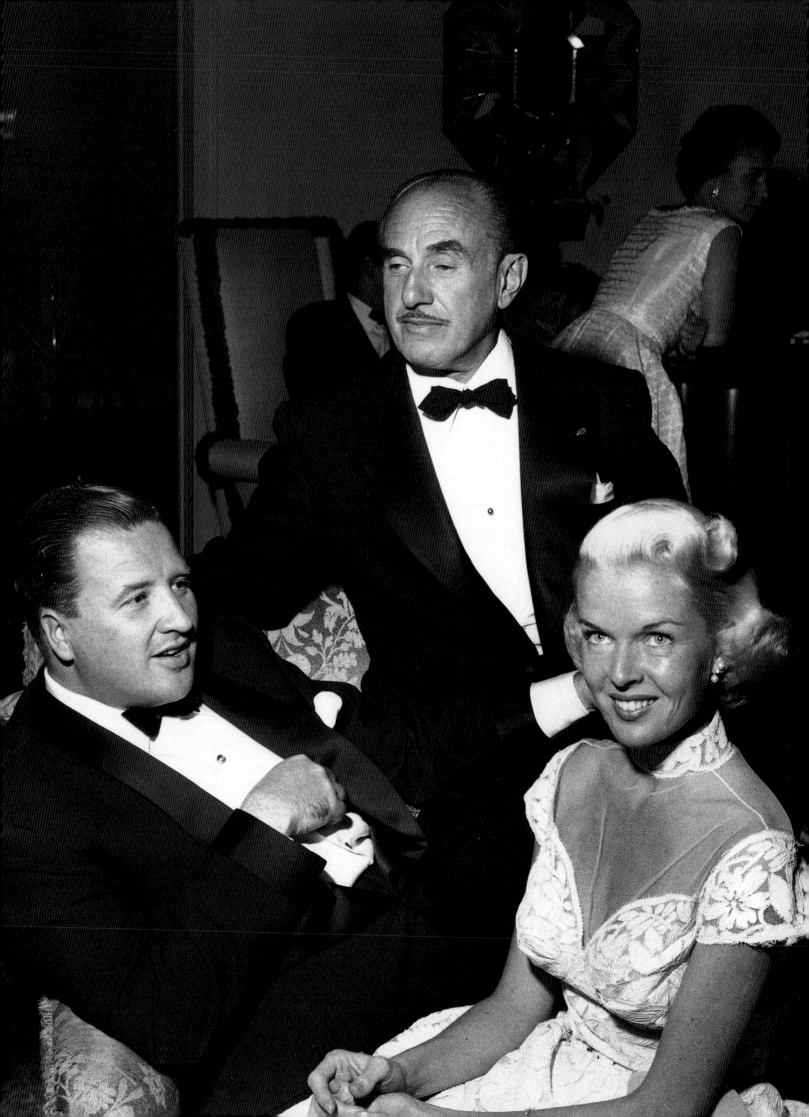

More guests at Rocky Cooper's. Opposite, from top: Merle Oberon, Richard Burton, and Roger Edens. Director Henry Hathaway, Anne Ford, Richard, and Merle. A

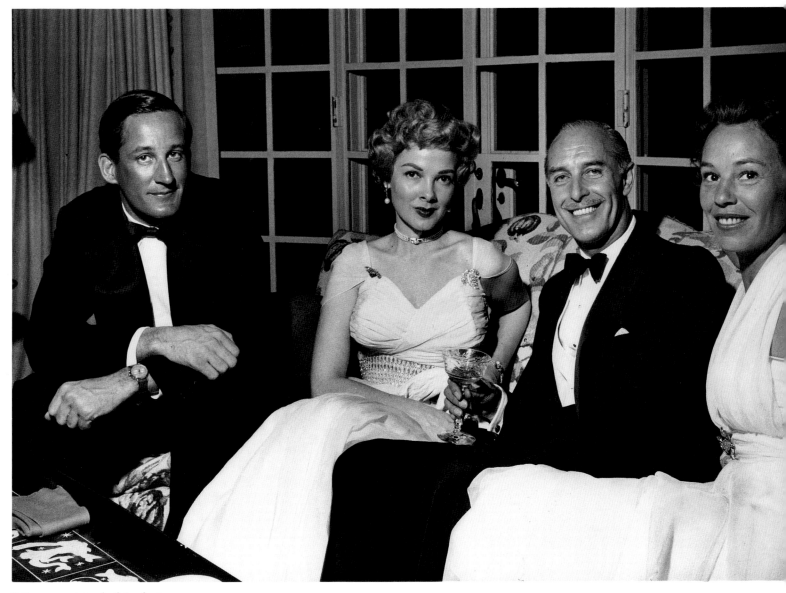

fellow guest took this shot of me with Anne, Jack Warner, and Charlie Feldman. Above: R. Fulton Cutting II, Kathryn Grayson, journalist Richard Gully, and Skip Hathaway

Below: Sammy Davis, Jr., entertains at Rocky Cooper's. This was the first time I ever saw a black performer at a private social gathering in someone's living room in Beverly Hills. Sammy was tremendous, as always.

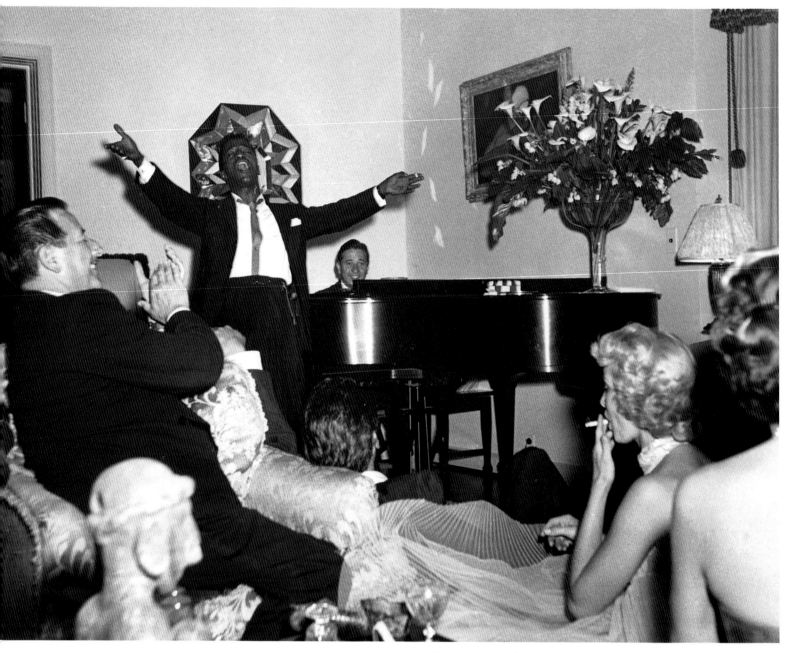

Opposite: Rocky's guests enjoy the musicale. In front is Gloria (Mrs. James) Stewart; second row, from left, Merle Oberon, Lord Astor, Janet Gaynor, and Marti Stevens; and in the back, Rock Hudson, Sharman Douglas (behind Janet), Edward Lasker, and Uri Fellon

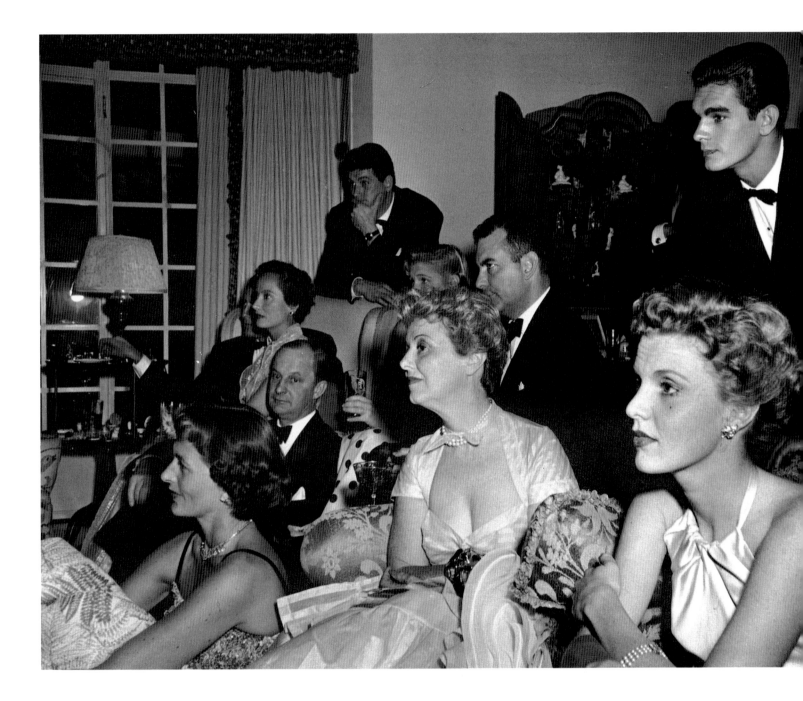

Mitchell Leisen had an aesthetic eye. You can see it on the screen in his memorable legacy. He did the art direction for the elder Douglas Fairbanks's best work, *The Thief of Bagdad*, and many of the DeMille silent spectacles. He came into his own as a director of high style with a prolific output at Paramount in the 1930s and 1940s: *Murder at the Vanities*, *Death Takes a Holiday*, *Easy Living*, *Kitty*, and *Midnight*. Carole Lombard, Marlene Dietrich, Jean Arthur, Claudette Colbert, and Paulette Goddard all loved him, and I did too. One of my fondest memories of him was this 1952 July Fourth outing to Catalina Island on his boat *Escapade*.

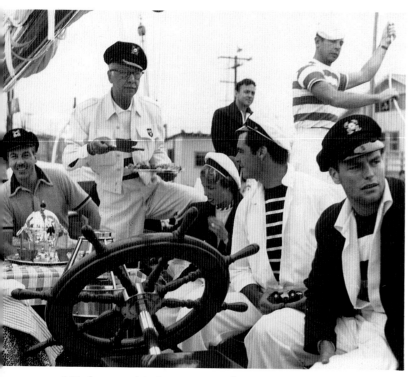

Mitch spent his last years at the Motion Picture County House and Hospital. Before he died he lost a leg, yet his many friends rallied round and he partied to the end, which came in 1972. Above: On the *Escapade* with (from left) Cesar Romero, Mitch, Mona Freeman, Rory Calhoun, and Robert Wagner. Billy Daniels, Mitch's life-long friend, is in the background. Opposite, clockwise from far left: A Fox public-relations representative; Robert; Mitch at the wheel; Patrick Nerney, then married to Mona; Billy; Susan Zanuck; Cesar; Lita Baron (Mrs. Rory Calhoun); and Hedda Hopper

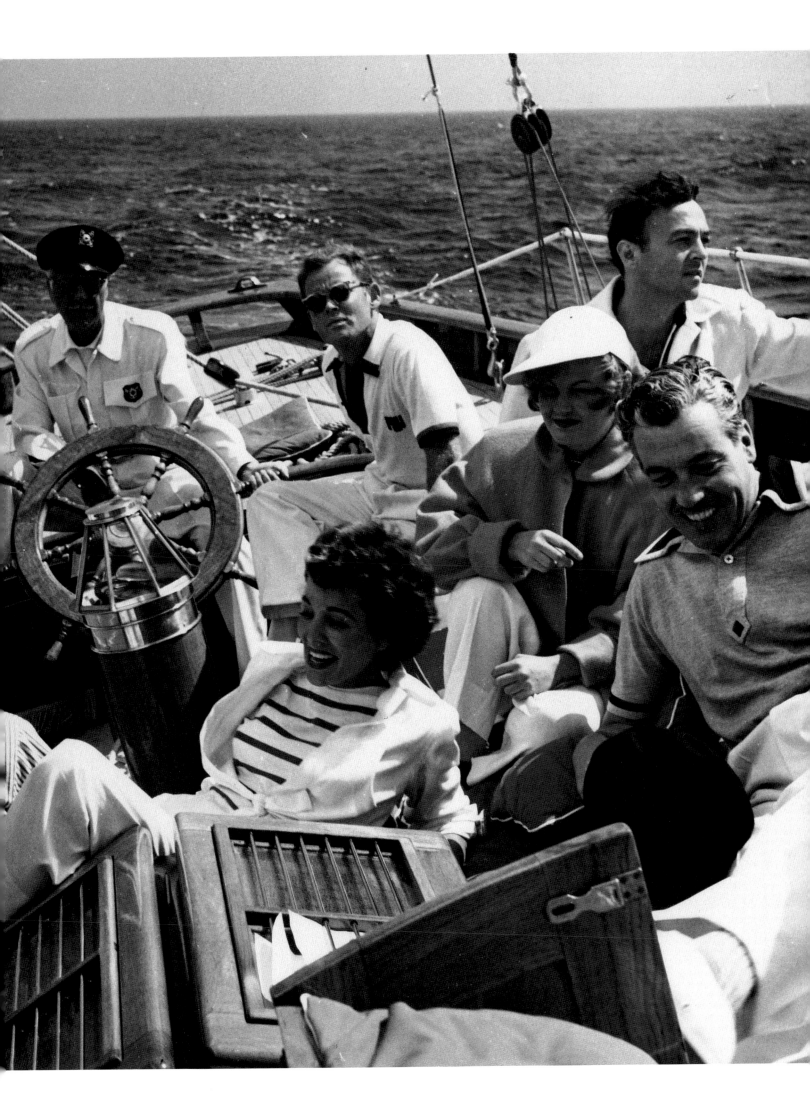

Talk about debonair young actors! You couldn't beat Robert Wagner and Rory Calhoun that day on Mitch Leisen's cruise to Catalina. Rory was already married to spitfire Lita Baron, but Bob was several years away from his first trip to the altar with Natalie Wood. Rumor had it that Barbara Stanwyck was smitten with Bob after he played her son in *Titanic*. When Lita divorced Rory, the trade papers gossiped that she hit him with charges of committing adultery with seventy-eight women, including my sidekick from the Goldwyn days, Betty Grable.

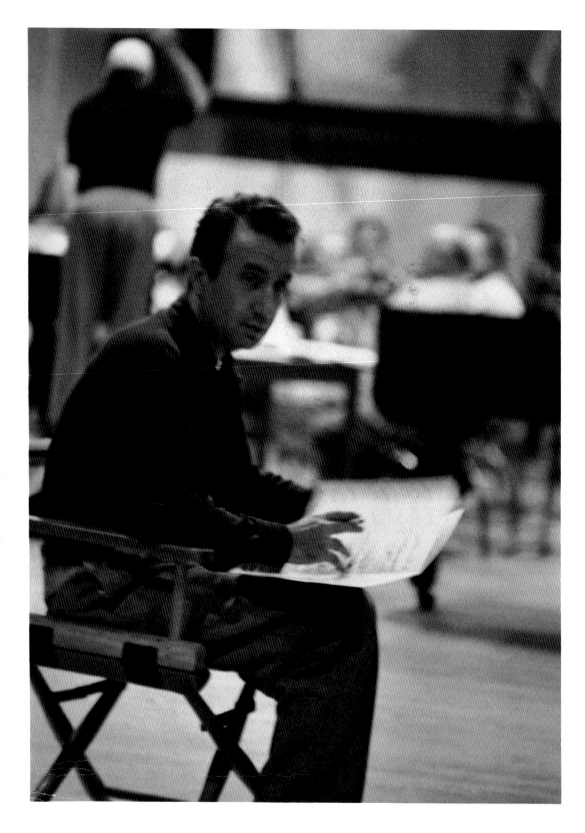

Vogue gave me a choice assignment. They wanted a picture story on "Hollywood's Creative Brains"— their title, their selection. It was one of the first articles in a national publication to single out cinematographers and composers, and *Vogue* picked the finest for the article, which ran in February 1952. <u>Left</u>: Alex North, a Guggenheim fellow, composed the scores for A *Streetcar Named Desire*, *Death of a Salesman*, A *Member of the Wedding*, and V*iva Zapata*, all prestigious hits from the 1950s. <u>Opposite</u>: The Oompahs—four of the creators who made *Gerald McBoing-Boing* the decade's classic cartoon— (from left) Steve Bosustow, T. Hee, Robert Cannon, and Ray Shearman

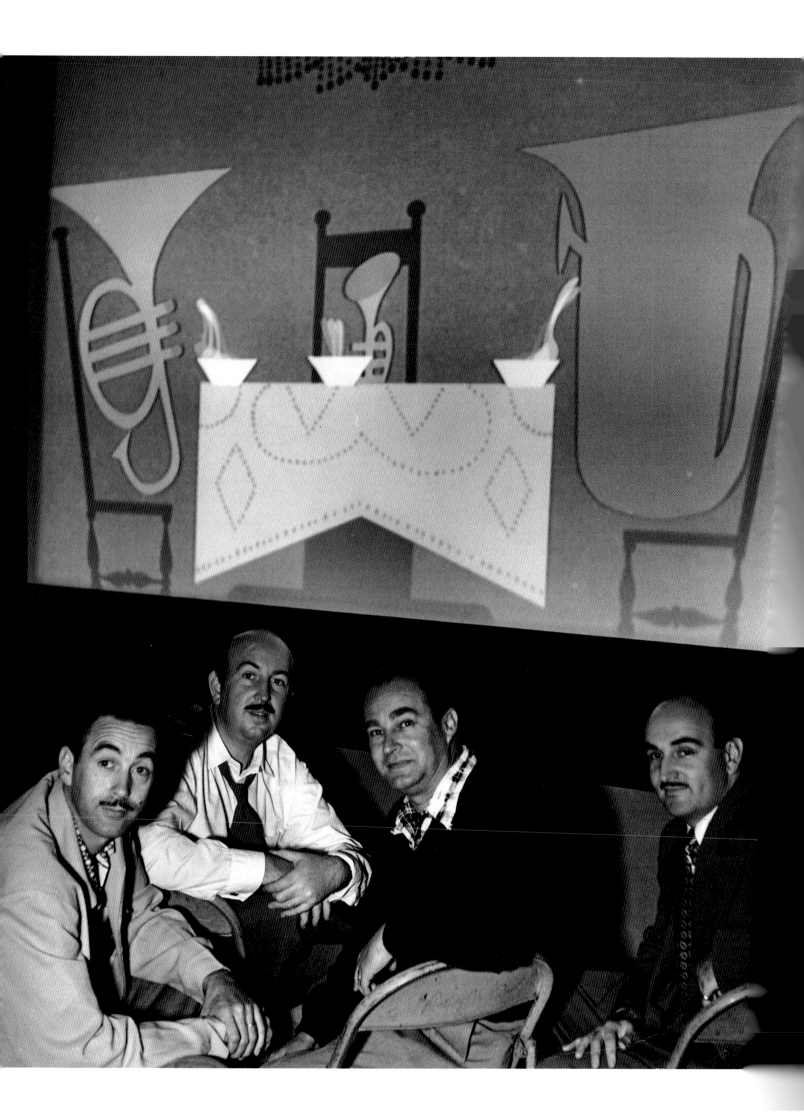

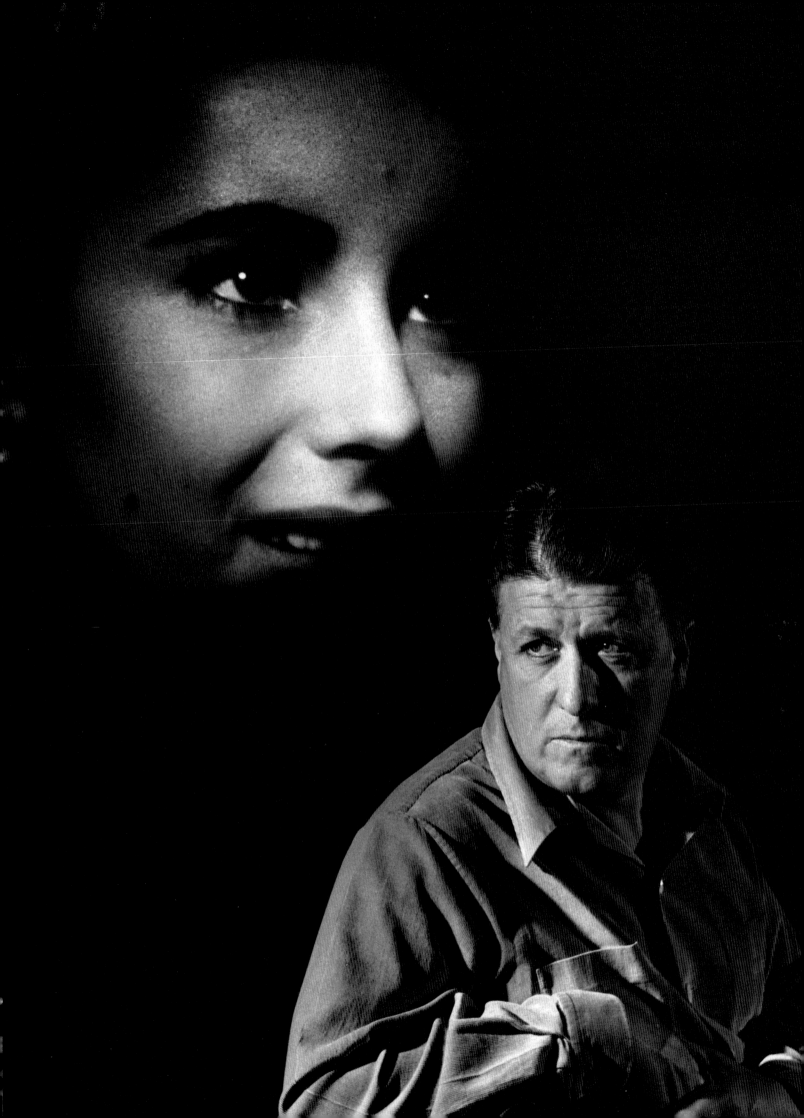

These three handsome men all began as camera operators. Opposite: Director George Stevens, who was both cameraman and gagman at Hal Roach's fun factory in the 1920s, went on to make such film classics as *Alice Adams, Gunga Din, I Remember Mama,* and A *Place in the Sun,* which he was editing here. The twenty-year-old Elizabeth Taylor had her first great role in the film. *Vogue* said George had

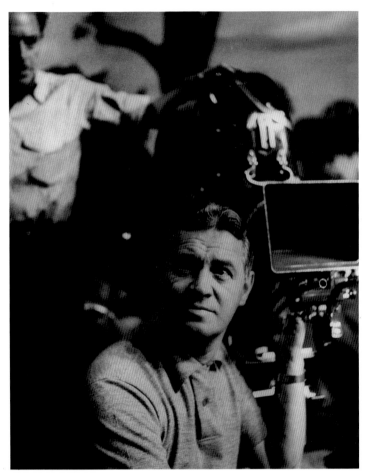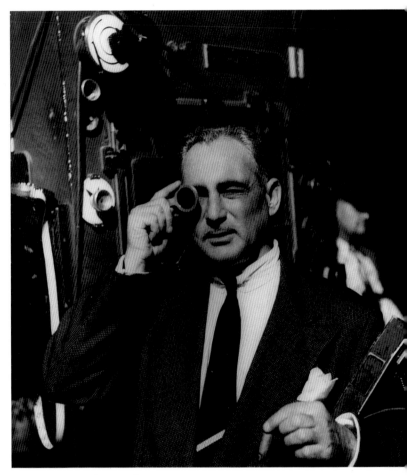

a "noble face that looks as if it had been carved out of a mountain." <u>Above</u>: In 1952 Harry Stradling (left) and Leon Shamroy were acknowledged master cinematographers. The former had just shot A *Streetcar Named Desire* and the latter, *David and Bathsheba.* Shamroy was famous for his use of color; he received three Oscars, for *The Black Swan, Wilson,* and *Leave Her to Heaven.*

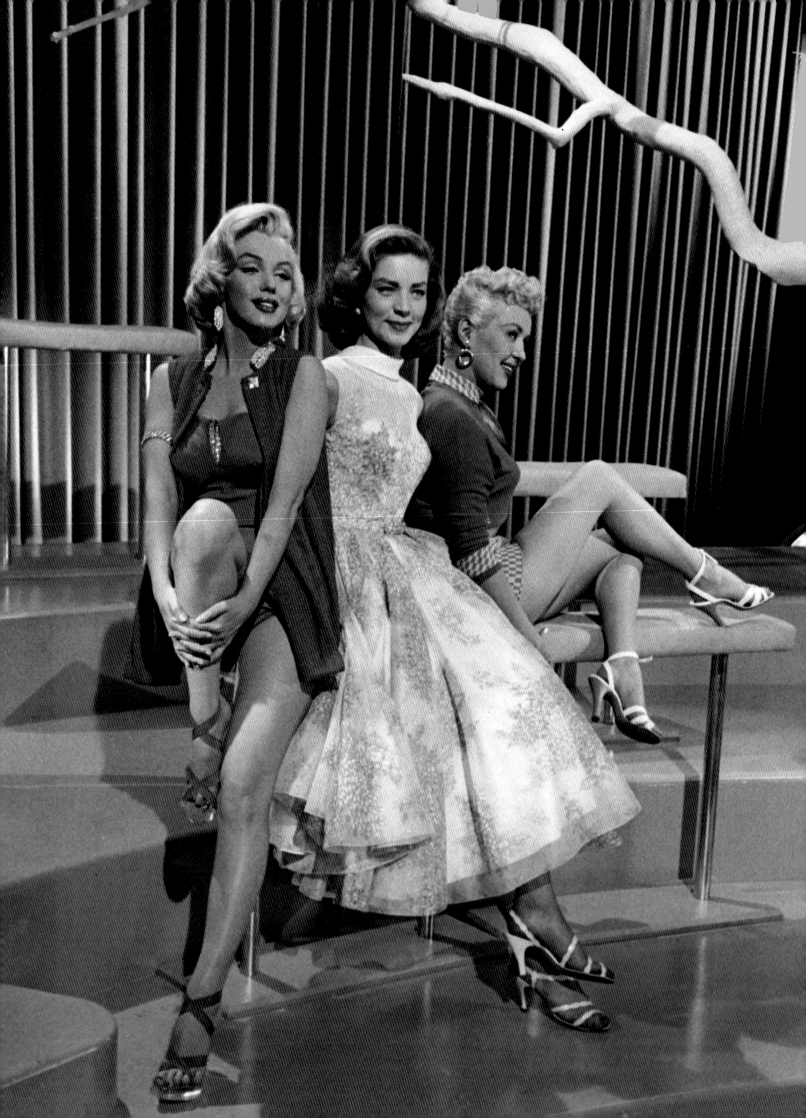

Hollywood went Cinemascope crazy in 1953 when Twentieth Century-Fox president Spyros Skouras convinced his studio chief, Darryl Zanuck, that a wide-screen process would lure audiences away from their television screens and back into the ailing movie houses. With customary ballyhoo Zanuck announced that his maiden Cinemascope epic, *The Robe*, would be followed up in the same year with *How to Marry a Millionaire*, a trifle based on Zoe

Monroe, who turned out to be the blonde of that decade, maybe the blonde of the century.

The three stars got along well, according to director Jean Negulesco, although Marilyn's problems were already beginning to surface. Being the easiest of stars to work with, despite her incredible tenure at the top of the box-office heap for nearly fifteen years, Betty took an almost motherly approach to Marilyn. Betty had severed her Fox

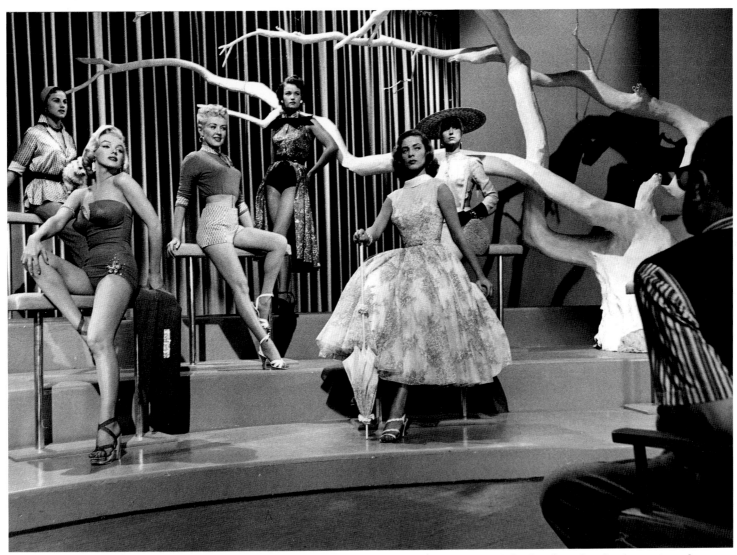

Akins's gold-digger chestnut, *The Greeks Had a Word for It*. I think Lauren Bacall, who had provided two offspring for Humphrey Bogart and now wanted to resume her career, suggested the property to producer Nunnally Johnson, who then updated the antifeminist plot. Realizing that Bacall could not carry a film alone, Zanuck shrewdly conceived the teaming of Fox's longtime box-office queen, Betty Grable, and the blonde of the hour, Marilyn

contract and Zanuck had to hire her back, paying plenty for the privilege. His revenge was to give Marilyn top billing in all the advertising. Betty didn't care one whit. She still had top billing on the screen, "where it counts," she confided. Lauren ended up playing third fiddle, but at least she was working again.

The famous trio poses for publicity stills alone (opposite) and with extras and director Negulesco (above).

Clockwise from below: I wasn't the only visitor to the set that day; Richard Burton clowns it up during a break from his *Robe* chores. Costar William Powell announced his retirement with the movie, but two years later he couldn't resist the doctor role in *Mr. Roberts*. Marilyn poses in character as the myopic Pola Debevoise. Rory Calhoun rehearses

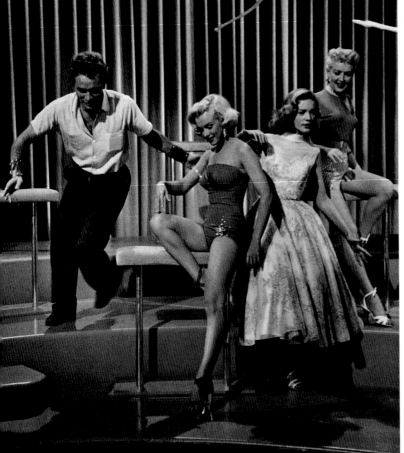

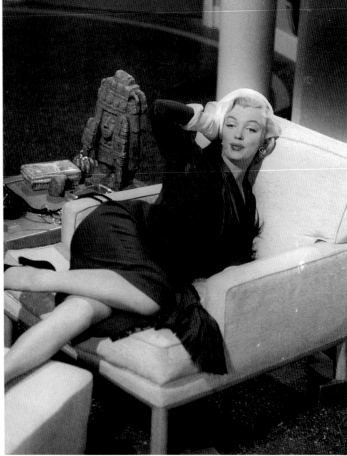

with relish. Opposite: Prior to my visit to the set of *How to Marry a Millionaire*, I had attended an exhibitors' screening, for which a portion of the slightly earlier film *Gentlemen Prefer Blondes* had been converted to Cinemascope. I took this shot of Marilyn performing "Diamonds Are a Girl's Best Friend" right from the screen.

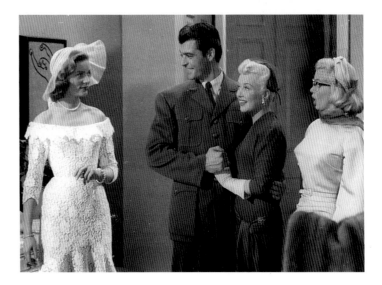

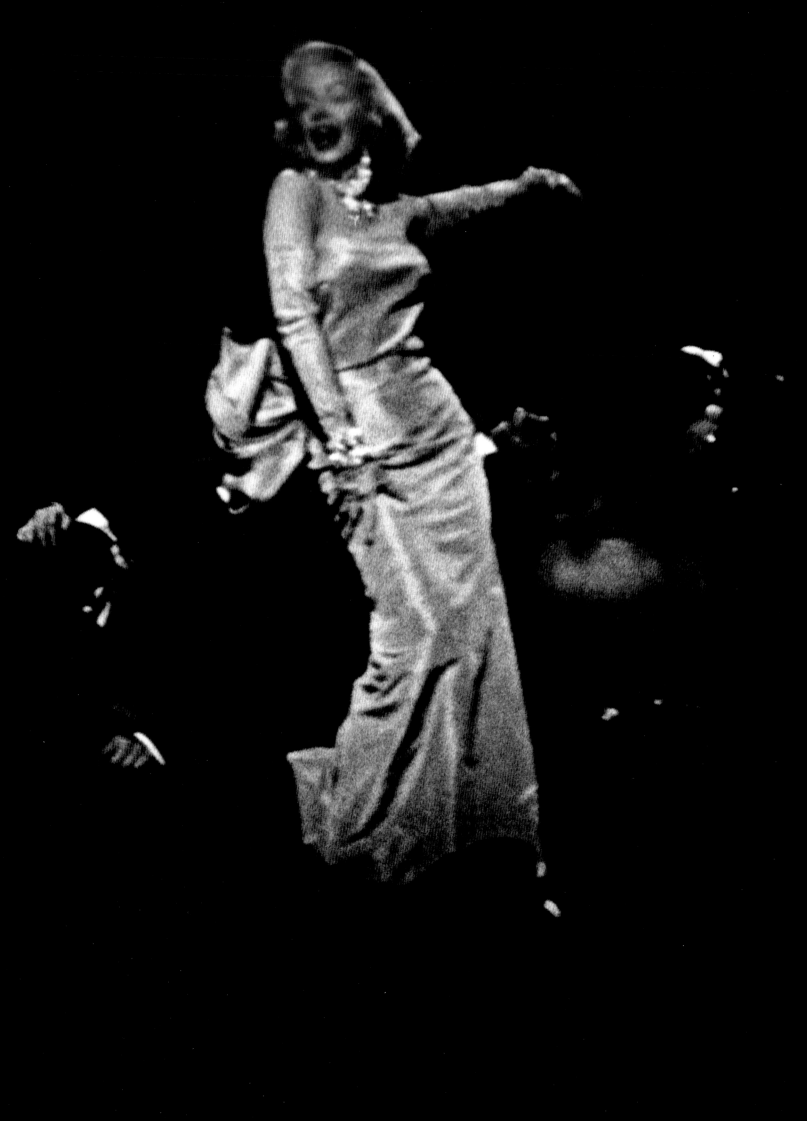

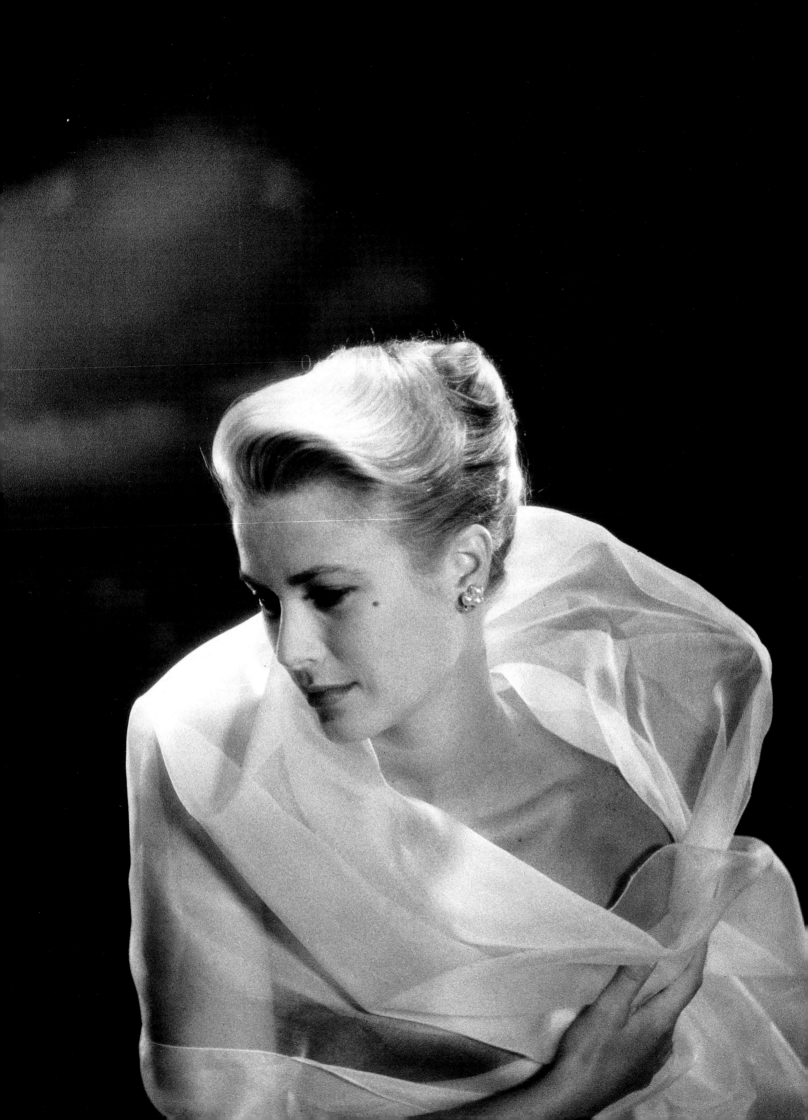

When *Vogue* published these portraits of Grace Kelly in the fall of 1954, the caption bragged that she had just landed three "plum parts." And plum they were: *The Country Girl* opposite Bing Crosby, the role that won Grace her Oscar over Judy Garland's memorable Vicki Lester in *A Star Is Born*; *The Bridges at Toko-Ri* opposite William Holden; and *To Catch a Thief*, the Alfred Hitchcock classic with Cary Grant that took Grace to Monaco and her date with destiny. Both Bing and Bill found Grace irresistible and fell in love with her, but when I was working on these pictures, she and Oleg Cassini were in love. Grace and her sister, Lizanne (right), wore simple skirts and blouses, almost like schoolgirl uniforms. Then Oleg dropped in on the shooting session. I said, "Oh, Oleg, please find something romantic for Grace." He went to the wardrobe and came out with the gauzy organza that perfectly framed the Madonna-like pose Grace struck so naturally.

Leslie Caron was about twenty-one when I made this portrait of her (below) in 1953 on an MGM sound-stage, but she looks all of twelve. Hers was the kind of fresh face that I thought

would never grow up. Thirty-odd years later I have to admit Leslie has matured, but in the best of ways; she's a smart Parisienne and a true sophisticate, and also a strong character actress, if only she would work more. Opposite: Leslie poses in a dazzling dress of satin and lace by Irene for my *Vogue* assignment while three of MGM's contract hunks lend their services to the young star. I can't remember which joker in the bunch turned the names on the chairs upside down. Van Johnson (top left) was the biggest star in the group, and this was at a time he was leaving behind his boy-next-door image to pursue more serious roles. He did *The Caine Mutiny* the next year. Fernando Lamas (top right) was Argentina's contribution to a long line of Latin lovers. After his marriage to Esther Williams, Fernando exerted a firm Continental-type control over this lovely all-American aquatic favor-ite. Peter Lawford, whose father was Sir Sidney Lawford, had the best of private tutors, yet his first job in Hollywood was as an usher at the Westwood Village Theatre. His carry-ings-on with the Rat Pack (which also included Sammy Davis, Jr., Dean Martin, and Frank Sina-tra), the celebrity marriage to John F. Kennedy's sister Patricia the year after this picture was taken, and his battle with booze have been well detailed. I remember his sense of humor about himself and life most of all.

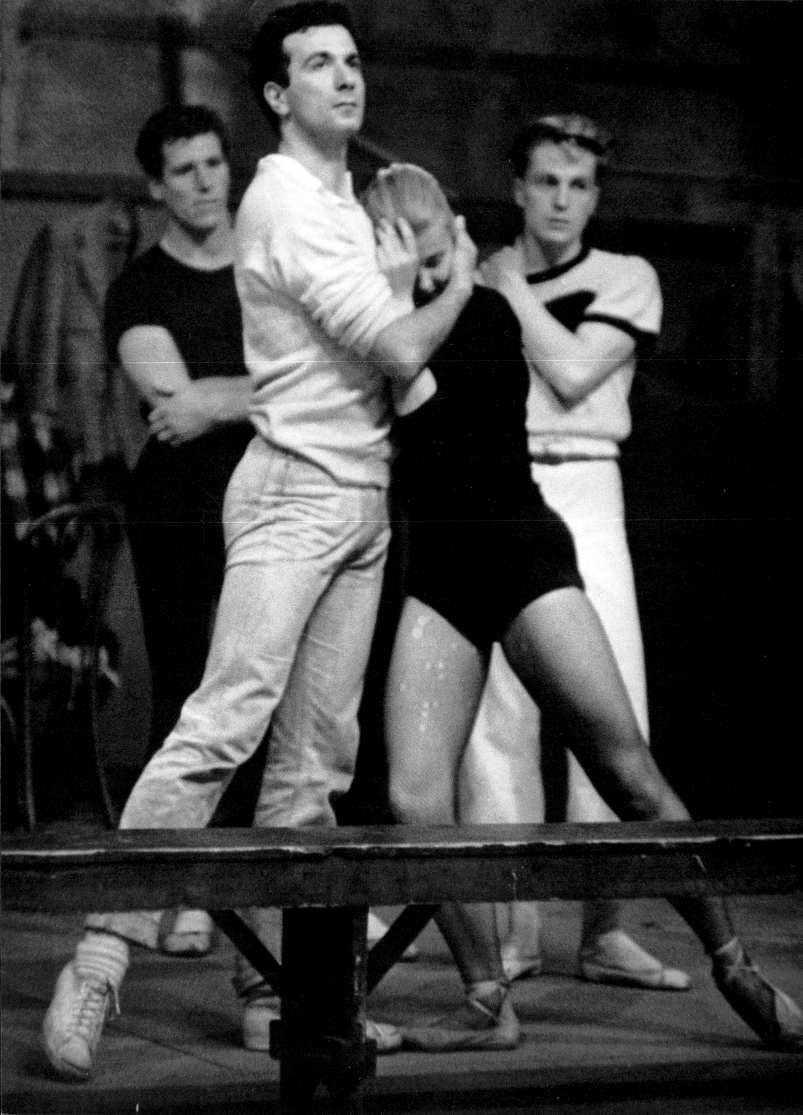

A little background about these two rehearsal shots taken at the Goldwyn studio in 1952. For eight years Danny Kaye was Sam Goldwyn's pride and joy and clowning box-office champ. Increasingly, Sam found it difficult to come up with the right vehicles for Danny's extroverted, unreal comic persona. Their swan song together had Danny playing Hans Christian Andersen in a fictionalized musical biography. Sam brought in Moss Hart to do the script and Frank Loesser to write the score. The master producer had one surprise up his sleeve. He hired the Parisian choreographer Roland Petit (opposite, rehearsing his dancers) and his mistress, later his wife, Zizi Jeanmaire (right), who replaced a pregnant Moira Shearer of *Red Shoes* fame. They had shocked international audiences with a high-voltage *Carmen* ballet. Nothing in the mix ever jelled. The movie concluded Danny's days with Goldwyn. Sam went on to produce only two more movies.

I found Zizi to be champagne bubbly tempered with steel. Her long, sexy legs were quite amazing, and Roland was handsome enough to be a movie star himself. However, they devoted most of their careers to stage and dance and cabaret, and in France they remain legendary names.

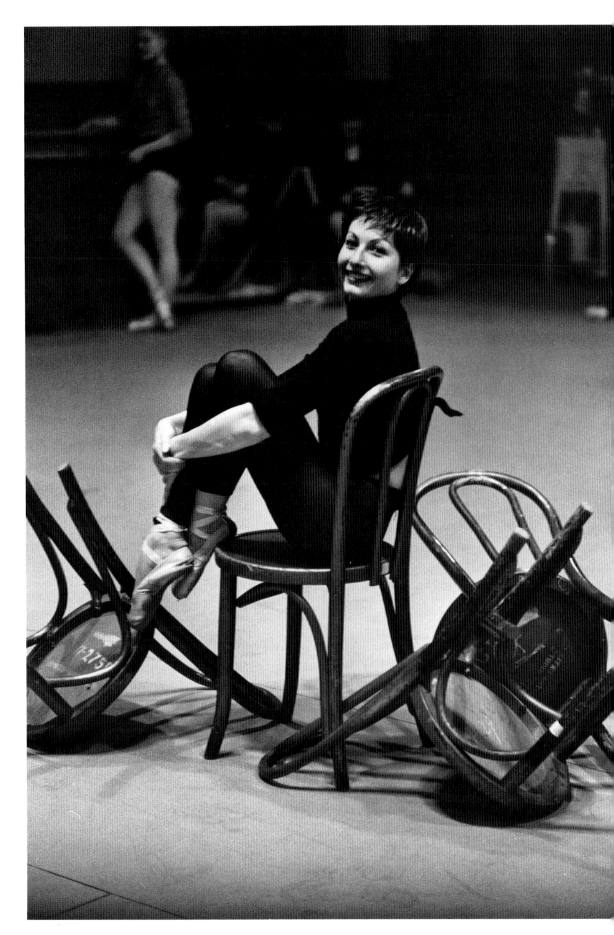

At the height of the Frank Sinatra–Lauren Bacall romance in 1957, I was invited to join them and Peter and Pat Lawford, Leland and Slim Hayward,

and Michael and Gloria Romanoff to fly to Las Vegas in Frank's private plane for the opening of *The Joker Is Wild*. We had a hilarious weekend; Frank was gallant and generous. Each of the women received a bag of chips to gamble with after dinner. Frank would sit on the floor and sing, always leaving us wanting more. I've never known a better host.

Frank's recording sessions were ultraprivate affairs. Once I was invited I was nervous about bringing along my cameras, but I did not want to miss an opportunity so rare. I dropped a tiny Minox in my purse. On the appointed day, I was taken to dinner. I had also received long-stemmed yellow roses. At the studio were more flowers, even on Frank's music stand, and drinks served all around. As would any woman, I was wondering how this attention would end.

After the session Frank drove me home. I suggested stopping by a friend's house for a nightcap, but Frank shook his head. As we approached my place, I began to agonize about whether I should ask him to come in for a drink. Before I knew it, Frank had pulled up at the bottom of my steps. He reached over me, opened the door, and said, "Good night, Miss Howard." " 'Night, Frank," I said, puzzled. I'm still puzzled by this clever charmer.

After all these years, here's my thank-you: two previously unpublished photographs of an artist in his element, in his prime.

Van Johnson (below) breaks in a nightclub routine. His movies didn't offer many chances for him to strut his musical stuff, but as Van likes to joke, "I'm the oldest chorus boy still at

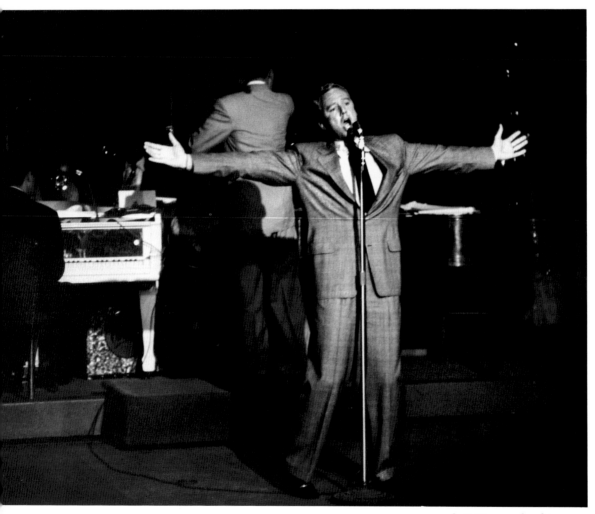

work." He was backing up June Havoc in the chorus of *Pal Joey* when the MGM talent scouts took note. Thanks to Irene Dunne, who was willing to wait out a serious injury

Van suffered in a car accident while they were filming *A Guy Named Joe*, he became the schoolgirl's delight of the 1940s.

The beautiful Merle Oberon (opposite) came from an exotic background. Born Estelle Merle O'Brien Thompson, she was raised and educated in India. She arrived in London at seventeen and early in her career worked as a café hostess under the name Queenie O'Brien. She was working as a film extra when she met Alexander Korda. They were married in 1939, the year her greatest success, *Wuthering Heights,* was released. Divorced from Korda in 1945, Merle subsequently married and divorced Lucien Ballard, who was her cinematographer for *This Love of Ours,* and Italian industrialist Bruno Pagliai. Other loves included David Niven, whom she had helped to get started in Hollywood but never married, and Los Angeles physician Rex Ross. Her fourth husband, Robert Wolders, her costar in her last film, *Interval,* was with her when she died in 1979.

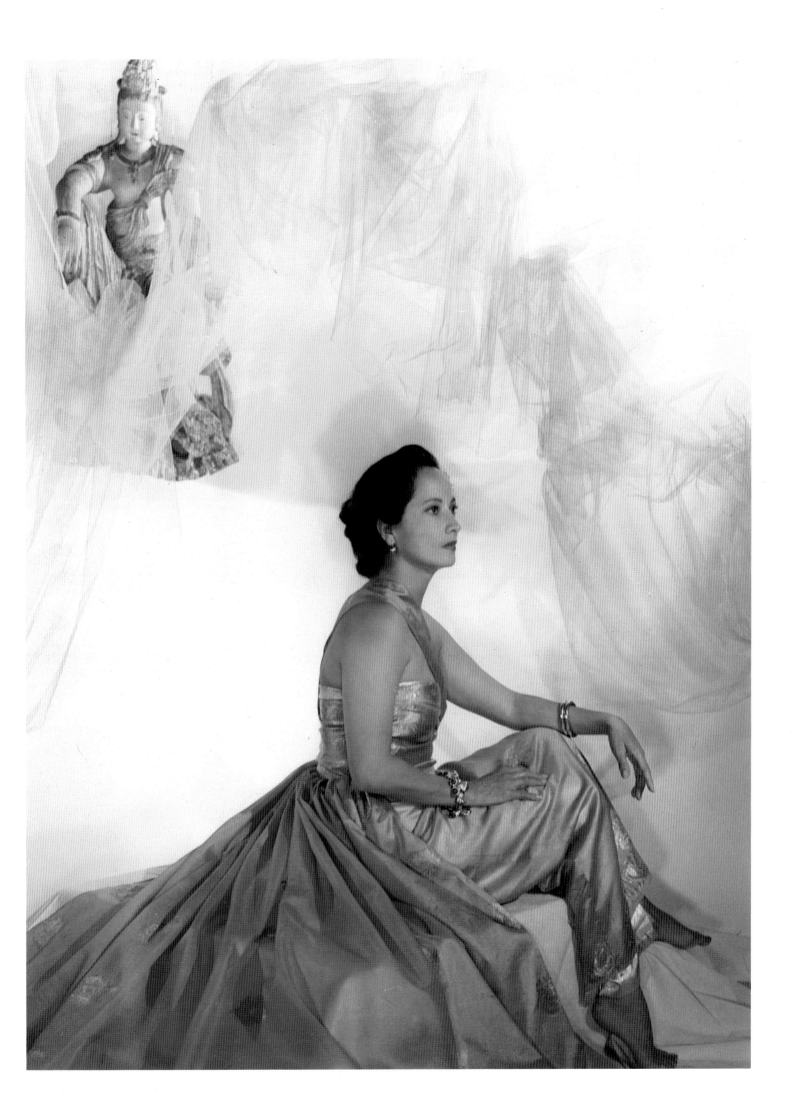

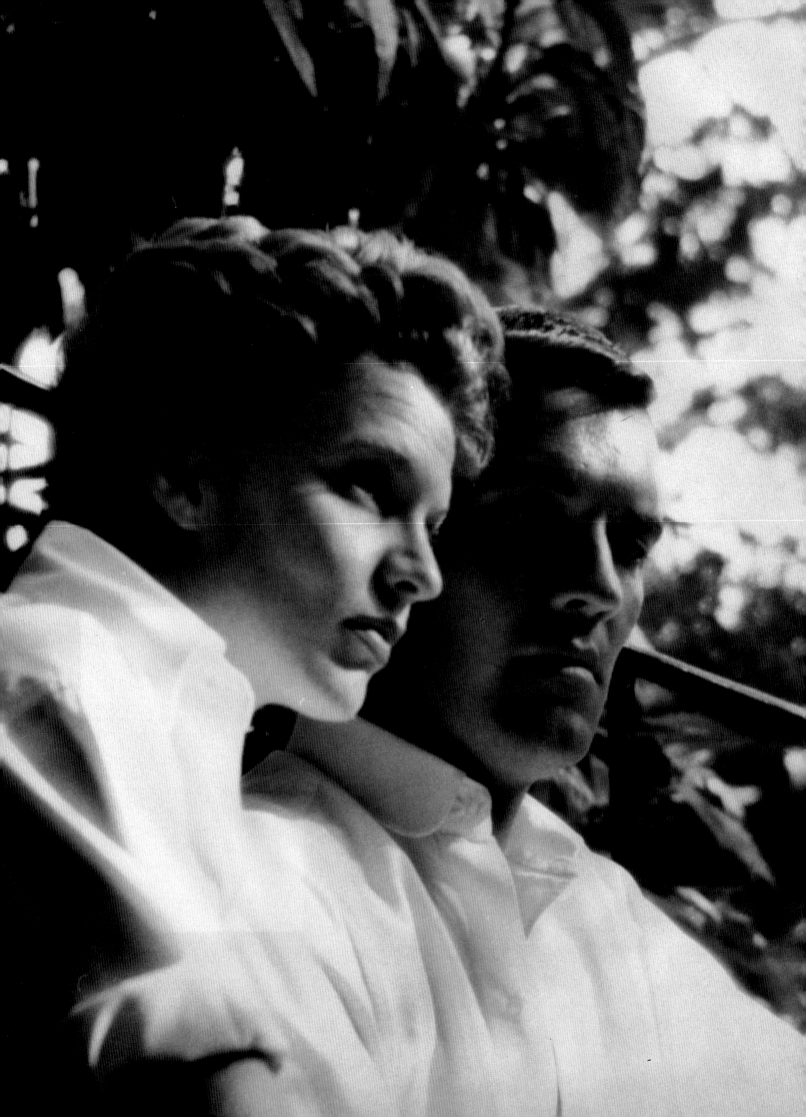

Marti Stevens, though to the manor born (she is the daughter of Nicholas M. Schenck, former president of Loews, Inc.), chose a singing career—theater, cabaret, and concert. She fell in love with producer Michael Butler in 1954, and I photographed them (opposite) the day before they flew to Mexico City to be married at Dolores Del Rio's home. Michael would make his millions fifteen years later producing that revolutionary musical called *Hair*.

The jolly family (below) is Freeman Gosden and his wife, Jane, with their son, Craig. A generation of Ameri-

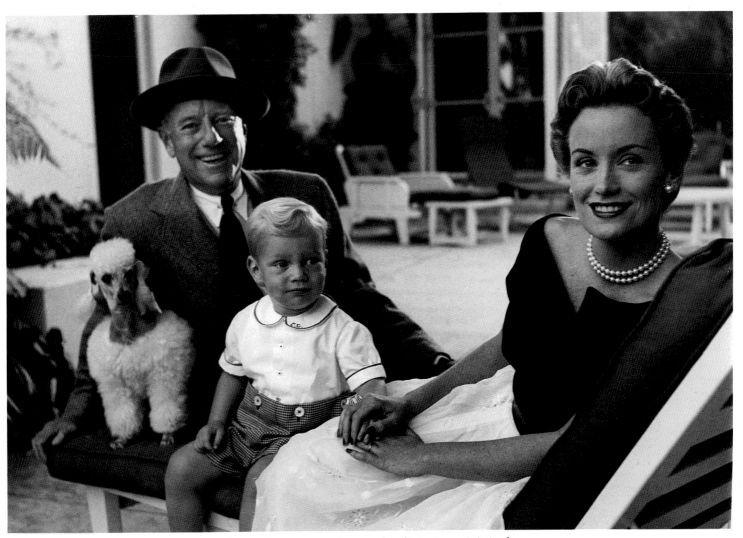

cans loved Freeman as Amos of radio's *Amos 'n' Andy* team. He and his partner, Charlie Correll, started in vaudeville doing a blackface routine called "Sam 'n' Henry." Ten years later, in 1929, they took a new name and made radio history on NBC. It was a time when stereotypes about blacks abounded, but the warmth of *Amos 'n' Andy* always came through.

I took this photograph in 1952 as part of a series on Hollywood families intended as a follow-up to my "Hollywood Mothers" piece for *Vogue*; unfortunately, the second series never ran.

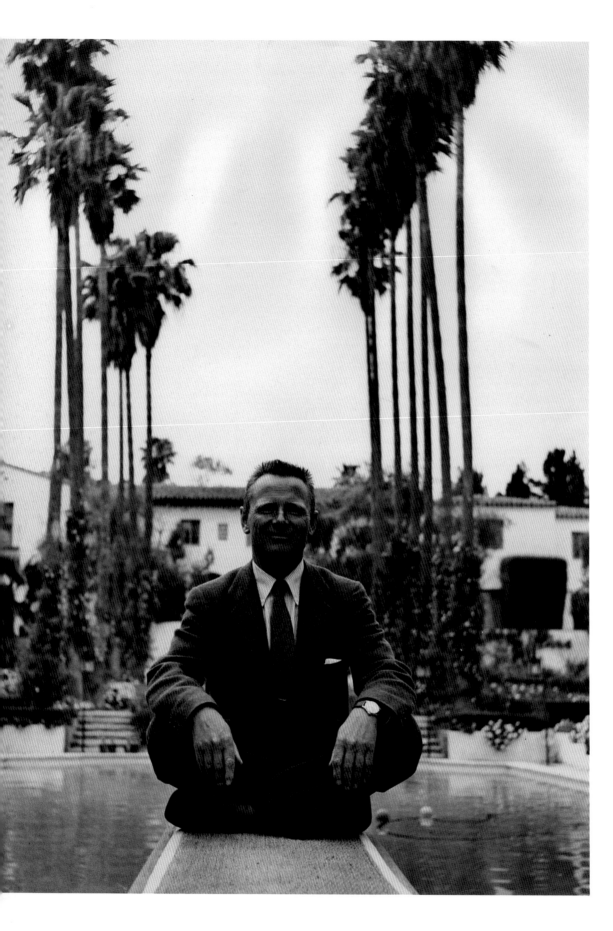

Christopher Isherwood (left) took to California like an avocado. As with so many Brits, deprived of sun much of their lives, he felt cozy and comfortable and, most importantly, productive in the California clime. I got him out on the diving board at the Marion Davies estate in Beverly Hills around 1953. His own modest life-style took root in the hills of Santa Monica, where for nearly two generations he was a guru to artists, writers, and filmmakers.

Geraldine Page (opposite) traveled a long road from Kirksville, Missouri, to achieve success, but she did achieve it and on her own terms, in her own fashion. When Charles Feldman brought her to Hollywood, she did a bit in a minor Dan Dailey comedy and then had the female lead opposite John Wayne in *Hondo*, for which she received the first of her many Oscar nominations. She was bemused at being cast in a Western opposite Mr. America, but somehow I think all of life bemused her. She was one of our greatest and most versatile actresses, playing everything from the heart. That afternoon in 1953, as she leaned against the side of the house in my garden, I could feel the power of her personality, the strength of her character.

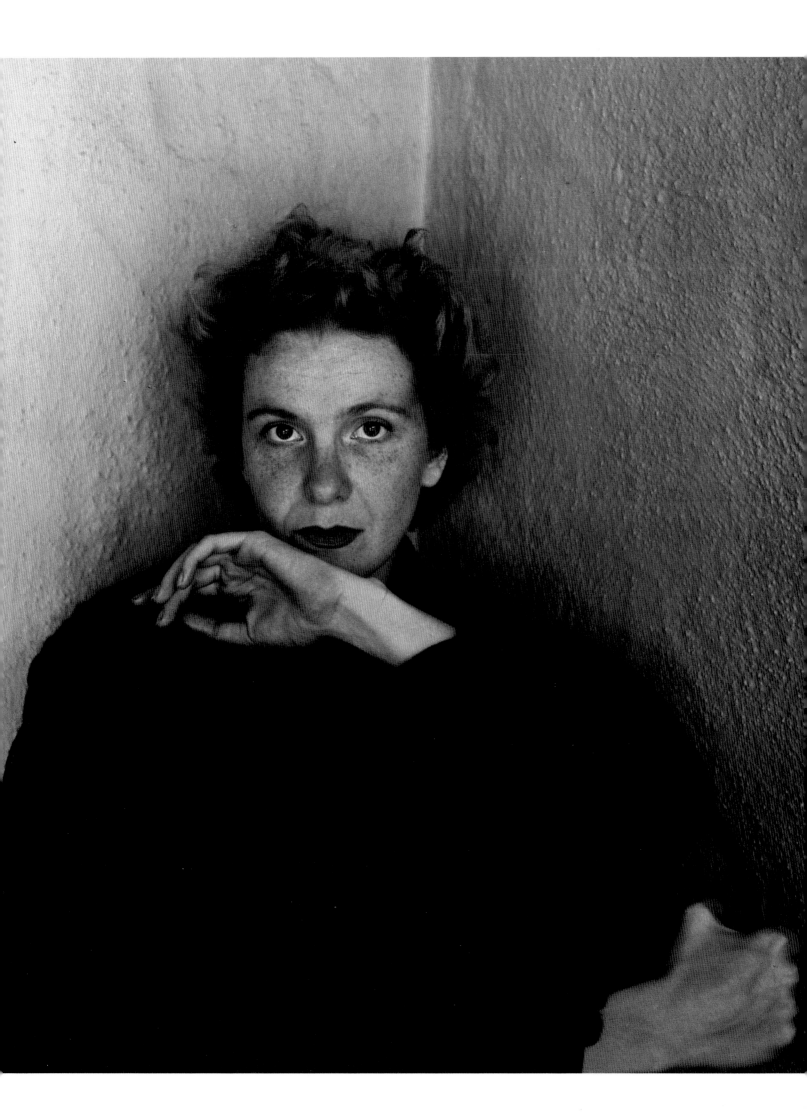

I shall never forget that voice. Thick, smooth, sweet as Grecian honey, except it came from Yorkshire by way of Central Casting in London. James Mason (left) physically brutalized his share of women as a dastardly screen scoundrel, but his mellow tones were the most seductive I ever heard. When I caught him in 1958, he had just come off the tennis court, thus the headband, and was fooling with some cameras. Daughter Portland is adding her two cents, a trait she inherited from her mother, Pamela. This and the other photographs on these two pages were taken as part of my unpublished *Vogue* assignment on "Hollywood Families." I traveled to Brentwood, California, to photograph Doris Warner Vidor and her family (opposite, left). Doris was the eldest daughter of Harry Warner of Warner Bros. Her second husband, Charles, directed numerous Hollywood films, including *Cover Girl* and *Gilda*. He died of a heart attack in 1959 during the filming of *Song Without End*. Clockwise from left are Doris Vidor; Linda and Warner LeRoy, Doris's children with her first husband, director Mervyn

LeRoy; Charles Vidor; and his two sons with Doris, Brian and Quentin. Warner LeRoy is now a New York restaurateur, whose establishments have included Maxwell's Plum

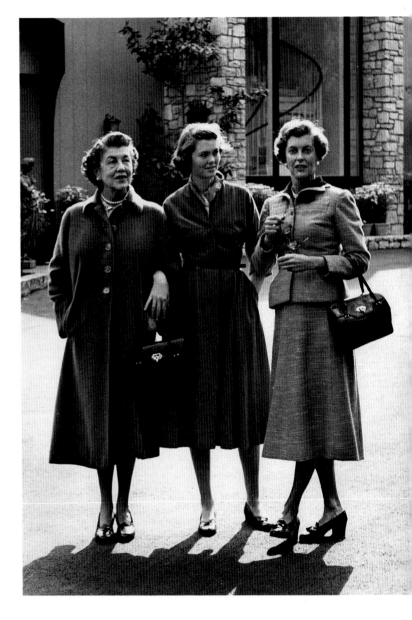

and Tavern on the Green in Central Park. <u>Above right</u>: Rocky Cooper with her mother, Mrs. Paul Shields, and her daughter, Maria, who married concert pianist Byron Janis

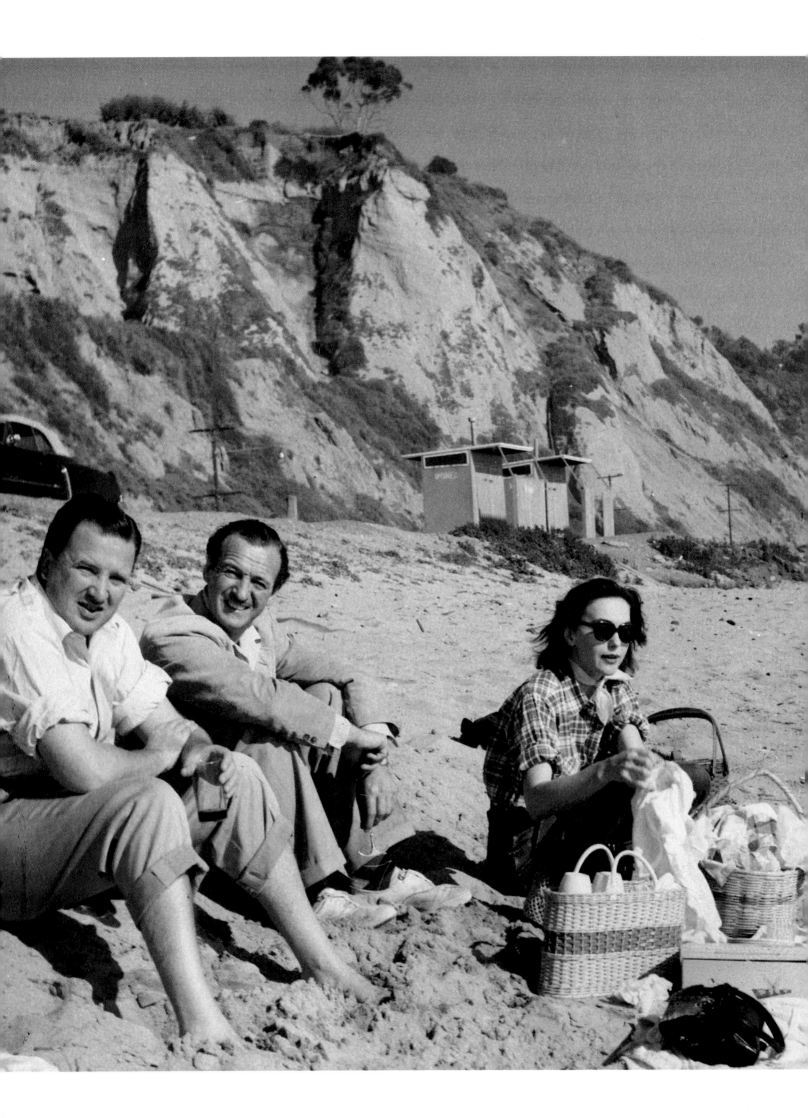

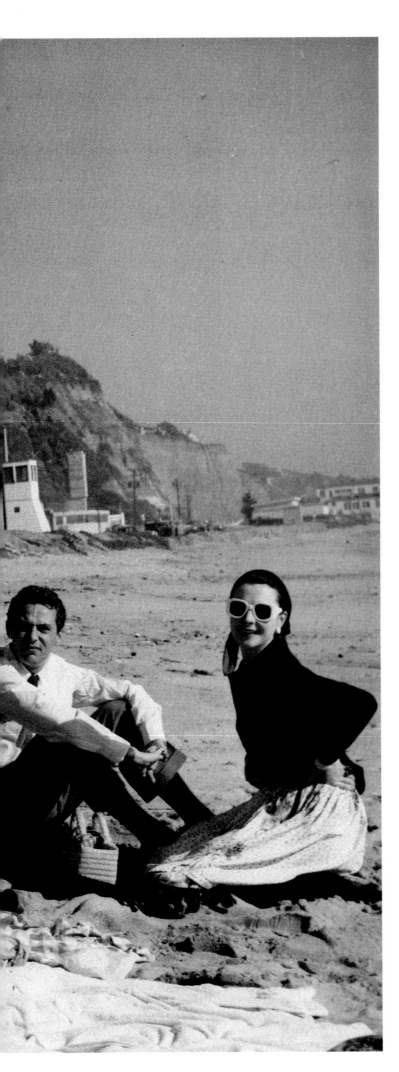

<u>Opposite:</u> Imagine strolling along the beach at Santa Monica in 1953 and coming upon this elite enclave (from left), Henry Ford II, David and Hjordis Niven, Peter Finch, and Vivien Leigh. <u>Below:</u> Anne Ford checks out the picnic goodies while Hjordis, Peter, and Vivien chat.

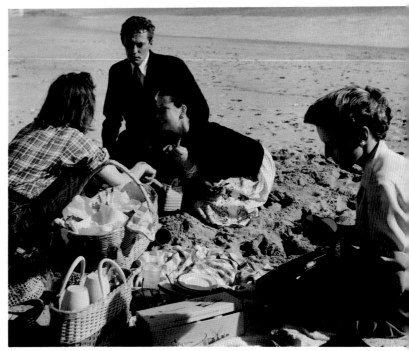

Peter and Vivien were in love and about to begin *Elephant Walk*, the ill-fated movie she was unable to finish. Elizabeth Taylor replaced her, but in the long shots you can still see Vivien. We all were charmed by her new Australian beau; Peter was magnetic as well as likable.

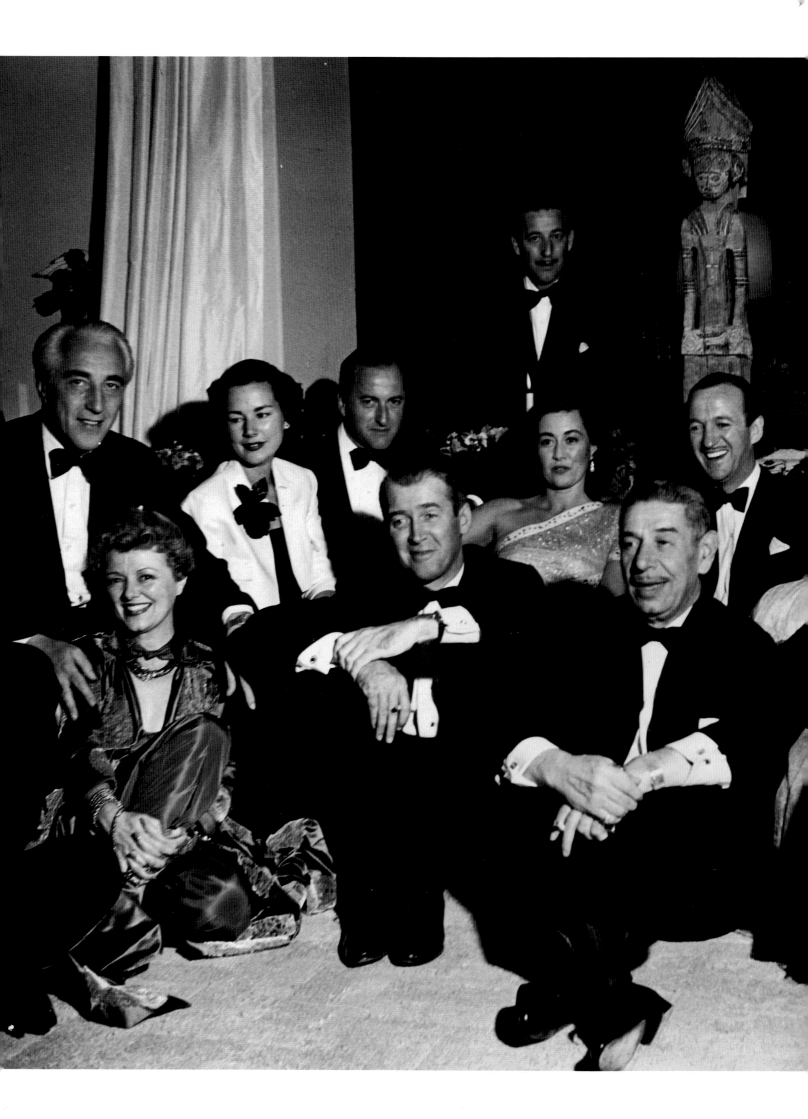

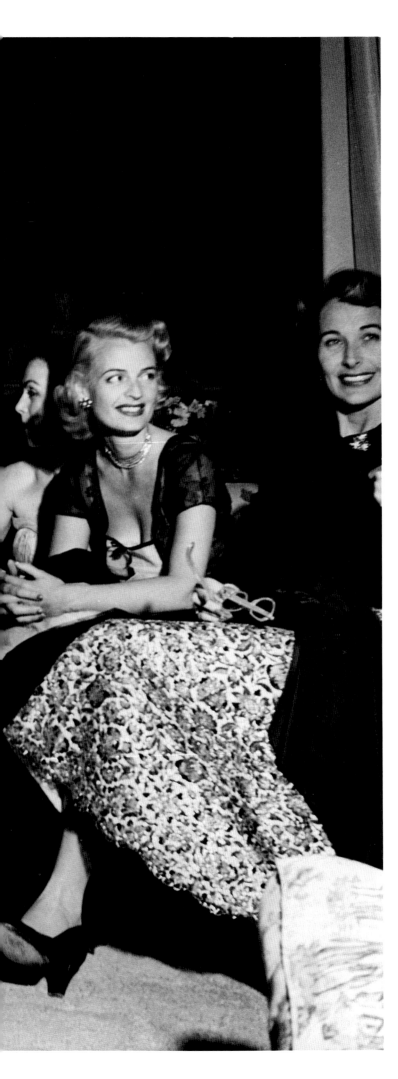

Laura Gainor of Philadelphia and Adolph Greenburg of Naugatuck, Connecticut, were Hollywood royalty under their professional names, Janet Gaynor and Adrian. She was the first actress to win an Oscar and was popular enough in the late 1920s and early 1930s to assume Mary Pickford's role of America's Sweetheart. During his fifteen-year reign as MGM's costume designer, Adrian created glamorous images for Greta Garbo, Norma Shearer, Jean Harlow, and, most especially, Joan Crawford. Joan was Adrian's dream come true. His coat-hanger silhouette became her trademark. He began as a menswear designer, but his corner of immortality will always be with the goddesses of MGM.

By the time they hosted this 1953 gathering of the rich and famous, both had long retired and were more interested in painting than past accomplishments. Front row: Janet with James Stewart and restaurateur Mike Romanoff; second row: Condé Nast president Iva S. V.-Patcévitch, Gloria Romanoff, Watson Webb, Jeanne (Mrs. Alfred) Vanderbilt, David and Hjordis Niven, Chessie Amory, and Gloria Stewart. Host Adrian stands guard in the back.

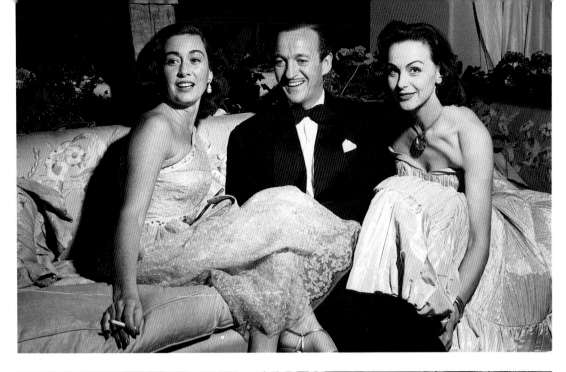

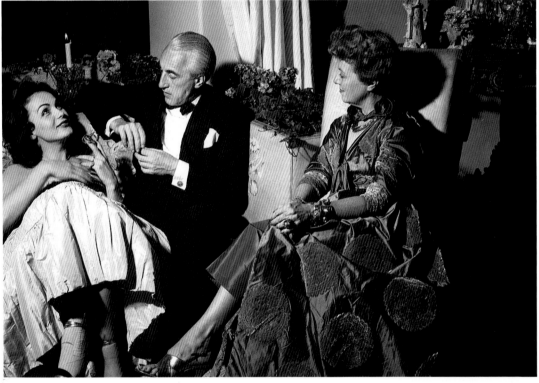

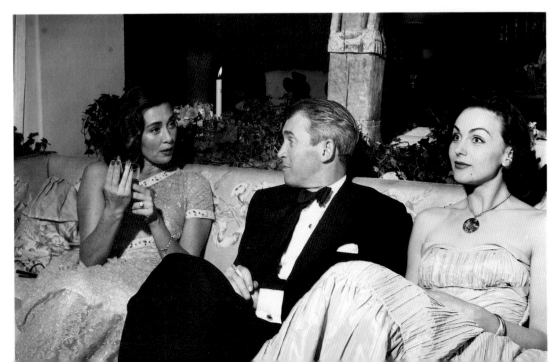

At Adrian's. Left, from top: Jeanne Vanderbilt with David and Hjordis Niven. Hjordis with Iva Patcévitch and Janet Gaynor, the hostess. Jeanne and Hjordis with James Stewart.

Opposite: In November 1954 Billy Wilder and Charlie Feldman gave a party for Marilyn Monroe that has gone down in the Hollywood history books. They had produced the movie version of George Axelrod's *The Seven Year Itch*, with Billy directing. To celebrate the completion of the filming, they threw a bash at Romanoffs and invite the crème de la crème of the industry to meet MM. At last, after five years of skyrocketing promise, she had made an important film with a major director. The respect she so longed for was at hand. LIFE magazine had exclusive coverage for one

of their "LIFE Goes to a Party" features, and the guest list was stupendous— the Zanucks, the Goldwyns, the Warners, Gary Cooper, Humphrey Bogart and Lauren Bacall, Groucho Marx, George Burns and Gracie Allen, Susan Hayward, Loretta Young, and dozens of other big names all showed up to check out Marilyn. It was the first time Marilyn and Clark Gable had met, and LIFE wrote that the King had danced with the new princess of Hollywood. She even asked for his autograph. When they got up to dance, I borrowed Sam Shaw's camera and snapped this fleeting moment of mutual admiration. Seven years later the friendly smiles faded when Marilyn proved to be at her most neurotic while making *The Misfits*, for both a tragic ending to their careers and lives.

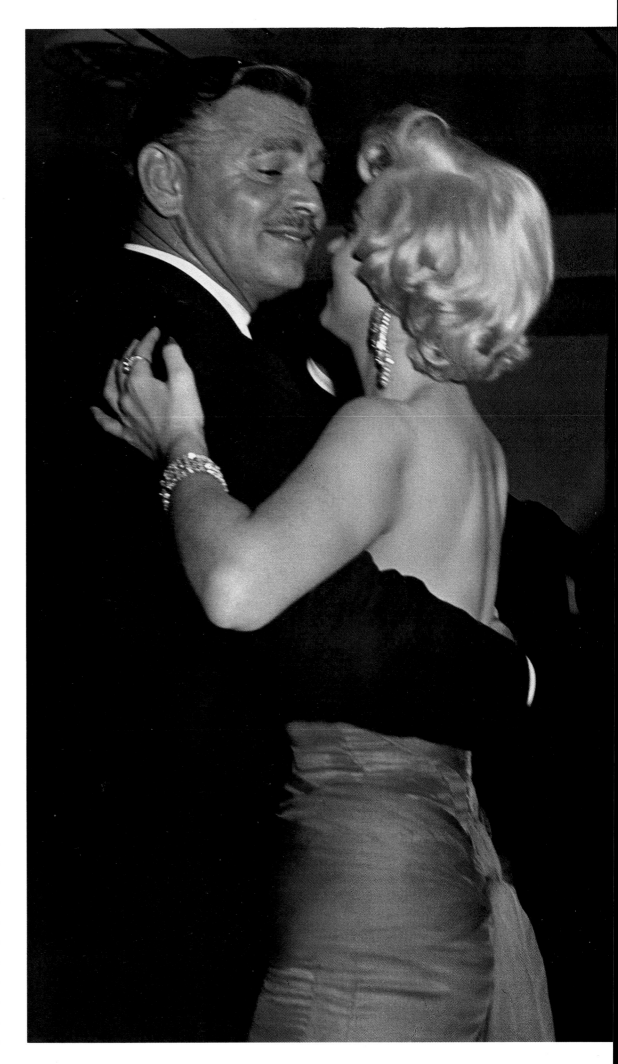

In the 1950s we had no hybrid like *bicoastal* to describe the life-styles of entertainment figures, socialites, and tycoons who lived and played on both coasts. Cole Porter was a good example; in warm weather he was at home in Brentwood, California, and he wintered in the Waldorf Towers off Park Avenue in New York City, when he wasn't gadding about the world. Of course in that prejet era, it took three or four days to travel by train from the Atlantic to the Pacific.

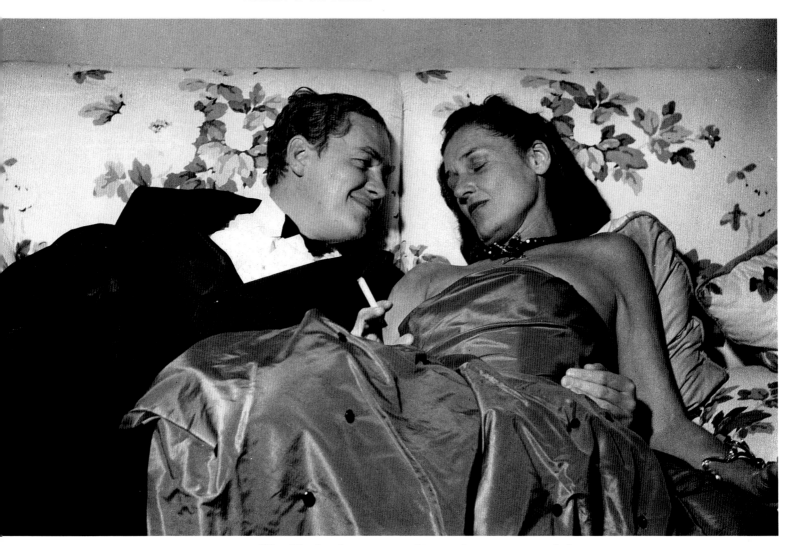

The Charles Amorys were bicoastal prototypes, and they entertained sumptuously in New York and Beverly Hills. Above: At one of his own intimate parties, given in 1952, Charles is laid-back, to say the least, and slouching in tandem is Dorothy Earle, another first-class bicoastal. Opposite, clockwise from above: Chessie Amory, Iva Patcévitch, Rocky Cooper, and Joan Fontaine. Agent Paul MacNamara, Celeste Holm, and director Ralph Nelson, who was Celeste's third husband. Iva with Charlie Feldman, Charles Amory, and Rocky

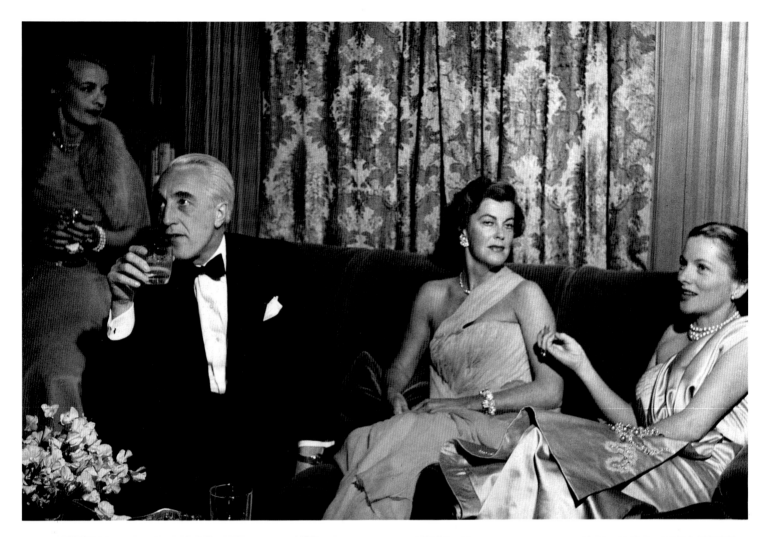
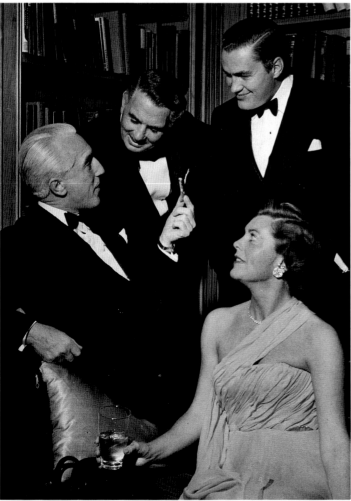
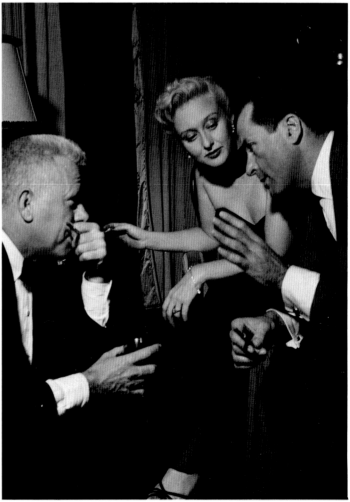

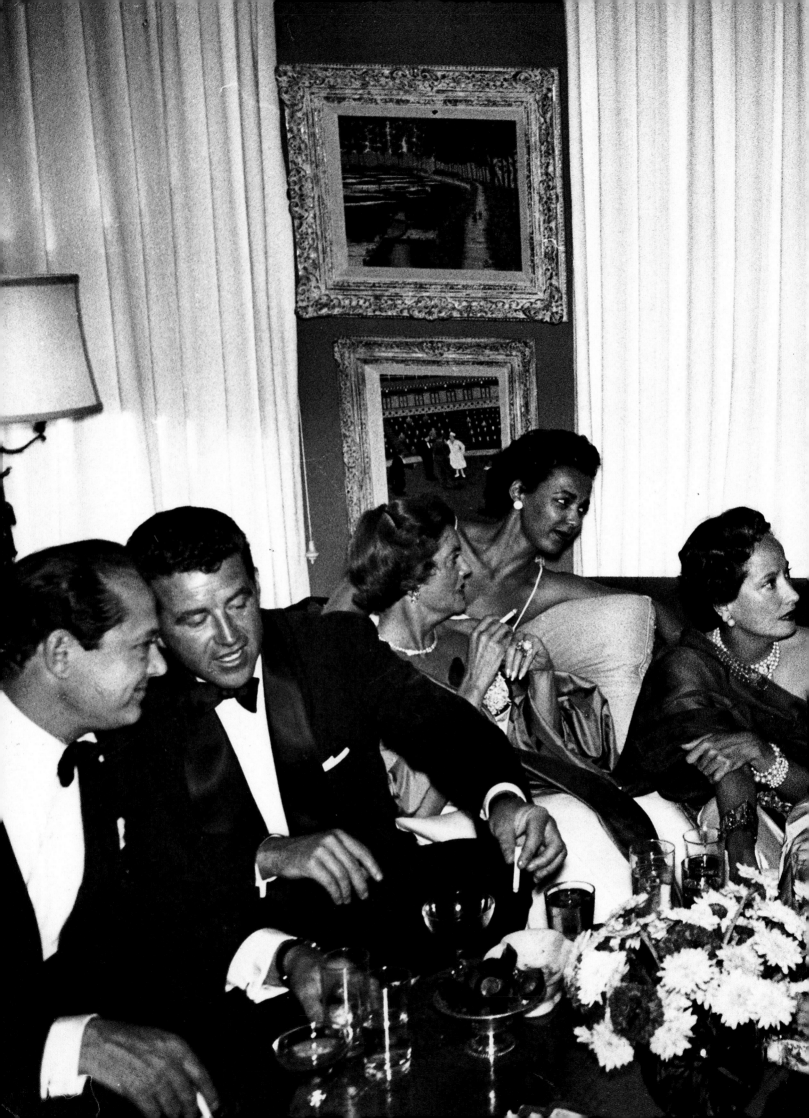

"Not only was the Charlie Feldman surprise party the nicest given in a long time but it was the best attended. Fannie Brice did her Baby Snooks number and was a riot, Marlene Dietrich gave out with three songs, Dick Powell did his best crooning too, and Elsa Maxwell, so excited about doing her first movie, is really thinner. Darryl Zanuck walked in and told her no dieting allowed. He wants her plumpish. Everybody was there, including Claudette Colbert and Miriam Hopkins with her new husband, Anatole Litvak. Those who didn't play cards danced until the wee hours."

That was Louella Parsons gushing in her *Los Angeles Examiner* column in 1939 about the first big party that Charlie and I gave. I've kept the clipping all these years, but now maybe it's more history than souvenir. We tossed our share of parties, and how I wish I had snapped away at each of them— rarely did anyone object! I had my cameras handy for one choice party to remember, the night of May 16, 1953, a celebration for Cole Porter. Left to right are Sid Luft, Judy Garland's third husband and producer of her greatest film, A *Star Is Born;* agent Peter Sabiston; Rocky Cooper; Dorothy Dandridge; Merle Oberon; Judy; and Cole, our guest of honor.

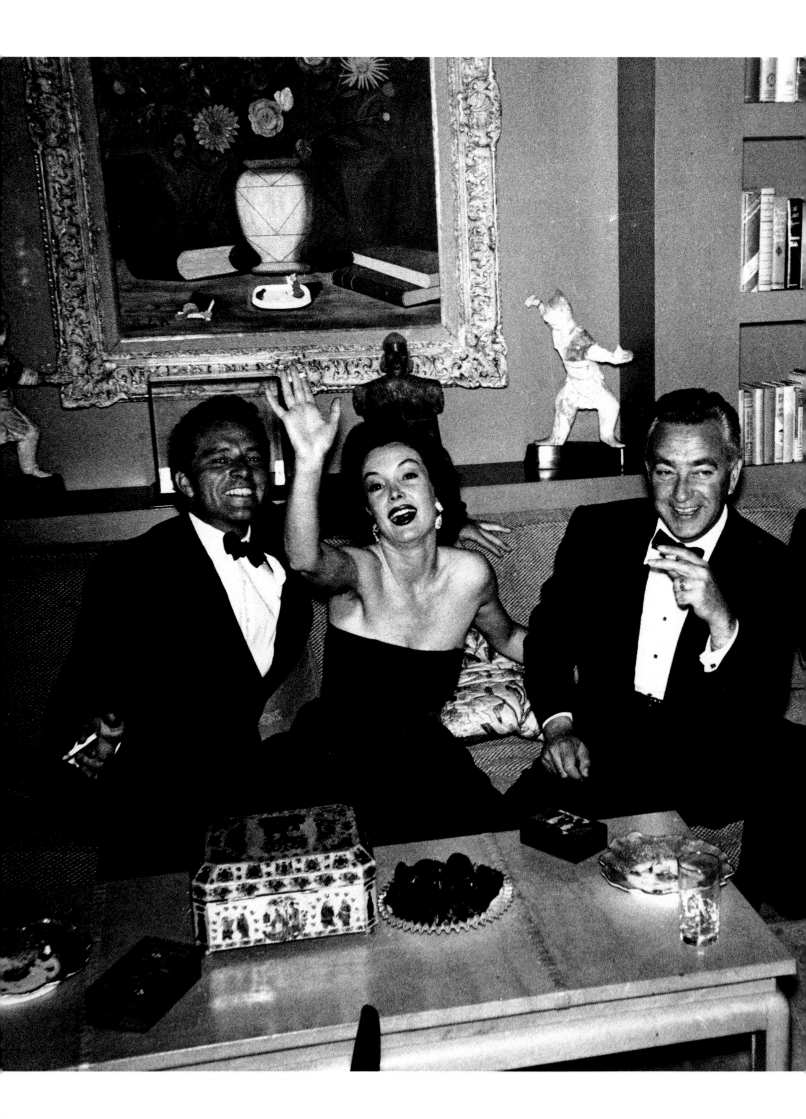

Having said that objections to my picture snapping were very few, I do recall an incident at our Cole Porter party. Richard Burton was a kisser, and the more he drank the more he kissed everybody in sight, and right on the mouth. <u>Below</u>: Clifton Webb resists Richard's show of affection, but eventually he lost the struggle. The next day Clifton phoned and asked to see the contact sheets. He

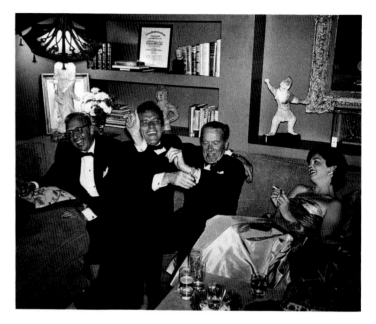

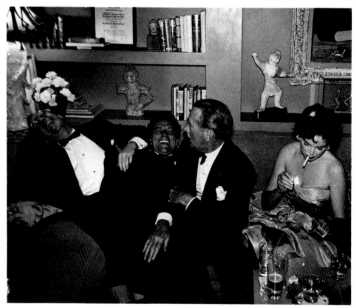

was horrified and asked that the negatives be destroyed. I never had a paparazzi mentality, and I gave in to my friend. Only the struggle survives. Producer Ray Stark gets a kick out of the fun, but Dawn Addams, blasé as only a starlet can be, lights up. <u>Opposite</u>: Richard, Audrey (Mrs. Billy) Wilder, and directors Charles Vidor and Billy Wilder

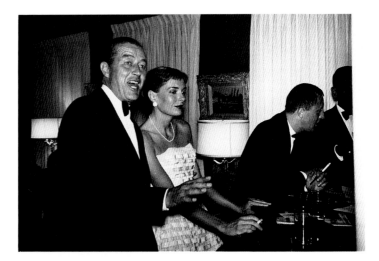

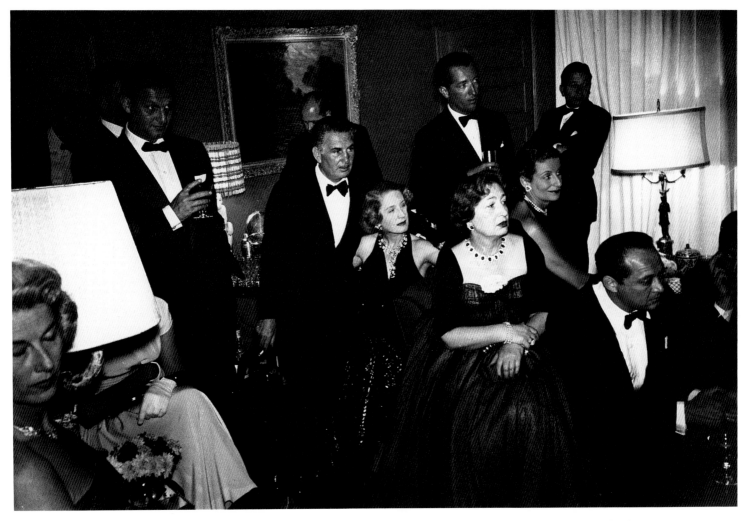

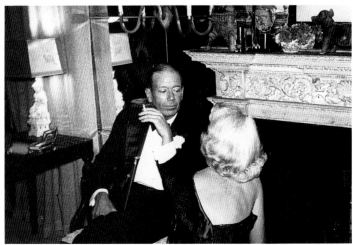

No party is a party without a piano, and ours always got a
workout from the best. The guests are about to be
enthralled by MGM's musical maven, Roger Edens.
Opposite, above: Ray Milland, Doe (Mrs. Richard)
Avedon, playwright Leonard Gershe, and Moss Hart.
Opposite, middle (left to right): Muriel (Mrs. Ray)
Milland, Cy Howard, Charlie Feldman, Norma Shearer,
Minna Wallis, Norma's husband Marty Arrougé (behind
Minna), Fran (Mrs. Ray) Stark, and Sid Luft (foreground).
The scheduled entertainer, who was replaced by Roger,
waits near the window for the show to begin. Opposite,
below: Cole Porter has a quiet chat with Jeanne Martin.

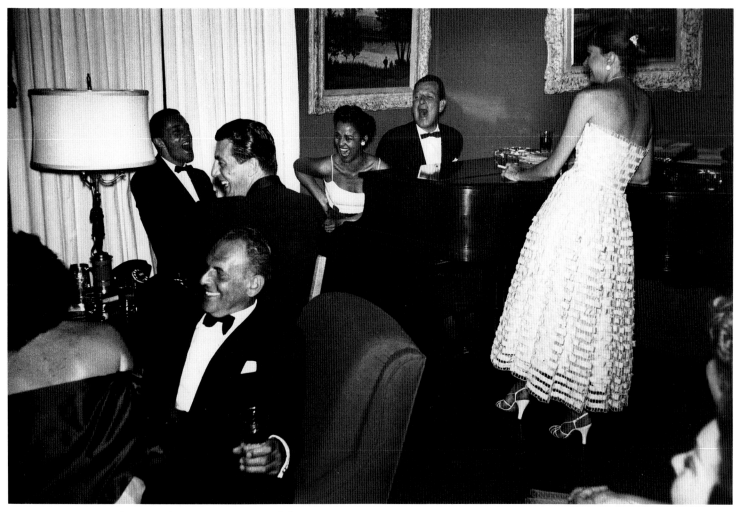

Above: Roger Edens (at the piano) is one of the unsung
musical heroes of Hollywood. Roger got his first break in
the early 1930s as a vocal arranger and accompanist for
Ethel Merman. Later he moved to MGM, where he was
associated with producer Arthur Freed as composer, arrang-
er, and, finally, producer. His final chore was coaching
Katharine Hepburn for her Broadway musical debut in
Coco. Without doubt, with his musical knowledge and
enormous talent, he helped shape the American movie
musical. Enjoying the show are Moss Hart (foreground),
Fred de Cordova (behind Moss), Leonard Gershe, Dorothy
Dandridge, and Doe Avedon.

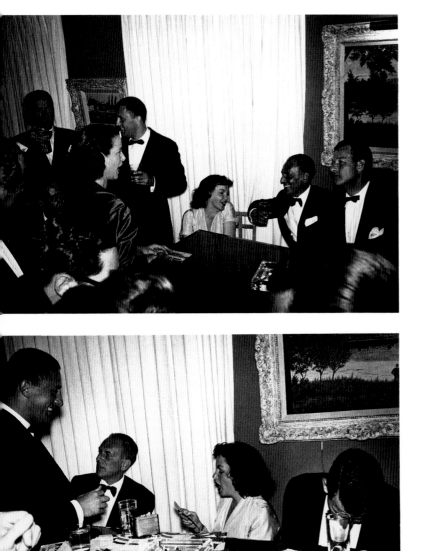

Above left: Cole (seated), Clifton Webb and Leonard Gershe (standing), Kitty Carlisle Hart, Judy Garland, Moss, and Roger. Below left: Leonard, Moss, Judy, and Roger. Moss had written the new version of *A Star Is Born* for Judy and her husband Sid Luft. It might have been an ordeal to make since Judy was at her most fragile, but what a memorable outcome. Opposite: Judy didn't really attend that many parties, but when she did, watch out. After a certain point in the evening she would burst forth with song. At our Cole Porter bash Judy even got some high-class help; Richard Burton liked to sing almost as much as he liked to kiss. From left are Lenore Cotten, Moss Hart, Richard, Judy, and Roger (head lowered at piano).

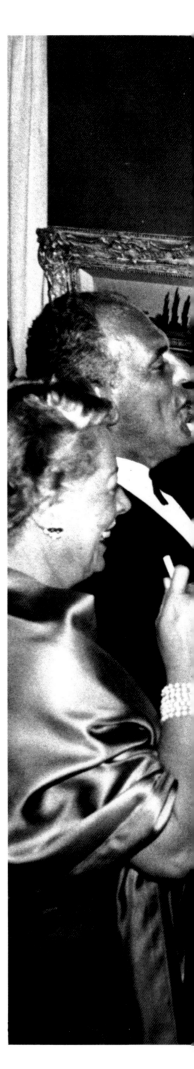

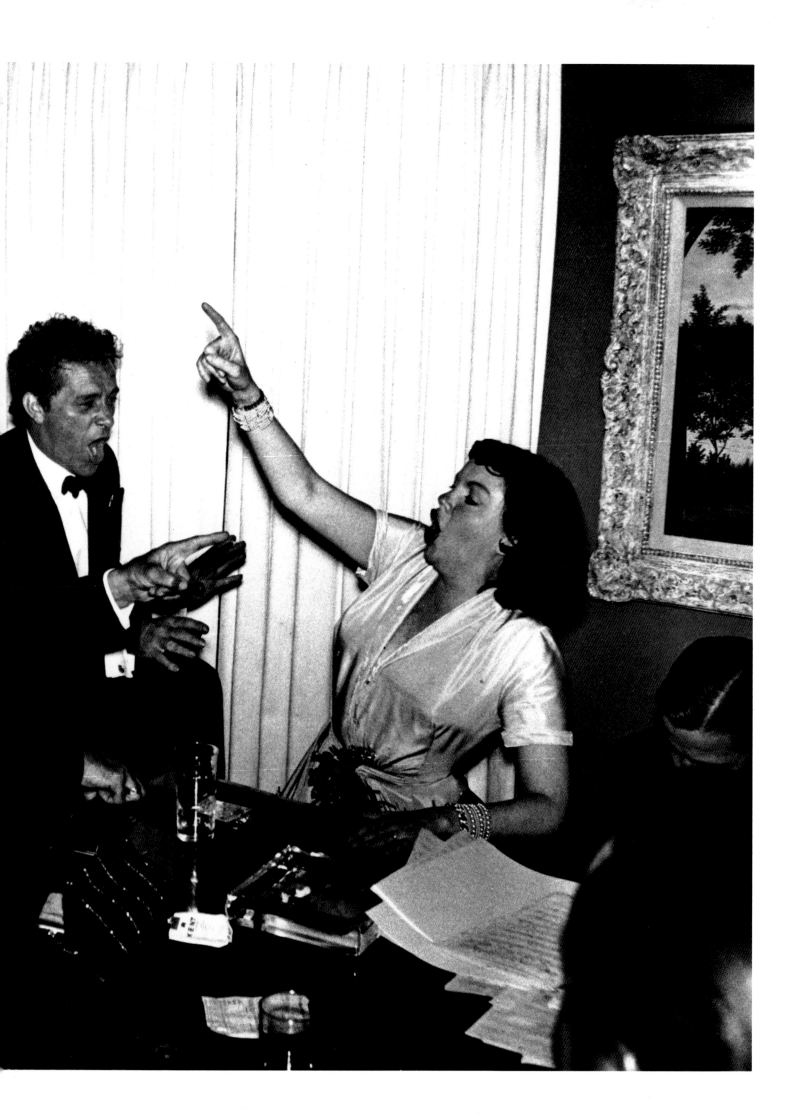

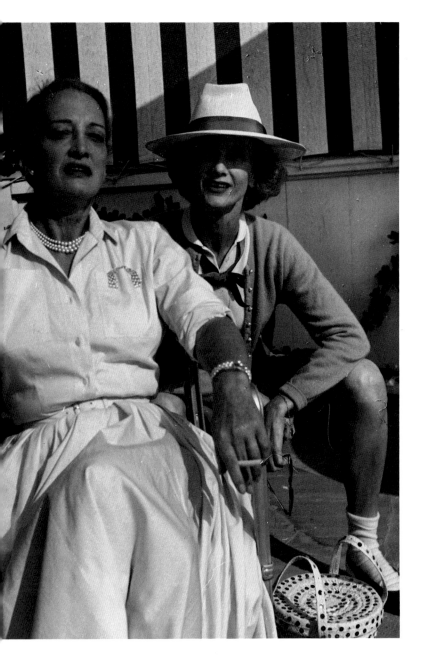

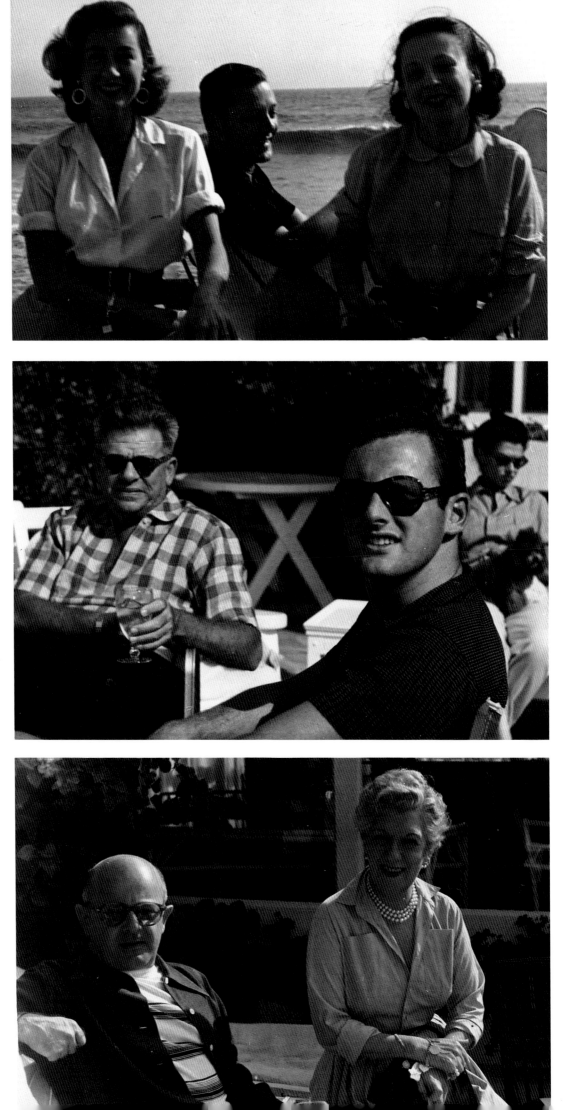

It took a dozen years for the great Rodgers and Hammerstein musical *Oklahoma!* to be turned into a movie, and when it was finally made, in 1955, they filmed it in Kansas because Kansas looked more like Oklahoma than Oklahoma did. Arthur Hornblow, Jr., was the producer. At their beach house in Santa Monica, he and his wife hosted a luncheon for the visiting Oscar and Dorothy Hammerstein. Opposite, from left: Dorothy Hammerstein, a woman of classic style, with Frances Goldwyn. Our hostess, Lenora Hornblow. Right, from top: Jeanne Vanderbilt (left) with Luke and Dolly Davis. Oscar Hammerstein and Samuel Goldwyn, Jr., with Lenora in the background. Irving Lazar and Ruby Schinasi, Lenora's mother.

We had been divorced almost eight years but you would never know it from this loving shot of Charlie Feldman and me at the Palace Hotel in Saint Moritz, Switzerland, taken Christmas 1953. Our friendship endured even if the marriage did not. We often met in Europe and continued to enjoy the world together with our mutual friends. I made this photograph with the aid of a tripod and a timed-release shutter.

During the winter season, many of our friends headed for Switzerland. I love this cold, clear, spectacularly beautiful land, but I never took to skiing. I left the downhill

racing to my athletic chums. When they came off the slopes I was happy to photograph them. Above right: I took this shot of Lord Warwick in Saint Moritz in 1955. Opposite, above left: In February 1955 the Stanley Mortimers hosted a party for Stavros Niarchos and his wife, Eugenie, at the Palace Hotel in Saint Moritz. Opposite, below left: Paulette Goddard, with Niarchos, came over the mountain from Locarno, where she had been visiting Erich Maria Remarque. A couple of years later, she and Remarque were married. Opposite, right: Gregory Peck takes a break from skiing in Saint Moritz.

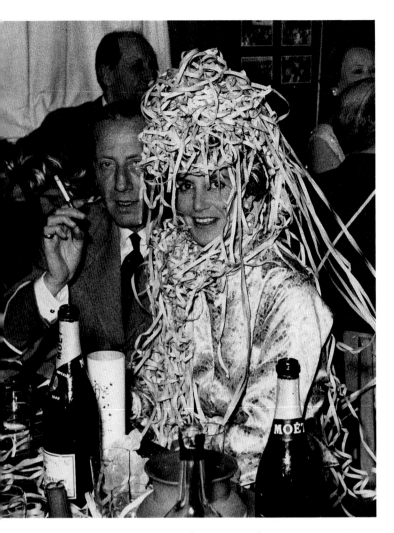

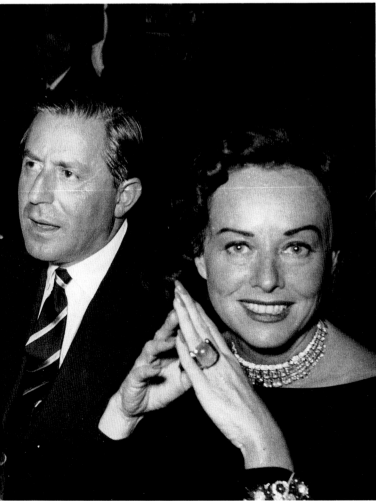

Switzerland

Opposite: My friend Cole Porter at Saint Moritz in 1955. With him are Contessa "Tookie" De Zappola and Christos Bellos (far left). It was at the Contessa's home that Cole took his morning horseback ride and had his tragic accident—breaking both legs—from which he never recovered.

Director Howard Hawks (below right) always said he made his own luck. When he was having problems on an Egyptian epic, *The Land of the Pharaohs* (which has a cult following thirty-five years later), he called William Faulkner (below left) for some script doctoring. Faulkner had helped Howard before, most memorably with dialogue for

Bogart and Bacall in *To Have and Have Not*.

I took this photograph of Faulkner at Saint Moritz on Christmas Eve. In my notes from that day I wrote: "Went for a long walk with Faulkner today. He talked about his latest book coming out next fall—says he thinks it's the best work of his life. It took him ten years to write. He got the idea from the tomb of the Unknown Soldier in Paris." *A Fable*, published in 1954, won the 1955 Pulitzer Prize for Fiction. In the same notebook I recorded my impression of Faulkner during our walk: "a fury boiling inside, but the eyes are gentle."

Terence Rattigan created a melancholy portrait of a woman on the verge of mental collapse in his play *The Deep Blue Sea*. As a stage vehicle for Peggy Ashcroft and Margaret Sullavan, it was moving and tender. Who better to bring such fragility to the screen in 1955 than Vivien Leigh, in her first film role since her Oscar-winning performance as Blanche DuBois in *A Streetcar Named Desire*. In many ways, she was perhaps too close in real life to Rattigan's depressed character. The package should

have been foolproof, with Anatole Litvak putting Vivien through such filmic agony; his reputation was second only to George Cukor as a woman's director. Sadly, the movie turned out poorly. Tola had only one more box-office success *(Anastasia)* to his credit before his career ended. Vivien made only two more films, and we lost her when she was only fifty-three. Opposite: Tola sets up a scene with costar Kenneth More, but he and that sly Vivien have their eyes on me. Above: The star and her director take a break on location in Klosters, Switzerland.

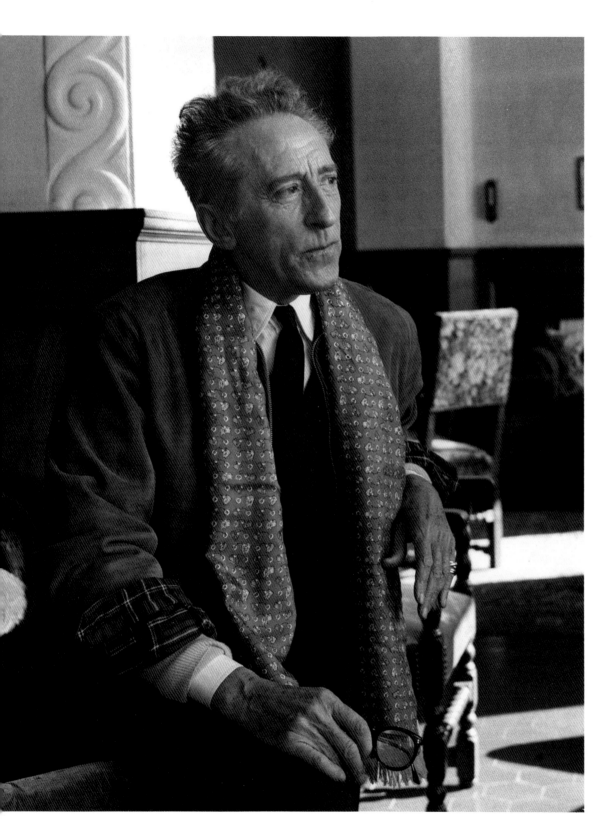

Jean Cocteau was a mercurial master of poetry, playwrighting, filmmaking, painting, and drawing. He spoke little English, and we communicated mostly in sign language. Opposite: When I photographed him in 1956, he wanted to be photographed at, of all places, Friedrich Nietzsche's house in Sils-Maria, Switzerland. Cocteau had recently been elected to the ultraconservative Académie Française, an extraordinary endorsement for this wiry character who indulged himself in the waterfront bars of Toulon, France, smoked opium, and resided in Paris at the Palais Royal near other iconoclasts such as Colette. If Nietzsche was a philosopher of paradox, then Cocteau was his living testament. He gave narcissism a good name. Left: Cocteau at the Palace Hotel in Saint Moritz

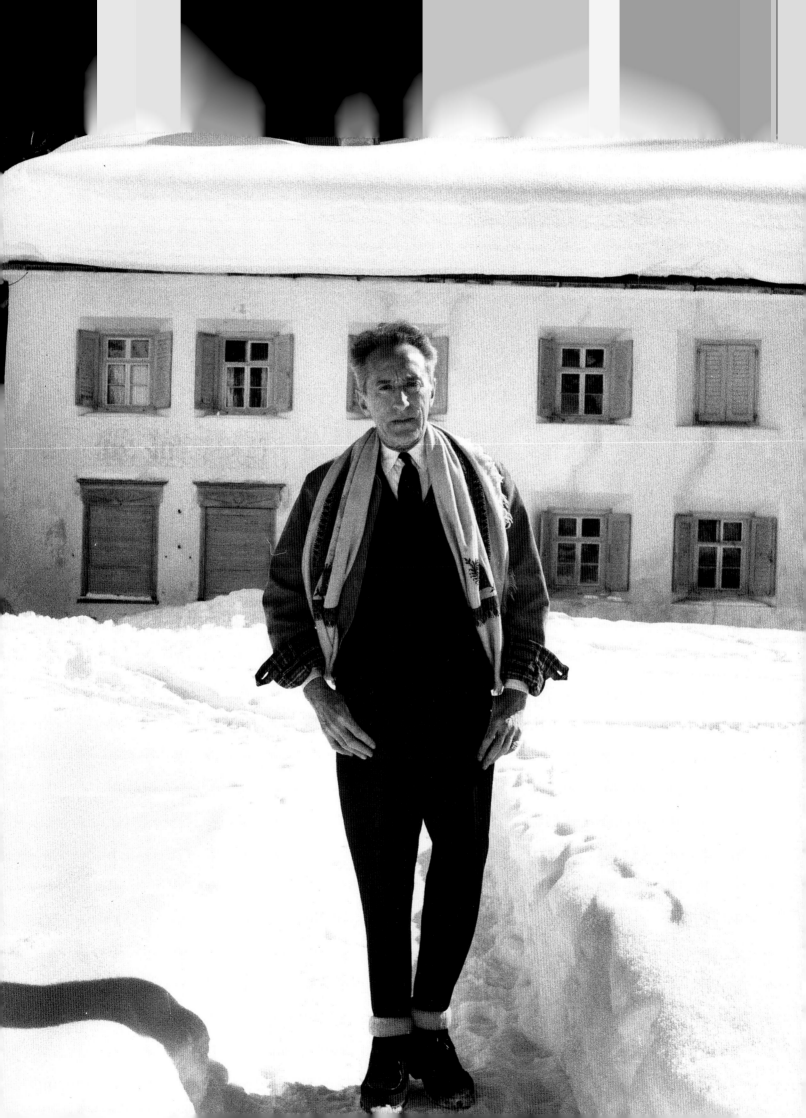

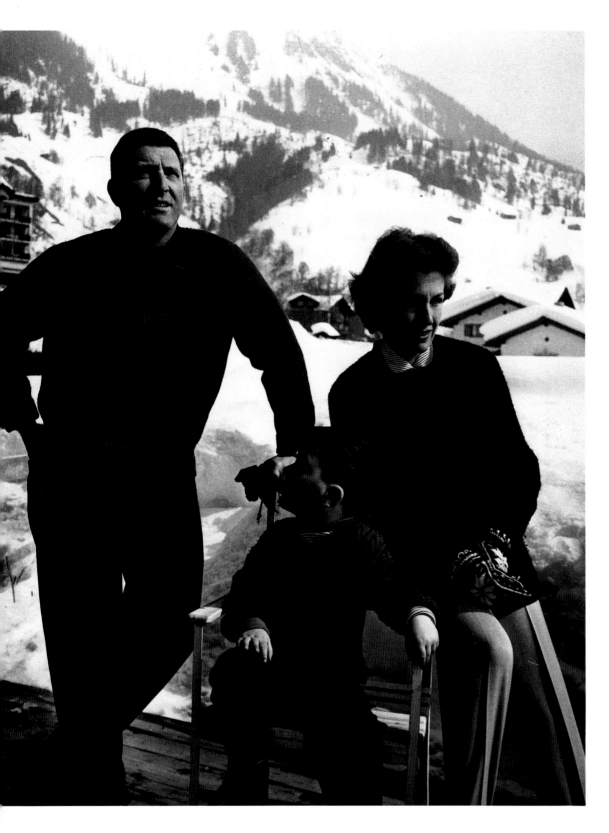

Irwin Shaw was the most ruggedly handsome writer of his time. I photographed him in 1955 on the ski slopes at Klosters with his wife, Marian, and their son, Adam. His virility was combined with versatility. Playwright, short-story-teller, novelist, and film scenarist, Irwin was superb and popular.

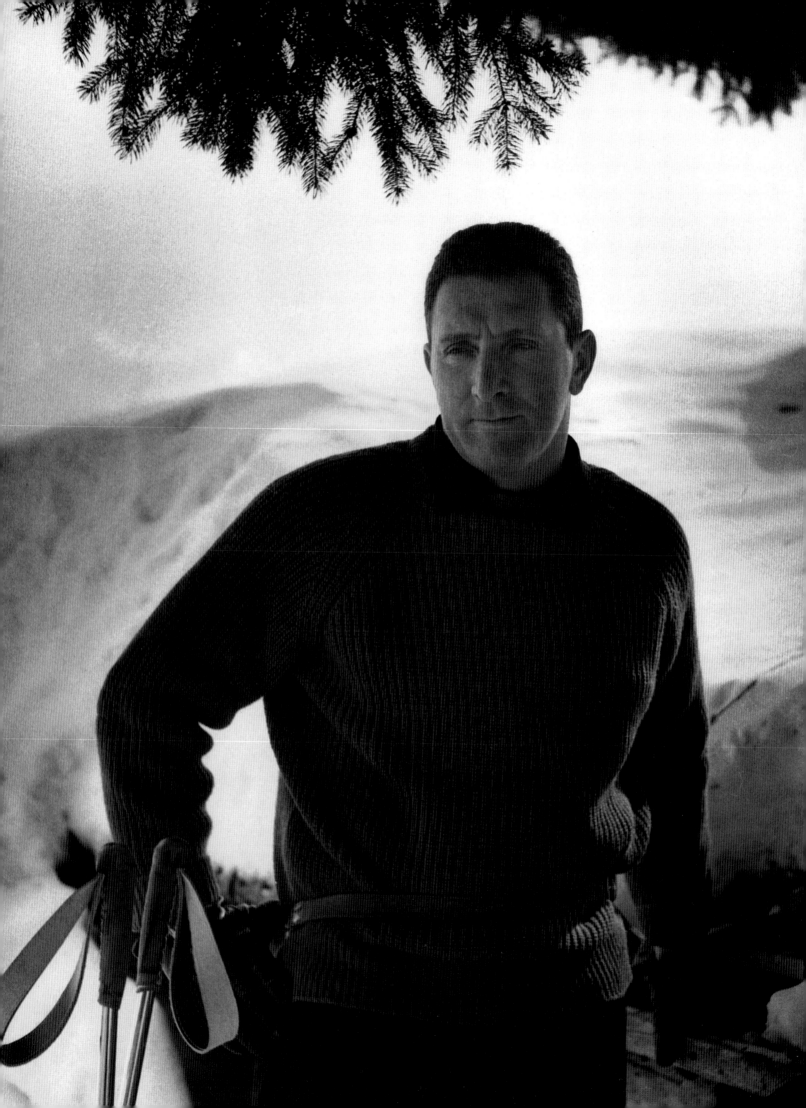

Below: Oh, to be a fly on the wall at this gathering in Montecatini, Italy, when a young Audrey Hepburn was on the brink of changing how we all looked and talked. I believe the date was 1951; the place was definitely the Hotel La Pace. Anita Loos, who was a powerhouse in miniature, had discovered Audrey for her stage adaptation of Colette's *Gigi*. Actually, the grande dame of French letters herself discovered Audrey and cabled Anita, "I have our Gigi." It worked out magically. Audrey wowed the Broadway critics and director William Wyler cast her in *Roman Holiday*. Left to right: Audrey, Le Compte de Ulun, Virginia Chambers, Howard Sturges, Anita, and Lady Sefton.

Opposite: Avram Godenbogen, Minneapolis's testament to twentieth-century hype, became Mike Todd, showman

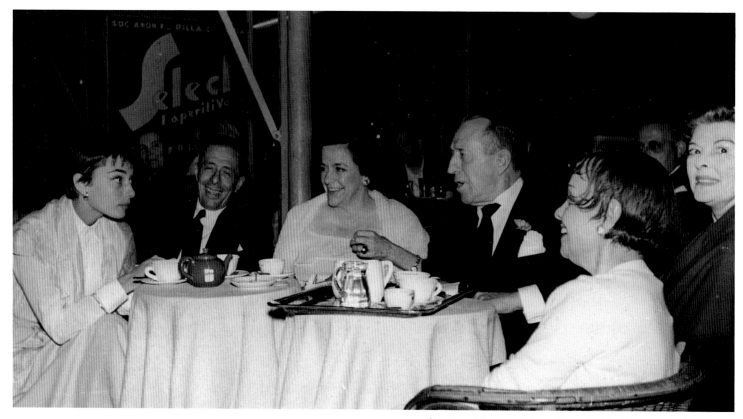

extraordinaire. He saw himself as P. T. Barnum reborn. Mike would brag: "A producer is a guy who puts on shows he likes. A showman is a guy who puts on shows he thinks the public likes." *The New Yorker* wrote that he was "half-smart to everything," and critic George Jean Nathan, a Todd fan, said, "He's an Oxford man posing as a mug." Mike's own assessment of himself: "There are no geniuses around today. If there were, I'd be self-conscious." Here in Venice in 1954, he was scouting locations for his pet project, *Around the World in 80 Days*, which won the Oscar for Best Picture in 1956. This blockbuster movie and his marriage to Elizabeth Taylor tamed some of his restless, irritable temperament. Mike was killed in a plane crash in 1958. He was only fifty-one.

Italy

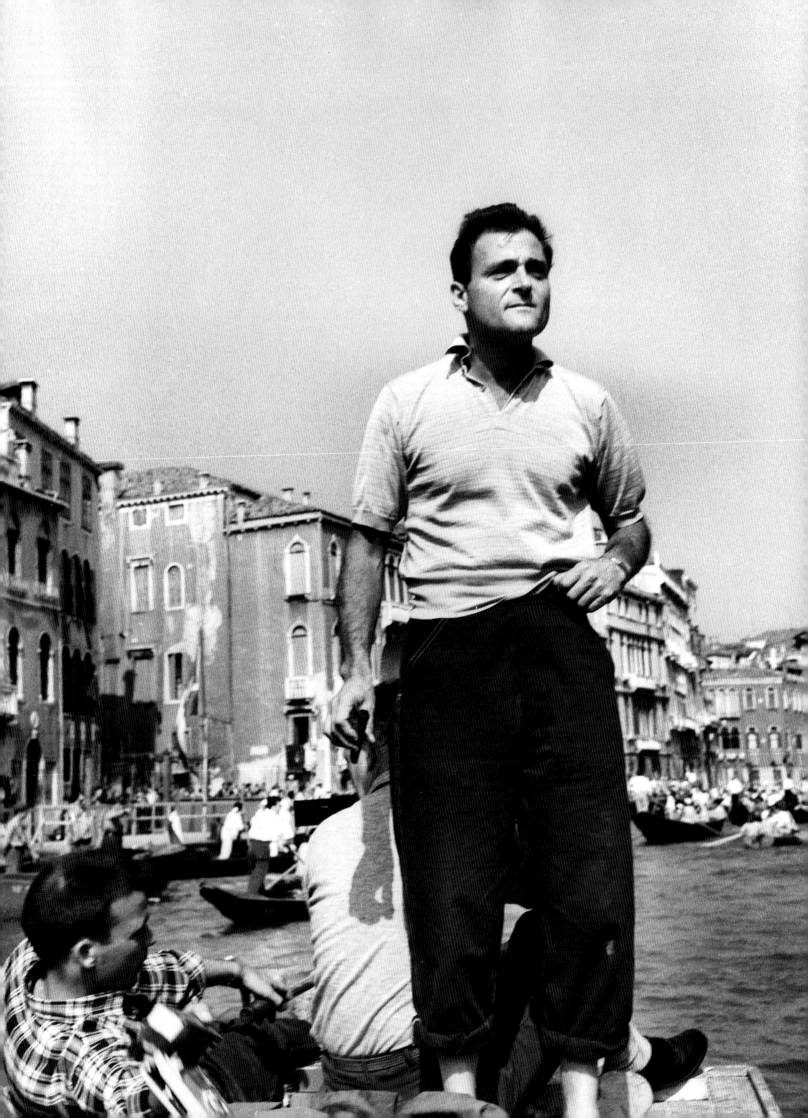

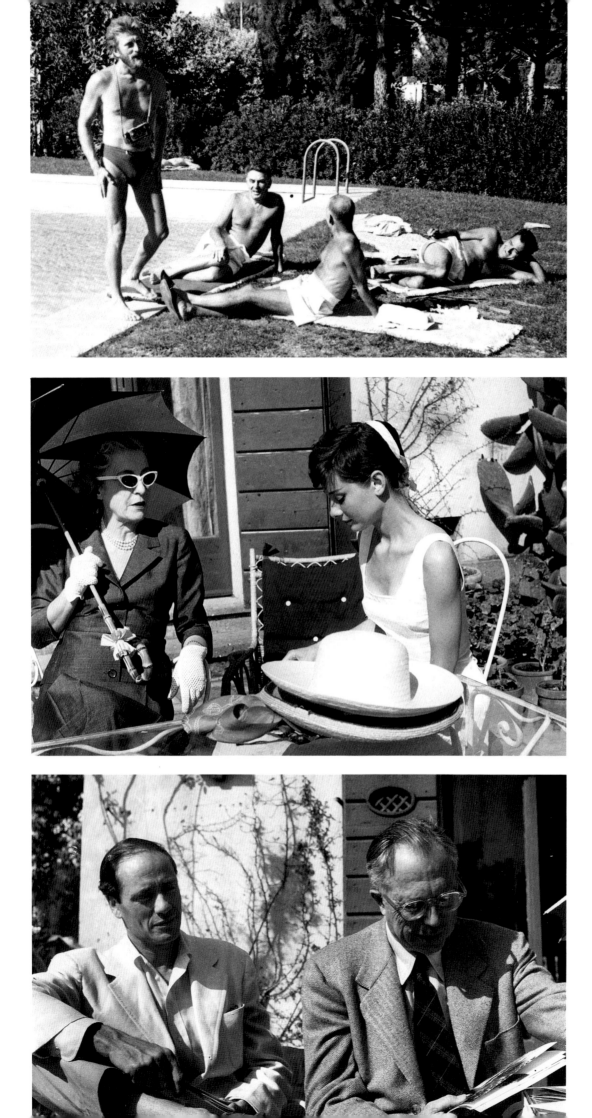

Hollywood travelers discovered Europe in the late 1940s; Hollywood filmmakers all but overran Italy within the next decade. No matter where I pointed my cameras, another famous face popped into view. Left, from top: Kirk Douglas sports a golden beard to play Homer's Everyman in the 1954 film *Ulysses*; Charlie Feldman reclines poolside. Outside Rome, Audrey Hepburn (right) and an unidentified friend relax in the sun; Hepburn and her husband, Mel Ferrer, were preparing to star together in *War and Peace*. Director King Vidor (right) does some script consulting with Mel for *War and Peace*. Vidor's 1956 film was magnificent to look at, but it would be impossible for any film to deal fully with the complexities of Tolstoy's novel.

Opposite, left: Charlie Feldman, in Antibes in 1955, discusses *War and Peace* with its producer, Dino de Laurentiis, a real wheeler-dealer who began as a salesman in his family's pasta place. On their right is French director René Clément, quizzically distracted. René's masterpiece, *Forbidden Games*, made him a hot commodity in the international movie market.

Opposite, right: Mexican enchantress Dolores Del Rio, in Madrid in 1955 with Edgar Neville, a rich Spaniard who

fancied himself a writer but who had more success at making friends with the famous. He was close to Charlie Chaplin. Dolores discovered the fountain of youth but never shared her secrets. All she would say was that she slept fourteen hours a day, which of course was not true. Unlike many of her beautiful

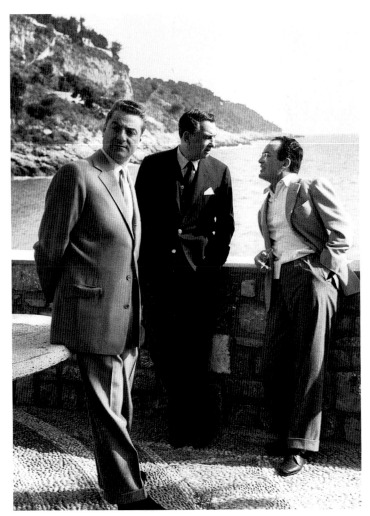

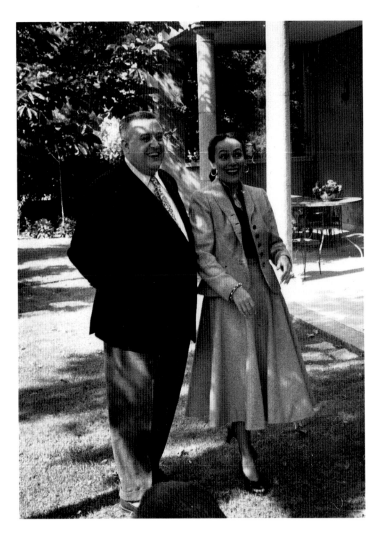

movie rivals, she was self-effacing to a fault. She didn't need constant adoration and assurances about her unique, mesmerizing looks. And when Dolores put aside the trappings of being a star and got into a realistic role, such as the aging Indian squaw in John Ford's *Cheyenne Autumn*, she was most beautiful of all.

South of France & Spain

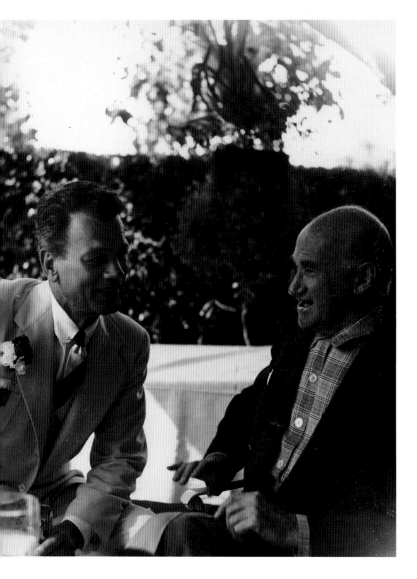

California

Whatta day! Huge powder-puff clouds slowly tumbled round in the blue sky above the Pacific Palisades. The good old red-white-and-blue flag gaily rippled in the gentle sea breezes, stretching its long, friendly arms out toward forever. There were women in white summer dresses galore, and the men also were in their summer whites and blue blazers. Tables were set with the finest linen, and the silverware was polished to such a shine that you could check your makeup on the reflection of a dinner knife. A marching brass band was dum, dum, dumming in the background, slightly muted.

It was the Fourth of July, 1955, and the Joseph Cottens, known for their Southern hospitality (Joe was from Virginia), gave one of the loveliest parties I ever had the pleasure of attending. Joe and Lenore were wonderful hosts, and it was a day to remember. Opposite, left: Joe with Sam Goldwyn, for whom he made *The Farmer's Daughter*. Opposite, right: Producer-writer Collier Young and Cole Porter. Collier (Collie to his friends) was another Southerner; he was Joan Fontaine's third husband at the time, and maybe it was Joan who labeled him a "perennial Peter Pan, a wit, and a wag." In her autobiography she complained he bought her frying pans rather than roses. Cole looks happy, and that day he really was. Right: Our host with his mint julep. After Lenore's death, I'm happy Joe found a good second marriage to beautiful Patricia Medina.

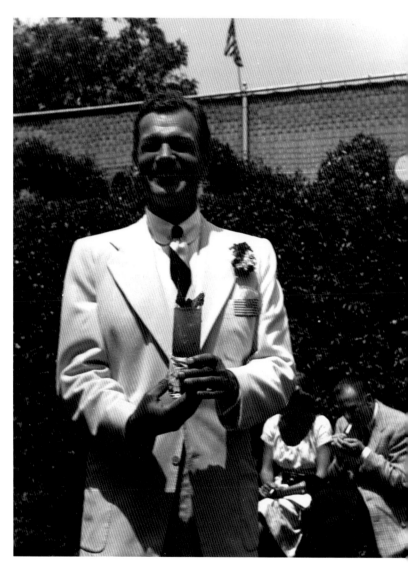

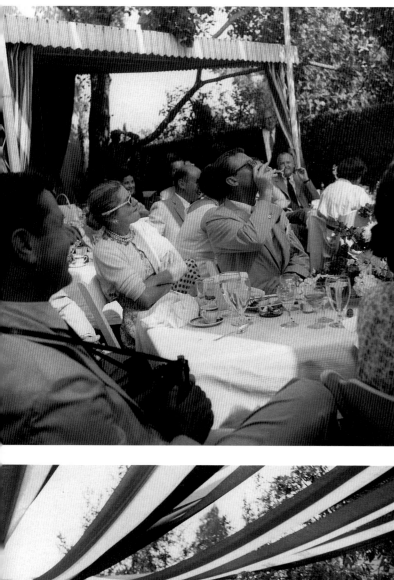

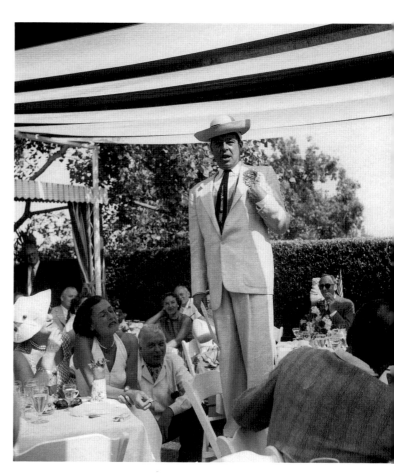

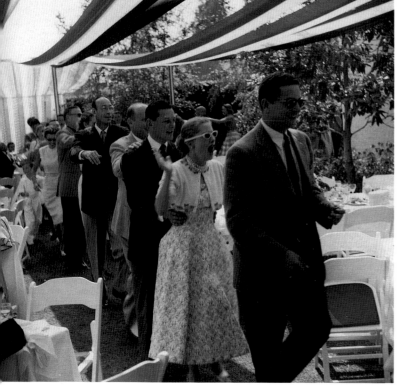

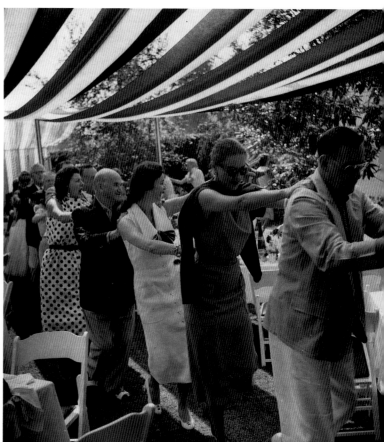

Legends on the lawn. Opposite, above: With Merle
Oberon, Henry Hathaway, and David O. Selznick in the
background, Joan Fontaine listens to her husband Collier
Young's toasts. Collie fancied himself a toastmaster, but
his wit was more juvenile than sophisticated. Dorothy
Earle (on Collier's right) wasn't amused. Opposite, below:
Usually a quiet type at parties, Jennifer Jones suddenly
stood up, walked to the middle of the crowd, and started
to march in and out of the tables. Her actions were conta-
gious. Jennifer became the Pied Piper that afternoon, and
she led the guests straight down the garden path to the

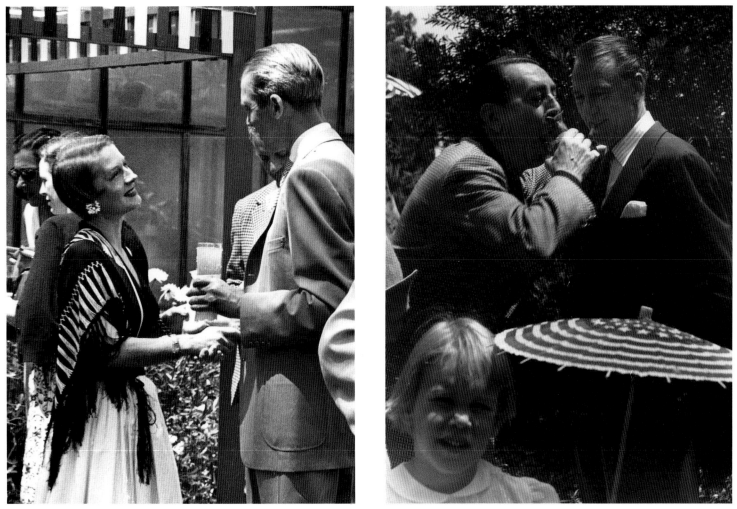

swimming pool, white linen dresses and all. Jeffrey Selz-
nick leads Joan and Luke Davis (far left), while Sam
Goldwyn guides Slim Hawks, Jennifer, and John O'Hara.
The fact was that Jennifer had suffered a big disappoint-
ment that day. She had lost the part of the compassionate
coach's wife in the film version of *Tea and Sympathy* to
Deborah Kerr, who had created the role on Broadway and
was at the party.

Above left: Norma Shearer chats up James Stewart. Above
right: Reginald Gardiner distracts Gary Cooper. Lenore
Cotten's granddaughter is in the foreground.

Opposite: Jennifer Jones (far right) and a few of her fun-loving marchers, including Dawn (Mrs. Lou) Soles, jumped right in the pool fully clothed

while we all cheered. Dolly Davis shouts for more guests to take the plunge. Above: William Haines, the former silent star turned interior decorator, heeded her call.

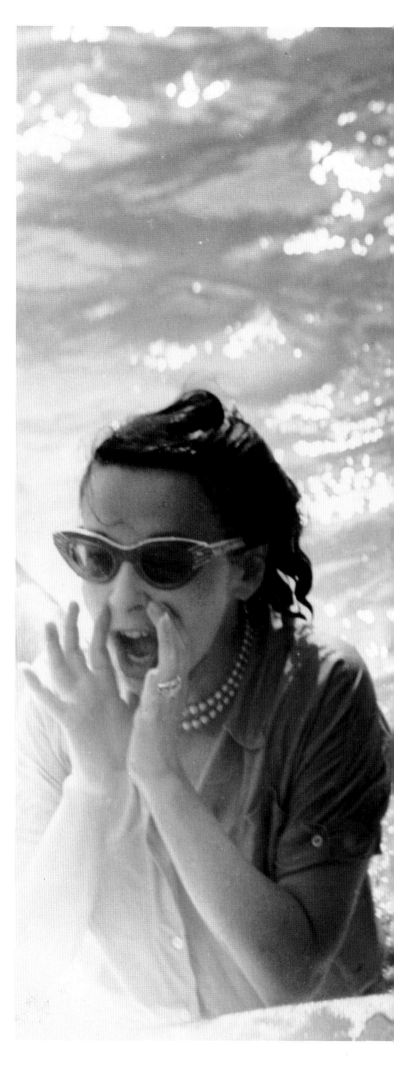

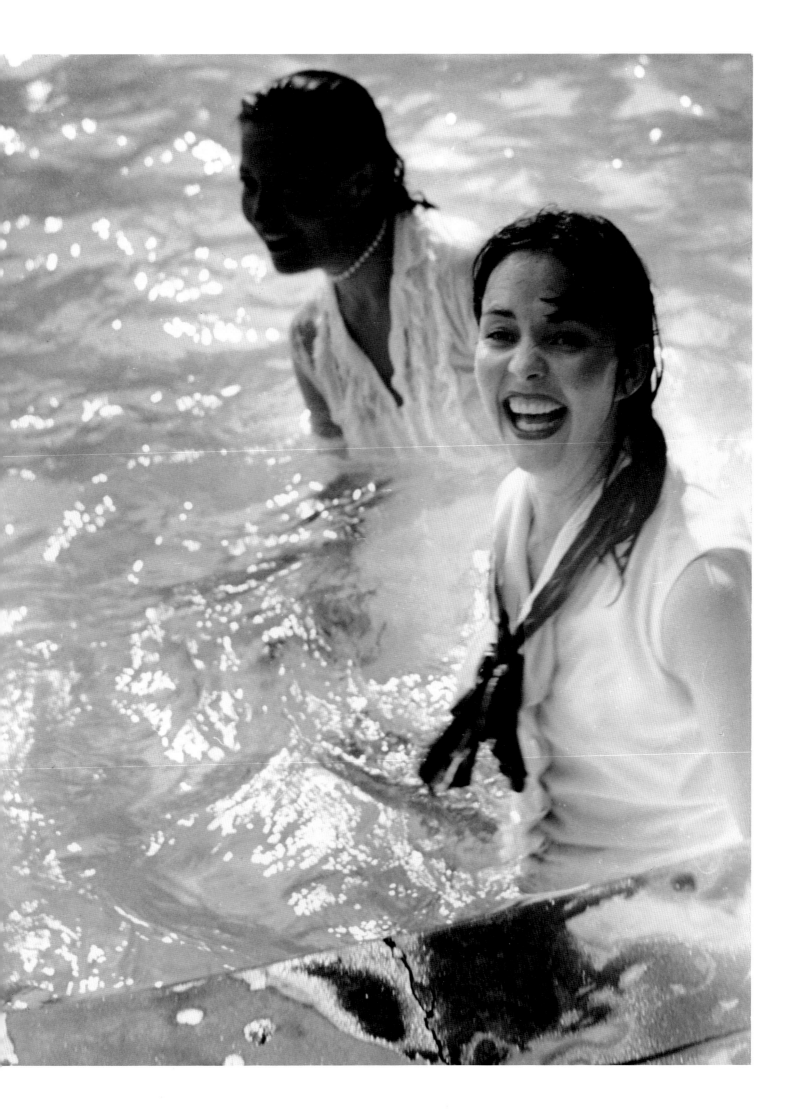

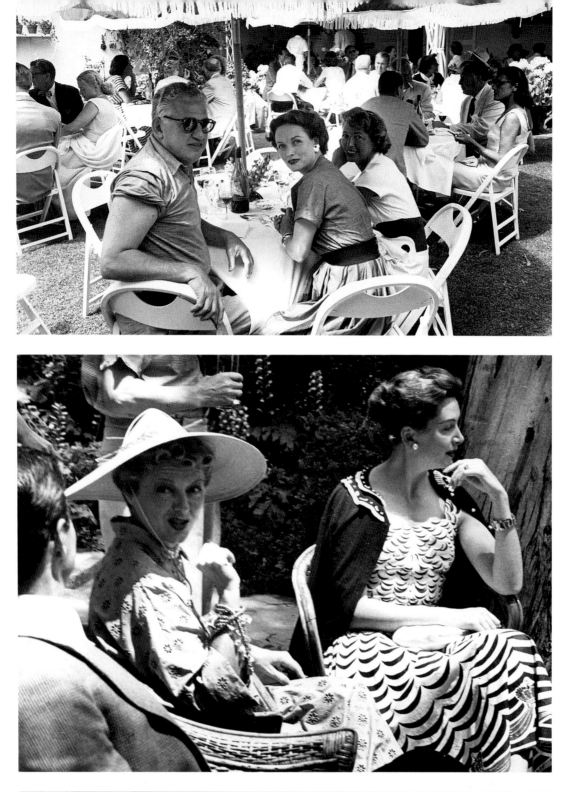

Left, from top: David O. Selznick, Nadia Gardiner, and Quique Jourdan. Janet Gaynor and Deborah Kerr. Another guest takes the camera as I enjoy lunch with Mary (the first Mrs. Otto) Preminger (foreground), Deborah, and Charlie Feldman. Opposite, clockwise from top left: Mr. and Mrs. John O'Hara. Billy Haines admires Virginia Zanuck, who really got into the spirit of things and wrapped herself in a flag. Billy with Skip Hathaway. Merle Oberon and Dr. Rex Ross, whom we thought she would marry

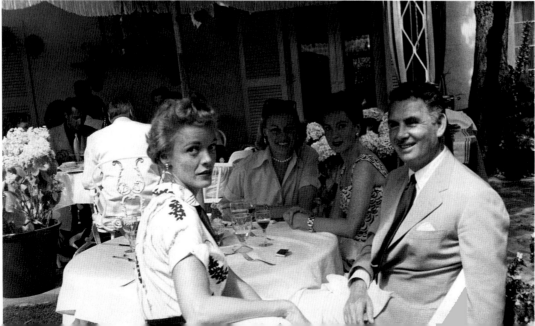

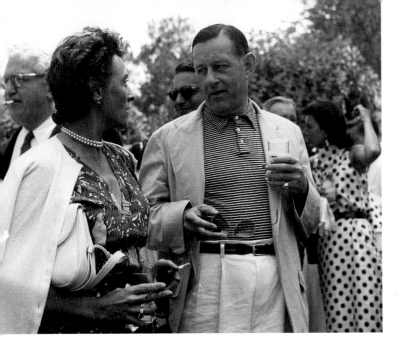

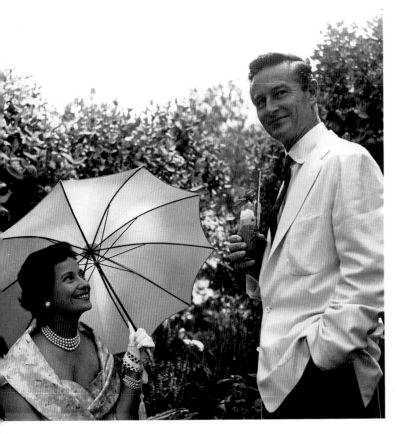

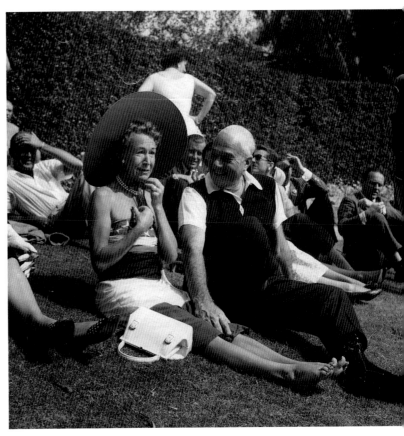

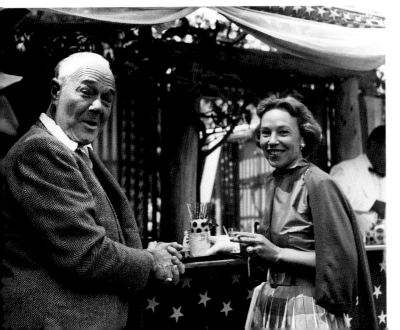

The guests congregated on the great lawn to watch the shenanigans going on in the Cottens' swimming pool. Someone even threw a chair into the pool (oppo-

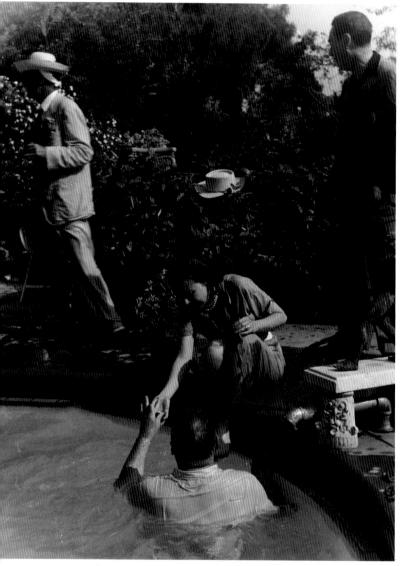

site) and tried to sit on it. Above: Henry Hathaway recovers Dolly Davis's earring, while a drenched Collier Young (left) makes his exit, still holding onto his fan.

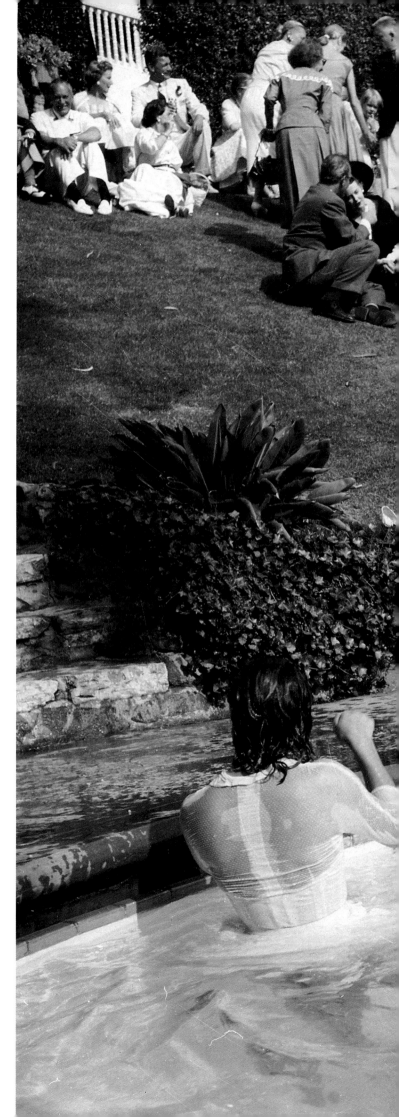

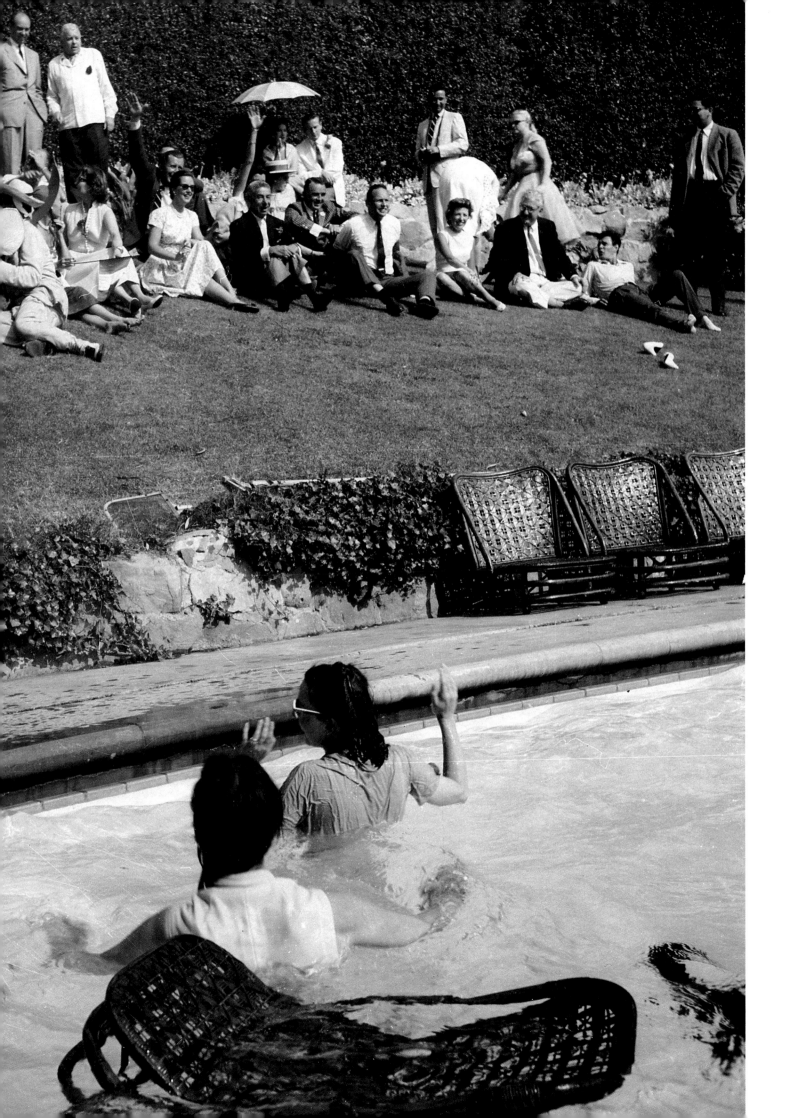

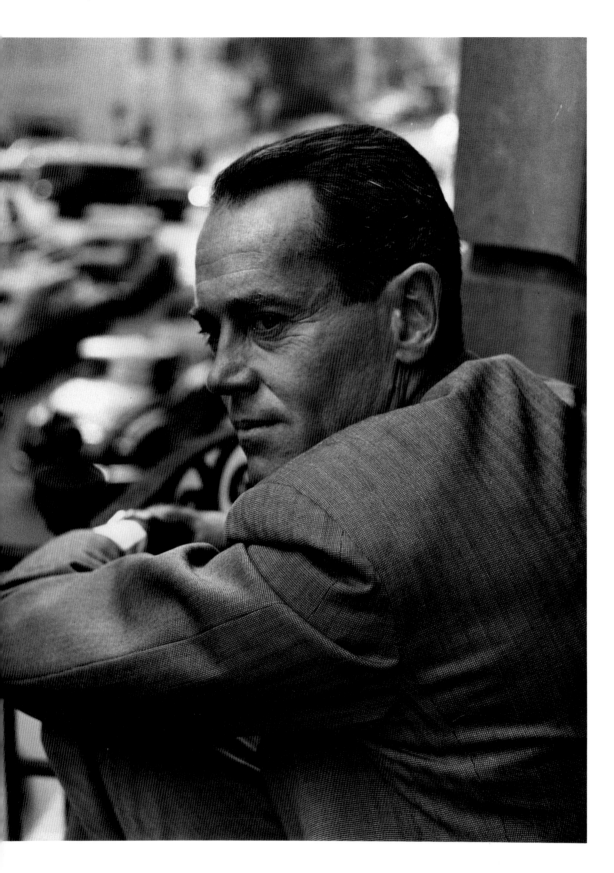

Henry Fonda was an invisible actor. I don't mean literally, but you never saw the machinery at work when Henry was in top form. In person, he sort of faded into the woodwork, which was his wont; he preferred painting to partying. When married to his fourth wife, Afdera, he would leave the theater still in the mood of his performance and find Afdera hosting a party in their New York townhouse. Their living room often teemed with dozens of guests he hardly knew and many not at all! This more than anything ended that marriage, but in his final years Henry had the ideal partner, his fifth wife, Shirlee Adams, who understood this gifted, moody man as no other, including his children.

Henry was undeniably attractive, and he had a haunting wistfulness about him that was most appealing.

At the request of producer Leland Hayward, I photographed Henry at my studio while he was doing *Point of No Return* on Broadway in the 1952–53 season. Leland liked the pictures enough to have them blown up life-size outside the Alvin Theater on Fifty-second Street.

New York City

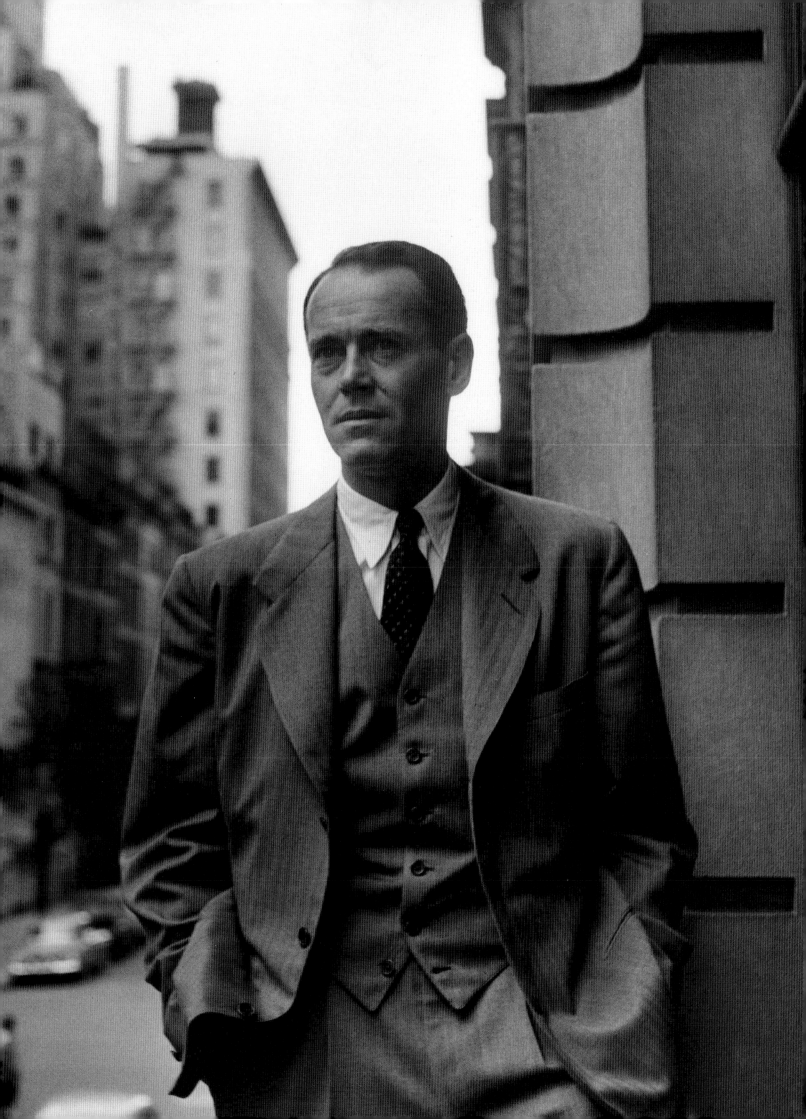

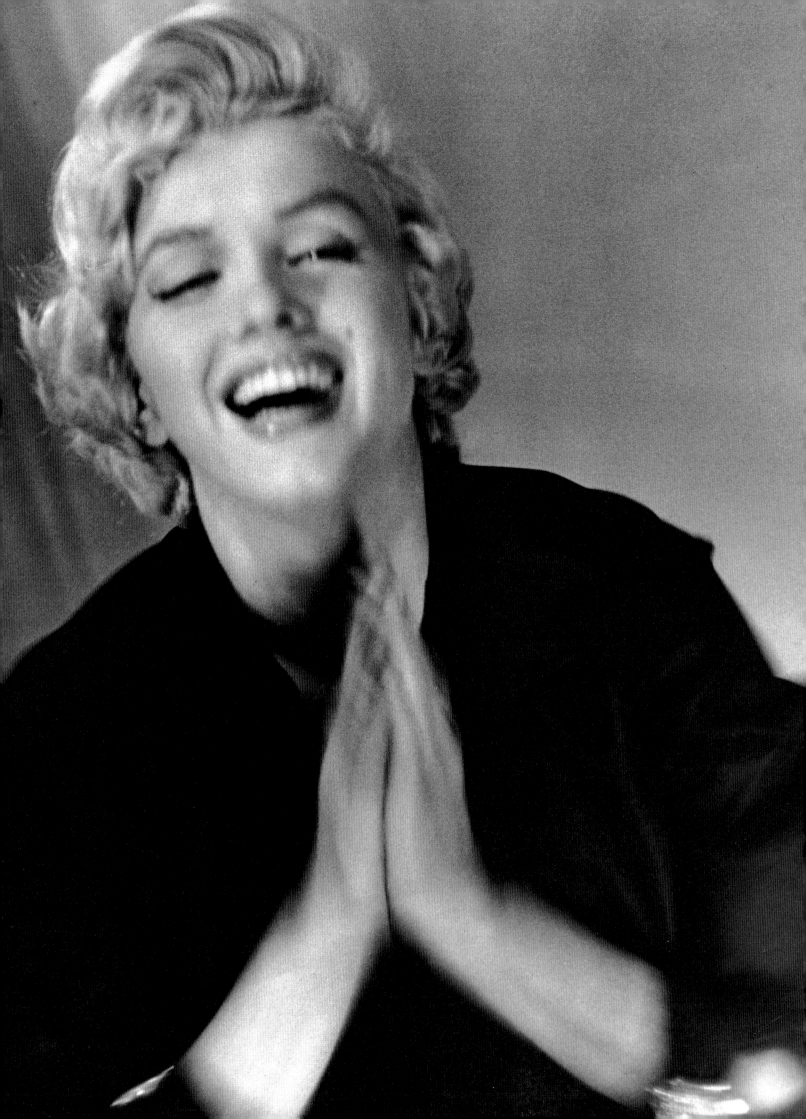

The first time I saw Marilyn Monroe was in my own garden in 1950. She had come to our house with Elia Kazan, who had a business meeting with Charlie Feldman. I was leaving for a lunch date when I spotted her, a lonely little girl sitting by the pool doing nothing. I asked if she would like something to drink. She softly refused and I went about my business. We met again in 1953 at the Fox studios, where she was making *Gentlemen Prefer Blondes* and *How to Marry a Millionaire*.

Several years later in New York, around 1957 or 1958, I asked her if she would come by my East Seventy-seventh-Street studio to sit for photographs. Marilyn willingly accepted. She arrived an hour and a half late. I had just about given up and started to take down the lights when she rushed in, breathless. Once we got going, Marilyn was as cooperative as any person I have ever photographed.

First she eyed the birdcage that Tony Duquette had given me and simply found her own pose (right). But this was not exactly what I had wanted. Although Marilyn had brought along that little tight-fitting, almost strapless black dress she called her "lucky dress," I wanted to get away from the stereotyped, sexy shot that I had seen so often. We looked in my closet and came out with my favorite Hattie Carnegie black taffeta jacket. In the

photograph that followed (opposite), I found the true spirit and soul of that beautiful, gifted girl.

Some time later, at a party at Gloria Vanderbilt's,

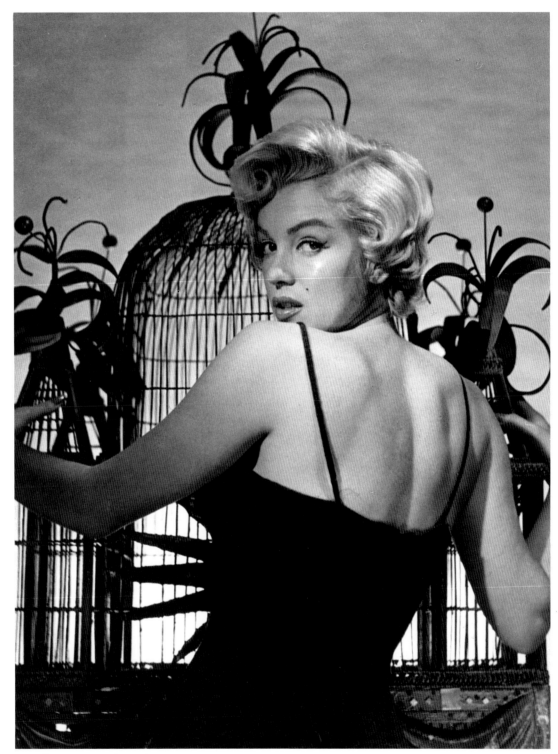

Marilyn appeared. In her sweet, soft way, she said something that startled me and I'm certain the others: "Jean took the best pictures of me I've ever had."

With British friends, July 1959. <u>Below left:</u> Lord Dudley, who was a schoolboy friend of the Duke of Windsor. <u>Below right</u> (left to right): Lord Dudley; Mrs. Thomas Shevlin; Merle Oberon with husband number three, Bruno Pagliai (behind Merle); David Selznick's son Jeffrey; and Jordy Ward, Dudley's brother. In the foreground are Thomas Shevlin and his daughter, Durie.

In later years whenever I ran into Noel Coward—we first met in New York City in 1932—we always greeted each

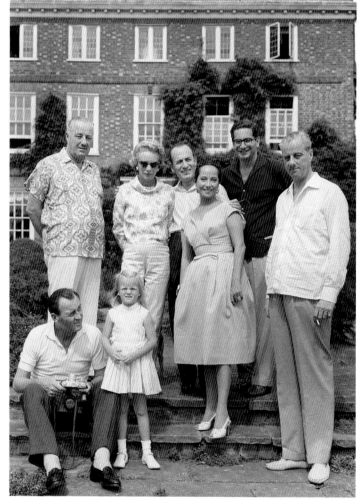

other with "baa-baa-baa," our little joke about visits to the clinic of Professor Paul Niehans, the Swiss specialist in rejuvenation treatments. The Niehans clientele was celebrity heaven, from Winston Churchill and Marlene Dietrich to Gloria Swanson and Rebecca West. Noel teased that Cole Porter should do lyrics for a theme song for the old doctor: "I've Got *Ewe* Under My Skin." <u>Opposite:</u> Noel poses at his newly acquired Swiss chalet at Les Avants, near Montreux, in 1959.

England & Switzerland

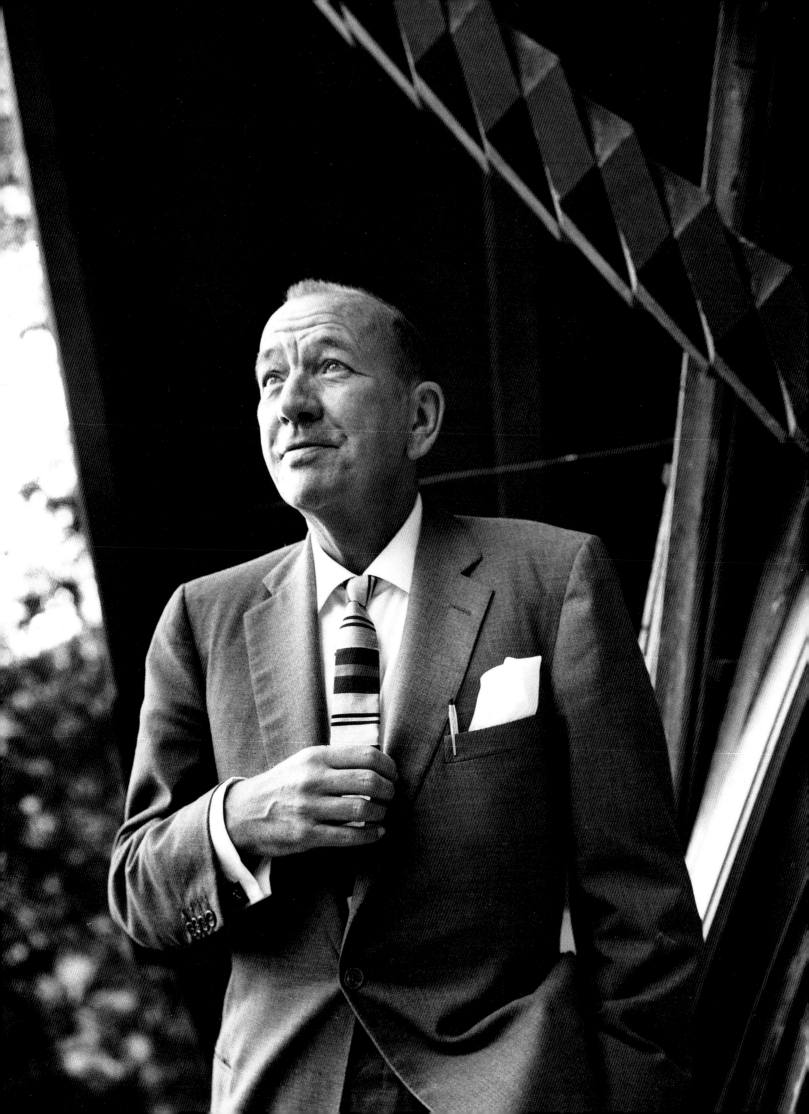

By the 1960s the classic Hollywood of glamour, discretion, censorship, and continuity dictated by the studio system was breaking into pieces. I was spending more and more time in New York and Europe. The Beverly Hills party scene had become a mix of the old guard and new faces, few of whom were as sparkling, sexy, or individual as their starry predecessors. Two exceptions were (opposite) Warren Beatty and Natalie Wood, fresh from Elia Kazan's *Splendor in the Grass*. Natalie seemed to be madly in love with Warren, but I don't know if he has ever been in love with anybody. Maybe Joan Collins, Leslie Caron, Julie Christie, Diane Keaton, and Isabelle Adjani will compare notes one day. Alas, Jean Seberg and Natalie Wood can not. I photographed Warren and Natalie at a Sunday brunch hosted by Minna Wallis. Behind Natalie is the great George Cukor, a director who thought young all his life and was productive right up until his death at the age of eighty-three in 1983. Another veteran, Henry Hathaway, is behind Warren. Right: Minna with Joan Axelrod, Denise (Mrs. Vincente) Minnelli, Natalie, Warren, James Woolf, Henry, and Glynis Johns (with her back to the camera)

Later

On

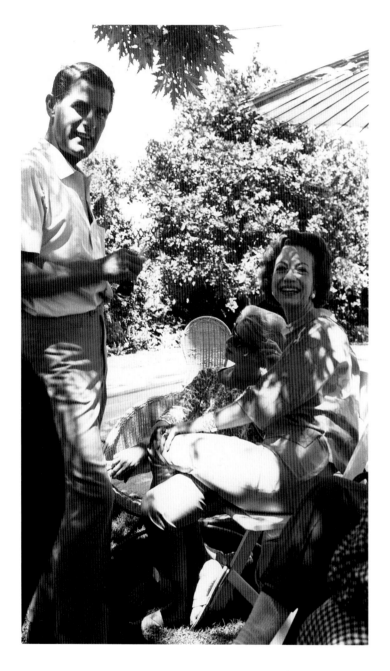

Dropping by for lunch at Minna's place. <u>Clockwise from below left:</u> Director Peter Glenville; Joan Axelrod, the second wife of writer-director George Axelrod; and Doris Vidor. Denise Minnelli and producer Jacques Mapes. Nancy Olson with Henry Hathaway; she might have been married to lyricist Alan Jay Lerner at this time, but Alan

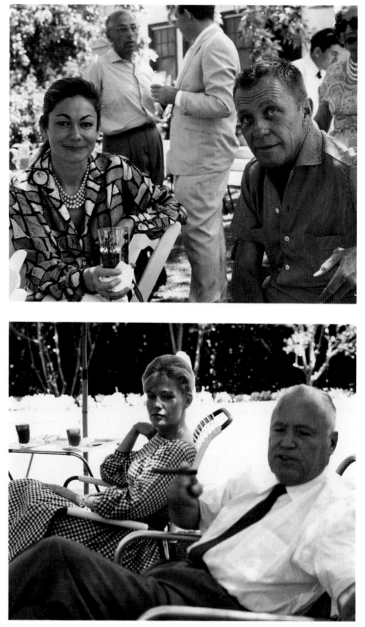

had so many wives, who could keep count or the dates straight.

<u>Opposite:</u> Gathered in my garden are (left to right) George Axelrod; Sandra Church, who created the title role in *Gypsy* on Broadway; New York lawyer Bob Schwartz; and

Joan Axelrod, to whom George reportedly exclaimed: "If you think it's a hell living with me, why don't you try being me for a while."

George and Joan rolled into Hollywood on the success of his 1953 Broadway smash hit, *The Seven Year Itch*, which by 1954 had become a movie property, followed by

Will Success Spoil Rock Hunter?, *How to Murder Your Wife*, and *The Secret Life of an American Wife*. Nothing attracts people like success, and in the 1960s the Axelrods became famous for their parties, which always included the "in" crowd and were loads of fun. Through the years their gatherings diminished in size but never in quality.

I never thought of myself as a serious political animal like some of the movie crowd (such as Democrat Myrna Loy and Republican Irene Dunne), but in the summer of 1960, when the Democratic presidential convention came to Los Angeles, I hosted a luncheon for my fellow Democrats. Below left: Louella Parsons (left) with Clifton Webb and Anita Colby. Louella's archrival, Hedda Hopper, was

a killer Republican. Above right: Afdera Franchetti Fonda, Henry's wife, and David O. Selznick, with *Vogue* editor Margaret Case looking over their shoulders. Opposite, clockwise from top left: Columnist Jimmy Cannon, Marti Stevens, and Martin Gabel. Stefan Grueff with Arlene Francis of *What's My Line?* fame. David Selznick and Henry Fonda with Afdera

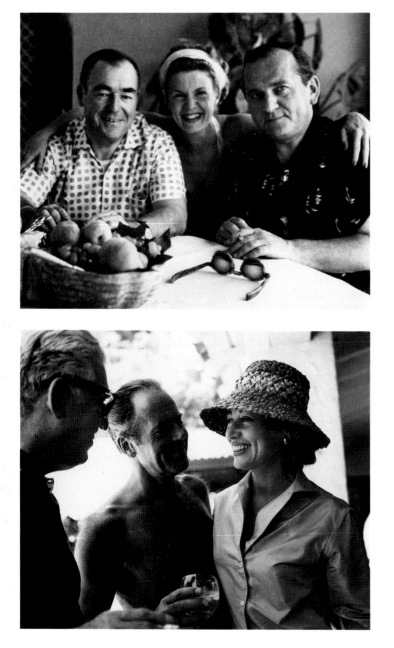
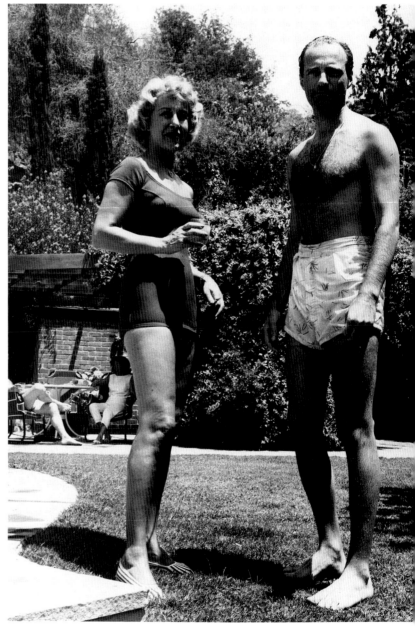

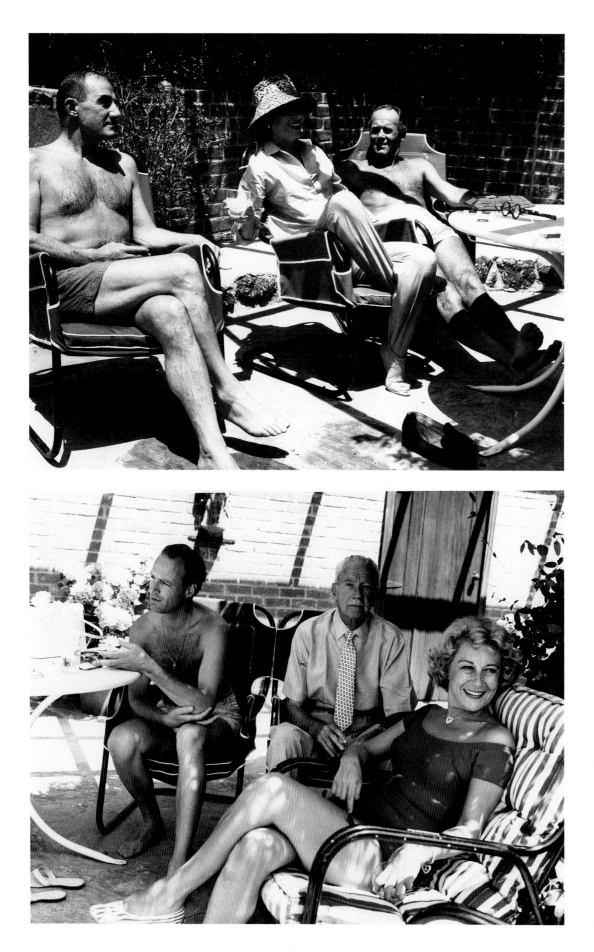

Who said Democrats don't know how to relax? Above left: Joseph Alsop with Afdera and Henry Fonda. Afdera was not able to vote, being a Venetian. I got a kick out of that first name. Her parents reportedly named Afdera after a volcano in Ethiopia. Below left: Stefan Grueff, Clifton Webb, and Arlene Francis wearing her famous diamond-heart necklace. Opposite: Efrem Zimbalist, Jr., and Flo Smith poolside. Efrem was the son of the great violinist, and his mother was Alma Gluck, the opera star who became the first singer to sell a million phonograph records. He was a Yalie, also. After the death of his first wife, Efrem gave up acting. When he returned to the profession, his *77 Sunset Strip* and *The FBI* series made him a household word. Now his daughter, Stephanie, is carrying the theatrical torch.

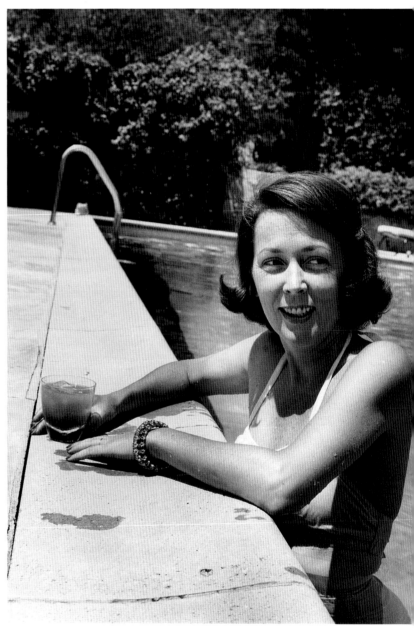

In 1961 director John Frankenheimer (left) and Warren Beatty were young, gifted filmmakers at a point when each was about to fly to genuine heights of achievement. Coming out of television, Frankenheimer would have three prestigious movies released within the year—*The Manchurian Candidate, The Birdman of Alcatraz,* and *All Fall Down.* Warren was starring in the last, having been touted as the most potent new actor since James Dean, thanks to his smoldering sexiness in *Splendor in the Grass* and *The Roman Spring of Mrs. Stone.*

On the set of *All Fall Down* at MGM, the lighting was poor and the setting bleak. Yet as is often the case in photography, everything came together for the right mood.

Christmas 1960 I was Noel Coward's guest at his Jamaican villa, Blue Harbor. Clifton Webb was also visiting and was simply inconsolable over the death of his mother. He was seventy-one, but according to Noel, he "looked ninety." He kept dwelling on the loss of friends going as far back as Rudolph Valentino and Jeanne Eagels in the 1920s. To break this miserere I suggested that Noel's houseguests celebrate the arrival of 1961 by jumping into the pool. Like children, counting the minutes—a kitchen clock was put alongside the edge of the pool next to the champagne—we

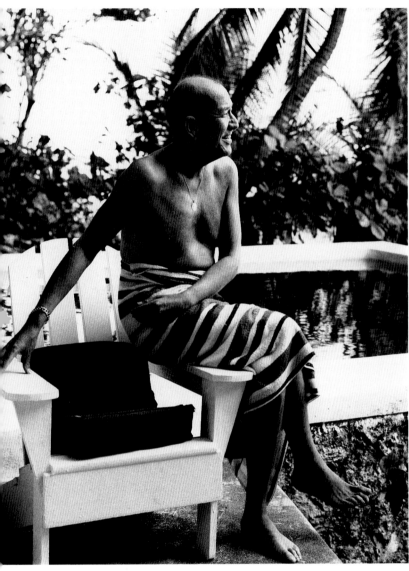
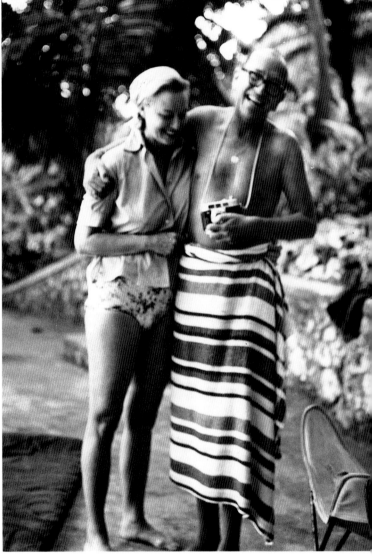

squealed, threw off our towels, and at midnight took the plunge, starkers. But while we all kissed and hugged, lifting our glasses to the New Year, poor Clifton disappeared into his own room, hugging only his grief. Above: A betoweled Noel, alone and with me. Opposite, above: Noel's guests, (back row) Cole Lesley, Noel's valet, secretary, biographer, and heir, with producer Charles Russell; (front) Clifton, me, British heiress Blanche Blackwell, and her son Chris, who would become the big music and movie producer behind the Island empire. Opposite, below: The nude Noel

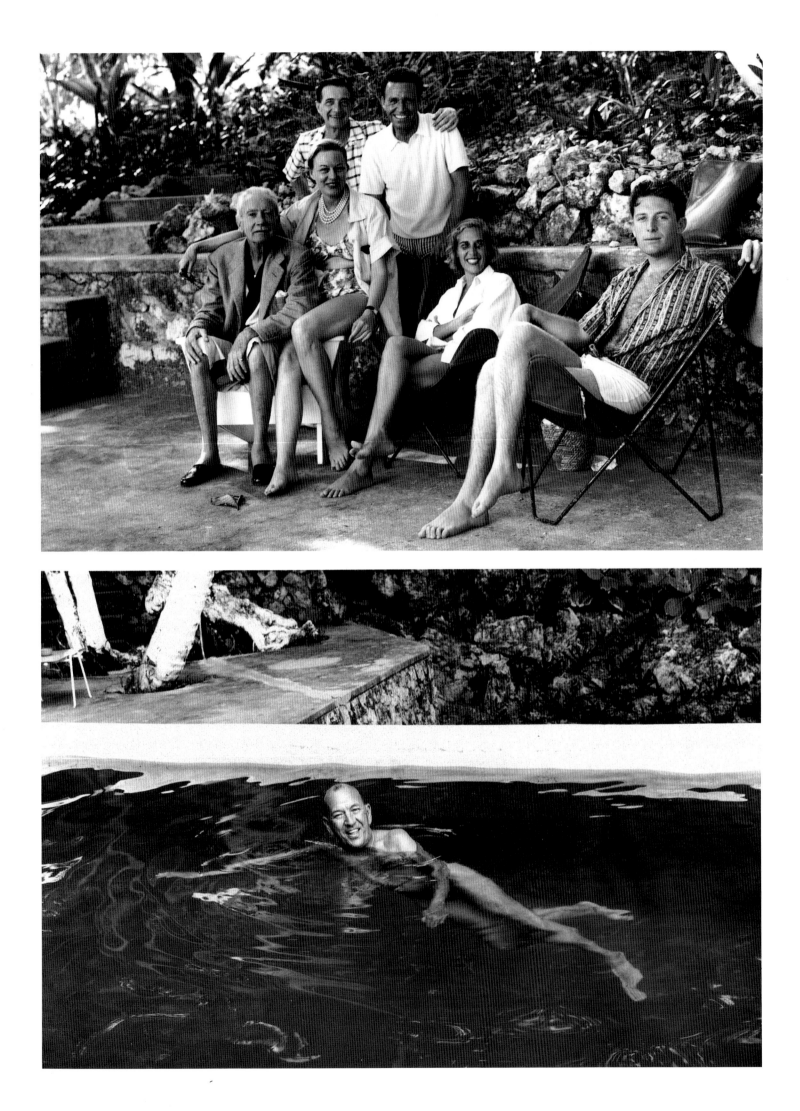

Above left: New York
financier Watson Blair
(left) with Tony Santoro
and me in Capri in 1967.
My friendship with Tony
began in Capri in 1964
and ended in marriage in
California in 1973.
Below left: Noel Coward
with Clairol cofounder
Joan Bové and Gian-Carlo
Menotti in Capri in 1966.
Opposite, above left: Primi-
tive painter Carmelina, here
in her Capri studio in 1965,
is to Italy as Grandma
Moses is to the United
States. She was never a
worldly person, even after
she became successful. On
a trip to Rome to receive
an award for her art, her
suitcase, which was tied
together with rope, came
apart in the middle of the
busy Rome train station.
She became so confused
and upset that she vowed
never to leave her native
Capri again, and she rarely
has since, traveling only
occasionally across the way
to Naples. Opposite, below
left: Tony in Capri in
1966. Opposite, far right: A
friend snapped this shot of
my lifelong friend Michael
Pearman and me in Capri
in 1964 with my dog
Brutus, who lived to be
twenty-two years old.

Opposite: In 1963 I was doing a photo essay on five American artists. A friend, set designer and producer Dick Sylbert, came along on this day to introduce me to David Levine (left). It had just rained, and the Brooklyn Heights Promenade gave me the effect that I wanted.

Right: I dedicated these memories to the most important person in my life, Charles Feldman, and I end with a favorite photograph of my dear friend Cole Porter, who made life special and exciting for me, in Spain in 1955, studying his guidebook before heading out to view the sites of Jerez de la Frontera.

How lucky can you get to have a friend who is a genius, an artist, a supreme stylist in everything he did. Cole was as witty as his lyrics and as memorable as his music. To travel with him, as I did many times, was to experience a unique personality, a talent nonpareil, a character of outrageous fury and fun. But that's another book. Until then, au revoir.

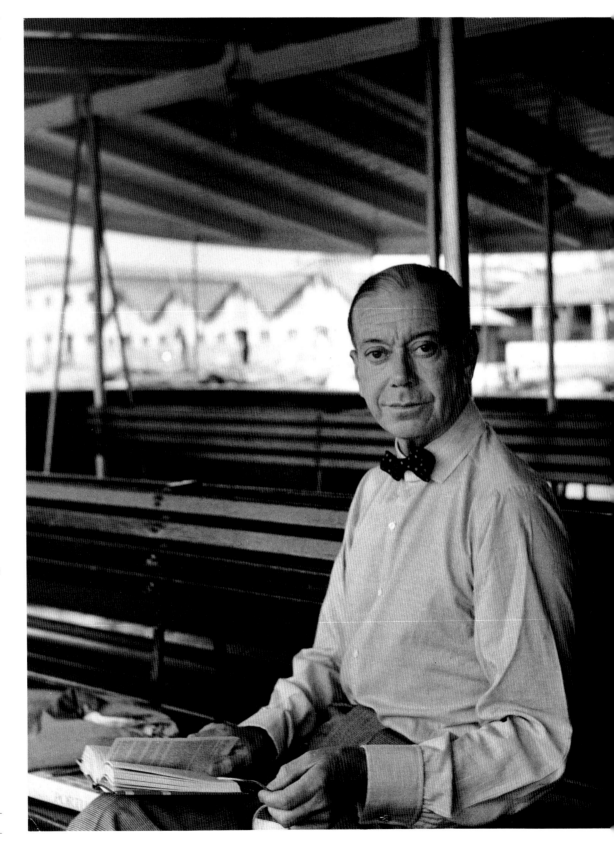

SELECTED BIBLIOGRAPHY

Arce, Hector. *Gary Cooper.* New York: William Morrow & Co., 1979.
———. *The Secret Life of Tyrone Power.* New York: William Morrow & Co., 1979.
Carter, Randolph. *The World of Flo Ziegfeld.* New York and Washington, D.C.: Praeger Publishers, 1974.
Chalon, Jean. *Portrait of a Seductress: The World of Natalie Barney.* Translated by Carol Barko. New York: Crown Publishers, 1979.
Cottrell, John. *Laurence Olivier.* Englewood Cliffs, N.J.: Prentice-Hall, 1975.
Davies, Marion. *The Times We Had.* Indianapolis and New York: Bobbs-Merrill Co., 1975.
Gourlay, Logan, ed. *Olivier.* New York: Stein & Day Publishers, 1974.
Guiles, Fred Lawrence. *Tyrone Power: The Last Idol.* Garden City, N.Y.: Doubleday & Co., 1979.
Gussow, Mel. *Don't Say Yes Until I Finish Talking.* Garden City, N.Y.: Doubleday & Co., 1971.
Hurrell, George, and Whitney Stine. *The Hurrell Style.* New York: John Day Co., 1976.
Kaminsky, Stuart M. *Coop.* New York: St. Martin's Press, 1980.
Lesley, Cole. *Remembered Laughter.* New York: Alfred A. Knopf, 1976.
Loos, Anita. *Cast of Thousands.* New York: Grossett & Dunlap, 1977.
Maxwell, Elsa. *R.S.V.P.* Boston: Little, Brown & Co., 1954.
Michael, Paul, ed. *The American Movie Reference Book: The Sound Era.* Englewood Cliffs, N.J.: Prentice-Hall, 1969.
Minnelli, Vincente. *I Remember It Well.* Garden City, N.Y.: Doubleday & Co., 1974.

Mosley, Leonard. *Zanuck: The Rise and Fall of Hollywood's Last Tycoon.* Boston: Little, Brown & Co., 1984.
Murray, Ken. *The Golden Days of San Simeon.* Garden City, N.Y.: Doubleday & Co., 1971.
Payn, Graham, and Sheridan Morley, eds. *The Noel Coward Diaries.* London: Weidenfeld & Nicolson, 1982.
Powell, Michael. *A Life in the Movies.* London: Heinemann, 1986.
Sealy, Shirley. *The Celebrity Sex Register.* A Fireside Book. New York: Simon & Schuster, 1982.
Shipman, David. *The Great Movie Stars: The Golden Years.* New York: Crown Publishers, 1970.
———. *The Great Movie Stars: The International Years.* New York: Crown Publishers, 1972.
Time-Life Books. *This Fabulous Century.* Vol. 6, 1950–1960. Alexandria, Va.: Time-Life Books, 1970.
Time-Life Books. *This Fabulous Century.* Vol. 7, 1960–1970. Alexandria, Va.: Time-Life Books, 1970.
Tornabene, Lyn. *Long Live the King.* New York: G. P. Putnam's Sons, 1976.
Vreeland, Diana. *D. V.* New York: Alfred A. Knopf, 1984.
Watters, James, and Horst P. Horst. *Return Engagement.* New York: Clarkson N. Potter, 1984.
Ziegfeld, Patricia. *Ziegfeld's Girl: Confessions of an Abnormally Happy Childhood.* Boston: Little, Brown & Co., 1964.

INDEX

PHOTOGRAPH CREDITS

Most pictures in which the photographer appears were taken variously by friends and bystanders. Credit is given where known, as listed below.

Aarons, George: 3; Ball, Russell: 13; Bull, Clarence Sinclair: 12; Coward, Noel: 241 above; Dean, James: 89; Feldman, Charles K.: 16 below left; Foto Rossi, Capri: 242 above; Goulding, Edmund: 21; Hearst News Photos: 17 below right; Hurrell, George: 2, 15; Kolin, Max F.: 17 above right; Leslie, Cole: 240 right; Mahoney Studios, Dallas: 9, 10 (for A. Harris Department Store); Radio Pictures, Robert W. Coburn: 17 left; Hal Roach Studio: 8; Sturges, Howard: 18 above left

Image on page 165 photographed from *Gentlemen Prefer Blondes*, © 1953, renewed 1981 Twentieth Century-Fox Film Corporation. All rights reserved.